Passionate Discontent

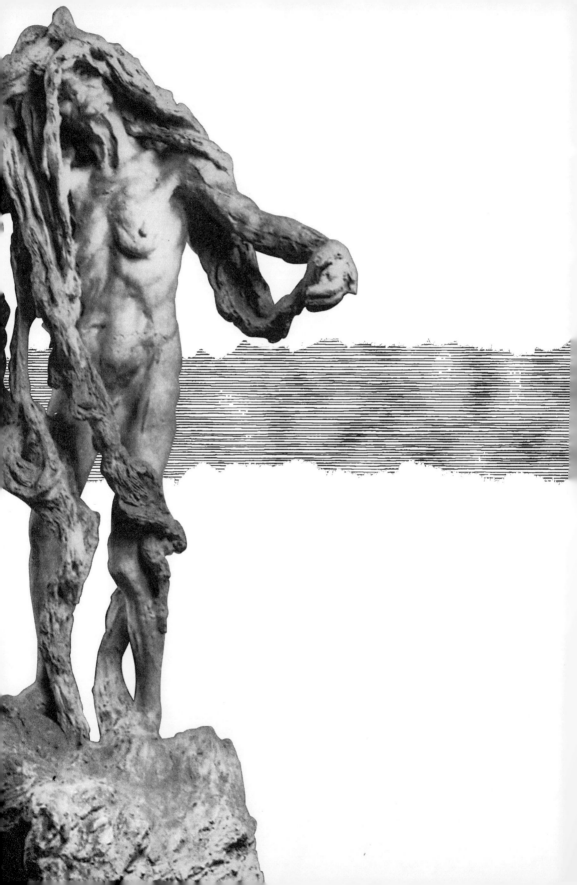

Patricia Mathews

PASSIONATE

DISCONTENT

Creativity, Gender,
and French Symbolist Art

THE UNIVERSITY OF CHICAGO PRESS • CHICAGO AND LONDON

Patricia Mathews is associate professor of art history at
Oberlin College.

The University of Chicago Press, Chicago 60637
The University of Chicago Press, Ltd., London
© 1999 by Patricia Mathews
All rights reserved. Published 1999
08 07 06 05 04 03 02 01 00 99 1 2 3 4 5

ISBN 0-226-51018-2 (cloth)

Library of Congress Cataloging-in-Publication Data

Mathews, Patricia Townley, 1946–
 Passionate discontent : creativity, gender, and French
symbolist art / Patricia Mathews.
 p. cm.
 Includes bibliographical references and index.
 ISBN 0-226-51018-2 (cloth : alk. paper)
 1. Symbolism (Art movement)—France. 2. Gender
identity in art. 3. Art, French. 4. Art, Modern—19th
century—France. I. Title.
 N6847.5.N3M37 1999
 709′.44′09034—dc21 99-22167
 CIP

This book is printed on acid-free paper.

Contents

Illustrations

Preface

This book has been long in the making. It is the result of my intellectual journey from graduate student to mature scholar, from intellectual history to feminism and poststructural theories. My ideas have expanded considerably since its inception. Accordingly, the range of the book has grown as well. The chapters form a contiguous rather than continuous narrative.

The difficult problem of gendered language must be addressed. I have used the male pronoun exclusively at times in this text, recognizing the implicit sexism that informs such usage, because the artistic vocabulary and aesthetic discussed referred specifically to males.

The translations from the French are my own, with the help of Stanley Mathews, unless otherwise noted. Late-nineteenth-century Symbolist language is often obscure, mystical, and philosophical. I have avoided English translations except when the text was unavailable to me otherwise. For a number of writers directly influential for Symbolists, I have used translations from the original language into French dating from the Symbolist period as much as possible in an effort to come as close as possible to the edition that Symbolists would have known.

I would like to thank Sandra Zagarell and Paula Richman, members of my research support group, for their invaluable help at crucial moments throughout the writing of this book. My research assistants Robin Cowie, Jennifer Flock, Cora Guss, Maya Kabat, Matt McNair, Josh Neufeld, Elizabeth Otto, Wynne Pei, Alison Redick, Roula Seikaly, and Adrienne Sudhalter deserve recognition for their bibliographical and

personal support. I thank Mark Antliff, Melissa Dabakis, Thalia Gouma-Peterson, Patricia Leighten, Sarah Schuster, and Athena Tacha for valuable suggestions on the manuscript. Thanks too to the Pétridès Gallery in Paris for their help in numerous ways with the Valadon materials. I greatly appreciate the assistance of Barbara and Pascal Picat with knotty translations and especially with illustrations. Joseph Romano's help was also invaluable in respect to illustrations. They came through for me at crucial moments. My daughters Adrienne and Alice have lived through this book with great sensitivity and empathy. I am so grateful to both of them. Adrienne's editing skills have proven most helpful. Without the intellectual and moral support, as well as editing skills, of my husband Stanley Mathews, this book would not be what it is. However, none of these people can be held responsible for its shortcomings.

My editors at the University of Chicago Press have done a remarkable job. I thank Susan Bielstein for her intellectual support at significant junctures; Paige Kennedy-Piehl for her patience, good humor, and assistance during the complex and difficult process of obtaining permissions and photographs; Kathryn Kraynik for her steadfast patience, emotional stamina, sense of humor, and careful attention to the manuscript; and Anita Samen for backbone in finalizing the project. These women have given me much more support and attention than I ever expected.

This project was carried out with the help of a one-year Oberlin College Research Status appointment, as well as other College research and development funds, and finished under the aegis of a National Endowment of the Humanities Fellowship.

Introduction

A landscape of anxious masculinity, ecstatic suffering, pathology, and spirituality dominated cultural and artistic conceptions of creativity and genius in fin-de-siècle France. Material and social conditions from economic instability to class conflict encouraged a mentality of cultural crisis. For the first time in the history of Western art, a group of artists and writers engaged by these cultural symptoms, worked together to develop a theory and practice of art now known as Symbolism. Mysticism, the occult, byzantine dreams, transcendence, the primitive, a language of vibratory energies and formal innovations merged and collided in this aesthetic.

Various bodies of knowledge were brought to bear in the struggle to define creative genius. The Symbolists marshaled discourses of artistic intuition and Platonic Idealism; scientists and psychologists fought with the weapons of empirical method and objective facticity. These two opposing perspectives found their common ground in belief in the feminized pathology of creative genius.

By the 1880s, shifting gender boundaries threatened the coherency of what was the most rigidly theorized division between masculine and feminine conditions in modern times. Symbolists took on the creative personae of feminized masculinity, only to obfuscate it with masculinist rhetoric and imagery.

Not surprisingly, given the masculinist culture, commentators declared women artists unable to conform to their constructed profile of feminized genius. Many of the writers, including some Symbolists,

stooped to nefarious and vaudevillian theoretical tactics to ensure that such an anomaly as an actual female creative genius remained a structural impossibility. In the practice of art criticism, such tactics were refined and manipulated to bestow limited recognition on certain women artists. The *femme-artiste* and the "masculine" woman artist were produced as critical subcategories, though neither attained the status of the male artist.

Various artistic and literary factions came and went in the mid-1880s, from Hydropaths to Decadents. Within a few years, however, several distinct circles of artists and critics appeared, each with overlapping but different theoretical artistic programs. The two most vocal and commanding, albeit diversified, groups were the Neo-Impressionists and what I will call the Idealists. The Idealists, with whom this book is concerned, were a very loosely knit group which included critics Albert Aurier, Remy de Gourmont, Camille Mauclair (in the 1890s), the Wagnerians represented by Téodor de Wyzewa, and the Roman Catholic mystic aesthete Sâr Joseph Péladan, the originator of the Salon de la Rose + Croix. Idealist Symbolists sought social transformation through spiritual and artistic transcendence in the face of what they perceived as a dying culture. These Symbolists assimilated into their aesthetic other artists with similar interests and compatible suggestive styles, such as Gustave Moreau, Pierre Puvis de Chavannes, and Odilon Redon. Artists close to Aurier included Vincent Van Gogh, Paul Gauguin, and the Nabis,[1] particularly artists and theorists Paul Sérusier, Émile Bernard, and Maurice Denis. The more literary, mystical Idealist artists revolved around Péladan and his Salon and the group included Alexandre Séon and Lucien Lévy-Dhurmer. They had very close ties to the Belgian Symbolist group, Les XX, and almost all the Idealist Symbolists, including Van Gogh and Gauguin, exhibited with them in Brussels. Work by Belgian artists such as Ferdnand Khnopff, Félicien Rops (who actually lived in Paris), and Jean Delville were known in Paris through the exhibitions held by Péladan.

A second group of Symbolists, the Neo-Impressionists, consisted of the critic Félix Fénéon and artists Georges Seurat and Paul Signac, among others. Their interest in Charles Henry's scientific theories of color and form did not preclude their Symbolist search for universal truths. The numerous interactions between groups—Seurat and Séon for example were very close—resist any attempt to define strict boundaries between them. They all responded to the same cultural conditions and social changes in the production of their art.

Writers, scientists, psychologists, and historians from the previous generation—Baudelaire, Balzac, Flaubert, Michelet, and Proudhon

among them—fertilized the ground of the collective unconscious out of which Symbolism grew. The Symbolists mined the poetry rather than the criticism of Baudelaire, particularly *Les Fleurs du mal*, certain novels by Balzac (*Louis Lambert, Seraphita*), and Flaubert (*Tentation de Sainte Antoine*). Such works provided elaboration and support of their mystical, decadent, antibourgeois attitudes. The others—historians and social scientists—exemplified and helped produce the regime of truth—that is, the skein of naturalized and dominant discourses through which a culture envisions itself—in areas particularly important for the Symbolists—gender identity, creativity, and social aspirations. More contemporary forces of biological determinism, especially philosophers of degeneration such as Césare Lombroso, and the social darwinist agenda of the medical establishment created an environment in which biology was destiny.

By looking at the intersecting sites of these cultural strands, themselves interwoven, never fixed or stable, and vying for dominance or voice, this book develops a similar structure of loosely interconnected cultural positions in order to convey the complexity of the nature and gender of artistic identity and practice in fin-de-siècle France. From the perspective of the intellectual structures relevant to French Symbolist Idealist art and artists from circa 1885 through 1895, a study of connections and discrepancies between theory and practice, aesthetic ideals and enactments, gender roles and their performance, elucidates conditions in which artistic identity was forged.

The Symbolist aesthetic is the core but not the focus of the book. The following chapters not only place the Symbolist aesthetic *in* cultural context, they also depend on it *as* context. Chapter 1 outlines the nature of this aesthetic, distinguished by a philosophical synthesis of concepts of genius and gender, of productive suffering, of creative responsibility, and of artistic identity. The evaluation of the Symbolist aesthetic is the subject of chapter 2. It establishes a historical context for the Symbolist aesthetic and focuses on several of its founding discourses—capitalism, primitivism, and bourgeois values. Chapter 3 elaborates on the consequential debate over the nature of genius from the perspective of science and art.

Gender played an important role in this debate as well. Women artists were theoretically banished from the creative realm. Hysteria, for example, a disease that was coded female and one which afflicted large numbers of women in the late nineteenth century, was instrumental in the maintenance of gender difference and notions of female vulnerability. Accordingly, the feminizing structure of ecstasy and intuition so central to the Symbolist aesthetic posed a potential threat to the structure of

masculine creativity. On a primary level, the debate on women and ge-
nius can be understood as a debate over masculine identity. This debate
is the topic of chapter 4.

Chapter 5 looks at Symbolist representations of "woman" from the
perspective of masculinities, including a discussion of the power relation-
ships between these images of woman and the visual and spiritual form
of the (male) androgyne. Chapter 6 considers the practice of women
artists within this exclusive and gender-bound milieu. Analysis of their
social and political condition, artistic accomplishments, and critical re-
ception reveals the options available to avant-garde women artists, the
impediments to their growth, and the critical stereotypes under which
they struggled. Artist Camille Claudel and other women Symbolists are
the focus of this discussion.

The final chapters, 7 and 8, are case studies—the gendered bodies of
Symbolist Paul Gauguin and of independent artist Suzanne Valadon—
that present contrasting examples of how these differently gendered art-
ists produced similar themes. The reception of Valadon also demonstrates
some specific ways in which critics contended with both the class and
gender of women as artists.

Plate 1. *(left)* Paul Sérusier, *The Talisman (Landscape of the Bois d'Amour at Pont-Aven),* 1888, oil on cigar-box cover, 10.625" x 8.625". Musée d'Orsay, Paris. © Photo: RMN, Jean Schormans.

Plate 2. Alphonse Osbert, *Vision,* 1892. Musée d'Orsay, Paris. © 1999 Artists Rights Society (ARS), New York/ADAGP, Paris. © Photo: RMN, Jean Schormans.

Plate 3. *(right)* Gustave Moreau, *Jason and Medea,* 1865. Musée d'Orsay, Paris. © Photo: RMN, Hervé Lewandowski.

Plate 4. Camille Claudel, *The Gossipers,* 1893–1905, onyx and bronze. S. 1006. © Musée Rodin, Paris. © 1999 Artists Rights Society (ARS), New York/ADAGP, Paris. Photo: Erik and Petra Hesmerg.

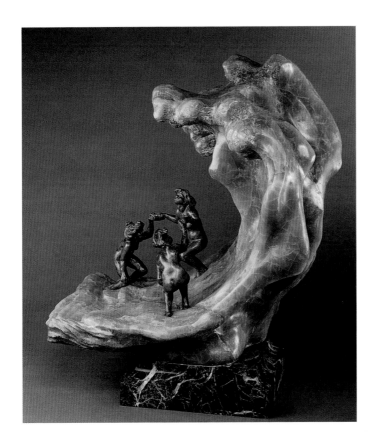

Plate 5. *(left)* Camille Claudel, *The Wave,* 1897-98, bronze and onyx. S. 665g. © Musée Rodin, Paris. © 1999 Artists Rights Society (ARS), New York/ADAGP, Paris. Photo: Adam Rzepka.

Plate 6. Jeanne Jacquemin, *Daydream,* c. 1892–94? Pastel, 32 x 22 cm. Whereabouts unknown.

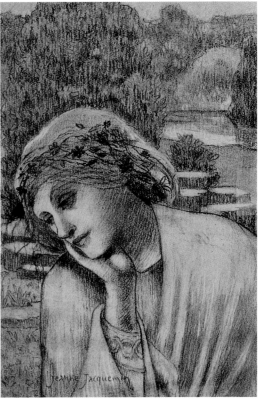

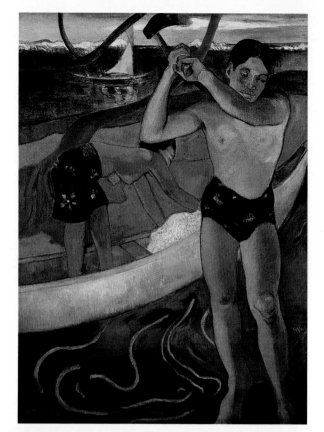

Plate 7. *(right)* Paul Gauguin, *Man with an Axe,* 1891, oil on canvas, 36.25" x 27.25". Private collection, Courtesy Galerie Beyeler, Basel, Switzerland.

Plate 8. Paul Gauguin, *Spirit of the Dead Watching,* 1892, oil on burlap mounted on canvas, 28.5" x 36.375". Albright-Knox Art Gallery, Buffalo, New York. A. Conger Goodyear Collection, 1965.

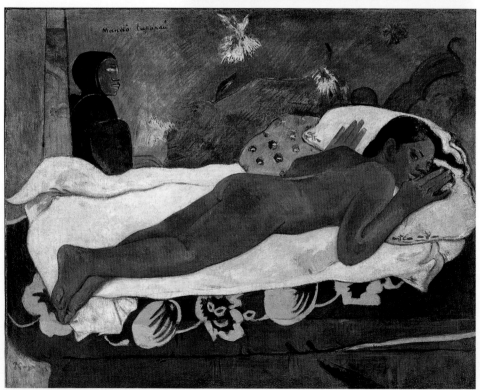

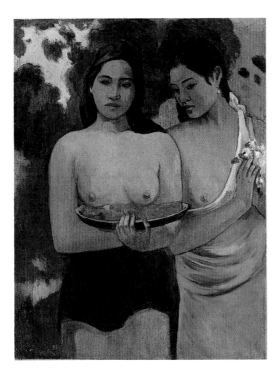

Plate 9. *(left)* Paul Gauguin, *Two Tahitian Women,* 1899, oil on canvas, 37" x 28.5". Metropolitan Museum of Art, New York. Gift of William Church Osborn, 1949. (49.58.1). Photo: © 1997 The Metropolitan Museum of Art.

Plate 10. Suzanne Valadon, *Catherine Nude Seated on a Panther Skin,* 1923, oil on canvas. Private collection, France. © 1999 Artists Rights Society (ARS), New York/ADAGP, Paris. Photo: Courtesy Fondation Pierre Gianadda, Martigny.

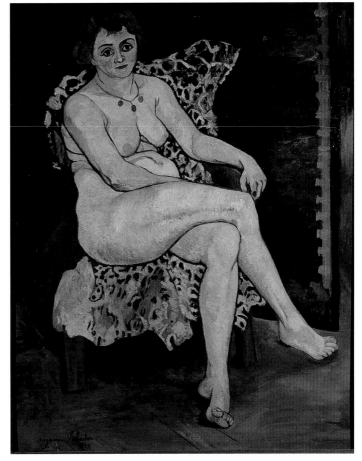

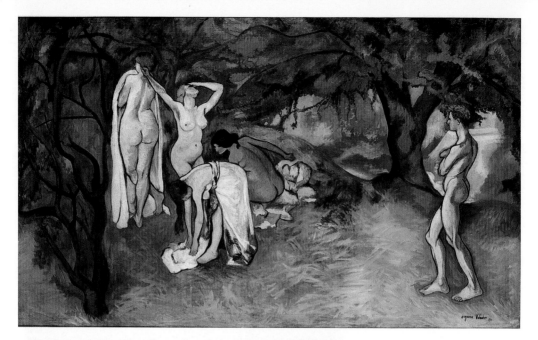

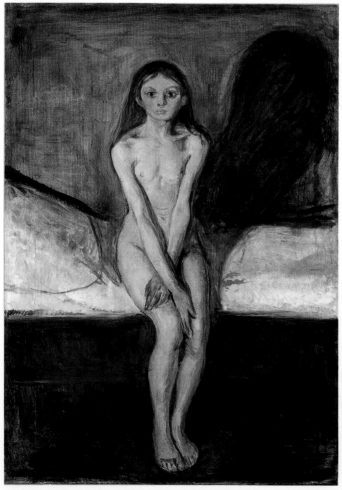

Plate 11. *(above)* Suzanne Valadon, *The Joy of Life (La Joie de vivre),* 1911, oil on canvas. The Metropolitan Museum of Art, New York. Bequest of Miss Adelaide Milton de Groot (1876–1967), 1967. (67.187.113). © 1999 Artists Rights Society (ARS), New York/ADAGP, Paris. Photo: © 1980 The Metropolitan Museum of Art.

Plate 12. Edvard Munch, *Puberty,* 1894–95, oil on canvas. © 1999 The Munch Museum/The Munch-Ellingsen Group/Artists Rights Society (ARS), New York. Photo: J. Lathion, © 1988 Nasjonalgalleriet, Oslo.

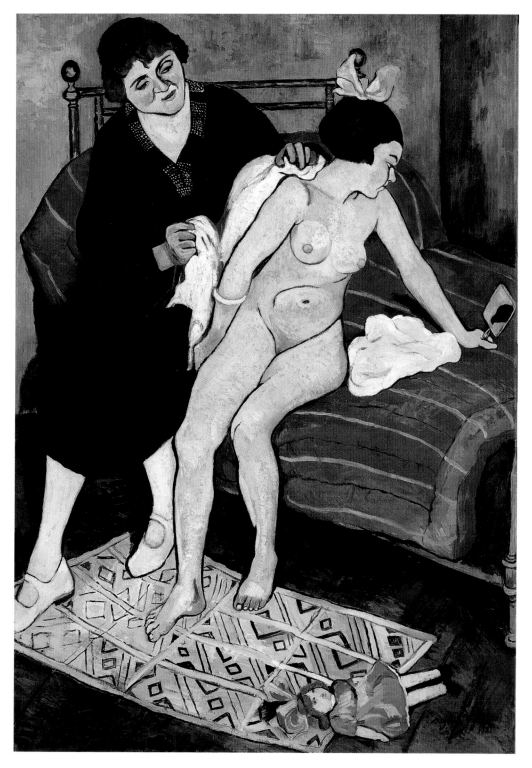

Plate 13. Suzanne Valadon, *The Abandoned Doll,* 1921, oil on canvas, 51" x 32". The National Museum of Women in the Arts, Washington, DC. Gift of Wallace and Wilhelmina Holladay. © 1999 Artists Rights Society (ARS), New York/ADAGP, Paris.

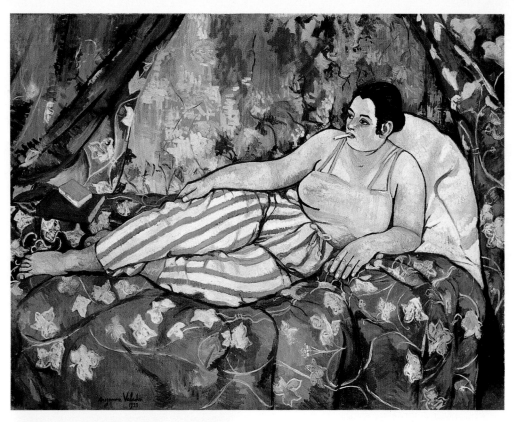

Plate 14. *(above)* Suzanne Valadon, *The Blue Room,* 1923. Musée National d'Art Moderne, Centre Georges Pompidou, Paris. © 1999 Artists Rights Society (ARS), New York/ADAGP, Paris.

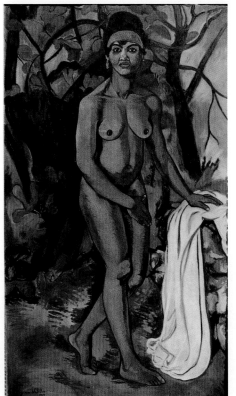

Plate 15. Suzanne Valadon, *Nude Black Woman,* 1919. Musées de Menton, Menton, France. © 1999 Artists Rights Society (ARS), New York/ADAGP, Paris.

The Symbolist Aesthetic

Our religion, morality, and philosophy are
decadent forms of man.
The *countermovement: art.*
(Nietzsche, 1888)[1]

From the Symbolists through the Abstract Expressionists, avant-garde artists claimed to be advocating revolution and social reform through formal means. In Paris during the 1880s and 1890s, the Symbolist urge for reform of the social order was part of a larger cultural anxiety over the social crises and rapid change occurring in all spheres.[2] The Symbolists' "passionate discontent" with contemporary cultural values and social conditions informed every facet of their aesthetic. They were determined to replace what they considered to be a corrupt bourgeois value system with their more spiritually attuned, highly idealistic, mystical, and transcendent aesthetic. The Symbolist aesthetic codified creativity and the artist as the purveyors of Truth. Artistic and literary efforts, however, did not lead to the social transformation the Symbolists envisioned.

The Symbolist aesthetic constructed here relates most directly to the focus of this study, the Idealist branch of Symbolism, but pertains to the Neo-Impressionist Symbolists as well in certain of its aspects—such as its universalizing, essentializing impulses. Tenets of the aesthetic were derived by appropriating the most commonly found stances and attitudes developed by artists and critics of art and literature. This visual aesthetic resembled but was not identical to its literary counterpart. Literary critics often addressed artistic issues or spoke to equivalent concepts in art theory and have been used widely here.[3]

By the time of the Symbolist period in France, which dated from about 1885 to 1895, the model on which avant-garde artists structured meaning had shifted from the Realist investigation of natural appearances

and commentary on the social framework to a Symbolist search for the transcendent Absolute believed to be inherent in all things. Artists who adhered to this mystical Idealist view of the world sought to reveal the hidden relations between the spiritual and material worlds described variously as essences, absolutes, Neo-Platonic Ideas, Baudelairean correspondences, and the Universal Unconscious. In his homage to the teachings of the eighteenth-century Swedish mystic, Emanuel Swedenborg, Baudelaire succinctly characterized this worldview: "everything, form, movement, number, color, perfume, in the spiritual as in the natural world, is significant, reciprocal, conversely related, and corresponding."[4] For some, such as the Decadents, these revelatory correspondences had darker resonances such as that of the femme fatale, but for most Idealists this truth belonged to a higher, more spiritual plane.

It was the visionary artist or *poète-voyant* who had the exceptional ability to perceive the language of correspondences, which was regarded as lost to the dulled senses of most other people and comprehensible only after sensitization and initiation into the mystic universe. According to writer, art critic, and Symbolist theorist G.-Albert Aurier, the "true artist, the absolute artist," must undergo the "preliminary and necessary initiation" in which the "eyes of [one's] interior self" were opened and made ready to see into the world of Ideas.[5] Knowledge was thus revealed through a subjective, mystical process. The artist looked into his own soul, the eyes of his "interior self" were opened, and the correspondences between the natural and the spiritual world were revealed to him. He had become a seer, a *voyant,* a visionary. As Baudelaire noted, in this model, the artist's creativity lay as much in his perceptual as in his intellectual faculties.

Intuition was the means by which the artist-genius grasped correspondences and through which the world of essences and ideas was revealed. Aurier spoke of "our infallible intuition . . . which even in the savage, divines or discerns . . . the universality of psyches."[6] However, if intuition was to reveal the artist's inner vision of the Absolute, it must equally be linked to a superior intellect able to recognize what it has seen and be capable of turning that visionary experience into messianic art.

Aside from artists, only "savages," "primitives," and "simple folk"[7] had such insight into the Absolute. However, according to Aurier, such naive "folk" lacked the intellectual ability to communicate the universals to others through works of art. Women had the gift of intuition if not of insight, but the Symbolists considered it to be squandered and deformed by their feminine shortcomings and fragilities.

The artist brought the "drama of the undulating abstractions" (that is, the Baudelairean or Neo-Platonic Ideas behind appearances) to life

through his own mystical, revelatory, creative power. The artwork itself was conceived of as a synthesis of revealed truth and the artist's subjective response to it. He was thus a genius, "the Expresser of absolute beings," capable of grasping the "radiant Truths" through an experience of inspired revelation referred to as *extase*.[8]

The experience of *extase* was thought to be characterized by an overwhelming emotional state verging on madness.[9] Aurier described the emotion felt in the presence of the essential inner truth of any being or object as "transcendental emotivity." The true artist experienced an "ecstasy" that moved him "body and soul." The soul would "vibrate" and "shiver" before the "sublime spectacle of Being and pure Ideas" revealed to it.[10]

In this experience of mystical revelation that was prerequisite to the creative process, the "being of Being" rose up before the artist in the pulsating, reverberating lines, shapes, and colors of its essence.[11] Thus the Ideas were revealed to the artist through abstract forms and colors. The displacement of faith in concrete social progress to mystical utopian aspiration located meaning in the formalist language of art. As art critic Camille Mauclair put it, line and color are "traces of the divine in the world."[12] Art could reveal Truth through a re-creation of the vibrations of the universe; the language of correspondences was considered to be equivalent to the language of art. Theories of form and color psychology were appropriated to support the notion of art as a universal language and therefore more profound than any other language.

Accordingly, the Symbolist artists, in league with critics, developed a mystical, abstract, synthetic language of color and line so as to represent more abstractly (and thereby more *directly* in their view) the inner essence of all things.[13] They considered appearances of reality to be only a simulacrum of truth as Plato understood it—a mimicry of higher, more perfect forms. From this perspective, Realist attempts to represent illusory appearances only obscured essential meanings. Academic art offended the Symbolists even more than Realism because it claimed to represent the Ideal when, in their view, it only presented a superficial simulation of higher truths.[14] In this way, the Symbolists believed themselves to be structuring a "truer" reality that was more *real* than Realism and more ideal than Academic art.

Symbolist artist Paul Gauguin, and Nabis such as Émile Bernard, Paul Sérusier, and Maurice Denis, helped to formulate and then practiced this aesthetic. In a well-known incident, Gauguin tutored Sérusier in the abstraction of nature for greater expression. In 1888, Sérusier painted an autumn landscape of the Bois d'Amour at Pont-Aven on a cigar-box lid under Gauguin's guidance (see plate 1 in color gallery).[15] The work is

highly abstract, theoretically as well as visually, according to Gauguin's often-cited pronouncement to Sérusier, reported reverently by Maurice Denis:

> Comment voyez-vous cet arbre, avait dit Gauguin devant un coin du Bois d'Amour: il est vert? Mettez donc du vert, le plus beau vert de votre palette;—et cette ombre, plutôt bleue? Ne craignez pas de la peindre aussi bleu que possible.

> [How do you see this tree, Gauguin asked in front of a corner of the Bois d'Amour: is it green? Then paint it green, the most beautiful green on your palette; and that shadow, rather blue? Don't be afraid to paint it as blue as possible.][16]

Denis characterized the work on first sight as "un paysage informe à force d'être synthétique formulé, en violet, vermillon, verte véronèse et autres couleurs pures" ["a crude landscape because of its synthetic formulation in purple, vermilion, Veronese green, and other pure colors"].[17] The Nabis later gave this small painting the name *Le Talisman* in tribute to its importance for the development of their synthetist, Symbolist aesthetic. Although all the Nabis had distinct interests and styles, there is a similar flattening and radical use of color and line in their works (figures 1.1, 1.2, 1.3, 1.4, 1.5).

The Symbolists perceived society not only as trapped in the language of illusion, but as decadent, materialistic, and wholly lacking in spirituality; society could only drag one into the muck of materiality, and its institutions and values had destroyed people's natural ability to grasp universal Truth intuitively. As Sérusier suggested, most people could only recognize the innate universal language through abstraction and generalization instead of through the intuitive inner self because education had effaced their "natural" relationship to it.[18]

The Symbolists' use of spiritual doctrines such as Neo-Platonism was part of a widespread mystic and occult revival.[19] As alternatives to the materialist system based on scientific rationality and fact, these systems offered intuition and revelation as paths to spiritual knowledge and enlightenment. Few poets or artists between 1880 and 1890 failed to succumb to the desire to explore the secrets of the "*au-delà.*" In some, mysticism or the occult inspired a conversion to mystic Catholicism; in others, such as the Idealist Symbolists, theories of mystical correspondences became the basis of their aesthetic; for some, it remained only a thematic prop.[20]

Several branches of mysticism provided important actual and metaphorical tools in the development of the Symbolist aesthetic.[21] In magne-

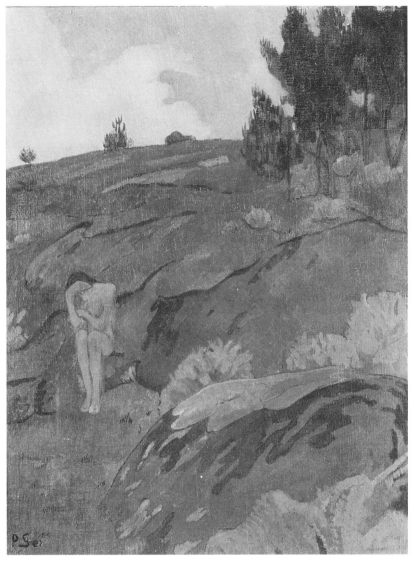

1.1 Paul Sérusier, *Breton Eve or Melancholy*, c. 1890, oil on canvas, .725 × .585 m. Musée d'Orsay, Paris. Photo: Lauros-Giraudon.

tism, mesmerism, or hypnotism, as it was later called, suggestion was the technique used to control the hypnotic subject. The Idealist Symbolists, literary and artistic, founded their aesthetic doctrine on suggestion, as Mallarmé noted in his well-known remark: "*Nommer* un objet, c'est supprimer les trois quarts de la jouissance du poème qui est faite du bonheur

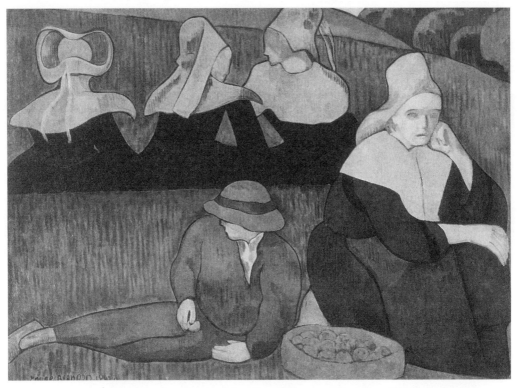

1.2 Émile Bernard, *Breton Women in the Meadow,* 1892, 33″ × 45⅝″. Present where-abouts unknown. ©1999 Artists Rights Society (ARS), New York/ADAGP, Paris.

de deviner peu à peu; le *suggérer,* voilá le rêve" ["To *name* an object is to suppress three-fourths of the enjoyment of the poem that comes from the delight of divining it little by little; to *suggest* it, there is the dream"].[22] For artists and writers alike, suggestion became the primary language to express the mystical correspondences between nature and soul.[23] Sugges-tion also empowered the artist as hypnotist to mesmerize the viewer into a state of revelation.

Alchemy, as an occult "science," also experienced a revival among the mystically inclined at the end of the century. Although some actually dabbled in alchemy, its greater significance for the Symbolists lay in its metaphoric potential. The transmutation through purification of the most prized of all elements from the most base had long symbolized death and resurrection. The alchemical process, then, served as analogies for transcendence from the material flux of everyday life to the purified realm of the Absolute; for the transmutation of the natural world into a purer and more spiritual experience through the reductive, synthetic

1.3 Maurice Denis, *April,* 1892, oil on canvas, 38 × 61 cm. Rijksmuseum Kröller-Müller, Otterlo, Netherlands. ©1999 Artists Rights Society (ARS), New York/ADAGP, Paris.

aesthetic of the Nabis, Gauguin, and Van Gogh; and for the search for the subjective self as a means to encounter a higher reality.[24]

Since the social realm was to be transcended, the concept of the isolated artist, the *isolé,* was vital to the Symbolist aesthetic. The artist must isolate himself from the pollution of society's influence—the mud on the wings of the swan, as Aurier described it—in order to remain pure and, thus, able to receive the initiatory rites necessary to enter the unpolluted realm of the Absolute. The very details of everyday life were considered a burden to the sensitive artist, whose true existence remained above the mundane concerns of the average human being. Such details kept the artist earthbound rather than permitting him to soar into the realms of higher meanings.

The notion of the *isolé* appeared in a wide range of Symbolist texts. According to Symbolist critic Charles Morice, artists must revolt against a society which enchained them and escape into the intimate sanctuary of the soul.[25] Mallarmé described the poet as "en grève devant la société" ["on strike against society"] since "tout ce qu'on peut lui proposer est inférieur à sa conception et à son travail secret" ["everything one can

1.4 Maurice Denis, *Sacred Wood,* 1897, Hermitage State Museum, St. Petersburg, Russia.
©1999 Artists Rights Society (ARS), New York/ADAGP, Paris.

offer him is inferior to his own conception and to his private work"].[26]
For Aurier, the relative quality of a work of art depended on its degree
of separation from the debased social realm: "The value of a work of
art is inversely proportional to the influence of the milieu that it has
sustained."[27]

The Symbolists reified the artwork as a living entity, isolated in its
own pure environment.[28] It did not *represent* essential Ideas, but rather
embodied them. Aurier maintained that the artwork possessed a soul of
its own, superior to that of humans because it was immutable and im-
mortal.[29] Since the art object was considered to have absolute autonomy
from the social realm, the transcendent realm of pure, eternal values

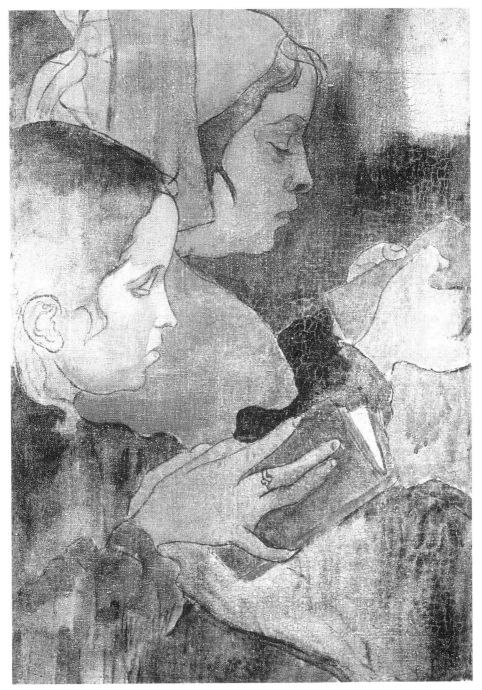

1.5 Armand Séguin, *Breton Peasants at Mass,* c. 1888–89, 21½″ × 15″, National Museum of Wales, Cardiff.

created by the artist-genius through his art had the capacity, according to the Symbolists, to liberate subjects from the laws of bourgeois order and return them to the originary "primitive" state of consciousness. In this state, one was ecstatically aware of the emanating essences that surround and penetrate everything. According to the Symbolist aesthetic, the Symbolist work of art had the power to transform individual consciousness and thereby to transform society itself.[30]

Despite their disengagement from society, the Symbolists envisioned their art and literature as an engagement with life, but life as the realm of the Absolute experienced ecstatically and mystically within the interior self rather than as everyday existence.[31] Art in its disinterested, Symbolist form was meant to be contemplated on a more elevated plane than daily life. According to philosopher Gabriel Séailles, worldly life was an incomplete and perpetual effort, full of multiplicity and contradictions. Art, on the other hand, offered what reality did not. "Il crée une vie artificielle et complète en créant un monde qui, fait de l'esprit, répond à toutes ses lois" ["It creates an artificial and complete life by creating a world based on the spirit and responding to all its laws"].[32]

Artists' antagonism (in theory if not in practice) toward art as commerce issued from this ideology of disengagement. Symbolist artists and theorists stood in moral opposition to the capitalist economy—the decadent "age of gold," as Gauguin described it—and advocated keeping art "pure" from capitalist contamination. Artists should eschew the urge of all capitalist economies—economic acquisition as the principal aim of life, according to Max Weber—and instead subordinate this drive to its proper place as the means to satisfy material needs.[33] Utility and communication systems had become equivalent to marketability and vulgarization respectively. Thus Aurier, who strongly advocated a socially transformative art, could also endorse the "uselessness" of art—"the grandeur of unnecessary things"—as a counterpoint to utilitarianism. He contemptuously described the "profession" of art as a commercial enterprise.[34] Aurier wrote scornfully of the official Salon as a marketplace and complained that art had become only a "lucrative commerce." "Real" artists were not concerned with the latest fortune, fashion, popularity, medals or crosses, but only with the approbation of their own conscience.[35] Morice, too, bemoaned that art itself had become a form of commerce while the "man of letters" starved, yet indignantly proclaimed that the very sale of a work of art or poetry was repugnant to one's honor.[36] He endorsed the example of the painter Eugène Carrière as a model for all true creators: first ignored, then condemned, only after years of struggle did Carrière at last win respect.[37] Again and again, Morice and others reinforced the ideal of the starving artist, isolated outside

of culture, rejecting material accumulation to concentrate solely on his prophetic art, poverty-stricken and ignored by the public and critics alike.[38] The lives of those few artists, such as Van Gogh and Gauguin, who literally experienced the burden of the *isolé,* agonistically sacrificing all for their art and suffering poverty and its attendant consequences thereby, established the popularized myth of the heroically suffering modern artist. Such artists were thought to have "sauvé péniblement nos âmes écoeurées de la glu excrémentielle du matérialisme . . ." ["painfully saved our sickened souls from the excremental muck of materialism . . ."][39]

Indeed, the notion of creativity embodied in the Symbolist aesthetic required that the true artist endure pain and suffering—*la douleur*—as initiation into the ecstatic heights of mystic communion with universals or Ideas. *La douleur,* however, was no mere suffering such as the masses might endure, but the exquisite and refined anguish of only the most sensitive souls. Accordingly, *la douleur* was considered to be a "fertilizing pain" that heightened and refined the sensibility and thus fortified and purified the artist, preparing him to experience the Absolute. "Le génie arrose ses oeuvres de ses larmes" ["The genius fortifies his works with his tears"], as Balzac so eloquently and succinctly put it.[40] Baudelaire expressed this as well in his poem from *Les Fleurs du mal,* "Bénédiction":

> Thanks be to God who gives us suffering
> as sacred remedy for all our sins [impuretés],
> that best and purest essence which prepares
> the strong in spirit for divine delights![41]

The passionately hypersensitive and suffering creative soul, "le poète maudit," was a Symbolist ideal exalted by Rimbaud among many others. Gauguin assumed this role in his *Agony in the Garden* of 1889 (figure 1.6), in which he depicted himself in the guise of Christ and thus as a martyr to his avant-garde art. Again, at the end of his life, Gauguin portrayed himself as Christ on Golgotha being led to crucifixion (figure 1.7), ravaged and tortured by his difficult life and his enemies.[42]

The insistence on suffering as the essential condition of creativity led to a predicated connection between artistic sensitivity and mental illness. Aurier characterized Van Gogh as a "terrible and maddened genius, often sublime, sometimes grotesque, always near the pathological," and praised him for his unhealthy and neurotic qualities. The critic linked the artist's exacerbated state of *extase* to *la douleur* as well: Van Gogh perceived "with abnormal, perhaps even painful intensity, the imperceptible and secret characters of lines and forms, and even more, the colors, lights, nuances

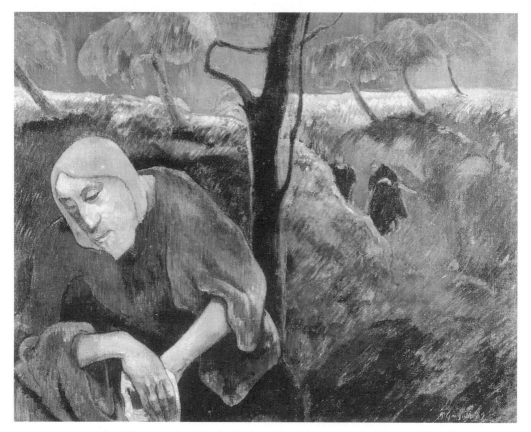

1.6 Paul Gauguin, *Agony in the Garden,* 1889, oil on canvas, 28¾″ × 36¼″. Collection of the Norton Museum of Art, West Palm Beach, Florida.

invisible to healthy eyes, the magic iridescence of forms" (figure 1.8). His art was "sublimely unbalanced" and expressed more profound sensitivities than that of healthy persons.[43]

Mental illness as the extreme condition of *la douleur* became for many the ultimate paradigm for creativity during this period. The mad were thought to have the direct access to the sort of mystical revelation advocated by Symbolists. Their theories of artistic genius encouraged the connection to madness by deploying the terminology developed from the medical codification of mental illnesses during the period by pioneers in psychopathology such as Pierre Janet. Aurier, for example, used medical terms such as hyperaestheticism, "névrosé," and "idée fixe" to describe the sources of Van Gogh's creativity.[44] Outsiderism, the *isolé, extase,* and *la douleur* interacted to construct the Symbolist artist as mad genius.

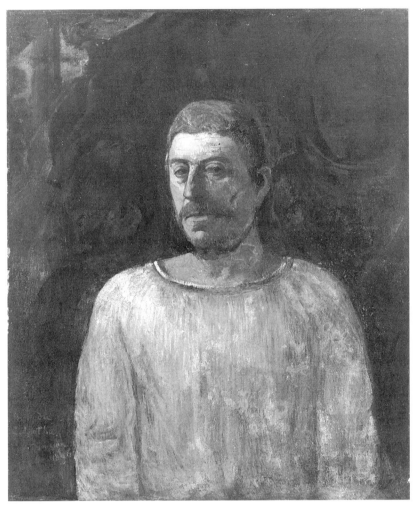

1.7 Paul Gauguin, *Self-Portrait Near Golgotha*, oil on canvas, 76 × 64 cm. Museu de Arte de São Paulo, Assis Chateaubriand. Photo: Luiz Hossaka.

Not long after the appearance of the Symbolist model of creativity, Freud developed his own similar model. His concept of the neurotic artist had a particular resonance with the notion of *la douleur*. He suggested that repression of sexual "researches" at an early age produced neurotic artists. "The suppressed sensuality returns from the unconscious 'in the form of compulsive brooding, naturally in a distorted and unfree form, but sufficiently powerful to sexualize thinking itself and to colour [creative or artistic] operations with the pleasure and anxiety that belong to sexual processes proper.' The brooding never ends, eros is transferred

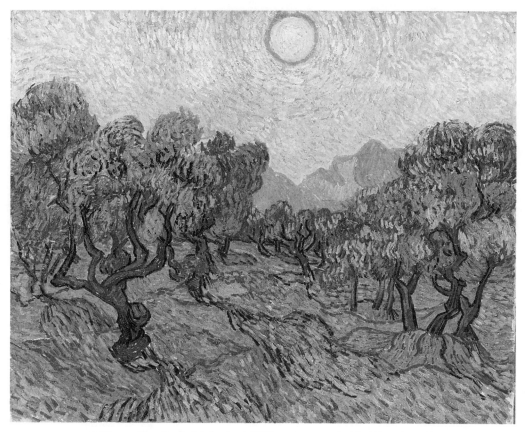

1.8 Vincent Van Gogh (Netherlands XIXc., 1853–1890), *Olive Trees* (*Les Oliviers*) 1889, oil on canvas, 29″ × 36½″, The William Hood Dunwoody Fund. The Minneapolis Institute of Arts.

to the creative activity and the latter becomes a substitute for it."[45] Freud's vision of the creative soul as formed from sexual repression and manifested through neurotic "compulsive" brooding paralleled the Symbolist model of artistic ego, although Freud never posited the extremes of mad genius.

The return of the repressed as "sexualize[d] thinking" which brought the "pleasure and anxiety" of "sexual processes" to artistic "operations" was explicitly echoed in Symbolist theory. The Symbolist formulation of the ecstatic creative process and the experience of Ideas had overt sexual overtones. Yet the Symbolists, in theory, scorned the physical sexual act. Earlier in the century, the Romantic writer Alfred de Vigny

already had described the creative process as an ecstatic delirium that recalled but surpassed sexual pleasure.

> Il y a . . . en moi quelque chose de plus puissant [que la gloire] pour me faire écrire, le *bonheur* de l'inspiration, *délire* qui surpasse de beaucoup le délire physique correspondant qui nous enivre dans les bras d'une femme. La *volupté* de l'âme est plus longue. . . . *L'extase* morale est supérieure à l'extase physique.

> [There is something more powerful [than glory] in me which makes me write, the *delight* of inspiration, a *delirium* which surpasses by a great deal the corresponding physical frenzy which intoxicates us in the arms of a woman. The *voluptuousness* of the soul lasts longer. . . . Moral *ecstasy* is superior to physical ecstasy.][46]

In a very similar way, Aurier privileged the experience of love in the "communion of two souls" in a work of art—the superior soul of the work and the inferior human soul—over human love, which was "always spotted with some kind of dirty sexuality." For Aurier, the experience of the artwork was that of pure, mystical love.

> It is mysticism alone that can save our society from brutalization, sensualism and utilitarianism. . . . We must relearn to love, the source of all understanding.

The divine love of the Ideal as incarnate in art was a purer experience than love of a woman because "in the work of art, matter hardly exists and love will almost never degenerate into sensualism."[47] Vulgar physicality in the guise of woman or of realism in art would only pollute this experience. Yet this very disgust for the bodily also bore "the imprint of desire," and thus returned in the form of eroticized theories of aesthetic experience.[48] Plotinus's Neo-Platonism, for example, so vital to Symbolist theory, had long equated materiality with evil and the realm of Ideas with ecstatic, erotically charged experience. In the tradition of such religious and Platonic mysticism, the Symbolist work of art was meant to move one, literally, body and soul, in an experience that transcended mere physical pleasure but simulated its sexual ecstasy. Aurier employed terms such as penetration and fusion that even he himself recognized as provocatively sexual: "To understand a work of art is to . . . penetrate it, I will say, at the risk of facile jests, with immaterial kisses."[49] He enlisted the dominant/submissive model of the sexual act to describe the act of love for the work of art in mystical terms: one passively submits to a superior being, the work of art, in order to accept that being's divine

revelation. Most Symbolists concurred that in order to receive the artist's vision of Absolute Truth which the work of art was to embody, one must become—to use the language of the day—a lover of the work of art. Both the artist and the viewer then experienced the transcendent as a form of self-pleasuring without sexually debasing themselves. Such images of sexual pleasure without physicality correlated almost word for word with Freud's formulation of the artistic process.

Not surprisingly, considering its links to mysticism, the Symbolists pronounced their aesthetic model as a new religion which people were meant to emulate and aspire to as they previously had traditional religious values.[50] Like religion, art was considered a form of divine revelation meant to offer personal and social redemption. Many Symbolists believed that the religion of art was the last hope for spiritually revitalizing bourgeois culture. During his second visit with Gauguin at Le Pouldu in Brittany, Sérusier inscribed on the wall of the inn Wagner's apocalyptic and zealous statement on the religion of art:

> I believe in a Last Judgment at which all those who in this world have dared to traffic with sublime and chaste art, all those who have sullied and degraded it by the baseness of their sentiments, by their vile lust for material enjoyment, will be condemned to terrible punishments. I believe on the other hand that the faithful disciples of great art will be glorified and that—enveloped in a celestial tissue of rays, of perfumes, of melodious sounds—they will return to lose themselves forever in the bosom of the divine source of all Harmony.[51]

The art critic, writer, and mystic Catholic, "Sâr" Joseph Péladan went further to prophesize the salvation of works of art at the Last Judgment:

> On the last day, just as He will save the souls of the just, God will save the souls of works of art. The heavens will have their Louvre and the hearts of masterpieces will adore throughout eternity their creator the artist as we worship God.[52]

The artist/genius was the savior/martyr/priest/prophet of the new religion of art, the one who could overcome social conditioning and education, isolate himself from the social world, and seek and find the universal language of truth again.

Art critic Camille Mauclair described this idea from a mystical Hegelian point of view: "La ligne et la couleur sont des éléments abstraits, imposés à la matière et distincts d'elle, car ils sont immatériels. Ce sont les traces du divin dans le monde. Le poète et l'artiste sont donc en quelque sorte, des prêtres. Ils apprennent aux hommes à voir Dieu sous les symboles." ["Line and color are abstract elements imposed on matter

and distinct from it, because they are immaterial. They are the traces of the divine in the world. The poet and the artist are therefore in some way priests. They teach men to see God through symbols."][53]

The Symbolists considered themselves and their audience to be a "new aristocracy of the sensibility."[54] They were cynically dismissive not only of decadent, materialist culture, but also of the masses of people who inhabited it. The "ignorant" masses were seen to be both the product and the cause of a decadent society. Indeed, the aim of much Symbolist work according to Aurier was to "stupefy the bourgeoisie." Aurier spoke of the "progressive imbecillization" of the public as society became more materialistic, utilitarian, and industrial.[55]

Avant-garde animosity toward the public and society had existed at least since the late 1840s in the person of Gustave Courbet, and the Impressionists also considered their audience to be limited to an enlightened bourgeoisie, but the Symbolists expressed a greater cynicism, pessimism, and elitism toward their class than their predecessors.[56] Perverted by their education and too caught up in the material realm, the "dull masses," according to Morice, could not possibly understand works of art. The real danger to Idealism, according to art critic Camille Mauclair, came not from its critics but from the public who embraced it: "une foule d'insectes bavards . . . à la cervelle molle" ["a crowd of babbling insects . . . with feeble brains"].[57] Rather, they preferred that which was sentimental and easily assimilated and feared the new. Morice claimed that, prior to modern times, the masses ("la foule") and the poet were in "natural communion," but by the fin de siècle, "Le Public corrompt tout ce qu'il touche" ["The Public corrupts everything it touches"].[58] French official art, too, had deteriorated in Aurier's view. The works exhibited at the Exposition Universelle of 1889 were only "foolish mediocrities" empty of ideas compared with the at least "honorable works" at the previous exposition.[59] Ultimately, although the Symbolists often spoke as though everyone was included in their utopian social reformation, it was actually directed toward and dependent on a sophisticated, educated, enlightened audience.[60]

Accordingly, only an elite audience of sensitive intellectuals was considered capable of truly experiencing Symbolist artworks. The viewer must recreate the work of the artist in his soul in order to receive the poetic/aesthetic emotion parallel to that which the artist experienced.

La Poésie . . . doit demeurer incompréhensible à ceux qui n'ont pas assez l'amour des jouissances esthétiques pour leur dédier, patiemment, toute leur âme. Il faut en faire un temple très haut, fermé aux lâches de l'art, accueillant aux volontés bonnes.

[Poetry must remain incomprehensible to those without enough love for aesthetic pleasures to patiently dedicate their entire soul to them. One must make a very lofty temple, closed to the fainthearted toward art, welcoming to the strong-willed.][61]

The aesthetic experience thus demanded unconditional commitment to the art object as emanating an immanent Truth.[62] The viewer must surrender to the work, entering "un état analogue à celui de l'artiste qui la créait" ["an analogous state to that of the artist who created it"].[63] The experience of the work of art remained as elitist as the conditions of its creation.

The only solution to what the Symbolists perceived as cultural decline was to exile themselves from the unhealthy influences of European society. Primitivism, along with transcendence, was one of the founding discourses of the Symbolist aesthetic.[64] It motivated the Symbolists' desire to return to a direct communication with the Absolute. The Symbolists understood the "primitive" to be equivalent to an originary state of prescient being and its peoples to have an intuitive relation to the pure, unspoilt, "natural" world outside of civilized culture. In other words, the transcendent realm of the Absolute still remained accessible to the world of the "primitive." "Primitivism" was the means through which the Symbolists sought to attain that state of grace. The Symbolists identified with the primitive both in their art and in their lives. Gauguin's abandonment of Western culture to live among the "primitives," Van Gogh's move to the South of France to live "like the Japanese" in nature, the Pont-Aven artists' retreat to the wildness of Brittany, the general simplification and purification of their art—all were manifestations of Primitivism. In conjunction with transcendence, it was the justification for their purist isolationism and for their aestheticization of art.

History was the discourse against which the Symbolists asserted the value of the primitive. History served as a metaphor for the social realm in diametrical opposition to the alternative realm of primitive purity and universality. The Symbolists elided actual historical circumstances and divorced themselves from the worldly discourse of history. Their attack on history was the nexus of a complex series of interacting motivations that issued from their primitivist stance.

History signified different things in different contexts for the Symbolists and for the nineteenth century generally.[65] Two major formations may be distinguished during the period under study: history as a science, that is, as an accumulation of facts and events that purported to represent, selectively and authoritatively, the development of humankind; and history as a teleological, evolutionary force. The Symbolists maligned the former and embraced the latter.

History as the narrative embodiment of a decadent civilization was renounced in order to repudiate the present and progress to a better future situated not in historical events but in the idealized realm of the Absolute. In its role as the authenticator of the dominant bourgeois society, history bore the indelible stain of complicity for the Symbolists.

These pessimistic attitudes toward history prompted the Symbolists and others to abandon the Enlightenment view of the "doctrine of historical [material] progress" as a "move towards some ideal and perfect and rational society"[66] in favor of a theory of historical decline. Baudelaire considered the corrupt and decadent modern world as the last age of man. Aurier, too, felt himself born "too late into a world too old," where even children had "the souls of old men." Morice implicated history in the decline of civilization, contending that the "historical sense is . . . the sign of the old age of a race, a mark of decadence."[67]

In a similar vein, a number of Symbolists condemned the contemporary preoccupation with history as an indication of a widespread inability to come to grips with the present. Aurier held that in this "skeptical and materialistic epoch," this "century of myopic analysis, hideously industrialist and utilitarian," one could no more love art than believe in religion; so, for consolation, one turned to "the *history* of religion and the *history* of art."[68] Nietzsche also condemned modern culture for not being "a real culture at all but only a kind of knowledge of culture . . ." One must rebel, he said, against "a state of things in which [one] only repeats what he has heard, learns what is already known, imitates what already exists." He, too, conceived of history as obstructionist through its structuring of knowledge as the chronicle of the dead past.[69]

The Symbolists also belittled the "science" of history, a status it held since midcentury, for its empirical and analytical nature.[70] The seeker of Truth disdained such scientific rationalism and instead delved into the "mysterious centers of thought" of which Gauguin spoke, through his own "power of divination."[71]

The static body of historical knowledge was perceived by Symbolists to be an educational tool destined to distort and stifle instinctive knowledge.[72] New theories of knowledge at the time "place[d] [an] intuitive, engaged understanding of the world in a different category of knowledge from that which is rational and objective. The former was thought to be the exclusive domain of primitive man and the child; the latter, the domain of civilized Western man."[73] According to the Symbolists, an intuitive, "natural" understanding existed as well in the "universal" language of art, but not in the limited and superficial language of history. Since truth for them resided in universal symbols and not in amassed empirical facts, it was only through the "purity" and "native clairvoyance

of souls" that such symbols could be grasped.[74] History hampered the inherent ability to comprehend the universal nature of reality.

Thus understood as filters that obscured rather than revealed, history and tradition were thought to hinder the artist by fettering the creative imagination to precedent and convention. Morice claimed that the historical sense "restrain[ed] the spontaneity of the creative faculty." Nietzsche, as the most vitriolic among many voices, said that history represented the death of creativity. He felt that it thwarted all potential to act unhindered by imposing its structure of "thus it was" and thereby frustrating any sense of "thus it might be."[75]

In contrast to their repudiation of temporal history, the Symbolists embraced a model of history based on Hegelian theories of an evolutionary and progressive historical force and the teleological progress of art toward greater spirituality.[76] As architectural critic Alan Colquhoun points out, the idea of historical evolution was vital to the avant-garde "flight into the future."

> It was necessary to replace the notion of a fixed ideal, to which historical phenomena had to conform, with the notion of a potential ideal, which historical events were leading up to. . . . History was now oriented toward an apocalyptic future and no longer toward a normative past.[77]

Just as "useless species were fated to disappear" according to evolutionary theory, so Academic art and decadent society too would disappear—to be replaced by a new society constructed from a new art.[78] Morice employed this dichotomous view of history in his writing. He spent much effort explaining his theory of the history of aesthetic evolution as independent from and more progressive than political evolution, while elsewhere berating Balzac for employing a more traditional historical viewpoint.[79]

Despite their condemnation of scientific method as a tool of empiricism, many Symbolists made use of scientific theories, particularly evolution, in developing their teleological histories of art. Jean Moréas, in the first manifesto of Symbolism, advocated a theory of the cyclical evolution of literature with "des retours strictement déterminés" ["strictly determined recurrences"]. Each new phase corresponded to the senility of the preceding. De Wyzewa wedded Platonism, Schopenhauerism, Wagnerism, and evolution in his theory of the laws of art and its progression toward the ultimate creation of a superior life. Yet he claimed at the same time to detest science, for "the uselessness of its so-called knowledge with which it encumbers our spirit."[80]

The Symbolists' metahistorical model of progress incorporated the nihilistic and utopian urge of the avant-garde to wipe away the immedi-

ate past in order to create an ever new and more perfect future. In order to remain fresh, historical memory had to be effaced as soon as it began to be built up and structured. Otherwise, the engagement with the primitive and originary realm would be stifled. The Symbolists considered it their task to constantly erase historical memory and to perpetually excavate the primordial memory of Ideas.

Basic elements of the Symbolist aesthetic can be found in numerous writings of the period. For Nietzsche, for example, the artist and the aesthetic were ideal forces for the dynamic expression of life. He believed, however, that the significant forms of artists were not to be found in the Symbolist notion of a universal, essential Truth based in higher Ideas, but rather in a dionysian and furious ecstasy of creativity. Nietzsche also disdained bourgeois culture as stale and insisted on artistic necessity and individual freedom from social constraints.[81]

The timeless realms of Symbolist art, from Gauguin's Tahitian paradise to Puvis de Chavannes's or Denis's harmonious visions embody the Symbolist aesthetic just described. Of this group, Gauguin came closest to fulfilling its aims and potential. In a work such as *Parau na te varua ino* (*Words of the Devil*), 1892 (figure 1.9), the richly colored foreground suggests a "secret life" expressed through his saturated, "exotic" colors and undulating, even epigrammatic, lines and shapes. The gazes of the figures invoke mystery and wizardry. The world of concrete events is banished in favor of a dreamy, visionary realm in which nature seems to be alive with mystical correspondences, and plants look at the figures and each other with "familiar glances." Gauguin relies on the language of form and color rather than narrative. His works are meant to touch our senses directly and bypass the intellect to reach our intuition.[82]

Symbolist critics considered Gauguin to be the quintessential Symbolist. Speaking of Gauguin's painting, *Bonjour M. Gauguin,* 1889 (figure 1.10), Morice presented the artist as a Symbolist: "How can we fail to understand the artist's feelings? Do we not discern his anguished soul quivering in the depths of the troubled landscape, whence he comes toward us? And the peasant woman, is she not right to feel uneasy?"[83]

Gauguin also promoted himself through his paintings and his writings as a savage and a suffering outsider. His description of his self-portrait, *Les Misérables,* 1888 (figure 1.11), recalls the *isolé* as well as psychologist Césare Lombroso's characterization of mad genius as wild-eyed and feverish: "It is the face of an outlaw, ill-clad and powerful like Jean Valjean—with an inner nobility and gentleness. The face is flushed, the volcanic flames that animate the soul of the artist. . . . this Jean Valjean, whom society has oppressed, cast out—for all his love and vigor— . . . a portrait of all wretched victims of society who avenge us by doing

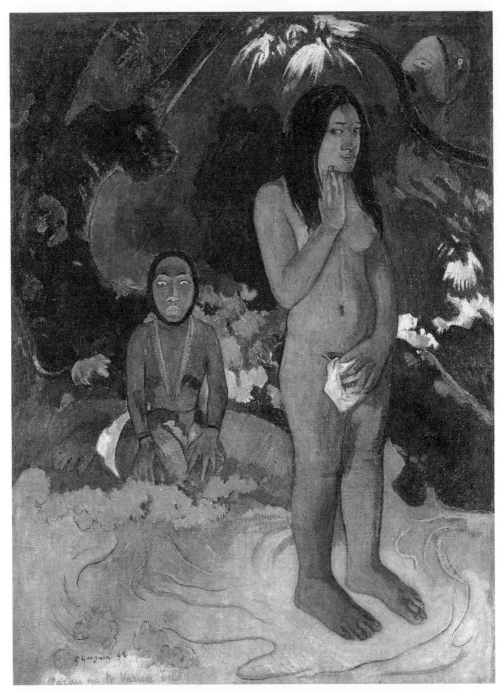

1.9 Paul Gauguin, *Parau na te varua ino* (*Words of the Devil*), 1892, oil on canvas, 36⅛″ ×
27″, Gift of the W. Averell Harriman Foundation in memory of Marie N. Harriman,
Photograph © Board of Trustees, National Gallery of Art, Washington.

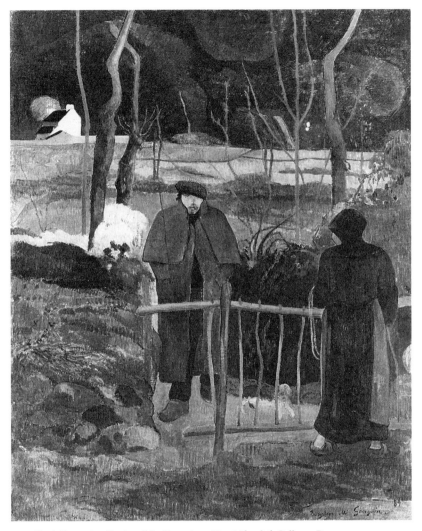

1.10 Paul Gauguin, *Bonjour M. Gauguin,* 1889, Národní Gallery, Prague.

good. . . . All the reds and violets streaked with bursts of flame as though from a glowing furnace, the site of many battles in the painter's thoughts." Van Gogh, when he received the painting, "reproached Gauguin . . . for exhibiting his wounds and forcing others to share his anxieties and distress."[84]

The stringent theory of Symbolist art developed by artists and critics outlined in this chapter was much more elastic in practice. Like any category of art, in practice its boundaries fluctuated greatly, to the dismay of critics who sought to stabilize them. A number of art critics of the

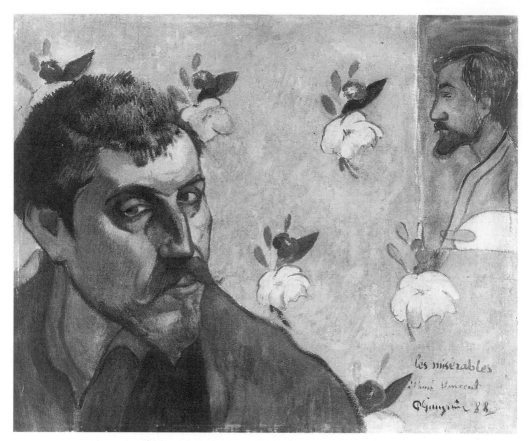

1.11 Paul Gauguin, *Les Misérables (Self-Portrait)*, 1888, oil on canvas, Vincent Van Gogh Foundation, Rijksmuseum Vincent Van Gogh, Amsterdam.

period were particularly invested in the Symbolist aesthetic and at times misrepresented works of art by applying its principles inappropriately. Artists participated in the Symbolist aesthetic to varying degrees. Some, like Gauguin, synthesized its theory and practice. Those artists less theoretically oriented, such as Van Gogh, who had close parallels in his own art to the Symbolist aesthetic, were fully incorporated into the aesthetic by Symbolist writers because their art seemed to these writers to reflect its tenets. Still others, such as Eugène Carrière, Émile Bernard, and Nabis such as Maurice Denis or Paul Sérusier, accepted most of its principles or emphasized certain aspects of them. Despite their circumscription from the Symbolist aesthetic, women artists appropriated what they could from it, considering it was predicated on masculinity, to develop their own eclectic aesthetics.

The Symbolist
Aesthetic in Context

C O M M E N T A R Y A N D
C R I T I Q U E

> The aesthetic is at once, . . . the very secret prototype of human subjectivity in early
> capitalist society, and a vision of human energies as radical ends in themselves which
> is the implacable enemy of all dominative or instrumentalist thought. . . . it repre-
> sents on the one hand a liberatory concern with concrete particularity, and on the
> other hand a specious form of universalism. . . . Any account of this amphibious
> concept which either uncritically celebrates or unequivocally denounces
> it is thus likely to overlook its real historical complexity.
> (Terry Eagleton)[1]

My aim in this chapter is neither to celebrate nor denounce the Symbolist
aesthetic. Rather, I want to explore how Symbolist opposition func-
tioned in both progressive and reactionary ways within the historical,
economic, and philosophical matrix of the society to which it was ad-
dressed and to tease out some of the consequences of the cultural embed-
dedness of its principles.

The Symbolists' antimaterialistic idealism was largely a response to
the concrete social conditions of the fin de siècle.[2] A widespread social
and financial crisis afflicted France in the last decades of the nineteenth
century. The grave and prolonged economic stagnation (1883–96) called
the Great Depression began in 1882 with the failure of the Union Géné-
rale Bank. The economy continued to erode as industrialized countries
such as Germany and the United States came to monopolize the con-
sumer market, even weakening the French privileged niche in the export
market for fine luxury goods.[3] At the same time, agrarian production
and profit dropped dramatically,[4] and the workforce diminished due to

29

a decline in birth rate and an aging population.[5] The stability of the early Third Republic was further menaced by threats of war and revolution; the mobilization of labor through strikes, agitation and collectivism; the rise of activist socialist and anarchist movements; the emergence of a nationalistic new Right; the bitter feud between clericals and anticlericals; and the intensified challenges to gender roles through the emergence of the New Woman and the expansion of the feminist movement.[6] According to Eugen Weber, the entire climate of the last thirty years of the century was one of continual crisis.[7] These volatile circumstances also helped to destabilize class distinctions and aroused anxieties about individual identity. Social theories such as the degeneration of the social body and the determinist bigotry of social darwinism helped produce a sense of impending peril, competitiveness, fear, and prejudice that permeated social discourse. Such theories increased the rate and rigidity of the "normalization" of (qualitative) divisions between genders, races, and sexualities.

Notions of the unified, stable self were further brought into question by the disorienting experience of modernity, itself the product of massive, interdependent transformations during the nineteenth century, including the rise of the bourgeois and its values; the industrial revolution and the predominance of mass production; the transition from a rural, agricultural society to an urban, industrial one; and the success of market capitalism seen in avid consumerism and the rise of department stores at the expense of small shops.[8] All of these changes worked to corrode humanist as well as elitist values in favor of a "democratic" culture of commodification and materialism.[9] Radical labor movements, problems in the marketplace and economic instability, the organization of political extremism on both the Left and Right, religious antagonisms, shifting identity constructions, and the experience of modernity through capitalism—such were the social conditions under which Symbolism developed.

The devastating effect of an urban, industrial mass culture on individual identity and experience had particular importance for the Symbolists. Georg Simmel, in his classic essay on the psychological effect of the metropolis on its inhabitants, described attempts to recover lost subjectivity amidst an overadministrated society:

> he [sic] can cope less and less with the overgrowth of objective culture. The individual is reduced to a negligible quantity, . . . [and] has become a mere cog in an enormous organization of things and powers which tear from his hands all progress, spirituality, and value in order to transform them from their subjective form into the form of a purely objective life.

. . . He has to exaggerate this personal element in order to remain audible even to himself. The atrophy of individual culture through the hypertrophy of objective culture is one reason for the bitter hatred which the preachers of the most extreme individualism, above all Nietzsche, harbor against the metropolis.[10]

Simmel further suggested that the hollowness of the capitalist money economy and the amount of nervous stimulation in large cities necessitated a form of individual dissociation which he referred to as "reserve," a "blasé" attitude, that ironically granted personal freedom through detachment from this stressful and overstimulating milieu.[11] The Symbolists shored up ego boundaries through an insistence on difference and a reaffirmation of the unity of the self and isolated themselves from the fragmented, dislocating experience of the modern world in order to transcend to a realm of lucid intelligibility where their individuality and personal freedom could be privileged as genius rather than subsumed into mass culture.[12]

As Simmel indicated, the culture developed through commodity capitalism was integral to the late nineteenth-century crisis of subjectivity.[13] Preceded by earlier events such as the World Fairs of 1855 and 1867, which Walter Benjamin described as "sites of pilgrimages to the commodity fetish," consumer capitalism was in full force by the end of the nineteenth century.[14] Max Horkheimer and Theodor W. Adorno, in their consequential essay on the individual and social effects of capital, "The Culture Industry: Enlightenment as Mass Deception," wrote that

> the breaking down of all individual resistance, is the condition of life in this society. . . . The most intimate reactions of human beings have been so thoroughly reified [by the culture industry] that the idea of anything specific to themselves now persists only as an utterly abstract notion: personality scarcely signifies anything more than shining white teeth and freedom from body odor and emotions.[15]

The extent of the commodification of social realms, "the marketing, the making-into-commodities of whole areas of social practice which had once been referred to casually as everyday life," had strongly affected the artistic and critical strategies of the Realist avant-garde in the 1860s and 1870s.[16] The alienated subject of capital had been the theme of Realist works, from Manet's *Bar at the Folies Bergère* to Degas's monotypes.[17] Meyer Schapiro and others have argued persuasively that the Impressionists fashioned—from the newly developed spaces of public leisure—sites of resistance in response to the bourgeois class's increasing powerlessness against the haut bourgeois and governmental institutions.[18]

However, by the Symbolist epoch, the Idealist avant-garde no longer considered the commodified social realm to contain an oppositional space. Aurier aligned himself with what he described as a vanishing group of refined intellects, "pauvres imbéciles d'un autre age," who were born "too late into a world too old."[19] More estranged from their culture, they advocated Schopenhauer's dictum, "the world is my representation" and forcefully championed individuality and subjectivity.

In effect, the Symbolists regarded mass culture and its public as the enemy. They perceived the materialist and boorish bourgeois class to be completely identified with capitalism, to have been little affected by previous avant-garde art practice, and to be incapable of imagining, much less acting within, public sites of resistance.

The appearance of two distinctive types of (bourgeois) avant-garde individualism in both life and literature during the nineteenth century— the rarefied aesthete and the dandy—was intimately linked to the need for distinction and individuality in the face of a rising commodity culture. Both kept emotional distance from society, the earlier dandy a more blasé and amused observer of the social scene, the Symbolist aesthete a more haughty and hyperaesthetic participant in fantasy and decadence.[20] Both relied on consumerism to determine their "look" even if only through a rejection of the latest fashion. The aesthete, however, much more than the dandy, sought to disengage himself from society in order to create a refined atmosphere of the spiritual and the exquisite and thus represented another Symbolist manifestation of the retreat from the worldly. The conflict between the escapism of the aesthete and his dependence on commodity culture exemplified the deeper cultural conflict of Symbolists and bourgeois alike—individuality and distinction arose against, yet were complicit with, commodity capitalism.

Marcellin Desboutin conveyed these aspects of the aesthete in his *Portrait of Le Sâr Mérodack Péladan,* 1891 (figure 2.1). Symbolist art critic, novelist, and religious mystic Joseph Péladan was founder and "Sâr" of the Ordre de la Rose + Croix Catholique du Temple et du Graal. He established the Order's often lavish international Salons in Paris that took place between 1892 and 1897, "Les Salons de la Rose + Croix," the first of which was supported by another arch aesthete, Le Comte Antoine de la Rochefoucauld. Participants included a stylistic range of Symbolist painters such as Charles Filiger, Émile Bernard, Armand Point, Carlos Schwabe, Paul Gauguin, and Vincent Van Gogh.[21] Max Nordau's description of Péladan in his notorious book *Degeneration,* a tirade against what he considered to be the decline of Western civilization, conveyed well the spirit of Péladan the aesthete also seen in Desboutin's portrait

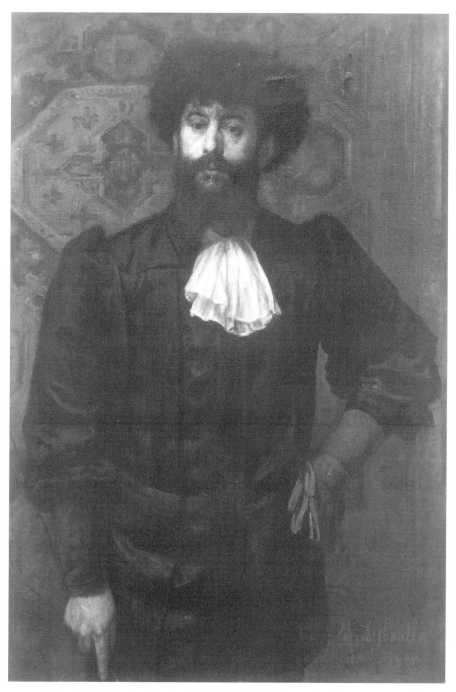

2.1 Marcellin Desboutin, *Portrait of Le Sâr Mérodack Péladan,* 1891, oil on canvas, Musées d'Angers. Photo: J. Evers.

and more specifically in Alexandre Séon's portrait of the Sâr in robes
(figure 2.2):

> He has . . . arrogated to himself the Assyrian royal title of 'Sâr,' . . . He
> maintains he is the descendant of the old Magi, and the possessor of all
> the mental legacies of Zoroaster, Pythagoras and Orpheus. . . . He dresses
> himself archaically in a satin doublet of blue or black; he trims his ex-
> tremely luxuriant blue-black hair and beard into the shape in use among

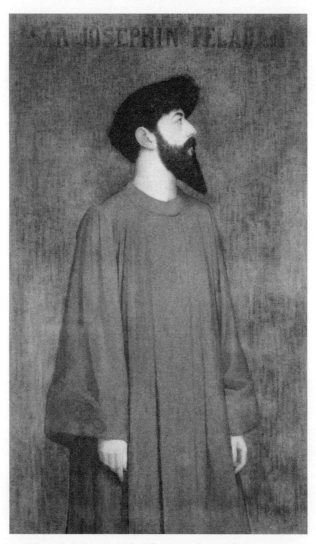

2.2 Alexandre Séon, *Portrait of Le Sâr Mérodack Joséphin Péladan,* 1891, oil on canvas,
Musée des Beaux-Arts de Lyon, France. Photo: Basset Studio.

the Assyrians; he affects a large upright hand, which might be taken for mediaeval character, writes by preference with red or yellow ink . . . a composer . . . has composed for him a special fanfare, which on solemn occasions is to be played by trumpets at his entrance.[22]

Péladan's entire lifestyle and body of work exemplified an extreme example of the retreat from bourgeois reality into a byzantine dream world of mysticism and ritual that distinguished the aesthete, and yet the creation of an individual style so central to his identity was largely determined by his own precious form of consumption described in Nordau's account.[23]

A flamboyant form of costume marked the aestheticist identity for a number of Symbolist artists, even those who might not be aesthetes in the byzantine fashion of Péladan. Gauguin, for example, while in Paris "cut an extremely bizarre and ostentatious figure wherever he went; his costume was a form of drag," according to Stephen Eisenman's recent study of the artist.[24]

In the Symbolist novel, *A Rebours*, 1884, by J.-K. Huysmans, the aesthete Des Esseintes, based on the figure of the aesthete Le Comte Robert de Montesquiou-Fezensac (figure 2.3) and the ultimate *isolé* as Huysmans pictured him, was a "heroic" consumer. As Rosalind Williams recently described Des Esseintes, he "singlehandedly tried to resist an unauthentic market and to create his own ideal of consumption."[25] The novel is "an indictment of the duplicity, greed, folly, and shamelessness of modern consumption." Nevertheless, the aesthetic of Des Esseintes was as dominated by the commodity market as any other of the period.[26] Benjamin's description of the nineteenth-century Parisian art collector/connoisseur, a type similar in his refinement to the French aesthete, suggests why: "To him falls the Sisyphean task of obliterating the commodity-like character of things through his ownership of them. But he merely confers connoisseur value on them, instead of Intrinsic value." As the aesthete demonstrates, "the fetish of individuality provided a form within which consumer capitalism could operate."[27] Indeed, as Thorstein Veblen pointed out in his now classic study of the leisure class (1899), "conspicuous leisure" and "conspicuous consumption" were [are] essential and conventional means to attain status and honor within culture.[28] The ownership of items in "high" culture in the form of works of art, other precious objects, and elaborate, expensive clothing, along with the disdain for everyday activity created a style for the aesthete that can only be termed aristocratic. The refinement necessary to become an "aristocrat of the sensibility" ultimately depended as much on wealth, ownership, and display as on sensitivity. Refinement itself connoted for many the ability to distinguish the value (that is, the "quality") of commodities.[29]

2.3 Antonio de La Gandara, *Portrait of Robert de Montesquiou-Fezensac,* Musée des Beaux-Arts de Tours. Photographie Archives d'Indre-et-Loire.

Class identity was also destabilized by capitalism, further fueling the crisis of subjectivity. Although the hierarchical *structure* of class remained relatively stable during the last decades of the century, individual class *identity* was in almost constant flux, such that the set of behavioral codes which determined one's status in the social pecking order was elaborated and refined, and distinctive manners and style took on greater import than before.[30]

Although the *grande-bourgeoisie* remained relatively secure during the

early Third Republic due to its political power, wealth, and highly elitist nature, there was much greater flux among the other classes. Rural immigration to the cities continued to increase, and the *moyenne* and *petite bourgeoisie* grew rapidly.[31] Salaried professionals—members of the *petite bourgeoisie* such as civil servants, engineers, teachers—greatly enlarged their numbers during the early Third Republic. The rise of this *petite bourgeoisie* brought with it the beginning of a new meritocracy. Unable to depend on more traditional forms of patronage for their success, they relied on self-promotion and the newly secured universal education to gain power and stature. The coexistence of these modern strategies with older conventions for achieving distinction is just one of countless examples of the shifting and precarious nature of class identity at the fin de siècle. As the "most upwardly mobile" group and the "greatest force for social change" among the bourgeoisie, this *petite bourgeoisie* represented the greatest threat to class distinction and its codes, and the threat came from within their own class.[32]

The working classes, however, were the most overt menace to boundaries of bourgeois identity. The bourgeoisie's fear of this class had burgeoned after the role of workers in the revolutionary Commune of 1870–71 and its increasing numbers during the 1880s also alarmed the middle class.[33] The labor movement's "individualistic, self-sufficient, pseudo-anarchist ideology" was cemented during the fin de siècle, and its "ideological objective of replacing capitalism with a new social order" made the threat of the working classes even greater.[34] The volatile nature of working-class politics was no doubt heightened by the discrepancy between the Republic's professed policy of unity and equality among classes and the actual practice of bourgeois class rule—that is, to integrate the working class into their own ranks and to suppress it when necessary.[35]

Such circumstances and class tensions amplified the already anxiety-ridden weakening of visible and cultural boundaries within class identity. Department stores, for example, made it possible for working-class women to purchase inexpensive goods that allowed them to simulate bourgeois appearance.[36] Indeed, an increasing number of female workers (typists, bank workers, cashiers, and school teachers comprising "a new white-collar proletariat, often recruited from educated daughters of the declining petty bourgeoisie") had "no desire to be considered 'ouvrières,'" according to historian Roger Magraw. The shopgirls of the *Bon Marché,* for example,

> were often ill-paid, lodged in cramped dormitories, subject to curfews and customer arrogance. . . . [Yet] The class status of these girls, who dressed well and frequented city cafés in the evenings, was ambiguous.[37]

Most threatening to class barriers were the increasing number of prosti-
tutes that appeared on the streets dressed like bourgeois women, making
it more and more difficult to distinguish the proper from the improper
women.[38] Many feared the disintegration of difference and thus of the
socially stabilizing factors of distinction and hierarchy.[39] This, in turn,
encouraged among many groups a hardening of class distinctions wher-
ever possible, including emphatic declarations of individualism such as
that of the aesthete.

The Symbolists' critique of capitalism centered particularly on its for-
mative role in creating materialist values and on the alienating and level-
ing effects of the society of spectacle and display arising from the penetra-
tion of capital into all realms of existence.[40] Their cultural retreat thus
issued from a pessimistic and antagonistic resistance to the barren direc-
tion in which they believed their culture to be recklessly headed. At the
same time, they exhibited a conservative urge for stability in a period
of upheaval, accompanied by a utopian optimism in the redemptive
powers of art.[41] In the final analysis, the Symbolist aesthetic was a min-
gling of traditional Idealism—both conservative and utopian—and avant-
garde progressivism—antagonistic, pessimistic, and counterdiscursive.

As a counterdiscourse, the Symbolist aesthetic had a progressive social
function in late-nineteenth-century France. Its proponents reaffirmed
art as a powerful discourse that could redirect and change society and
reclaimed for the artist the domain of superior sensibility and the role
of purveyor of Truth. In a positivistic world in which the concrete,
the practical, and the precise were more and more highly valued, the
Symbolists asserted the primacy of abstraction, the evocative, and the
suggestive.[42] They offered a more intense experience of the world
through their dialogue with transcendence and their evocation of the
mystical. The artist-seer experienced the ecstacy of being in the presence
of the Absolute and the security of "knowing" that there was something
more beyond mundane existence and was able also to take charge of his
own experience and heroically recreate it in a work of art for his audi-
ence. To submit without loss of control, to experience the "other" with-
out loss of self, were fundamental desires of the period to which the
Symbolist construction of art and the artist responded.[43] As an opposing
voice to bourgeois values based in materialism and capitalism, their aes-
thetic exposed discordant notes with the potential to disrupt the "ideo-
logical closures" otherwise hidden within the dominant harmonies of
culture.[44] In its purist, autonomous, and disinterested stance, the Sym-
bolist aesthetic also indicated at least the potential for cultural difference
within the bourgeois regime of normalcy.[45] Schulte-Sasse argued simi-
larly:

Autonomous art has satisfied residual human needs of the bourgeois world by offering the "beautiful appearance/semblance (Schein)" of a better world, but it has also functioned in society by creating hope through its very existence for the realization of social ideals in the future.[46]

The Symbolists at times did directly address some of the anxieties, tensions, and contradictions of the fin de siècle. They often took antagonistic positions to issues strongly supported by the government, for example. The following analysis briefly outlines some of the major political issues of the 1880s and 1890s to which the Symbolists reacted: universal secular education, art education, nationalism, and imperialism.

According to historian Sanford Elwitt, through policies such as universal secular education, which provided socialization and discipline, the governments of the early Third Republic were successful in their efforts to stabilize and institutionalize "the ideological hegemony of the bourgeoisie."[47] The Symbolists recognized and decried the use of education as a manipulative socializing tool and astutely perceived such a tactic as an important factor in the erosion of an enlightened bourgeoisie and in the increase in materialistic values. According to Aurier, secular education, such as that enforced by the state, limited rather than enhanced knowledge.[48] However, the Symbolists' alternative to such an educational system—an individual return to a state of naive prescience with works of art as guides to immanent knowledge—was anarchic, individualistic, and antisocial.

Art education, too, was instrumental in the Republican project to promote their platform of social values. Indeed, the Symbolists were not alone in their belief in the socially transformative potential of art. The governments of the Third Republic considered art education essential, for reasons that ranged from training workers and policing them to art's economic utility for industry. Not all proposals were altruistic, however. In 1879, moderate Republican arts administrator Henry Havard suggested that art appreciation courses could actually serve to control the working class:

> if the worker's mind has been polished [and] refined, if his intellect has been altered to conceive and analyze metaphysical ideas, if his eyes have been interested in the marvels of painting . . . [then] far from becoming a source of trouble for the urban centre of which he is a part, he will form an element of harmony and unity for his fellow citizens. . . . they [the fine arts] form, in this way, a sort of pre-emptive police.[49]

Symbolists objected exactly to such utilitarian purposes for art. Aurier claimed that art and poetry, "les Inutilités Vitales," were the only things that differentiated humans from monkeys.[50]

Symbolists considered their own use of art to have a higher, less materialistic purpose and dreamed of a spiritual world where "things are free of the drudgery of being useful," an attitude Walter Benjamin attributed to the nineteenth-century Parisian art connoisseur as well.[51] Art education was anathema to the Symbolists, since it muted the privileged realm of the naive and instinctive. Yet in reality, most Symbolist artists had been educated in art—even Gauguin worked with Pissarro and others—and could not have accomplished as much without such formal training.

The exaggerated patriotism and fervor of French nationalism was also scorned by the Symbolists, especially the urge for a national art advocated by the governments of the Third Republic. Nationalism was revived and strengthened after the defeat of the French in the Franco-Prussian War of 1870–71. Rather than the populist nationalism that "identified the nation with popular revolt" and played a role in the Commune and in socialist movements, the government sponsored a popularized nationalism identified with the power of the state. Indeed, "calculated efforts were made by governmental officials to link national pride with prestigious accomplishments by the state."[52] In his review of the "Exposition Universelle" of 1889, Aurier poked fun at the ambitions of France and the city of Paris to conquer and take their revenge on the world for humiliating military defeats in the past, not by arms or brutal force but by lethally injecting the "national French virus" of official art, exemplified by Jean-Louis-Ernest Meissonier, Adolphe Bouguereau, and Alexandre Cabanel, throughout the civilized world and beyond. Those who supported this national school of official art could no longer be called art critics but rather "fanatics escaped from the League of Patriots."[53]

Despite their derision of French chauvinism, race and nation were often central markers of identity even for the likes of the Symbolists, who were opposed to nationalistic, patriotic posturing. These ideologies were deeply embedded in the social matrix—rigidly constructed through the discourses of degeneration, social darwinism, the physical sciences and anthropology, and corroborated by government policies. De Wyzewa, for example, mentioned earlier as proclaiming the purist origins of the genius, insisted in his study of Japanese art on the importance of studying the "dominant traits of the Japanese soul" as well as their particular way of feeling and thinking. Earlier studies had not, in his opinion, sufficiently dealt with the "intimate links that attach the art of Japan to the race which had produced it."[54] Aurier, too, saw race as a determining factor in artistic production. He considered Van Gogh's Dutchness essential to his artistic temperament and one of the formative elements of his aesthetic, yet at the same time characterized Van Gogh as an *isolé* eager to totally begin again in art. However, Dutchness was

not understood as deriving from any social condition but from inherent, atavistic laws.

> Vincent van Gogh n'est point tant en dehors de sa race. Il a . . . subi ces inéluctables lois ataviques, desquelles M. Taine fait volontiers mystère. Il est bien et dûment Hollandais . . .
>
> Et d'abord, en effet, comme tous ses illustres compatriotes, c'est un réaliste dans toute la force du terme. . . . comme tous les peintres de sa race, il est très conscient de la matière . . .

> [Vincent van Gogh was very much a part of his race. . . . He underwent the influence of those ineluctable, atavistic laws which M. Taine deliberately mystifies. He is fully and properly Dutch . . .
>
> And before all, effectively, like his illustrious compatriots, he is a realist in the strongest sense of the term. . . . as all the painters of his race, he is very conscious of the materiality [of paint] . . .][55]

Race was essentialized by Symbolists and other writers as a form of hereditary influence, despite their criticism of Taine and their insistence on the necessity of the artist's freedom from his social milieu.

The Symbolists also protested against certain aspects of France's vigorous imperialist expansion, which had been sanctioned and popularized by state-sponsored nationalism.[56] Aurier strongly condemned the French army's torture of Algerians and compared these "unlucky martyrs" to the earlier French Calvinists.[57] Gauguin was distressed by the polluting effect of French colonization on the originally "primitive" and thus pure culture of Tahiti.[58] However, the Symbolists' representation of the "primitives" as innocent, instinctive, and savage unwittingly offered further justifications for imperialism as a "civilizing" force.[59]

These brief examples of the Symbolists' conscious opposition to certain policies of the Third Republic illustrate the sporadic and often indirect nature of their responses. Their politics were liberal, and they were generally antagonistic to the state, but from our vantage point today, we can see that their hostility was frequently contradicted or tempered by its dialogue with other, more normative and conservative beliefs or concerns. Typical of their abstract tendencies, the Symbolists put much more energy into combating amorphous dragons. They were a great deal more aggressive and consistent in their criticism of the pervasive effects of capitalism, for example. It posed a greater threat to Symbolist notions of the self than did individual government policies and was at the root of much of their pessimism about bourgeois society.

The range of political activism varied greatly among Symbolists. Unlike the Idealists who revolved around Aurier and Gauguin, those Sym-

bolists who clustered around the critic Félix Fénéon—Neo-Impression-
ists such as Seurat—were often politically engaged; many had an
anarchist bent and sympathy for the working classes.[60] Fénéon was actu-
ally jailed and tried for his participation in anarchist events.[61] Among the
artists, writers, and critics discussed here, allegiance to anarchism was less
prevalent. Camille Mauclair, the critic who replaced Aurier at the *Merc-
ure de France,* was a devoted anarchist in the early 1990s. Octave Mirbeau,
a naturalist writer who wrote Symbolist art criticism in the 1890s, also
professed his anarchist beliefs.[62] Both critics Paul Adam and Adolphe
Retté began as anti-anarchist and later in the 1890s became total support-
ers of the cause.[63] Others among the Idealist Symbolists considered them-
selves revolutionary in their resistance to social decay.

Nevertheless, the direct manifestation of their specific political views
in their art was rare among both groups.[64] Whether or not they partici-
pated in anarchism or other political movements, the Symbolists relied
on aesthetic force rather than propaganda or illustration to carry their
political messages. Pierre Quillard, a hardened anarchist and scholarly
Hellenist spoke for many when he declared in 1892 that "the fact alone
of bringing forth a beautiful work, in the full sovereignty of one's spirit,
constitutes an act of revolt and denies all social fictions . . ." Although
he insisted that artists must also be activists, he believed that art alone
had the power to make "rebels and outlaws" out of those who under-
stood it.[65] Symbolist artists and critics from the Idealists to the Neo-
Impressionists believed in the liberating force of art. As theorist and
writer Remy de Gourmont said: "[Symbolism] translates literally by the
word liberty. And, for the violent ones, by the word Anarchy."[66]

The Symbolist aesthetic was the most significant, counterdiscursive
tool employed by the Symbolists. The most enduring Symbolist works
(art from Seurat to Gauguin; criticism from Fénéon to Aurier) expressed
the desire for freedom through radical formal innovations. Artistic non-
conformity threatened the social structures for at least one of the many
critics who fiercely discredited their art. Nordau attacked Symbolists for
their disruptive effect on social norms.[67] Paul Signac, a Neo-Impression-
ist and professed anarchist, described the relation between artistic form
and political meanings: "[Experimental artists are] revolutionaries by
temperament, who, moving far off the beaten track, paint what they see,
as they feel it, and . . . give a hard blow of the pick axe to the old social
structure."[68]

The Symbolists construed their alienation and strategies of retreat as
a heroic challenge to the increasing institutionalization and administra-
tion of society and the self. In the face of the homogenization and control
of the "culture industry," that is, of modes of being in a capitalist-domi-

nated society, the insistent individualism and the production of challeng-
ing and difficult art was an antidotal act of resistance. The literary and
artistic Symbolists represented a primary, self-conscious, oppositional
voice that maintained a cultural space of challenge to the complacent
dream of social harmony and consensus among supporters of the Third
Republic. Through constructs of the superior individual such as the *isolé*
and the aesthete, the Symbolists refigured their individual social alien-
ation as a privileged status. Alienation became a force to reinvent and
thus redeem and reify the unity of the subject in the face of the social
order's suppression and fragmentation of subjectivity. From this perspec-
tive, the Symbolists' transcendent strategy was not only one of escape;
it was also a reassertion of control. The romantic embrace of alienation
and self-banishment to the margins of society became vital components
of the myth of the avant-garde. The Symbolist aesthetic also established
self-conscious artistic norms important for the twentieth-century avant-
garde. Its legacy included a utopian concern for social change, a con-
sciously directed antagonism toward bourgeois values, a formulation of
the neurotic artist-genius and his agonism, and a reductive formal vocab-
ulary. Utopian transcendence and purist, universalizing content were also
crucial doctrines for the abstract art of the next decades.

A more conservative cultural agenda coexisted with these progressive
aspects of the Symbolist aesthetic. The Idealist Symbolists' radical with-
drawal from social engagement through an art that dealt with "higher"
issues must inevitably be read as an escape from social realities as well.
Transcendence such as that of the Symbolists, based in mysticism and
otherworldliness, had long been connected to a "disaffection with terres-
trial existence." It offered a semblance of stability and eternal values in
a world of flux and turmoil.[69] Indeed, although the Symbolists appropri-
ately considered their aesthetic to be a politically progressive strategy to
grapple with the crises of modernity, such a retreat from cultural changes
also associated the Symbolists with the rise of powerful reactionary forces
at the end of the nineteenth century. The notion of an unstable society
in decline also permeated movements such as ultramontanist Catholi-
cism, the right-wing nationalism of the "League of Patriots" whose
members preached revenge against the Germans, or Maurice Barrés'
brand of nationalism based on an idealized French cultural heritage
which excluded those "alien" to French Culture.[70] These and other such
groups favored stability, authority (especially of an [idealized] past), fixed
doctrines, and "stratification in the social body."[71] The language of con-
servative art critics often echoed that of the Symbolist aesthetic. Gustave
Ollendorff, conservative director of museum administration during the
early Third Republic, wrote in 1883: "Art is a religion that does not

need many priests; it is aristocratic in nature. In order to remain pure and elevated, it should remain the patrimony of a small elite."[72] The Symbolist aesthetic incorporated all of these values in their insistence on the authority and universality of the Ideal and their elitist notions of artist and audience. In addition, Symbolists as well as anti-republican monarchists and Roman Catholics of the Right had in common their contempt for the positivism and naturalism espoused by republican politicians. Michael Marlais has demonstrated the increasingly conservative elements in the work of a number of Symbolist artists and critics.[73] However, they differed from conservative groups in their concern with progress (toward the spiritual), their intellectual rather than class or money based elitism, their nihilistic avant-gardism, and the innovative approach of a number of Symbolists to artmaking and art criticism. Moreover, their individualism was also a leftist position in opposition to the "family values" of the religious Right. Nevertheless, under the guise of the pursuit of a new freedom, the Symbolists' retreated into transcendence and abandoned the Realist project which had attempted to come to terms with modernity within its own social spaces.[74]

Most significantly, the Symbolist aesthetic was inadvertently complicit with developing capitalism. Nicholas Green has demonstrated the phenomenal rise of the market for avant-garde art as a new form of exchange value as early as the late 1860s. The Symbolists recognized the deadening effect that complicity with the art market could have on creativity. Nevertheless, even their philosophical alienation from the market worked to the market's advantage. At the same historical moment that the Symbolists represented themselves as highly individualistic, isolated neurotics and prophets of divine truth, the criteria for the valuation of artworks shifted from the "rarity of the object to the uniqueness of the artist."[75] The Symbolists' display of disinterest in the "dirty" commerce of art further framed the artists in terms favorable to the market—as superior individuals elevated above worldly concerns. They could be "ardent, sincere and disinterested" at the same time. The cult of the artist and of individualism became a central factor in market development, a factor satisfied by the Symbolist *isolé/poète-voyant.*[76]

A contradiction between the artists' proclaimed antimaterialism and their need for financial support from the marketplace was inevitable. Gauguin, for example, even when isolated in Tahiti, continually (although mostly unsuccessfully) wrote to critics, artists, and dealers promoting sales of his work. Characteristically of idealists who must support themselves in a society in which capital rules, the solution to the contradiction between the artists' commercial dealings and their higher principles was simply to keep the two separate in their mind.[77]

In their desire to articulate a realm in which they could have con-trol—that of the aesthetic—the Symbolists unwittingly utilized strategies vulnerable to commodification and cooptation.[78] Although their aes-thetic served an important function as a counterdiscourse in a commodi-fied culture, the avant-garde myth of the power of aesthetics alone to change the world was nonetheless especially vulnerable to dissolution of its critical edge. The Symbolists' attempt to politicize the language of art through a disinterested, autonomous aesthetic—to engage politically through disassociation from the immediate world of politics—under-mined the revolutionary potential of their art and led to the aestheticiza-tion of the political and socially transformative aims they avowed. They constructed their art as a refuge—"ce refuge suprême"—from the stresses of modern life, but for a bourgeois audience their art served only as a momentary respite from the "actual [bourgeois] values of competi-tiveness, exploitation and material possessiveness."[79]

The Symbolist position as a counterdiscourse was not only compro-mised by commodification and aestheticization; it actually helped to pro-duce the conditions under which capitalism could operate. The avant-garde's commitment to constant renewal through innovation and their attempt to "épater le bourgeois" helped to develop a taste, even a desire, for change, of which the commodity market could take full advantage. By eroding traditional forms to effect new ones, and conditioning its audience to value the new, the tactics of the Symbolist avant-garde paral-leled the actions of capital, the more covert but more truly radical agent of "transgression and shock." With few exceptions, "the avant garde was, if not an agent of capital then at least in its ambivalent service."[80]

In retrospect, the Symbolists' attempts to combat the devastating ef-fects of capitalism on modern culture could hardly have been expected to have great effect. The Symbolists realized the threat to identity posed by consumer capitalism, but their attempts to defy it with vehicles such as transcendence, individualism, and elitism could not withstand the se-ductive force of commodity fetishism that penetrated and came to define even these modes of distinction. The failure to circumvent capitalism is less a sign of the inadequacy of Symbolism as a counterdiscourse than of the success of capitalism in absorbing and commodifying its antagonists.

Finally, although their estrangement from society may have been real, their marginality was illusory. The generally middle-class, white, male sta-tus of most of the Symbolists allowed them to align themselves intellectu-ally with the disenfranchised and disillusioned elements of society while maintaining their own privileges.[81] Ultimately, the elitist, exclusionary na-ture of the Symbolist aesthetic replicated on many levels the very system of bourgeois capitalist values it had been designed to overcome.[82]

The Ecstasy and the Agony

CREATIVE GENIUS

AND MADNESS

Ce bonheur me tue, il m'accable. Ma tête est trop faible, elle éclate sous
la violence de mes pensées. Je pleure et je ris, j'extravague. Chaque plaisir est
comme une flèche ardente, il me perce et me brûle!

[This happiness is killing me, it exhausts me. My head is too weak, it explodes
with the violence of my thoughts. I cry, I laugh, I rave. Each pleasure is
like an ardent arrow, it pierces me, and I am on fire!]

The hero of Honoré Balzac's novel, *Louis Lambert* ([1832] 1954), cited
here, epitomized the notion of the intuitive artist-genius embodied in
the Symbolist aesthetic. His hypersensitivity and his passion over-
whelmed him, leaving him incapable of coping with the exigencies of
everyday existence. Even love, when reciprocated, brought him to the
threshold of ecstatic pain. Although outwardly Lambert appeared to be
driven to madness on the eve of his wedding, inwardly he experienced
an escape from the mundane world into the higher realm of spiritual
knowledge, "La Spécialité."[1]

La Spécialité consiste à voir les choses du monde matériel aussi bien que
celles du monde spirituel dans leurs ramifications originelles et consé-
quentielles. Les plus beaux génies humains sont ceux qui sont partis des
ténèbres de l'Abstraction pour arriver aux lumières de la Spécialité.

["La Spécialité" consists of seeing things in the material world as well as
things in the spiritual world in their original and consequential ramifica-
tions. The most lofty human geniuses are those who have left the shadows
of Abstraction to reach the enlightenment of "la Spécialité."][2]

In Lambert, we recognize parallels to the Symbolist theory of correspondences and the realm of the Ideal, as well as its transcendent attainment through hypersensitivity, pain, and madness.[3] Like Van Gogh as Aurier portrayed him, Lambert's mental suffering allowed him access to the Absolute, but unlike Van Gogh, Lambert was incapable of bringing his genius to fruition.[4] The dilemma of Balzac's hero illustrates the conditions that framed the debate over the nature of creativity and genius among writers of various disciplines in late-nineteenth-century France: a struggle located at the tenuous, shifting, and contested border between debilitating madness and divine madness.

Competing ideological camps both between and within disciplines vied for dominance over fin-de-siècle definitions of creativity and genius. Although a number of cultural sites could be examined, the debate over the nature and role of creativity and mad genius was most heated, most influential, and represented the most extreme position among the discourses of science[5] and medicine, literature and art.

Despite the obvious differences in their focus and methods, the positions on the nature of creativity emanating from these disciplines were indebted to the notion of genius as mad. Bolstered by the widespread doctrines of pessimism, mysticism, evolutionary theory, and a growing interest in physiological and hereditary determinants for human nature (social darwinism), in conjunction with a rhetoric of illness and degeneration, Symbolists as well as scientists cloaked creative genius in the language of pathology and marginality. However, each group valued the pathology of genius and assumed its agency very differently, depending on whether they understood madness to be an illuminating force or a debilitating disease. The epistemological models of these two groups conflicted so dramatically that disagreement was inevitable. Although both Symbolists and scientists appropriated aspects of the other's discourse in order to further legitimize their own positions, the limits of their circumscribed forms/languages through which each discourse generated meanings to some extent predetermined or prevented certain content.

Medicine and psychology had particularly vocal roles in this debate. As socially authoritative discourses, they greatly influenced the ways that notions of creative genius were received. However, each of the positions outlined below had its own sizable audience. Neither the authoritative disciplines of science and medicine nor the Symbolist aesthetic could claim absolute hegemony over definitions of creative genius amidst the cacophony of competing voices.

SCIENCE AND GENIUS

Notions of madness and degeneracy as determined by heredity and biology dominated the debate over the nature of genius among scientific writers. A group of late-nineteenth-century physicians and psychologists writing on genius, whom I will refer to as the "scientific" camp, joined empirical method to biological determinism. The latter pervaded all disciplines and further polarized already rigid social categories by assuming "that shared behavioral norms, and the social economic differences between human groups—primarily races, classes, and sexes—arise from inherited, inborn distinctions and that society, in this sense, is an accurate reflection of biology."[6] Although many of the scientists important for the French understanding of genius were English, Italian, or German, their influence can be gauged by their rapid translation into French and their obvious presence in French texts of the period.

Ultradeterminist Francis Galton, who predicted genius statistically through heredity charts, expressed incredulity that free will rather than biology had been considered earlier to determine human ability:

> At the time when [this] book was [originally] written [1869], the human mind was popularly thought to act independently of natural laws, and to be capable of almost any achievement, . . . Even those who had more philosophical habits of thought were far from looking upon the mental faculties of each individual as being limited with as much strictness as those of his body, still less was the idea of the hereditary transmission of ability clearly apprehended.[7]

Galton assured his readers that by this time (of the new edition, 1892), such was no longer the case. He credited biology rather than free will with determining human potential.

Indeed, the majority of scientists and thinkers believed that evolution and heredity were responsible for almost all forms of behavior. Even psychological states were considered to be hereditarily determined. Renowned psychologist-philosopher, Th. Ribot, claimed that all forms of mental activity were transmissible through heredity, including habits, sentiments, passions, imagination, as well as "madness, hallucination, idiocy and suicide."[8] In other disciplines as well, a whole range of behaviors, from alcoholism to the appetite for oysters, were considered to be inherited.[9] According to a large faction of scientific writers during this period, biology was synonymous with destiny.

Many scientists believed genius to be hereditary. Defined within the restricted realm of scientific investigation as an absolute, inherent force, a fluid, or an electrical charge, in limited supply, genius was reified as

a category to be described, quantified, debated, and charted through history. Writers from various scientific camps perceived genius as a tremendous physiological force that threw the body and mind out of balance, and one that could potentially drain the body of both physical and intellectual vitality. In this model, the body is seen as a site of finite and interactive forces, so that if one faculty or force was predominant, such as genius or physical strength, the others were diminished. As a result, genius was often understood to be degenerative. These theories, and others like them, read rather like an economic theory of the psyche, in which physical and intellectual endowments represented some sort of capital and the distribution of traits represented an expenditure of those finite resources.

Evolutionary degeneracy was fundamental to the idea of genius as physiological capital.[10] Degeneracy was a widespread concept in the late nineteenth century that was used by cultural critics as well as scientists. Max Nordau, a physician, critic, and influential proponent of the philosophy of degeneracy, defined it as a form of evolutionary biological deterioration enforced through heredity. Generations pass on their debilities and deformations to their offspring "in a continuously increasing degree."[11] Degeneracy and its corollary, atavism (defined as reversion), were thought to be forms of "retrograde evolution" and, as such, were deemed responsible for a range of behavioral types supposedly originating from "primitive" times, such as the insane and the genius.[12] Evolutionary degeneracy was thus considered responsible for a variety of social ills, such as alcoholism, prostitution, crime, societal decline, and asocial behavior. The notion of degeneration was an important link between genius and the pathological.[13]

For our purposes, it is useful to distinguish between two groups among the numerous subgroups of the scientific camp—the more influential if controversial "philosophers of degeneracy," as I refer to them, and the conventional positivists. These two positions represented the extremes of scientific opinion on the relation between genius and madness. While remaining within the same range of ideas, many other writers were more eclectic in their views. I have chosen to discuss in particular four out of a large number of writers on this topic because they are representative of relatively clear-cut positions. Césare Lombroso, an Italian physician, psychologist, and "philosopher of degeneracy," whose work was controversial and widely debated, and J. Moreau de Tours, for example, considered genius and madness to be absolutely interdependent; whereas positivists Henri Joly and Dr. Édouard Toulouse, both psychologists, strove to separate the two and distanced themselves from Lombroso in particular.[14] The data these writers accumulated as "proof"

of their deterministic views were often culled from dubious and biased sources, such as presynthesized material in histories or biographies. Each writer brought his own background and allegiances to bear as he grappled with how best to formulate a working definition of genius based on the interaction of degeneracy, heredity, and madness.

PHILOSOPHERS OF DEGENERACY

The conjunction of three elements—the doctrine of biological determinism, the social upheaval and dis-ease at the end of the century, and a cultural climate in which illness was a metaphor for the condition of the entire social body—were at the root of the construction of mad genius by the philosophers of degeneracy. These writers did not focus on the healthy, but gave free rein to their fascination with the pathological and the deviant. The most exaggerated, infamous, and influential treatise of this nature was written by Lombroso and translated into French as *L'Homme de génie* (*Man of Genius*) in 1889.[15]

Like the Symbolists, Lombroso argued that certain forms of mental illness were a stimulant to genius. Illness actually had the potential, he said, to change a mediocre intelligence into an extraordinary one. The "true genius" was necessarily mentally and physically ill, "marked by alienation (usually paranoia, monomania, epilepsy) [and his] products were, one might say, all the more sublime as the body was sicker, in fact, precisely because the body was sick."[16]

Both genius and madman stood in a privileged relation to creativity, possessing an innate and natural creativity, "la force créatrice."[17] "Nothing so much resembles a person attacked by madness as a man of genius when meditating and moulding his conceptions."[18] The genius stood outside of his milieu, separate from the common populace, in a state of lucid grace that allowed him to see better and more clearly what others could not. This exalted state paralleled the Symbolist ideal of the *isolé* and *poète-voyant*.[19] Lombroso understood creativity not as a reasoned, deliberate process but, similarly to that of the Symbolist aesthetic, as an inspired, excessive act that allowed the imagination to soar beyond the boundaries of mundane existence. In a classically Romantic representation of the mad genius, Lombroso described the physiological parallels between inspired genius and madness: pale, cold skin, but feverish forehead, and brilliant, radiant eyes, bloodshot and distracted.[20] Such a state echoed that of ecstatic mystical revelation and "transcendental emotivity" so central to the Symbolist aesthetics.

This model of creative madness suggests the prophetic madness of the oracle and the potential for divine wisdom. However, Lombroso's pro-

file of the genius was one of "abnormality" rather than the superior difference of the Symbolists. In his overdetermined economy of the psyche, the genius was characterized by degeneration: small stature, pallor, emaciation, tendency to rickets, weakness of sexual and muscular activity, precocious baldness, cranial abnormalities and above-average skull capacity, frequency of stammering, left-handedness, sterility, etc.[21] His abundant expenditure of life-energy—the "hypertrophy of certain psychic centres" was "compensated by the partial atrophy of other centres."

> Just as giants pay a heavy ransom for their stature in sterility and relative muscular and mental weakness, so the giants of thought expiate their intellectual force in degeneration and psychoses. It is thus that the signs of degeneration are found more frequently in men of genius than even in the insane.

Most significantly, Lombroso's construction opposed the Symbolist one in his argument that genius creates out of necessity rather than choice: "Genius creates, not because it wishes to, but because it must create."[22] Creative control was involuntary and in the hands of unconscious forces: "After the moment of composition it often happens that the author himself no longer understands what he wrote a short time before. . . . When the moment of inspiration is over, the man of genius becomes an ordinary man, if he does not descend lower." In this construction, Lombroso denied the artist-genius both will and agency. Yet he was nonetheless sympathetic toward genius. He was attracted to the pathological as a site of meaning unavailable to normal minds.[23]

Evolutionary theory, heredity, physiological determination, and degeneracy were also the bedrock of Nordau's "scientific" conception of genius described in his book, *Degeneration*.[24] A disciple of Lombroso, he, too, believed that genius was the result of physiological mutation and characterized the ecstatic creative process as degenerate.[25] Unlike Lombroso, he maintained distinct boundaries between the superior genius and the deviate degenerate. In his formulation, genius was a healthy though still hereditary condition that did not threaten normative values.[26] He disdainfully described the "contempt for traditional views of custom and morality" as a common feature of fin-de-siècle types and found no redeeming value in their work. To Nordau, Symbolism and its focus on *la douleur* represented a symptom of social *malaise,* and he considered those—from Schopenhauer to the Symbolists—who claimed a form of madness as creative to be only degenerates, not geniuses.[27] He condemned the Symbolist transgressors as worthless polluters of a moral and social order which must be upheld at any cost. He railed against the pessimistic mood of French society, calling it "the impotent despair of

a sick man, who feels himself dying by inches in the midst of an eternally living nature blooming insolently for ever."

He rejected Lombroso's assertion "that highly-gifted degenerates are an active force in the progress of mankind." Rather, "They corrupt and delude . . ." Thus, "the enthusiasm of their admirers is for manifestations of more or less pronounced moral insanity, imbecility, and dementia."[28]

Nordau's description of emotionalism, a mark of disease in degenerates, could pass as an illustration of the Symbolist ideal:

> [The afflicted one] is quite proud of being so vibrant a musical instrument, and boasts that where the Philistine remains completely cold, he feels his inner self confounded, the depths of his being broken up, and the bliss of the Beautiful possessing him to the tips of his fingers. His excitability appears to him a mark of superiority; he believes himself to be possessed by a peculiar insight lacking in other mortals, and he is fain to despise the vulgar herd for the dulness [sic] and narrowness of their minds.

But his attitude toward this condition was diametrically opposed to the Symbolist celebration of it. "The unhappy creature does not suspect that he is conceited about a disease and boasting of a derangement of the mind."[29]

Galton's views on genius might profitably be returned to at this point. He positioned himself between Lombroso, whom he suggested was too extreme, and Nordau, who refused to credit illness or madness with any value for genius. Although he could not accept the absolute linkage of madness to genius, he admitted that "there is a large residuum of evidence which points to a painfully close relation between the two":

> Those who are over eager and extremely active in mind must often possess brains that are more excitable and peculiar than is consistent with soundness. They are likely to become crazy at times, and perhaps to break down altogether. . . . If genius means a sense of inspiration, or of rushes of ideas from apparently supernatural sources, or an inordinate and burning desire to accomplish any particular end, it is perilously near to the voices heard by the insane, to their delirious tendencies, or to their monomanias. It cannot in such cases be a healthy faculty, nor can it be desirable to perpetuate it by inheritance.[30]

Genius for Galton might in many cases inevitably commingle with madness (shades of Lombroso), but he agreed with Nordau that such a conjunction was unhealthy.

Despite their different sympathies, "philosophers of degeneracy" such as Nordau, Galton, and Lombroso fostered the notion that mad geniuses

(or specifically Symbolist artists, in Nordau's case) lacked intellectual control because of their relation to mental illness, since ecstatic inspiration overtook them almost like a physical force before which they were powerless. The theories of the "philosophers of degeneracy" marginalized mad genius as degenerate other to what they perceived as their dominant center.

POSITIVISTS

A less influential scientific voice, belonging to those stricter positivists left over from an earlier era, opposed the influential determinist position of Lombroso, Nordau, and Galton and insisted on a more rational and less mystically and biologically predetermined notion of genius. However, even this group was influenced by aspects of the *malaise* from which Symbolism also emerged.

Henri Joly's relation to the Symbolist aesthetic is more conflicted than that of Lombroso. Less attracted to degeneracy and more the Tainean positivist, he nevertheless accepted the basic principles of the Symbolist aesthetic—inspiration, pain, and "natural" genius—but tried to rationalize and thus normalize these traits. He had particular problems with the notion of *extase*. Agreeing with Byron that "l'artiste ou le poète soient souvent troublés jusqu'à la souffrance par le désir passionné d'exprimer tout ce qui'ils sentent et tout ce qu'ils rêvent" ["the artist or the poet is often troubled by and even suffers from the passionate desire to express everything he feels and everything he dreams"], he went on to say that inspiration did not issue from this agitation. While he admitted that artists might suffer, his argument to defuse the power of *la douleur* and normalize the act of inspiration rested on his assertion that such pain could not possibly nourish genius. Inspiration simply followed *la douleur;* it was not initiated by it.[31]

Both Joly and the philosophers of degeneracy conceived of genius as physiologically linked, but Joly distinguished between the positive nature of sane genius in search of unity and harmony and the destructive nature of mad genius.[32] Genius, he implied, could *only* exist in a healthy body because of the amount of energy necessary for its tasks; otherwise an incoherent madness resulted. His position on genius resembled Nordau's, but without embracing degeneration. Yet he deferred to one of the major underlying tenets of the Symbolist aesthetic when he admitted that artists might suffer as a result of their passion.

Physician Édouard Toulouse, like Joly, also actively refuted the position of the philosophers of degeneracy. He questioned the role of heredity in genius and even doubted that intelligence was transmitted geneti-

cally. Yet his attempt to dissociate genius from madness by suggesting instead a connection between genius and nevropathy still supposed a link between illness and genius. Toulouse further compromised his position when he argued that although nevropathy and intellectual superiority existed separately at times, they quite often occurred in conjunction.[33] This argument differed little from Aurier's notion of the hyperaesthetic as one whose emotions were exacerbated or Lombroso's thesis that hypersensitivity was a function of evolution. Most tellingly, Toulouse made an exception for the visual artist: abnormal sensitivity might be a condition for works of art, even if it was not for all men of genius such as those in the sciences.[34]

Toulouse walked a tightrope in his ambivalent attempt to deny Lombroso's thesis, which he claimed was not as "clinical" in approach as his own. Like Joly, he believed that health and equilibrium were useful to "travail de la pensée" ["the work of the mind"], yet at the same time asserted (unlike Joly) that "le tempérament névropathique est une condition favorable à la sensibilité et à l'activité cérébrale qui sont nécessaires au travail de l'esprit . . ." ["the nevropathic temperament is a favorable condition to the sensibility, and to the cerebral activity, which are necessary to the work of the spirit . . ."][35] Despite Toulouse's indignant stance against Lombrosian extremes, he remained close to the Italian's coupling of madness and genius.

Joly's and Toulouse's positivist distinction between creativity and madness foundered in the face of the more popular tide of biological determinism and pessimism in late-nineteenth-century France. They had their audience, but most scientific theory had moved away from their positions and toward determinism. Their need to justify their denial of the biological link between madness, genius, and suffering was evidence of how deeply embedded the rhetoric of suffering and pathology was in social discourse.

Dr. J. Moreau de Tours, writing around midcentury but still quite influential for theories of creativity and genius in this period, throws into bold relief the relation of the later nineteenth-century writers just discussed to the Symbolist aesthetic.[36] He did not advocate the pessimistic determinism of the philosophers of degeneracy, nor did he follow the positivist attempts to normalize genius as simply superior intellect. Although based in scientific method, Moreau de Tours's characterization of genius as an aggravated hypersensitivity approaching the state of madness was nearer to that of the Symbolists than to any of the scientific writers just discussed.[37] He described poetic inspiration as an awakening of the passions through overexcitation and compared it to a state of madness. These two experiences were so similar because ecstatic inspiration,

intellectual faculties, neuroses and madness, all derived from the "same organic conditions."[38] Nervous illnesses, especially "ecstatic and convulsive" ones, not only led to an "excess of spirit and feeling" that allowed one to create "with a passionate ardor," but also offered the most favorable conditions for intellectual activity.[39] George Becker rightly suggested that Moreau de Tours (like the philosophers of degeneracy) denied free will to the genius: "matter having conquered the mind, the individual from then on acts only by a kind of automation, without liberty, without conscience."[40] Nevertheless, by suggesting that *extase,* genius, madness, and intellect originated from the same biological conditions and were manifested similarly, Moreau de Tours furnished an argument for the interconnection of intellect and mad genius that was vital to the Symbolist doctrine.[41]

The role of intellectual control was indeed central to the debate on genius, since it determined the element of artistic control and thus agency. For the more deterministic scientists, genius as physiological force consumed too much energy, leaving the intellect impoverished and unable to take charge and resulting in physical and intellectual degeneracy.[42] In direct contrast to this position, Aurier, among others, argued both that the intellect determined the level at which inspiration occurred and that the intellectual process guided intuition and maintained control over the creative act—the "head guides the hand."[43] Moreau de Tours's position, based on the method of the scientific writers but containing many aspects of the Symbolist approach to genius, exposed the provisional nature of the scientific debate over definitions of mad genius.

ARTISTIC VERSUS SCIENTIFIC CONSTRUCTIONS OF GENIUS

Once one enters the realm of Symbolist writers, the landscape changes considerably from that of the scientific writers. It is not that it is more fantastic than the realm of Lombroso or Nordau, whose language of the degenerate and the decadent, the demented and the pathologically ecstatic, was just as passionately bizarre as that of their literary and artistic counterparts. Rather, the difference lay in their valuation of mad genius.

As opposed to a "Lombrosian rhetoric of sickness," the Symbolists "might be said to adopt a Baudelairean rhetoric of sickness."

> While the Baudelairean rhetoric converts symptoms into signs that the subject himself is able to read, the Lombrosian rhetoric reduces psychic activity to the tyranny of the symptom.[44]

Whereas medical men like Lombroso were fascinated by the convulsions of creativity, they defined genius against a supposed norm as degenerate and pathological, thereby reducing any potential as cultural exemplar. The artists praised the pathology of genius as superior to that norm, assuming control of the creative process and appropriating the power of the creative for themselves.

Numerous Symbolist writers and artists/theorists—Charles Morice, Téodor de Wyzewa, Albert Aurier, Camille Mauclair, Remy de Gourmont, Paul Gauguin, Paul Sérusier, Maurice Denis, Émile Bernard, and others—have already been marshaled here to testify to the revival of the Romantic tradition of ecstasy, mysticism, intuition, and the transformative force of "divine madness."[45] Although their rhetoric was very similar to that of the scientists, and they employed ideas central to the philosophers of degeneracy and the positivists, the Symbolists did so selectively as either foil or support for their own beliefs. They vacillated between general scorn for the empirical method of science on the one hand and appropriation of its legitimizing function and its evolutionary theory of progress on the other.[46] The Symbolists' position on the role of biological determinism and heredity in the development of genius depended on the individual writer, although they generally preferred a construction of freedom from all constraining influences as embodied in the ideal of the isolé.[47] Aurier, for example, caricatured determinism and arguments against free will in his short story, "Le Magnétiseur," of 1886.[48] The Symbolists' position was an inversion of the strictly and inevitably predetermined individual of the philosophers of degeneracy.

The Symbolists also rejected cultural determinism for a state of pure self-determination. They unilaterally ridiculed the positivists' position that milieu determined the artist. Huysmans's well-loved hero Des Esseintes (from A Rebours), for example, created his own environments to match his reading material. Hippolyte Taine, influential for positivist theorists such as Joly, was a particular target of such attacks. Aurier published a lengthy rebuttal of Taine's three "causes" of artistic genius—heredity, milieu, and environment—and directly opposed the isolé to Taine's concept of the culturally determined personnage régnant.[49]

Contradictions in notions of the isolé as unfettered by social influences existed, however, as noted in chapter 1; race, for example, was considered an inherent trait. Despite the inevitable disjunctions in a philosophy such as Symbolism that aimed to deny its cultural roots and its ideological embeddedness, on a theoretical level the Symbolists maintained a contemptuous distance from the scientific notions of genius as culturally or biologically determined.

The different valuation of the pathology and agency of genius be-

tween the Symbolists and scientists originated from opposing traditions of defining madness. The configuration of madness among scientific writers stemmed from the opposition between an "objective" and therefore "true" scientific method and earlier definitions of madness as a debilitating and often degenerate loss of control. As such, madness was institutionalized, its threat to society contained, and those stricken with it controlled.[50] Joly's and Toulouse's strong desire to separate madness from genius resulted from this conception of madness as chaos and a threat to social stability. Lombroso's assumption of madness as debilitating and associated with degeneracy also derived from this model in its late-nineteenth-century biologically determined form.[51] The Symbolist aesthetic, on the other hand, was grounded in Romantic models of enlightened marginality. Madness was strategically defined as "divine"—an oracular state rather than a degenerative condition,[52] with the insight to recognize and defend against a decadent society.

Schopenhauer employed Plato's metaphor of the cave to define the "mad" artist as one who sees the limits of the social realm and escapes beyond it. This metaphor was referred to innumerable times by Symbolists. The "seer" returned to the cave after having been in the sun (the realm of Truth) and recognized the shadows in the cave for what they were—only the illusory appearance of Truth, but he was seen as mad and ridiculed by those still blind.[53] Degeneracy was displaced from the mad person onto the failure of civilization itself, thus madness was seen as illuminating rather than debilitating. The Symbolists coded madness as a visionary state of revelation—a return to an unstructured and pure truth, without constraints enforced through social codes. Madness was one of the few avenues open to civilized humanity to reach the pure, intuitive, and unspoiled state of the primitive. Like primitivism, it was a way to situate the "norm" as strange and artificial.

The Symbolist construction of madness had strategic value in the struggle against rationality as well. According to the Symbolists, ecstasy and "divine" inspiration were experiences beyond reason; they were not experiences of irrationality, but of Being itself. Rather than a mental condition that took control over one's faculties and that was physiologically derived and forced upon the passive victim, madness was a privileged state which artists actively sought to achieve. Dissatisfied with the restrictive, rigid, and uninspired tyranny of reason, the Symbolists cultivated madness as a voice of prophecy and revelation. By transgressing social norms based on reason, divine madness offered a form/structure that could contain the mystical and the spiritual denigrated by reason and science.[54]

Visionary madness played various roles in the theories of the scientific

writers. For Joly and Toulouse, madness did not provide privileged insights into Truth as it did for the philosophers of degeneracy and the Symbolist Idealists. The positivists preferred that genius remain within rational boundaries and avoid the dangerous waters of ecstatic and irrational experience. They wanted rather for artists to take their place in the social hierarchy as healthy members of society who would not oppose but only work to "harmonize" society, that is, to gloss over the contradictions of the status quo. Despite Nordau's extremist philosophy of degeneracy, he agreed with the positivists that pathology and genius were antithetical to each other. The philosophers of degeneracy who linked madness and genius allowed that madness was in some sense a site of meaning and knowledge, yet viewed the genius as enfeebled and degenerate and ultimately without creative control.

The representation of madness thus generated "pairs of antithetical signifiers," postulated only in terms of each other—"double-edged" as Gilman referred to them. "The 'pathological' may appear as the pure, the unsullied" as well as the irrational and perverse.[55] These dichotomous meanings constantly shifted and deferred to each other in practice, but as ideologies they tended to rigidify into polar opposites. A meaning could swiftly revert to its opposite if it became threatening, so that divine madness could seemingly without contradiction become degenerate. Lombroso embraced both extremes in his construction of mad genius, but privileged rationalism as having ultimate power. He viewed mad genius as in touch with Truth, but insisted upon the power of the rational to control it.[56]

Lombroso's acknowledgment of insightful madness thus issued from the position of the superior, controlling, rational role of scientist observing the irrational, unconscious, uncontrolled ecstatic experience of the mad genius. The power relations here are evident. The "knowledgeable" authority of the philosophers of degeneracy lent support to the ever-tighter constrictions and controls on the mad, further perpetrating the divisive practices of the social order.[57] Those who threatened to destabilize society's increasingly institutionalized order, such as prostitutes, homosexuals, or liberated women, were relegated to the pathological realm as physiologically perverted. In this discourse, "divine" genius, too, was represented as aberrant, degenerate, often sterile, and doomed to suffering, psychoses, and extinction. Thus, deviation from the "proper" as defined through dividing practices became "'disease' or its theological equivalent, 'sin.' "[58] Nordau's condemnation of Symbolist art as degenerate was an example of such a practice. His theory marginalized the threat to social norms of the disruptive voice embodied in Symbolism by pathologizing it. A strange inversion occurs here, one that is allied to the

biological determinism, pessimism, and dividing practices of nineteenth-century science. The zenith of civilization, the genius, occupied the same place in the atavistic evolutionary schema as did the nadirs of crime, idiocy, and the degeneration of society itself.

The Symbolists employed dividing practices as often as did the scientists. They courted the marginal and the pathological through their own form of hierarchical inversion of the value of these terms. The "deviant" subject of scientific discourse was privileged as a renegade, oppositional force in the avant-garde construction of genius as madness *because of* his outsiderism. Mysticism was reintroduced at the moment when objective science came into increasingly greater prominence, and extraordinary abilities of clairvoyance, hypersensitivity, and insight characterized the Symbolist aesthetic. Within the code of avant-garde creativity, madness was "normalized" and functioned as fuel in the paradigm of creativity, just as other ideologies of normalcy served to stabilize and define capitalist, bourgeois culture. At a time when art as a paradigm and artists as cultural voices had lost much of their power to the discourses of science, industry, and technology, the Symbolist construction of the uniquely gifted genius served in part as a compensatory strategy in the effort to reclaim lost authority.[59] Indeed, the epistemology of the Symbolist aesthetic stood in direct opposition to science as the prevailing cultural paradigm for the discovery of Truth.

For individual avant-garde artists such as Van Gogh, however, both divine madness and degenerative madness could be appropriated in the construction of artistic identity. Professor Aaron Sheon's recent analysis of Van Gogh demonstrated how elements of the theories of both Symbolists and scientists were incorporated into the artist's own constructions of artistic identity. Vincent was familiar with Lombroso's theories, especially that of epilepsy as a potential source of genius and as a sign of degeneration.[60] He took advantage of the legitimizing function of mad genius embodied in Symbolist theory and actually used his illness to create an interesting and eccentric persona.[61] Alternatively, he worried about the degenerative nature of genius demonstrated in scientific theory. Increasingly, Vincent attributed his own deteriorating health to what he considered his inevitable fate as a degenerative genius.

> Our neurosis, etc., comes, it's true, from our way of living, which is too purely the artist's life, but it is also a fatal inheritance, since in civilization the weakness increases from generation to generation. If we want to face the real truth about our constitution, we must acknowledge that we belong to the number of those who suffer from a neurosis which already has its roots in the past.[62]

He believed that illness was both the cost and the source of his creativity. At other times, he was reassured about his illness by his belief that society itself was degenerating and he was just like everyone else. The artist's response to Aurier's article on him in a letter to the critic indicated his ambivalent reaction to Aurier's characterization of him as a mad genius. On one hand, he confirmed Aurier's image of him as the hypersensitive artist: "the emotions that grip me in front of nature can cause me to lose consciousness . . ." On the other hand, he did not care to be singled out as an *isolé:* "what sustains me in my work is the very feeling that there are several others doing the same thing I am, so why an article on me and not on those six or seven others . . . ?"[63] Van Gogh exemplified the utility of the Symbolist aesthetic even for those artists who remained within the interstices of artistic discourse.

The form/structure of these different discourses—the artistic and the scientific—determined at crucial points the nature and direction of their arguments. Nineteenth-century science relied on a method of empirical observation opposed to the less material discourses of mysticism and the occult so central to the Symbolist revival of the spiritual realm.[64] According to empiricism, all phenomena, including creativity, are traceable to material, physiological fact; for the Symbolists, individual intuition provided evidence of and access to Truth. Yet both positions integrated elements of the other. These various positions demonstrate the complex nature of the debate, its continuities and contradictions, and register the intertwining nature of the supposedly opposing narratives that comprise the theories represented here.

The site of this integration exposes most clearly the way in which form affected meaning. The different forms of scientific and Symbolist discourses—their larger structural implications—absorbed and transformed cross-influences in order to gloss over the contradictions that such influences produced. As a result, the scientific emphasis on physiology, evolution, and deterministic laws merged with Symbolist beliefs in individuality and ecstatic inspiration in the most unexpected ways. Here we recall the underlying continuities that construct a cultural "regime of truth."

Mysticism (ecstatic inspiration and the suffering artist) was essential to the discursive formation of mad genius as advanced by the philosophers of degeneracy. However, a discourse based on objective truth could not allow the mystical to predominate. They integrated the content of mysticism into their theories by "scientizing" it, that is by attributing these traits to physiological or evolutionary causes as the epistemology of their discourse demanded. They thus sublimated mysticism to "objective" laws. Scientists could affirm mysticism but only if they could

maintain the superior status of empiricism.[65] Further, the urge to research degeneracy was rooted less in objective scientific curiosity than in the rhetoric of decadence and illness so prevalent in the period.

Scientific method was most often used by Symbolists to legitimize the transcendent mysticism of their aesthetic. They converted and inverted the scientific position to produce Symbolist categories of meaning. In sum, the form sublimated the contradictions in these discourses by privileging their respective epistemological ground as the ultimate test/condition by which other theoretical elements were judged and situated.

The prestige of science and the weight of its "objective knowledge" assured the legitimacy and authority of biological determinism by the end of the fin de siècle. The scientific writers were in a much greater position of authority than their Symbolist counterparts. Moreover, the Symbolists underestimated the power of the medical discourse to establish pathology and difference as deviance. The status quo ignored their inversion of values, and pathological genius remained at the margins of the social hierarchy. To have acknowledged the Symbolist position of an individual genius inspired by suffering to rediscover meaning would have forced a realignment of epistemology and norms art alone did not have the power to bring about.

The Symbolist aesthetic invited a reading of genius as ineffective in the social realm. Despite the Symbolists' participation in producing the discursive formation of mad genius through the theory of *la douleur* and *extase* for example, their willing identification with it further disempowered and marginalized their aesthetic. Within the field of art, Symbolism was a dominant discourse. It established artistic norms of theory, practice, stance, and content for the future avant-garde. But with their concentration on isolation, suffering, and hypersensitivity, they relinquished much of their claim to rational judgment from the perspective of a scientific worldview and left themselves vulnerable to a distortion and appropriation of their aims. We recall that Louis Lambert appeared mad to those still in the real world because of his withdrawal from it, even though Balzac suggested that he had attained a higher realm. However much the Symbolists attempted to heroicize these traits as essential to the artist-visionary's search for Truth, writers and thinkers in other disciplines interpreted the same traits as signs that genius was pathologically asocial and controlled by biological and psychological forces. No matter what claims both Symbolists and scientists made for the power of insight that mad genius might possess, the most influential characterization of the Symbolist artist–genius emanating from the sciences was as a degenerate deviant, without agency, who must be managed by society.

A pathological, irrational genius was the ideal topos with which to undermine the role of art in the cultural realm. The insights of mad genius might be useful, its products may have effect on culture as a whole, such geniuses might even be "active force[s] in the progress of mankind,"[66] but without control, they, as well as the discourses of art were disempowered and marginalized.

Thus, both scientists and Symbolists used dividing practices in their respective constructions of genius—the former in support of the status quo, the latter to transgress social bounds. As Foucault pointed out, however, to participate in such dividing practices, even in an attempt to overthrow the opposition, only reflects a shift in power—a see-saw movement—rather than any real change.[67] Madness and reason, mysticism and objectivity, were opposed, yet this very opposition defined them as dependent on each other for their respective meanings. They were linked together by the shared borderline of their division, no matter which side one might choose to privilege. Although the Symbolists inverted the normative relation of madness to meaning, their scientific colleagues had only to reinvert the same topos. The Symbolists' overdrawn profile of inspired genius was effortlessly absorbed into the scientific model of biological determinism and its power limited, but either position could have emerged victorious over the cultural field. Neither morality, fairness, nor factual accuracy but rather social influence and status within the "regime of truth" determined which group claimed the greater power to define these terms, and that position shifted according to the audience and the historical moment. The more dominant voices could take control of that field through the authority of their discourse or its alliance with other discourses, or both. In the case of the fin de siècle, the voice of the biological, medical, and human sciences most often carried greater impact, while that of aesthetics was diminished.

The studied contempt of the Symbolists for bourgeois values and their claim to have access to a form of knowledge unavailable either to the intelligentsia or to the "objective" scientific community must have been insulting and threatening to those who considered themselves as representatives of the norm. The Symbolist objective of social transformation may have further threatened these unwitting guardians of the status quo. The status quo was thus well served by the model of genius without intellectual control. "Since biological determinism possesses such evident utility for groups in power, one might be excused for suspecting that it also arises in a political context," Despite their generally liberal politics, the scientific writers "often acted as the firm ally of existing institutions."[68]

Although the codification of genius as "blind madness" and thus as ineffective and aberrant diminished the oppositional power of "divine madness" within the larger cultural arena, the Symbolist notion of mad genius came to define a major topos of the artist still with us in muted form today. The concept of degenerate, biologically determined genius, on the other hand, has languished, for the time being.

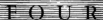

The Gender of Creativity

WOMEN, PATHOLOGY, AND
CAMILLE CLAUDEL

> Would any link at all be missing in the chain of art and science if woman,
> if the works of women were missing? Admitting exceptions—they prove the rule—
> woman attains perfection in everything that is not a work: in letters, in memoirs, even in
> the most delicate handiwork, in short in everything that is not a *métier*—
> precisely because in these things she perfects herself, because she here
> obeys the only artistic impulse she has—she wants to *please*— . . .
> (Nietzsche, 1888)[1]

As Nietzsche's statement illustrates, creativity is a gendered discourse.
For the majority of thinkers and artists in late-nineteenth-century
France, to be a creative genius was to be a man. Most notions of genius
were dependent on exclusivity of, superiority over, opposition to, and
difference from others such as "woman." With some important excep-
tions, arguments both for and against a woman's potential for genius
were supported by the ideology of femininity and the doctrine of sepa-
rate spheres. Indeed, rather than indicating any interest in manifestations
of women's genius, the (covert) subject of the fin-de-siècle discourse of
women and creativity was masculine genius.[2] This chapter deals with
dominant conservative attitudes toward female genius shared by the
Symbolists and the role of these attitudes in developing masculinities.
Attitudes within the arenas of cultural politics, biological determinism,
hysteria, and feminism will be examined.

The model used here for gender difference relies on Judith Butler's
theory of the performance of gender. Only in ideology is gender a coher-
ent, boundaried entity. In practice, boundaries are continuously trans-
gressed. Individuals perform gender differently, and either sex may take

up various gender positions. Rather than a "natural fact," Butler described gender as a "cultural performance . . . constituted through discursively constrained performative acts," a "kind of persistent impersonation that passes as the real."[3] In late-nineteenth-century France, conventional standards for sex as gender were buttressed by dividing practices so that other enactments of gender, such as the practice of homosexuality or the habits of independent women, were stigmatized as perverse. The Symbolists exhibited notorious signs of femininity in both their persons and their aesthetics. The fear of feminized masculinity among most Symbolists roused them to enact complicated constructions of gender for which their attitudes toward women and women artists were central.

The often disparaging and even misogynistic nature of allegations that a woman could never attain the heights of male genius ranged across disciplines, discourses, and political antagonisms during this period. The industrial age also brought a number of structural changes in patterns of work, family, leisure time and activities, politics, and economic possibilities. Standards for masculinity and femininity shifted and altered as life roles were adjusted to new conditions.[4] A debate over the "woman question"—briefly stated, what were the rights of women in a "free" republic that was based on the family unit—dominated the last decades of the century and involved a wide range of voices from both genders.[5]

The greater social and political presence of women derived from changes on a variety of fronts. Radical feminism was revived in the 1880s and 1890s, along with a more moderate and mainstream variety that advocated "familial feminism," "equality in difference," the sexual division of labor, motherhood, and country.[6]

Although the government responded sluggishly to women's demands for change, in 1884 the right of divorce was once again granted to women, and from the 1890s onward a series of minor reforms for women were approved.[7] Moreover, women had made inroads into a number of "male" professions, and more and more women, even of the bourgeois class, expressed a desire to work; some demanded birth control. However, according to Michelle Perrot, "these changes did not fundamentally alter women's subordinate and dependent relationship to men." Their newly won positions in professions, for example, were compromised by the stereotypical modes of their reception within those professions.[8] Nevertheless, improvements in women's conditions gave rise to a new type of bourgeois woman in the 1890s: the *femme nouvelle*, "a middle-class woman seeking independence and education rather than marriage and the home."[9]

The reaction against the "new woman" was dramatic. She was represented most commonly as perverted "other" to natural, domestic wom-

anhood. The medical profession corroborated this view of the *femme nouvelle* as pathological. She was figured as, among other things, an emaciated "hommesse" without feminine charms, who desired the destruction of the family and of gender difference (see figure 4.1). Caricatures of attractive "new women" abounded as well. In Henri Boutet's cover illustration for *La Plume* (1896; figure 4.2), a properly dressed, working-class woman watches from the background while a wicked "new woman" with legs akimbo and exposed to the knee uses her latest "weapon," the bicycle, to literally kill love—she runs over Cupid's genitals! P.-J. Proudhon, the radical and influential socialist working toward egalitarianism, retreated into a most reactionary position in the face of the independent woman's supposed threat to the established order. A woman was either a housewife or a whore, to quote his notorious pronouncement, and certainly without genius.[10] "Je nie radicalement les génies femmes" ["I absolutely deny the existence of women geniuses"]. Proudhon had the same stake in keeping women away from intellectual pursuits as he had in keeping them out of the workplace—they were needed for domestic duty.[11] The decline of the birthrate in France amplified fears of independent women and was promptly alleged to be an issue of national security.[12]

Women also participated on both sides of this debate; they held wide-ranging positions from radical feminist to arch conservative. Clarisse Bader, in her history of modern women, published in 1885 and including the views of revolutionary women, held the dominant conservative view that women are made for domesticity and are neither as intelligent nor as strong as men. She believed, however, that women could create distinguished works of art, worthy of display in the Louvre, as long as their domestic duties always came first. Accordingly, a better role than artist for a woman was "inspiratrice" for a male artist.[13]

Not all male responses to women's bid for equity and independence met with such arguments, however.[14] Léon Richer, for example, collaborated with Maria Deraismes on a feminist program during the 1870s and 1880s and edited the feminist newspaper *Le Droit des femmes*.[15] Many other male thinkers recognized that changing circumstances necessitated a different response to women's needs and demands than the insistence on separate spheres and, thus, offered more sympathetic statements on female nature and creativity. These thinkers hoped either to accommodate women's demands without totally disrupting the social fabric or to radically restructure society.[16]

In 1896, the influential *Revue Encyclopédique* dedicated an issue to feminism. As such, it is a good index for attitudes toward the ideology of femininity and women's equality. Contributions by both male and fe-

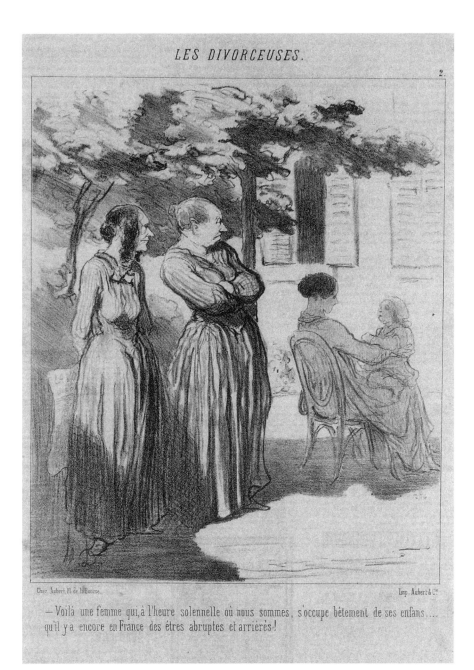

— Voilà une femme qui, à l'heure solennelle où nous sommes, s'occupe bêtement de ses enfans.... qu'il y a encore en France des êtres abruptes et arriérés!

4.1 Honoré Daumier, "Voilà une femme qui, à l'heure solennelle où nous sommes, s'occupe bêtement de ses enfans [sic]. . . . qy'il y a encore en France des êtres abruptes [sic] et arriérés!" ("There is a woman who, at our solemn hour, stupidly occupies herself with her children. . . . how can such narrow, dull-witted creatures still exist in France!"), *Les Divorceuses* (*Advocates of Divorce*), no. 2; published in *Le Charivari,* 12 August 1848 (Delteil 1770), lithograph, 14¼″ × 9¾″. Rose Art Museum, Brandeis University Libraries, Waltham, MA, The Benjamin A. and Julia M. Trustman Collection.

LA PLUME

Littéraire, Artistique et Sociale

Numéro 161. 1ᵉʳ Janvier 1896.

Etrennes aux dames de la part de HENRI BOUTET

Ceci tuera cela.

— *Bénis ta pauvreté, Mimi Pinson, elle te préserve de la bicyclette !*

4.2 Henri Boutet, *New Year's Gifts to the Ladies from Henri Boutet,* published in *La Plume,* 1 January 1896, frontispiece. Photo: Library of Congress, Washington, DC.

male writers from a variety of perspectives ranged from an article on modern women to one on feminist men; most were supportive of women if not always of feminism.

In the article "La Femme moderne par elle-même," all sorts of women spoke, from artists and poets to social workers. A musician and composer, Mlle Cécile Chaminade, was one of the most thoughtful, while at the

opposite end of the spectrum, Mme Bonnetain rather coquettishly claimed the dubious honor of being the first white woman to go to the Sudan.[17] Other articles, such as Marya Chéliga's on feminist men, used science to argue against the prevailing impression that women were intellectually inferior. Chéliga's article is particularly telling. She cites a number of experts' opinions from a variety of fields in support of women's equality. Strong political activists made statements that would be considered feminist today. Chéliga cited an anthropologist, M. de Dr Manouvrier, whose study of comparative anatomy supposedly demonstrated that women's brains were superior in size and thus in quality to those of men.[18] However, other opinions that are far from feminist are cited alongside these.[19]

In this same article, Chéliga described the transition in the work of mystic poet Jules Bois from an ideal of woman as pure maiden in the face of perverse humanity to an antifeminist position against "modern woman" for her lack of purity and, finally, to a more "feminist" stance in support of "modern woman." Bois published an article in this issue as well in which he demonstrated his feminism by insisting that a woman must be allowed to be herself rather than an extension of man as a wife, lover, or mother.[20]

Conservative opinion was also given voice in this issue. In an article on women's work, a number of men of stature with conventional attitudes on women and genius supported separate spheres and greatly limited women's creativity. Avant-garde art critic Gustave Geffroy gave a similarly negative assessment:

> Lorsque l'on pense à cette foule de créatures qui vivent par l'homme, qui sont vouées à la maternité par la loi naturelle, la seule solution qui apparaisse à cette terrible question du travail des femmes,—c'est que la femme ne doit pas travailler.

> [When one thinks of this crowd of creatures who are supported by man, who are dedicated to maternity by natural law, the only solution that appears to this dreadful question of women's work,—is that woman must not work.][21]

This issue of *Revue Encyclopédique* established the reality of discordant voices despite the authority of the dominant discourse on woman. Both moderates and radicals acknowledged here the space that women had defined for themselves, thereby allowing women's cultural voices to be heard to some degree. The Symbolists exposed their conservative side in this debate. They fell squarely within the dominant camp of those who preferred to maintain the status quo as far as women were concerned.

Otherwise antagonistic male groups competing for power in the cultural realm, such as the Symbolists and the scientific writers on genius, were in basic agreement on the nature of (bourgeois) woman as uncreative, unintellectual, and undesiring, even if they used different strategies to so position her.[22] The control of women ideologically and socially was an essential strategy to assure the masculinity of genius.

Despite the reality of individual variations and postures on the social role of women, the intricate interwoven fabric of ideology defining the category of "woman"[23] constituted a "regime of truth," a normative body of assumptions circumscribing the ways in which one could imagine women in late-nineteenth-century France. The institutions that incorporated these functions and strategies of differentiation ranged from the family to the state, the medical establishments, the Academy, and l'École des Beaux-Arts, which excluded women until 1896.[24]

This dominant discourse on woman's nature was nonetheless interrupted and destabilized in numerous ways. Despite the monopoly on knowledge that intersecting "master" discourses held, the category of woman was riddled with discontinuities, disjunctions, and contradictions which acted as potential sites of resistance. Political struggles by women, moralists and socialists, the collusion of women in their own gender construction, and the stresses of constructing and maintaining masculinity destabilized the discursive mechanisms that shaped representations of woman and genius.

The characterization of woman during the last decades of the nineteenth century as biologically, socially, and intellectually inferior is well documented.[25] Current research overwhelmingly demonstrates the way in which cultural attitudes about women were sanctioned and naturalized as inherent in the female nature. Christine Battersby has effectively traced attitudes toward women and genius from the ancient period to the present in her book *Gender and Genius*.[26] I will highlight here issues specific to late-nineteenth-century France.

The creative nature of woman was debated on the same grounds as those of male genius—by referring to the effects of heredity, evolution, and physiology on intellectual and spiritual capabilities. Certain attributes generally defined female creativity in the late nineteenth century: women's "natural sphere" was the domestic; their "natural" role in the cosmic scheme was to produce children; women's creativity lay solely in their bodies; women's anxiety and discontent resulted from abandoning their reproductive and/or domestic duty; therefore their "passionate discontent" would never lead to any "higher" form of creativity as *la douleur* had for male artists; and, finally, if women did pursue artistic creativity, they thereby repudiated their own gender.

Other traits long considered to be "natural" to bourgeois woman also excluded her from creativity and genius. Modest and timid by nature, woman did not have the intellectual fortitude necessary to the task of creating the new. Moreover, she was superficial. Her primary talents were to manage and decorate the home and to create herself as an object of display for male pleasure.[27] Woman was both an object and a consumer of objects.[28] Lombroso contended that women were inherently cultural reactionaries who had rarely done anything original or innovative:

> women have often stood in the way of progressive movements. Like children, they are notoriously misoneistic; they preserve ancient habits and customs and religions. . . . many ancient prejudices and pagan rites, perhaps of a prehistoric character—superstitious cures, for instance—are preserved by women. As Goncourt remarks, they only see persons in everything; they are, as Spencer observes, more merciful than just.[29]

The values espoused in this passage are equivalent to those of capitalism and imperialism—esteeming progress at the expense of other traditions and cultures, which were characterized derogatorily as pagan, superstitious, and out-of-date. Mercy and caretaking were demeaned.

The biological sciences, deeply biased by social theory and policy, pathologized the female body and read women's nature through this pathology, including her creativity.[30] The authority given to such biological determinism disarmed feminism, infected writers of both genders, and tended to drown out those who considered femininity to be a social construction.[31] According to the philosophers of degeneracy, while the male genius might use up his vital essence in manifestations of ecstatic revelation, and thus end up degenerate or leave a legacy of degeneracy, the female body's use of the energy necessary for reproduction left nothing at all for other, intellectually taxing, activities. Woman used up her life essence not in the creation of culture but in the reproduction of nature. Female genius was physiologically impossible.

Much evolutionary theory also imprisoned woman within her body. It "proved" that she was incapable of genius because of her physical and thus emotional and intellectual frailty. In *The Descent of Man,* written in 1871, Darwin explained that through natural selection, "man had become superior to woman in courage, energy, intellect, and inventive genius, and thus would inevitably excel in art, science, and philosophy." The talents of woman, on the other hand, lay in the areas of "intuition, perception, and imitation," which Darwin defined as signs of inferiority, "characteristic of the lower races, and therefore of a past and lower state of civilisation."[32] According to Darwin, women also lacked the intellect

to control and direct their intuition, a quality necessary to creativity as
the Symbolists defined it.

Henri Joly, who so adamantly opposed Lombroso's basic thesis on
the link between madness and genius, nevertheless agreed with Lom-
broso that women had little genius. Women of genius required less of
the vital substance since they were incapable of action or abstract, pro-
longed effort.

> par conséquent, là où la nature est devenue insuffisante pour créer un
> homme digne de ce nom, elle peut, grâce à l'économie qu'elle fait alors
> sans danger des qualités robustes et viriles, donner naissance à une femme
> remarquable.

> [consequently, where nature has become insufficient to create a man
> worthy of the title [of genius], she can give birth to a remarkable
> woman, thanks to the economy made by her lack of robust and virile
> qualities.][33]

Women either prepared the way for male geniuses by energizing the
fluids of genius without dissipating them or received the afterglow from
a genius brother.

Joly's attitude, however, appeared mild-mannered, even benevolent,
compared with those of other theorists. Lombroso held that women of
genius were traitors to their gender. "Even the few who emerge have,
on near examination, something virile about them. As Goncourt said,
'there are no women of genius; the women of genius are men.' "[34] Otto
Weininger, in his influential text *Sex and Character* (1903), insisted that
men embodied both masculine and feminine sides, but women could
only be feminine. Therefore, when a woman chose genius over feminin-
ity she was in a state of hysteria because she could only see herself as
pseudo-male.[35]

As discussed previously, Symbolist literary writers, art theorists, and
artists often opposed scientific theory, but most were in accord with
their scientific adversaries that creative genius was a specifically male
enterprise and that women of genius were anomalies. Remy de Gour-
mont saw women as fulfilled only through biology. Schopenhauer con-
curred, and further maintained that they have no "susceptibility" for
music, poetry, or fine art and that "it is mere mockery if they make a
pretense of it in order to assist their endeavour to please."[36] Although
Symbolist artists and critics were supportive of particular women artists,
in general they held similar views on women. Gauguin liked women,
he said, "when they are fat and vicious; their intelligence annoys me."[37]
Van Gogh, too, speaks in stereotypic terms of women: "A woman should

have a pelvis that can support a child." He loved to paint "young girls as fresh as the fields, every line of them a virgin."[38]

The arguments from various discourses assembled here defined female genius by a lack, not only of the penis but in a larger sense, maleness and its attributes (in Lacanian terms, the "phallus"[39]). This lack insured that the construct of woman remained useful and available as foil for masculine psychological ego needs. Indeed, the formation of certain masculinities was at stake in the debate over women's creativity.

Competing, differentiated and obsessively repeated definitions of femininity (although within a limited range) not only enforced gender difference but also exposed the struggle for power and identity *between* men. Eve Sedgwick addressed the apprehensions and anxieties within masculinities, signaling the precarious nature of its construction: "men enter into adult masculine entitlement only through acceding to the permanent threat that the small space they have cleared for themselves on this terrain may always, just as arbitrarily and with just as much justification, be punitively and retroactively foreclosed."[40]

In fin-de-siècle France, the more conventional constructions of masculinity based on notions of reserve and virility were under fire. Michelet produced, around midcentury, an influential example of an idealized form of masculinity in his book *Woman (La Femme)*. In his patronizing but seemingly benign text, he constructed an ideal masculinity of strength, power, vitality, action, creativity, objectivity, and nobility. This ideal was inscribed most forcefully in his text through juxtaposition with its dyadic other—the frail, sickly, and helpless woman.[41]

At the turn of the century, Idealist philosopher Alfred Fouillée produced an analogous form of masculinity, but one now ossified by biological determinism. Although an Idealist who sought to integrate the heart with the intellect, Fouillée relied on natural selection to rationalize a series of masculine/feminine traits based on the necessities of life in the wild: men were more inconstant in love in order to multiply their chances to propagate the race whereas women were more constant because of their tendency to integrate and conserve; men emphasized the individual, women the group; masculine intelligence rested in its ability to forge ahead and resolve problems whereas woman's intelligence lay in her cunning and in her ability to wait, observe, and fathom. In sum, Fouillée characterized masculinity as the embodiment of action, aggression, individuality, and exteriority; femininity was again its polar opposite.[42] Michelet's and Fouillée's models were typical in tone and content if not always in detail of the kinds of masculinity representing the norm. They will be used here as a background against which the very different masculinities embedded in the Symbolist aesthetic may be analyzed.

While a majority of male thinkers and artists retrenched into reactionary masculinist positions with rigid gender boundaries such as those described by Michelet and Fouillée, a surprising number of others embraced more feminized identities. In this period of exacerbated sensibilities, anxiety, and powerful historical pressures for change, men turned to the traditional female model to express interiority and emotional release. Symbolists drew upon notions of femininity such as intuition, spirituality, hypersensitivity, and emotionalism to create an alternative, feminized masculine identity antithetical to the norm. Even the agonism of the avant-garde—its self-sacrifice for the good of the future—suggested the role of woman.

Such a feminized aesthetic arose for many reasons, not the least being the crisis of subjectivity in a culture governed by a form of duty-bound patriarchal masculinity such as Michelet described. Rather than the man of action, the Symbolist performed the (feminized) man of sensibility. Both the androgyne and the aesthete, with his rarefied air and refined sensibilities, exemplified the Symbolists' retreat into the feminine. These personae were, among other things, escapes into refinement in an age of gross materialism and superficial spectacle.

Feminization was also an operational mode of resistance to the heroic, objective, and rationalist masculinity exemplified by Fouillée's philosophy, which dominated French bourgeois culture. Feminized masculinity had the potential to further confuse and efface gender boundaries at a time when those already unstable boundaries had aroused anxiety among most citizens. The aesthete, according to Jessica Feldman, challenged the supposedly "natural status of two distinct genders" because he blurred the distinctions between male and female.[43] In general, however, the Symbolists, rather than exploit the potential for a revolutionary position of difference, chose to reaffirm their allegiance to a more acceptable masculinity by privileging the role of intellect and control in their creative process.

By disrupting more conventional paradigms of the masculine ideal, such as that of Michelet and Fouillée, the soft masculinity embodied in the Symbolist aesthetic and in its agents, the aesthete and the androgyne, was in danger of being seen as effeminate. Effeminacy was a term that implied much more than emotional excess or even weakness, traits inimical to manliness; it also alluded to other aspects of the ideology of femininity, such as inconstancy, superficiality, and lack of intellect and control.[44] The philosophers of degeneracy also incorporated stereotypical notions of the feminine, such as overt emotionalism and hypersensitivity, into their models of creativity. However, they attributed the most damning female characteristic—lack of intellect and control—to the mad ge-

nius, thus implying the philosophers' superior rationality and distance from these traits despite their celebration of them.

In turn, Symbolists insistently defamed those aspects of woman with which they wanted to avoid identification—her lack of intellect and her gross physicality and dirty sexuality. They took up aggressive, masculinist stances of antagonism and nihilism toward society. They also considered the masculinist tradition of Platonic and Neo-Platonic Idealism rather than the female sensibility to be the source of their aesthetic. Aurier, for example, in his article on Renoir characterized women as dolls and the artist's "la Parisienne" as most likely sterile and useful only for male plea-sure—namely, as a degenerate prostitute. He described men's foolish blindness to the emptiness of women:

> Elle ne vit pas, elle ne pense point. Nous autres, tous plus ou moins psy-chologues et encore plus sots que psychologues, bêtement, nous tenons à lui attribuer nos sentiments, nos émotions, nos rêves d'êtres-vivants. Nous lui votons un coeur compliqué, une intelligence retorse. Nous la décrétons volontiers ange ou démon, nous nous plaisons à la trouver sublime ou ignoble, machiavélique, vipérine, féline! Pauvres fous! nous semble dire le peintre. Comme si un chat, une vipère, n'avaient point mille fois plus d'âme qu'une femme!

> [She [woman] does not live, she doesn't think at all. We others [men], all more or less psychologists, and yet more fools than psychologists, stu-pidly persist in attributing to her our sentiments, our emotions, our dreams of living beings. We men declare her to have a complicated heart, a cunning intelligence. We willingly pronounce her to be an angel or a demon, we enjoy finding her sublime or vile, Machiavellian, serpentine, feline! Poor fools, the painter [Renoir] seems to say to us. As if a cat, a viper did not have a thousand times more soul than a woman!][45]

Such a vehement attack on woman forcefully asserted her difference from man. The Symbolists resolved the paradox of feminized masculinity by both embracing and rejecting the signs of woman. They followed Baudelaire in their desire to inhabit the masquerade of feminine emo-tionality without abandoning difference. Such protection of gender boundaries served to maintain the categories of masculinity and feminin-ity. Both Symbolists and philosophers of degeneracy asserted their mas-culine forcefulness while creating a space appropriated from the ideology of femininity in which to emotionally express their anxieties and renego-tiate their male identity.

The concept of feminized genius was most effectively protected from accusations of effeminacy by the vociferous protestations against the no-

tion that women themselves could be receptacles of the substance of genius. For the majority of thinkers and artists, female traits were only beneficial and productive if found in the male sex.

Those exact female traits privileged by feminized masculinity, when experienced by women were repositioned as disease through the discourse of woman and madness.[46] Woman was believed to be particularly incapable of the lucid, profound, and sibylline madness that epitomized the male model of ecstatic, revelatory genius embodied in the *poète-voyant*. The purported frailty and weakness of the female constitution was thought to predispose them to an enervating form of madness, untempered by the intellect and uncontrolled by critical faculties. Accordingly, the medical establishment instituted a counterpoint—hysteria—that explained female traits that paralleled those of mad genius in men.[47]

The nineteenth-century transformation of the ancient disease of hysteria was perhaps the most debilitating construction of woman and madness in terms of her potential for creative genius. Arising as a widespread mental illness among women at exactly the same historical moment as the feminization of masculine models of creativity, hysteria was one of the mechanisms through which similar experiences of anxiety and emotionalism were coded differently according to gender. The symptoms and characteristics of hysteria included extremes of emotion, from hysterical loss of voice to screaming, laughing, sobbing, paralysis, fits, and unconsciousness.[48] As two psychologists concluded in 1958, hysteria resembled "a picture of women in the words of men and . . . what the description sounds like amounts to a caricature of femininity!"[49]

There is evidence to suggest that the startlingly rapid rise in the manifestation of this disease and the characterization of hysteria as an enactment of typically feminine emotional excess can be attributed in large part to its reinvention in late-nineteenth-century France by Dr. Jean-Martin Charcot in his Paris clinic, the Salpêtrière. Charcot had wanted so badly to carve out a medical territory for himself that he overlooked contradictory evidence and invented his own scenarios for the enactment of hysteria in order to create a consistent step-by-step paradigm of its progressive stages.[50] The theatrical rhetoric evident in the photographs of these demonstrations indicates their performative rather than symptomatic thrust. Women could perform hysteria for Charcot not only because they knew what he wanted, but also because he had extrapolated the general characteristics of his disease from the ideology of femininity already familiar to them. In short, hysteria as Charcot constructed it was the physical manifestation of the ideology of femininity, an "ideology of a masculinist society, dressed up as objective truth."[51]

Charcot's stages of hysteria paralleled the Symbolist stages of the cre-

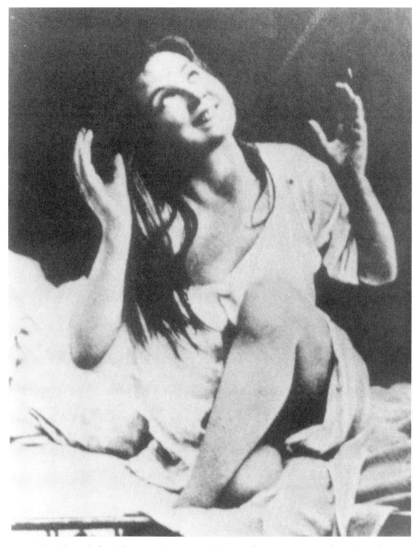

4.3 Paul Régnard for Charcot, Augustine, "Extase," 1878, *Iconographie, Attitudes passionnelles.*

ative process in many ways. He described them as visionary, hallucinatory, ecstatic, and similar to intoxication, all states reminiscent of the experience of ecstatic inspiration described in the Symbolist aesthetic. Indeed, the photograph for one of the steps in the "attitude passionnelle" was labeled *extase* (see figure 4.3). Moreover, terms such as "hyperesthésie" and "émotivité" were as common in discussions of hysteria as they were in the Symbolist aesthetic.[52]

The unconventional and defiant hysteric enacting her alienation through a structure of tension and release would seem to correspond to the Symbolist ideal of the rebellious and suffering *isolé*. Both were constituted from social crisis, both were situated in suffering and performed through ecstasy. We recall that the "maddened genius," Van Gogh, whom Aurier also characterized as hyperaesthetic and neurotic, gave vent to his excessive sensibility in "great" works of art. His illness was heroicized as a sign of his genius. Aurier validated the connection between the female hysteric and the sensitivities of the genius, but heightened their difference by surrounding this feminized attribute with hypermasculine traits. "Ce robuste et vrai artiste," Van Gogh, "aux mains brutales de géant, aux nervosités de femme hystérique, à l'âme d'illuminé . . ." ["This robust and true artist, . . . with the brutal hands of a giant, the nervousness of an hysterical woman, the soul of an enlightened one . . ."][53] While the hysterical woman suffered *la douleur,* her ecstasy remained a physical act in the material realm to which she passively submitted. According to Freud, hysteria remained "a caricature" not only of femininity but also "of an artistic creation."[54] Charcot's construction of hysteria reconfigured a woman's disease so that it paralleled, absorbed, and disempowered those female characteristics culturally privileged in men and helped constitute creativity as an exclusively male domain. In Charcot's caricatured, demeaned, and pathologized representation of hysteria, women were denied the creative outlet for their anxieties assumed by men.

A number of contemporary writers have suggested that the lived experience of hysteria may have been for some a form of release from their own symptoms of a "passionate discontent" derived from a repressive culture, or a form of rebellion against enforced social roles.[55] While the Symbolists appropriated aspects of the masquerade of femininity to stress their individuality, hysteria for many women may have been a result of a failed masquerade—their inability to accept or maintain their public and/or private feminine role.[56] If some women passively refused to submit to the ideology of femininity by becoming ill, others such as feminists and the "new woman" publicly voiced their opposition to that ideology. Hysteria was the disease "most strongly identified with the feminist movement" at the end of the century and may have represented the use of an oppressive structure to put independent women in their place.[57] Some feminists recognized Charcot's construction of hysteria as a strategy of control. Goldstein gave the example of Mme C. Renooz, who in 1888 criticized Dr. Charcot's intention as a "sort of vivisection of women under the pretext of studying a disease for which he knows neither the cause nor the treatment."[58] In sum, the representation of hysteria

demonstrated the power of the ideological assertion of difference to af-
fect real lives.

The institutionalization of the sculptor Camille Claudel for the last
thirty years of her life exemplifies how such constructions of difference
could be used to control and disempower women.[59] In 1913, Claudel's
mother and brother Paul had her forcibly committed to an insane asylum
where she remained until her death in 1943, despite pleas for release
from her and her doctors. In many ways, the manipulation of her sup-
posed madness paralleled the uses of hysteria to designate the collapsing
of frustrated professional women into nervous illnesses as declines into
pathology and madness.

Although sculptor Camille Claudel lived well into the twentieth cen-
tury, her mature work was done within the purview of the Symbolist
period, from the 1880s to the very early 1900s. After her forced intern-
ment in an insane asylum in 1913, she never touched clay again. Her
sculpture received major critical attention during her working life, but
soon she became known only as the sister of poet Paul Claudel and lover
of sculptor Auguste Rodin. Only recently has her work begun to be
seriously studied again. The effect on her life and the reasons for her
entrapment in the construct of woman and madness concern us here;
her development of a personal aesthetic will be discussed in the chapter
on women Symbolist artists.

There seems little doubt that Claudel needed professional help by
1913, but the nature and degree of her madness has never been entirely
clear. Most of the contemporary literature on Claudel, especially the
various publications by her grand-niece, Reine-Marie Paris, consider her
madness to be a given. They credit it to the termination of her affair
with Rodin, her lover and co-worker for eight years and friend for six
more.[60] However, she remained artistically active and mentally stable
until at least 1905, and possibly until 1910, when she executed some of
her most innovative work.

Medical records of the time classify her as a paranoid.[61] The strongest
evidence for such a diagnosis comes from her belief that Rodin was
persecuting her. In the first years of their relationship, the two artists
had a passionate creative collaboration. Claudel, an accomplished artist
prior to meeting Rodin, worked closely with him on the *Gates of Hell,*
contributed to the *Burghers of Calais,* inspired him as muse, and—more
important—sparked a new creative life in him.[62] Rodin indeed was
greatly stimulated by Claudel, and their collaborative work during their
years together recharged his flagging creativity. Their creative interaction
was incredibly fruitful for the development of both artists, but it was
only Rodin who reaped worldly benefits from it, "an expropriation of

4.4 Camille Claudel, *Giganti* (signed on the neck, A. Rodin), 1885, bronze, 28 cm. Kunsthalle, Bremen. ©1999 Artists Rights Society (ARS), New York/ADAGP, Paris.

credit which haunted Claudel's madness [*sic*] after their breakup."[63] Rodin did not give her the public credit she was due for her part in his work and seems to have offered her only limited help in establishing herself apart from him in the art world. Instead, he almost certainly sold works for which she was partially responsible under his own name. He even signed his name to at least one of her works, *Giganti*, 1885 (figure 4.4).[64] Claudel may have exaggerated Rodin's betrayal, however, in thinking for example that Rodin was selling works as his own that he

had stolen from her studio.[65] Nevertheless, her "paranoia" concerning Rodin was at least partially justified.

More important, other generally ignored factors, both material and psychological, also played a significant role in Claudel's failing mental health. Material problems plagued Claudel after her breakup with Rodin. Although her work was admired and regularly exhibited, she did not receive the public commissions needed to support the expensive processes of bronze casting and marble sculpture and therefore could not sustain a financially viable career.[66] Her father and brother helped her, but she fell into increasing poverty and her health deteriorated.[67] She wrote to her dealer and bronze caster, Eugène Blot, in 1905 that she could not go to the Salon d'Automne because she had no proper clothes. An exhibition of her work, organized by Blot in 1905, was not a financial success. Claudel wrote to Blot of her discouragement in that year:

Cet art malheureux est plutôt fait pour les grandes barbes et les vilaines poiré[e]s que pour une femme relativement bien partagée par la nature.

[This miserable art is made more for venerable male artists and nasty "poiré[e]s" than for a woman relatively well endowed [artistically] by nature.][68]

Jeanne Fayard suggests that Claudel did not receive commissions from the state because she was a woman.[69] Claudine Mitchell argues similarly that Claudel lost three different commissions from the state because her sensual, passionate representation of the nude female body in works such as *The Waltz* (figure 4.5) indicated sexuality to the reviewers;[70] it was considered improper for women to participate in the public debate on sexuality unless their work could be read as "pure." Jacques Cassar blames Rodin for Claudel's loss of one particular commission from the state.[71]

For whatever reasons, Claudel's lack of financial support for her sculpture thwarted her strong ambition, while Rodin received greater and greater critical acclaim. After 1905, she lived in increasing isolation, progressively becoming more eccentric according to several accounts. She broke and burned many of her plaster and marble works during this time.[72] Her brother Paul reported that she began to show signs of disintegration when he saw her in 1909 after several years away. Appalled, he wrote in his journal, "Camille insane, enormous, with a soiled face, speaking incessantly in a monotonous metallic voice."[73] She may also have been prone to depression and to heavy drinking during this period.[74]

This brief look at the circumstances of Claudel's life prior to her internment indicates that Claudel's degenerating condition did not result

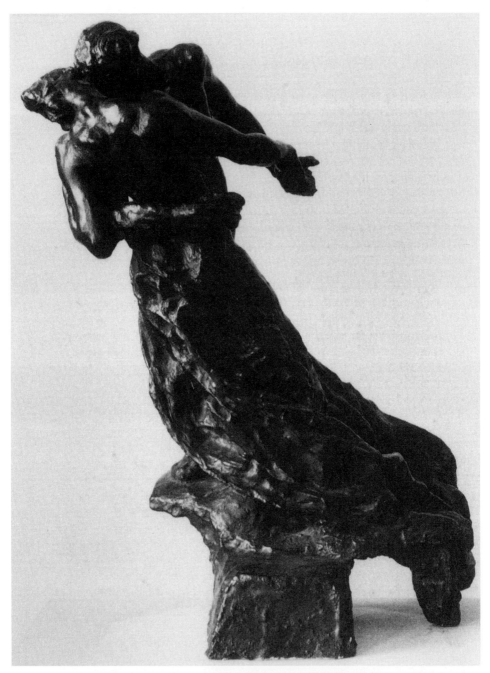

4.5 Camille Claudel, *The Waltz*, 1891–1905, bronze. Private Collection. Photo: Musée Rodin, Paris. ©1999 Artists Rights Society (ARS), New York/ADAGP, Paris.

from her pain over losing Rodin, an event that occurred a good twelve years before and after which she produced some of her most innovative work. Her frustrated ambition to become a successful, established artist, her increasing poverty and obscurity, and her sense of professional betrayal by Rodin and by the art world generally, which had failed to support her, were more than reason enough for her lapse into eccentricity. Her nervous illness may well have been a response to lack of control over her life.

Yet many continued and still continue to see her illness as related strictly to Rodin. Even after her death in 1943, Paul wrote in his journal: "Ma soeur! Quelle existence tragique! A 30 ans, quand elle s'est aperçue q(ue) R(odin) ne voulait pas l'épouser, tout s'est écroulé autour d'elle et sa raison n'y a pas résisté." ["My sister! What a tragic existence! At thirty years, when she realized that R(odin) would not marry her, everything collapsed around her and her reason could not resist."][75] Paul's characterization of his sister as deteriorating from age thirty on (1894), nineteen years before her internment, ignored the amount and quality of work she produced during this period.

Although Claudel may have needed medical attention, there is evidence to suggest that she need not have been detained in asylums for the last thirty years of her life. Her family, as well as the topos of woman and madness, bear the responsibility for any injustice done. Only three days after the death of her father, who had always emotionally and often financially supported her, her brother Paul asked for the permit to intern Camille.[76] Five days later, interns took her forcibly from her apartment. Although doctors recommended that she be released at least twice over the years, and Claudel wrote to her mother pleading with her to allow it, even offering to give up her inheritance, her mother refused. Louise Claudel, a proper bourgeois woman, had a long-standing distaste for her independent daughter's libertine lifestyle and may have at least unconsciously deprived her of her liberty as a means to censure her behavior and rid herself of a "problem daughter." She wrote to the director of the asylum in 1915 that: "[Camille] has all the vices, I don't want to see her again . . ."[77]

Paul never so totally abandoned Camille as did his mother, yet he did not release her when doctors recommended it, nor after their mother's death in 1929.[78] His public position as diplomat demanded a propriety that he feared, perhaps, Camille would disrupt. Claudel's offer to give up her inheritance suggests that money may have been an issue in her continued incarceration, especially considering that she was committed so swiftly after her father's death. Did the family have control of her inheritance?[79] In any case, Paul certainly must carry the weight of the

blame for keeping her interned all those years.[80] Camille's friend and
critic Mathias Morhardt agreed: "Paul Claudel est un nigaud. Quand on
a une soeur de génie, on ne l'abandonne pas. Mais il a toujours cru que
le génie, c'est lui qui l'avait." ["Paul Claudel is a fool. When one has a
sister of genius, one does not abandon her. But he always believed he
was the one with genius."][81]

Her family's motives are further brought into question by evidence
concerning Camille Claudel's mental health at the time of and after her
internment. Conflicting evidence exists as to her actual condition.
"Some of her friends claimed she was never crazy at all."[82] As doctors
then and now suggest, paranoia is not necessarily a debilitating illness.
One can function normally. From her letters it appears that Claudel was
generally lucid at least during those thirty years in which she remained
institutionalized.[83] She wrote to Paul: "Madhouses are houses made on
purpose to cause suffering. . . . I cannot stand any longer the screams
of all these creatures." To an old friend who had written her in 1935,
she replied, "I live in a world that is so curious, so strange. Of the dream
which was my life, this is the nightmare."[84] The awareness of her sur-
roundings and the emotional and logical clarity of these statements do
not seem to come from someone who has lost her reason as Paul main-
tained.

The press, too, described her internment as unjust and condemned
the brutal way in which Claudel was forced against her will into the
asylum. One such article called her a great sculptor and described her
internment as a "monstrous and unheard-of thing: while in full posses-
sion of her great talent and of her intellectual faculties, some men arrived
at her door, brutally and despite her indignant protests threw her into
a car, so that to this day [1913], this great artist is locked up in a lunatic
asylum."[85]

We may never know whether Paul and his mother made the proper
decision in committing Camille Claudel. Her mental state remains a
mystery to us, and we can only speculate on her family's motives. What
we do know indicates that the assumption of the unstable and fragile
female constitution located in the ideology of femininity and manifested
in the discourse of woman and madness would have prepared a ground
that made it quite easy for Paul and his mother to eliminate the problem
of Camille's behavior by proclaiming her mad. It suited both to have
her put away, and her erratic, paranoid behavior gave them the slight
evidence and self-justification needed to do so.

Women were extremely vulnerable to abuse through this system. In-
dependent action on the part of women already was considered out of
the ordinary, so it was only a small step to characterize unseemly and

eccentric female behavior as abnormal and pathological. Diagnostically, such behavior could be interpreted as it suited the doctor or the family with the power to commit their kin. Such positioning of women functioned to deny problematic and disruptive women a role in social intercourse. The last thirty years of Claudel's life were sacrificed to the structure of regulation and containment that maintained the boundaries of "normality." The tragic case of Camille Claudel was one of the most visible examples of the power of the ideology of women to affect real lives, but the same scenario was no doubt played out in many less prominent cases as well. Claudel's imprisonment foreclosed for her what was already a limited range of agency for women and exemplified the way in which disempowerment for women could be literalized and materialized in their very bodies.

The gender of creativity evident in the model of mad genius was established through notions of difference. So fundamental was the principle of difference to late-nineteenth-century French culture that feminized masculine genius was protected from gender pollution only by a most vociferous exclusion of women from its ranks. Even those radical voices in favor of gender equity often assumed a qualitative difference.

The gender of creativity ultimately rested on the debate over the woman question. Too much was at stake on all sides to resolve this debate satisfactorily, but there is little doubt that those who opposed the family structure in late-nineteenth-century France by demanding or even suggesting that women should be integrated into the wider culture did so against strong opposition from institutions, from most citizens, and from other discursive cultural agents.

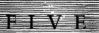
Gendered Bodies I

SEXUALITY, SPIRITUALITY, AND FEAR OF WOMAN

> One-half of mankind is weak, typically sick, changeable, inconstant—
> woman needs strength in order to cleave to it; she needs a religion of weakness
> that glorifies being weak, loving, and being humble as divine: or better, she makes
> the strong weak—she rules when she succeeds in overcoming the strong.
> Woman has always conspired with the types of decadence, the
> priests, against the "powerful," the "strong," the men.
> (Nietzsche, 1888)[1]

The anxieties surrounding the increasingly volatile categories of masculinity, the urge for a more spiritual existence, and the threat of feminism and the new woman were manifested in images of gendered bodies by a number of avant-garde artists at the fin de siècle.[2] A group of conceptually interrelated representations of male and female bodies that ranged from the grotesquely sexualized to the asexual materialized from these core issues. Lurid images of woman as sexually voracious femme fatale, as seen in German artist Franz von Stuck's *Sin* (c. 1891; figure 5.1), alongside innocuous images of woman as asexual, passive purist icon exemplified in Carlos Schwabe's poster for the Salon de la Rose + Croix (1892; figure 5.2) prevailed among Symbolists not only in France but throughout Europe.[3] At the same time, representations of the male nude reappeared in the guise of the ephemeral, asexual but often homoerotic androgyne, as seen in Gustave Moreau's *St. Sébastian* (c. 1878; figure 5.3).[4]

A considerable ambivalence toward male and female sexuality, manifested most concretely as a conflict between (female) sexuality and (male) spirituality, provides a link between these seemingly disparate images.[5]

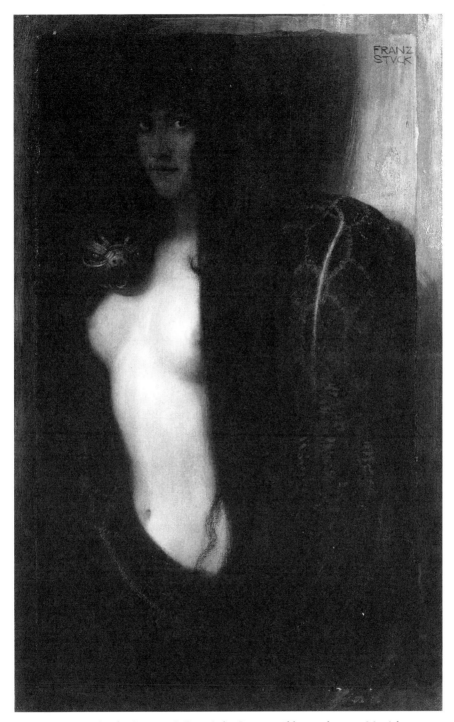

5.1 Franz von Stuck, *Sin,* 1891?, Bayerische Staatsgemäldesammlungen, Munich.

5.2 Carlos Schwabe, poster
for the *Salon de la Rose +
Croix,* Paris, 1892, lithograph.
Jane Voorhees Zimmerli Art
Museum, Rutgers, The State
University of New Jersey.
David A. and Mildred H.
Morse Art Acquisition Fund.
Photo by Victor Pustai.

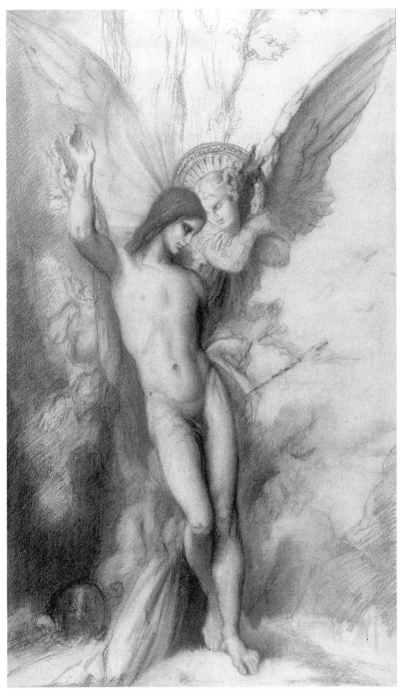

5.3 Gustave Moreau, *St. Sébastien,* c. 1878, pencil, charcoal and sanguine on paper, 24³/₁₆″ × 14¹/₁₆″, Musée Gustave Moreau, Paris (827).

The dichotomy between virgin and whore present in earlier nineteenth-century images of woman was exaggerated to its most extreme form ever by representations of the femme fatale and the pure woman. At the same time, certain representations of the androgyne signal a masculine retreat from sexuality, as evident in Gustave Moreau's *Jason* (1865; see plate 3). The androgyne also served as a vehicle for spiritual transcendence so central to the Symbolist aesthetic. In these three types—the femme fatale, the innocent woman, and the androgyne—the complex dynamic of masculine self-figuring was implicitly enacted in male artists' images of woman, and explicitly in the splitting off of masculine spirituality from (hetero)sexuality in images of the androgyne.

Despite the extreme and anxious nature of so many of the images discussed here, they were shown in numerous Salons or galleries and any critical contestation of them rested primarily on style rather than content. Few critics, however, were shocked by the scandalous sexuality of the femme fatale. We know little of how different audiences, particularly women, viewed them.[6] That these images found an audience at all indicates that they participated on some level in the popular mythology of sexuality and therefore remained at least within the bounds of recognizable forms of gender construction.

Accustomed to images of women wrestlers (Elysée-Montmartre Dance Hall, 1889), advertisements, posters for café-concerts, and other spectacles of the 1890s, images of the femme fatale may not have been so shocking to sophisticated and jaded Parisian audiences (figure 5.4).[7] The focus of this chapter will be less on reception than on the gendered power relations inhering in these works. My aim is to demonstrate how certain ideologies of gender were manifested and manipulated in late-nineteenth-century visual culture.

Images of these three tropes appeared simultaneously throughout Europe. Depictions of the femme fatale varied greatly depending on the nationality of the artist. For example, Belgian artists like Ferdnand Khnopff and Paul Delville (figures 5.5 and 5.6) tended to clothe the often animalized bodies of the femmes fatales in trance-like, other-worldly, occultist mystery. The Germans such as Franz von Stuck[8] (see figure 5.1) created earthy and satanic images of seduction. The Dutch Symbolists were best known for their flat, linear, decorative and rhythmic compositions, such as Jan Toorop's *Three Brides,* with its decadent femme fatale. Although this is a study of French Symbolism, I examine here a few examples of images from Belgium, so closely allied to the French Symbolists, and from Germany and Norway (Edvard Munch) in order to convey the widespread use of this image and affinities among national

5.4 Oswald Heidbrinck, *Le Champagne*, published in *Le Courrier français*, June, 1888.

5.5 Ferdnand Khnopff, *Art (Caresses)*, 1896, Inv. 6768, Musées Royaux des Beaux-Arts, Brussels.

representations of it. There are also direct connections. Some of these artists worked in Paris during the 1890s—Munch in 1889, for example; others lived there—Félicien Rops, who left Belgium for Paris in 1874 where he quickly became known for his erotic, often lewd works.[9] Almost all knew of each others' work through various avant-garde exhibitions, particularly the exhibitions by Les XX in Brussels and the Parisian Salon de la Rose + Croix (1892–97). Khnopff, for example, studied with Gustave Moreau in 1879 and participated regularly at the Salon de la Rose + Croix and at Les XX. He also exhibited in London, Vienna, and Munich during this period.

The femme fatale and the pure woman were reformulations of the ancient paradigm, "woman as nature," a model that tyrannically dominated discourses on womanhood in late-nineteenth-century France. Woman as nature was conceived of as an opposition to the higher masculine realm of human consciousness and culture, whose inhabitants strove to transcend and thus control both nature and woman as its embodi-

ment.[10] Woman as nature inflected models of what might be termed "woman as culture," such as "woman as pillar of morality," or as civilizing domestic force. No matter what her cultural role, reproduction remained her foremost duty and true cultural value, especially in the context of declining birth rates. Theorists of various disciplines from medicine and science to philosophy, literature, and art sought to naturalize this relationship of woman to nature by defining a woman's character largely in terms of her biologically unstable body. Woman was the exemplar of moral purity, and yet beneath this facade there also lurked the potential for a frightening but still enticing sexuality. Woman was frail and passive if kept under control, but if her emotions were unchecked, she became dangerously sexual.[11] This conflict between purity and perversity was also central to Symbolist definitions of nature at the time. Both woman and nature were understood to contain a base, material side, as well as a pure, spiritual side. Both were at once feared and desired.

Because the Symbolists had rejected science's claim to objective truth in favor of transcendental mystical truths, nature enjoyed a privileged

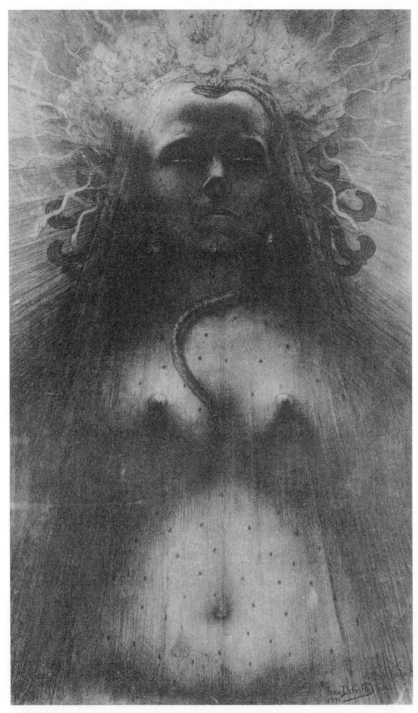

5.6 Jean Delville, *Idol of Perversity,* dr., 98 × 56 cm. Galleria del Levante, Munich.

position as the realm of those correspondences with the spiritual world which they sought. Yet uncontrolled nature, like uncontrolled woman, was seen as hostile and unsympathetic to man. Aurier spoke of the "hell of unconscious nature."[12] Baudelaire concentrated on the evil side of nature as well:

> it is [Nature] who incites man to murder his brother, to eat him, to lock him up and to torture him. . . . Nature can counsel nothing but crime. It is this infallible *Mother Nature* who has created patricide and cannibalism, and a thousand other abominations that both shame and modesty prevent us from naming. [my emphasis][13]

It was only through transcendence from nature's material realm to its spiritual realm that universal truth was revealed. Yet instinct and intuition, the conduits for such revelations, were rooted in the material. Both the material and the spiritual realms of nature contained powerful forces with which the Symbolists had to grapple. In either realm, woman was ideologically constrained, either bound so closely to the material world that she was not able to transcend it, as in the femme fatale, or positioned as purist symbol of the spiritual realm yet actually having no agency within it, as in the pure woman.

Material nature and the body were thus repressed through the ideal of transcendence; the femme fatale represented the return of the repressed. She was the epitome of one extreme representation of woman as nature/body—the incarnation of untamed desire and overwhelming passions unleashed by sexual instincts—and thus representative of what Friedrich Schiller referred to as "the heavy chains of desire" that weighed men down in worldly existence.[14] Indulgence in sensuality and "dirty sexuality," in Aurier's words, was believed to diminish the intellectual faculties. Such "filthy passion . . . like a leper, stalks and kills the artists of our villainous epoch."[15] The femme fatale threatened castration and the loss of self with her gaze and her engulfing subsuming desire. She was a sexualized version of Julia Kristeva's notion of the "monstrous-feminine"—a female body that is "the object of horror and threat," inciting the fear of being reabsorbed by the mother.[16] Her gaze persecuted because it had the power to bestow not only life but death when so grotesquely unbridled.[17]

Franz von Stuck's *Sensuality* (1891; figure 5.7; see also figure 5.1) flaunts such an image of pathological female sexuality.[18] The nude woman who gazes seductively and transgressively at the viewer from the shadows is identified with the grotesquely phallic snake who twines himself around her body, between her legs, and peers menacingly over her shoulder. The threat of woman's perverse and subsuming sexual desires,

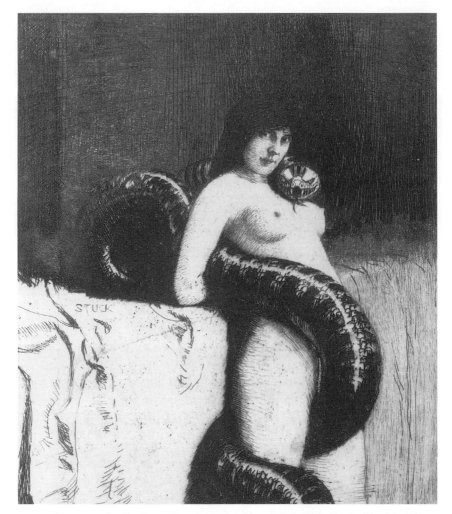

5.7 Franz von Stuck, *Sensuality*, c. 1891, etching, Musée Villa Stuck, Munich. Photo: Wolfgang Pulfer.

with allusions to the Fall of Man, has rarely been so overtly and aggressively imaged. Woman becomes sex; sexuality is defined as female. Belgian Symbolist Paul Delville's *Idol of Perversity* (1891; see figure 5.6) has a similar terrorizing effect. The femme fatale's seductively veiled body, trance-like gaze, and especially her medusa-like hair, are classic Freudian signs of castration anxiety. According to Freud's interpretation of the Medusa, Delville's femme fatale would symbolize the female genitals and thus the castrating woman par excellence.[19]

The salacious work of the Belgian artist Félicien Rops, *The Sacrifice*

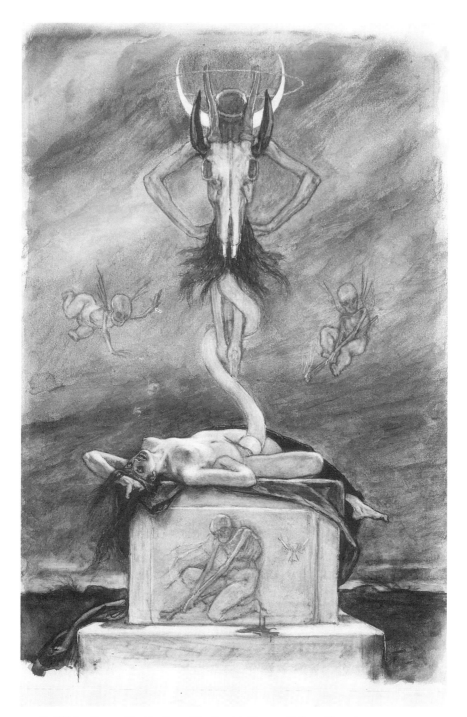

5.8 Félicien Rops, *The Sacrifice,* 1883, Patrick Derom Gallery, Brussels.

(1883; figure 5.8), visualizes what is only implicit in von Stuck's and Delville's painting. A monstrous skeletal figure with a huge, snakelike, sinuous penis is about to enter a reclining woman who grins hideously and curls her toes in hysterical ecstasy. Woman is represented as copulating with Death, implying her role as both giver and taker of Life. Images such as these exposed the seductive fantasy of being sexually overwhelmed and the titillation that such moral decadence could excite. At the same time, they may have reflected the fear of being reduced to the penis (as opposed to the phallus, the sign of masculine power) and unwillingly sacrificed to female pleasure. Desire and dread interacted in these attempts to possess and objectify female sexuality through representation.[20]

The idea of the femme fatale also no doubt aroused male anxieties about impotence and the loss of self. As historian Andreas Huyssens put it, "fear of losing one's fortified and stable ego boundaries . . . [was] the *sine qua non* of male psychology in that bourgeois order."[21] The femme fatale was a dominating and consuming woman, a succubus who would absorb man's will and before whom he was passive and helpless (figure 5.9). Munch's *Vampire* (1885; figure 5.10) indicates the destructive potential of women's sexuality.[22] Whether or not the title of this work is actually *The Kiss* rather than *Vampire,* as recently argued, the woman with streaming hair preys on the immobilized male and seems to devour his life force as if sucking his blood.[23]

Art (Caresses, The Sphinx) (1896; see figure 5.5), by the Belgian Symbolist Ferdnand Khnopff, illustrates another intrinsic aspect of the femme fatale—the reduction of woman to her animal nature. The woman-animal abandons herself to sexual desire at the expense of the reluctant, androgynous young male. Her erect tail curves sensuously from her elongated, phallic haunches as she embraces and entraps the young man with her paw and caresses his face. He expresses no sexual longing, only apathetic, languishing powerlessness. The phallic mother here is not desired but desiring.[24] She, as seductress, consumes him and uses him for her own desires.

Gustave Moreau's sphinxes and Salomes (figures 5.11, 5.12, and 5.13) were characteristic of the more refined images of the destructive woman found in France. Although many of Moreau's femme fatale paintings were done much earlier than the period under study, he was so deeply appreciated by Symbolists of all stripes that his work belongs in this context. His *Salome* (figure 5.12), despite its otherworldly, byzantine ambience and Salome's slight body, conveyed an intense carnality to aesthetes such as the hero of Huysmans's fashionable novel *Des Esseintes*. He described Moreau's *Salome:*

5.9 Edvard Munch, *Vampire (Vampyr)*, Schiefler 1907 4, dry point in dark brown, 1894, National Gallery, Washington, DC, Rosenwald Collection. Photograph © Board of Trustees, National Gallery of Art, Washington. Artists Rights Society (ARS), New York.

She became, in a sense, the symbolic deity of indescribable lust, the goddess of immortal Hysteria, of accursed Beauty, distinguished from all others by the catalepsy which stiffens her flesh and hardens her muscles; the monstrous Beast, indifferent, irresponsible, insensible, baneful, like the Helen of antiquity, fatal to all who approach her, all who behold her, all whom she touches.[25]

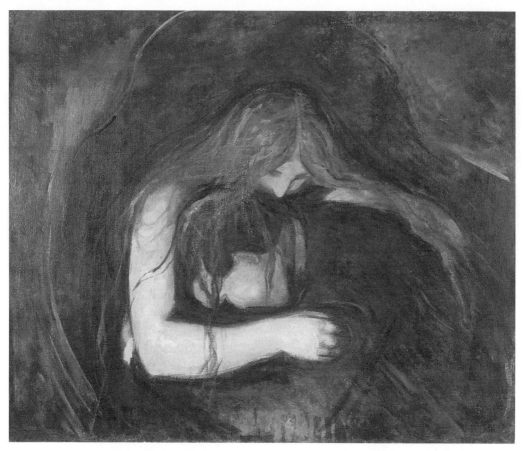

5.10 Edvard Munch, *Vampire,* 1893–94, oil on canvas, 91 × 109 cm. Munch Museet, Oslo. ©1999 The Munch Museum / The Much-Ellingsen Group / Artists Rights Society (ARS), New York.

Des Esseintes's menacing femme fatale was more worthy of von Stuck than Moreau.[26] It appears that the feverish, bejeweled, even mystical atmosphere of lust in Moreau's painting fired the hothouse imagination of the Decadents, the aesthetes, and Idealist French Symbolists more than the earthy wantonness of the German images.[27]

Other, more contemporary French Symbolists painted femmes fatales in the guise of sirens, sphinxes, and other forms of deformed and decadent women, often in literary or academic styles. Alexandre Séon, a student of Puvis de Chavannes who exhibited at the Salon de la Rose + Croix, produced such a creature in *The Despair of the Chimera* (1890; figure 5.14). Obviously reminiscent of Moreau's *Oedipus and the Sphinx*

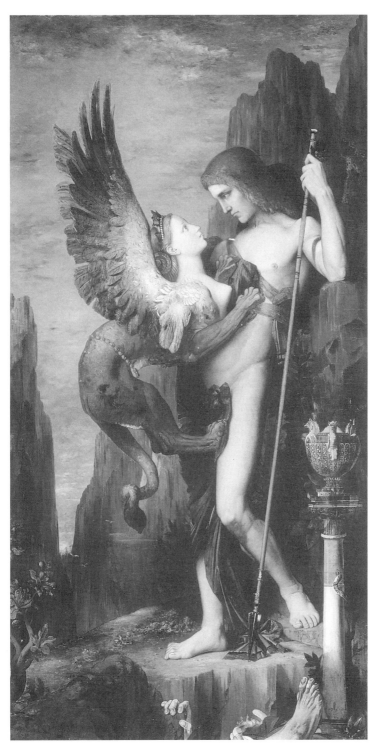

5.11 Gustave Moreau, *Oedipus and the Sphinx,* 1864, oil on canvas, 81¼″ × 41¼″. The Metropolitan Museum of Art, Bequest of William H. Herriman, 1920. (21.134.1).

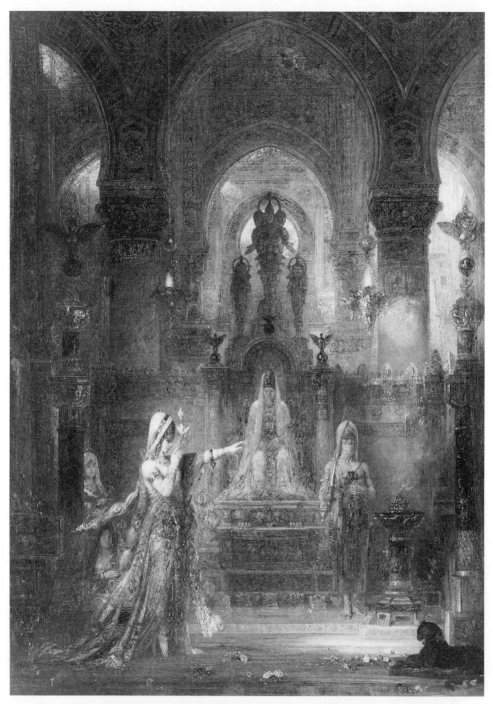

5.12 Gustave Moreau, *Salome Dancing Before Herod,* 1876, oil on canvas, 56¹/₂″ × 41¹/₁₆″, The Armand Hammer Collection, UCLA at the Armand Hammer Museum of Art and Cultural Center, Los Angeles, CA.

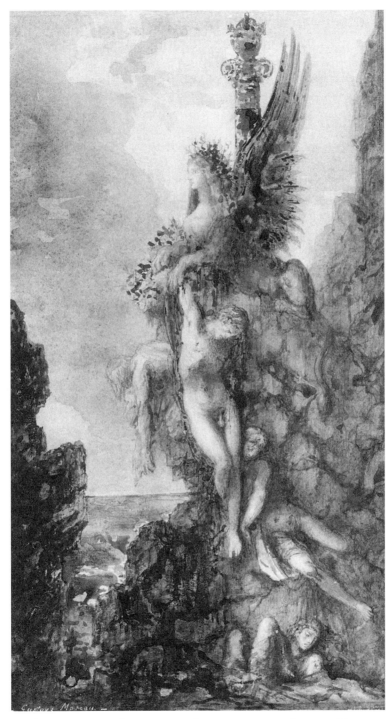

5.13 Gustave Moreau, *The Victorious Sphinx*, 1886, watercolor 31.5 × 17.7 cm., Clemens-Sels-Museum, Neuss, Germany.

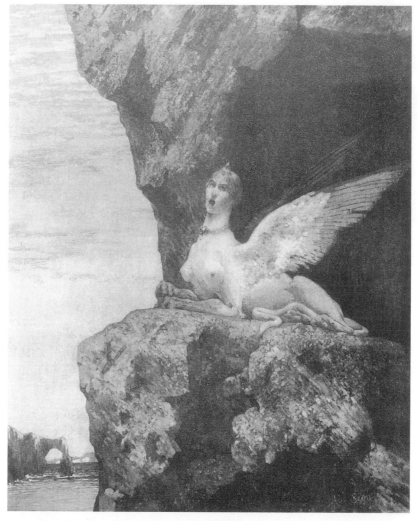

5.14 Alexandre Séon, *The Despair of the Chimera,* 1890, oil on canvas, 65 × 53 cm. Collection of Flamand-Charbonnier, Paris.

(see figure 5.11), Séon's canvas was very well received by Idealist Symbolist critics[28] even though it exemplified his friend Seurat's chromoluminarism in style. The distortions of the shoulders and neck of this winged creature and her open-mouthed wail—of despair as the title tells us—the anxious tension of her wings and upper, female body accentuated by her relaxed animal body and the freely painted surfaces of the landscape, strike a chord of sympathy and uncanniness. Uneasy in her own world, she can only articulate despair, unlike other representations

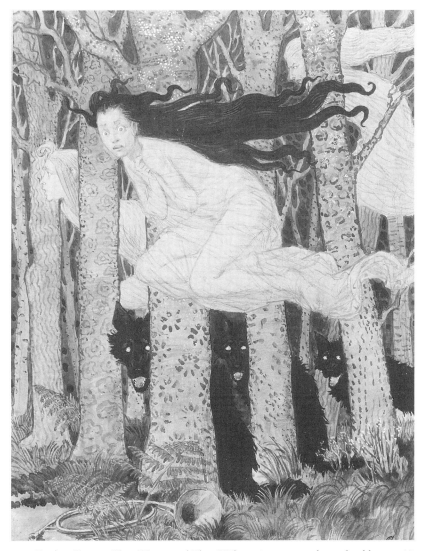

5.15 Eugène Grasset, *Three Women and Three Wolves*, 1892, watercolor and gold, 0.315 × 0.240 m. Musée des Arts Décoratifs, Paris. Photo Laurent-Sully Jaulmes.

of the femme fatale discussed earlier. Yet her taut breasts, bejeweled body and her very uncanniness arouse the terror of the monstrous–grotesque. Her despair disempowers the creature and yet at the same time that very quality suggests the presence of the human soul. A similar grotesque sympathy is elicited by Eugène Grasset's *Three Women and Three Wolves* (c. 1892; figure 5.15). In this beautifully articulated forest fly three witches of sorts in transparent gowns and with flowing hair while three wolves

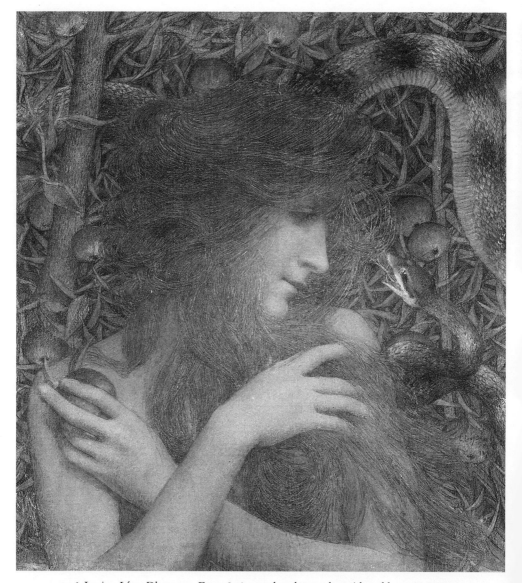

5.16 Lucien Lévy-Dhurmer, *Eve,* 1896, pastel and gouache with gold, 49 × 46 cm. Collection of M. Michel Périnet, Paris. Photo: Lauros-Giraudon.

stare out at us hypnotically from below. Yet this scene terrorizes the viewer as much by the wide-eyed, even fearful stare and defensive gesture of the foreground figure as by the strange presence of all six figures.

We confront a very different image of the femme fatale in *Eve,* from 1896 by the gifted Symbolist artist Lucien Lévy-Dhurmer (figure 5.16).

Eve, as the seductress and destroyer of man's higher self, necessarily invokes the femme fatale. Lévy-Dhurmer's Eve has a benign, alluring appearance, with strands of gold in her long, wavy hair which covers her bosom, but the eroticized communion between the snake of Satan and this highly feminized beauty holding an apple reveals her unthreatening femininity to be a lure that pulls men into the horrifying abyss of earthly, "dirty" desire.

Armand Point, who exhibited in the Salon de la Rose + Croix and designed the poster (with Dutch artist Sarreluys) for the fifth salon, produced a more academic image of the femme fatale in *The Siren* (1897; figure 5.17). Point's image is handled drily and stiffly; the result is rather sterile and cosmetic. However, the standard elements of the destructive woman are here, such as her monstrous body, in this case winged. The sexuality of this image, or in this case, lack of erotic charge, lies in the full body view rather than in a sultry and seductive gaze. She is on display like the other academic nudes of the period and carries little threat to male sensibilities.

Although it is difficult to determine the quality of Raoul du Gardier's *The Sphinx and the Gods* (1893; figure 5.18) in this black and white photograph and in light of the painting's poor condition, his femme fatale seems to lack the subtlety of Séon and Lévy-Dhurmer but embodies an aggressive tension lacking in the work by Point. This artist, apparently little known, was a pupil of Moreau and exhibited at the Salon de la Rose + Croix. In this work, inspired by Flaubert's *Tentation de Saint-Antoine,* the Greek gods have fallen before the triumphant sphinx, who bares her breasts and spreads her wings excitedly over the barren landscape. Her glowing, staring, unearthly eyes suggest the castrating gaze of Medusa.[29]

Such an aberrant exaggeration of female sexuality as that found in the femme fatale arose in the context of the shifting public roles of women and the increasing pressures on masculinities. The heightened visibility of capable, intelligent women in the role of the "New Woman" or involved in the feminist movement of the 1880s and 1890s threatened the social order by exposing the precariousness of gender roles insistently normalized through cultural discourses. Feminists, similarly to the femme fatale, did not respect conventional gender boundaries or rules and challenged the ideal of the pure woman by their public presence. Independent women were neither sexualized nor innocent but, rather, represented an abject "otherness that cannot be sublimated."[30] Such disorderly women also disturbed notions of identity and the coherent and stable boundaries of the self. As Francette Pacteau suggested, "when the other is not identifiable, my own position wavers." In consequence, "the in-

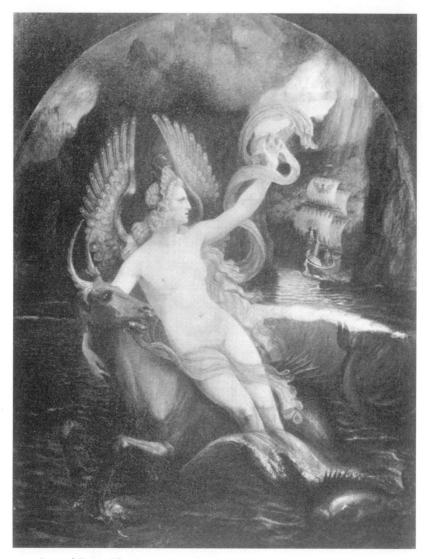

5.17 Armand Point, *The Siren,* 1897, oil on canvas, 90 × 71 cm.

jury to a body that wants itself whole is repaired through abolition of
the other."[31] Camille Claudel comes to mind in this context.

 The intensifying proliferation of prostitution also contributed to the
rise of the femme fatale. Prostitution was regarded as an immoral force
that threatened to destroy the social fabric both through venereal disease
and its degenerative effect on family structure. It closely correlated to
the stereotype of the sexually insatiable woman and thus to the femme

5.18 Raoul du Gardier, *The Sphinx and the Gods,* 1893, Musée des Beaux-Arts, Orléans.

fatale (figure 5.19).[32] The calamitous drop of the birthrate in France was also blamed on both feminists and prostitutes, who disrupted the family structure by refusing to remain in their proper roles.

So why was such a lethal threat to male potency and power so commonly imaged during the period? Her representation might be seen as "apotropaic," in Freud's terms, intended to ward off the very evil of the castrating woman that she embodied. By visualizing the terrifying form of the sexualized woman, her evil could be turned against her and displaced into a fetish that protects men from her power.[33] By transforming the ultimate threat of the desiring woman into the mythic form of the femme fatale, the male artist and viewer attempted to domesticate and reduce woman's sexuality to mere erotic fantasy. Whether we conceive of the femme fatale as a product of castration anxiety or as a threat to coherency of the self resulting from the spectacle and fragmentation of modern society, her excess sexuality offered an image against which one could construct a superior self in control while, from a position of power, taking pleasure in the vicarious experience of being sexually consumed.[34]

In more pragmatic terms, images of such irrational, pathological sexuality further legitimized cultural intervention and control over women's bodies. The sexual power of the femme fatale was situated solely in the body as representative of the culturally disempowered realm of nature. Her sexuality was unwilled and unconscious, a pathological state over

5.19 Félicien Rops, frontispiece to Monnier, *The Dregs of Society,* 1862, Houghton Library, Harvard University.

which she had no control, an unruly force that needed taming.[35] During a period of economic and political crisis, when both feminists and the working class threatened the stability and authority of the dominant powers, when conventional constructions of both masculinity and femininity were under fire, such images served to banish the threat of woman to the institutionally regulated and restricted margins of culture.[36]

Yet the femme fatale gazes. She dares to look and to desire. Much as these images may have been intended to assuage fears, they may also have incited them. Cultural critic Linda Williams, for example, speaking of horror films, described woman's sexual threat as a challenge to male power.[37] She argued that castration fear arises not from the vagina as the wound of the castrated and thus castrating mother, but rather from the mother's protected genitals that cannot be mutilated because she has no penis to castrate. In this scenario, female "lack" is not a wound but a privileged state in opposition to the vulnerability of the exposed male organ; the femme fatale would be an admission of women's power rather than an example of their perversity.[38]

The images of overt and dangerous sexual difference represented by the overbearing, all-consuming femme fatale were directly linked to another prevailing image at the time which denied sexual difference: the nondesiring but desirable androgyne. The dream of the union of male and female into a harmonious whole in the (male) androgynous body has a long and disparate history, from Plato to the present. The very instability of the representation of the androgyne accounts for its continual repetition. Throughout the nineteenth century, the androgyne was associated with various forms of idealism, especially in art and poetry.[39] Roland Barthes described, for example, how Michelet employed the androgyne to represent "reconciled humanity" and the "restoration of a seamless world." The androgyne was a figure that could "explore change while providing reactionary coherence against the threat of disorder."[40]

The unstable sexuality of the idealized androgyne rendered it perfectly suited to express conflicts arising in masculinity. Pacteau aligned the desire for the androgynous state with the desire for a return to that original, pre-Oedipal wholeness in which the body could experience ungendered sexuality.[41] However, in a period of the feminization of art—when masculinist art was threatened by its own feminized aesthetic, such as in Symbolism—as occurred in both the post-Revolutionary period in France and at the fin de siècle, the androgyne did not represent ungendered sexuality but was weighted toward the homoerotic or the asexual. The homoeroticism common to many of the Symbolist androgynes served, among other things, to further distance male sexuality from that

5.20 Anne-Louis Girodet de Roussy-Trioson, *The Sleep of Endymion,* 1793, Louvre Museum, Paris. ©Photo, RMN: R. G. Ojeda.

of woman. The feminized male body had a number of metaphorical significations for masculinity attached to it, as seen in chapter 4. As such, it could hold both spiritual and homoerotic meanings.

The androgynous images of male nudes by students of Jacques-Louis David, such as Anne-Louis Girodet de Roussy-Trioson's *The Sleep of Endymion* (1793; figure 5.20), were cases in point. This canvas portrays the moon goddess Selene's desire for the handsome shepherd Endymion. Selene is not present herself, except as a ray of light that reveals the upper torso of the beautiful androgynous youth posed as sensuously as any traditional female nude. Indeed, the artist would have been hard put to find another appropriate model of femininity to represent Selene in the presence of such a feminized male. The figure of Eros, itself androgynous, gazes appreciatively (lasciviously?) on the sleeping figure. Endymion's genitals are barely discernible in the shadow, but his body language is provocative and enticing. It is unlikely that this figure was meant to

express a longing for a return to wholeness, for a reunion with the pre-Oedipal, dispersed sexuality that potentially oscillated between feminine and masculine. It may have represented (and perhaps elicited) a range of both male and female desire. However, the painting very likely addressed itself more specifically to men, as does most cultural production in a homosocial society. Indeed, this and other images of the period have strong homoerotic charges.[42]

In the Symbolist period, however, such sensuality vacated one type of androgynous body, leaving a more spiritualized and passive shell.[43] This asexual androgyne was meant to symbolize the spiritual side of nature and the body's transcendence of the material realm so desired by Symbolists, in stark contrast to, but nevertheless dependent on, the femme fatale's enactment of base instinct. However, the androgyne was still linked to the construction of sexuality. Heterosexual difference was not asserted, as in the femme fatale, nor subsumed within a less differentiated and more diffuse and feminized sexuality as in Girodet's work. Rather, sexuality itself was repressed, producing a sexual ambivalence bordering on the asexual.[44] Power, however, remained only in the male body.

The disembodied androgyne as well as the femme fatale were particularly fashionable among the Rose + Croix group founded by Symbolist mystic Sâr Joseph Péladan.[45] His 1891 book, *L'Androgyne,* featured a frontispiece by Alexandre Séon. Séon's illustration depicts the androgyne as radically disembodied—only a head with staring eyes.[46] Péladan defined the androgyne as specifically asexual, existing "only in the virgin state; at the first affirmation of sex, it resolves to male or female."[47]

The asexual state of the Symbolist androgyne during this period indicated more than just a representation of the spiritual.[48] The "pure" androgyne became a sign of creative force for the Symbolists, incorporating the female principle without the taint of sexuality. Similarly to the construction of hysteria, it asserted the notion of the feminine as creative while maintaining the exclusion of actual women from the ideology of creativity.[49] The asexual androgyne may also have contained a strategy not only to oppose but even to subjugate or suppress "filthy sexuality" represented by women, especially in the guise of the femme fatale. Gustave Moreau employed such a tactic in his painting, *Oedipus and the Sphinx* (see figure 5.11):

> She [the sphinx] is the earthly chimera, vile as all matter and attractive nonetheless. . . . But the strong and firm soul defies the monster's bestialities. Man, [strong] and firm, defies the enervating and brutal blows of matter. With his eyes fixed on the ideal, he proceeds confidently towards his goal after having trampled her under his feet. (Moreau)[50]

Indeed, in a painting whose subject would normally represent a terroriz-
ing female sphinx, here the relationship between the two figures, exem-
plified by the position of masculine and feminine, is reversed. It is Oedi-
pus who stares down at the upturned faced of the sphinx. Her animal
power is subdued by her shocked and timid (or is it awed and desirous?)
stare into the intensely determined and threatening gaze of the male
androgyne. The real power lies in the male despite the physical threat
of the beastly female.

The androgyne denied sexual difference during a period when wom-
an's bodily difference was being enforced most strongly through ideolo-
gies of femininity, scientific theories of women's biological instability,
and constructs of woman as nature. Similarly to Freud's notion of the
apotropaic, psychoanalytic theorist J. B. Pontalis suggested that "the de-
sire to abolish sexual difference" may reflect "a desire to protect oneself
from its *effects*."[51] As Péladan pointed out, "Art created a supernatural
being, the androgyne, next to which Venus disappears."[52]

Such an image of passive and even sickly purity may have emerged,
at least in part, in response to some feminists' aggressive assertion of
female purity and spirituality as a sign of their evolutionary superiority.
More important, artists may also have turned to the transcendent body
at this time because it offered an alluring promise of imagined wholeness
and coherency in the face of the decentered, unboundaried experience
of modernity. In line with the Symbolist aesthetic, the androgyne signi-
fied an escape from the trials of the modern world through the privileged
state of transcendence.

The discourses of gender difference then prevailing construed the sig-
nificance of the asexual very differently for women than for men. Sexual-
ity in women, as seen in the images of the femme fatale, was considered
perverse, and the ideal woman was without carnal desire. The majority
of images of the "good" woman during the period depict vapid, ephem-
eral, disembodied womanhood, generally in the guise of lackluster and
barren metaphors.[53] They lack the intensity and conviction of representa-
tions of the femme fatale. Carlos Schwabe's poster for the Salon de la
Rose + Croix (1892; see figure 5.2), the Nabi Maurice Denis's painting,
April (1892; see figure 1.3), and *The Sacred Wood* (1897; see figure 1.4),[54]
nudes representing the lost golden age as pictured by Pierre Puvis de
Chavannes in his *Summer* (figure 5.21) and his *Hope* (c. 1871; figure 5.22),
and Henri Le Sidaner's *Sunday* (1898; figure 5.23), all use the female body
as desexualized vessel to symbolize either the pure, sexually "innocent"
woman in contrast with the femme fatale or the ideal of nonthreatening,
pastoral sexuality rooted in nostalgic images of the Classical past.[55] Al-
phonse Osbert's *Songs of the Night* (1896; figure 5.24) is a more affecting

5.21 Pierre Puvis de Chavannes, *Summer*, 1891, Ville de Paris, Musée du Petit Palais, Paris. © Phototheque des Musées de la Ville de Paris.

image of innocent purity. Osbert, a friend of Séon and Seurat and influenced by Puvis, exhibited with the Nabis as well as in the Salon de la Rose + Croix. He peopled his works with gentle, dreamy landscapes and serene and silent images of women, here in Classical guise with lyres. These women communicate a mystical knowledge made more explicit in Osbert's painting *Vision* (see plate 2).[56] Osbert's women may suggest visionaries, but their ephemerality and soft mysticism also align them with this group of disempowered "innocent" women.

This trope of the pure, disembodied woman had little resemblance to that of the androgyne. It did not signify preemptive, calculated abstinence as did the ciphers of spiritual longing that certain male androgynes personified. Rather, the majority of the bodies of these pure women were emptied even of the possibility of somatic *or* spiritual experience despite their supposed connection to nature's transcendent realm.

Indeed, the very concept of a female androgyne was an anomaly, because female sexuality or lack of it was as overdetermined as that of the androgyne's was historically shifting and vague.[57] Although a male androgyne might incorporate both masculine and feminine aspects, woman's masculine side, if accorded at all, was generally seen as a perversion of

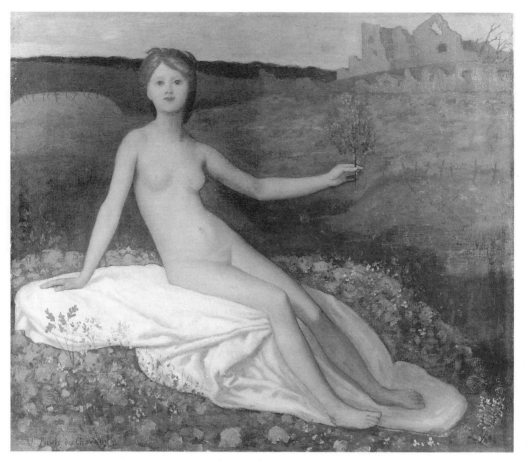

5.22 Pierre Puvis de Chavannes, *Hope,* c. 1871, Musée d'Orsay, Paris. © Photo RMN.

the feminine.[58] Péladan spelled out the impossibility of a female andro-
gyne very directly in his book, *The Gynander* (defined as a form of degen-
erate femme fatale), published in 1891: "The androgyne . . . is the virginal
adolescent male, still somewhat feminine, while the gynander can only
be the woman who strives for male characteristics, the sexual usurper:
the feminine aping the masculine!"[59] The transcendent ideal thus subor-
dinated the feminine, while at the same time reassigning the right of
sexual aggressor to the masculine.[60] The pure woman exemplified the
ideal role model for bourgeois femininity, and her difference from the
femme fatale situated the latter even more firmly among the aberrant,
marginal, and disempowered. A spiritual hierarchy was thus established
in this triad, with the androgyne superior to the pure woman and the
femme fatale at the bottom as body in opposition to spirit.

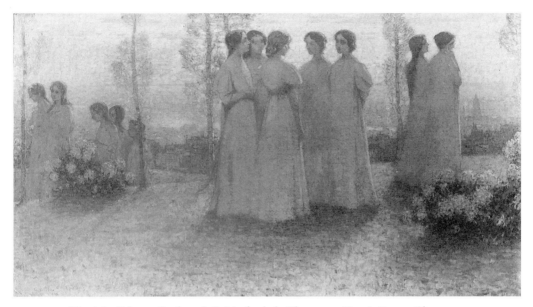

5.23 Henri Le Sidaner, *Sunday,* 1898, Musée de la Chartreuse, Douai, France. Photo: Giraudon. ©1999 Artists Rights Society (ARS), New York/ADAGP, Paris.

As Janet Wolff has shown, the virgin/whore dichotomy so characteristic of the fin-de-siècle representation of woman is situated in a bodily division that began in the seventeenth century between what Mikhail Bakhtin referred to as the Classical or absent body and the grotesque body. The former, typified by the images of the pure woman, is understood to be without orifices, genitals, protuberances, desires, or appetites, while the latter, symptomatic of the femme fatale, exhibits all these bodily functions and needs.[61] Bakhtin's Classical body signifies the body repressed; the grotesque body, the eruption of that repression. This relationship characterized the connection between the pure woman and the femme fatale as well. Each depended on the other for its significance.

Moreover, the rigid opposition amplified by these images—between voracious sexuality and asexual purity—left little room for the middle-class "proper" woman to establish a viable sexual identity which included her own pleasure. As Freud put it, "What arouses horror in oneself will produce the same effect upon the enemy against whom one is seeking to defend oneself."[62]

A more decadent imaging of these types existed during the Symbolist period as well. Von Stuck's *Innocence* (1889; figure 5.25) may be read as either "pure woman" or male androgyne. This image directs the asexu-

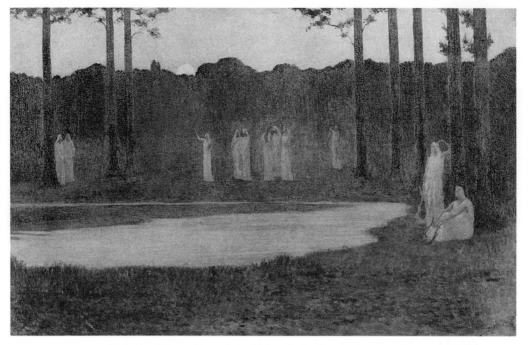

5.24 Alphonse Osbert, *Songs of the Night*, 1896, oil on canvas, 77 × 124 cm. Musée d'Orsay, Paris. Photo: Giraudon. ©1999 Artists Rights Society (ARS), New York/ ADAGP, Paris.

ality of the androgyne/pure woman into its decadent form of illness and total passivity. An example of the exacerbated sensibilities so coveted by the Decadent Symbolists, the body becomes a hindrance to the spirit. Purity and innocence become fevered states which deplete the body just as sexual energy charges the body in images of the femme fatale. A certain aestheticized eroticism imbued the decadent innocents of von Stuck, an eroticism that focused not on the idealism of the pure woman but rather on the sexual fantasy of possessing and degrading it.

The symbiotic relation between these three topoi—the femme fatale, the androgyne, and the pure woman—was central to conceptions of masculine power and the imagining of female sexuality and its lack at the fin de siècle. So authoritative were these categories that certain late-nineteenth-century audiences even read the more ephemeral images of nude women as femmes fatales, if placed in the appropriate context. Such interpretive confusion arose for example in a study of Gustave Moreau's painting, *Jason and Medea* (1865; plate 3). In the painting, both male and female figures are treated in a similar, de-eroticized, and passive manner. The male body is as comely and feminized as that of his female counter-

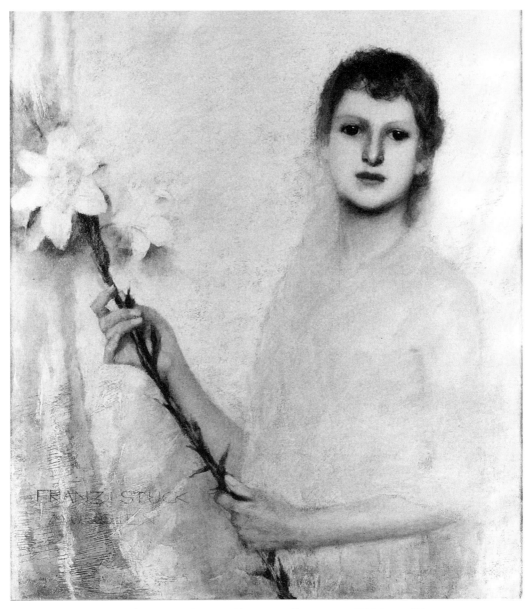

5.25 Franz von Stuck, *Innocence* (Innocentia) c. 1889, oil on canvas, 68 × 61 cm. Private collection, Paris, AKG photo, London.

part. The female genitals of this most unterrifying Medea are almost invisible and not only as a result of their veiling by a loose string of flowers. Nevertheless, at the turn of the century, the influential mystic and occultist Edmond Schuré interpreted the androgynous Jason typically as idealized masculine aspiration, but read Medea as a cipher for earthly and dangerous sexuality, revealing the extent to which the viewer read difference in the potential significations of the male versus the female body.[63]

Yet difference does exist in Moreau's *Jason,* even though it is not manifested through the difference in sexual charge between male and female types which so obviously dominates images of the femme fatale and the asexual androgyne. Jason expresses power in large part due to the exaggerated, if veiled, presence of the desexualized phallus. The phallus is signaled by the elaborately tied cloth around his thighs, the folds of which correspond in every detail to the male genitals, a motif repeated again in the scepter he holds next to his thigh. The charge of the phallus here alludes to the ideology of masculine power, which Schuré read as masculine ideals and aspirations, rather than to eroticism or sexuality which has been drained from both bodies. Here, the phallus is a sign of the patriarchal, Symbolic order, "le Nom [non] de Père" as Lacan refers to it. By effacing the sexuality from both bodies but retaining the phallus, Moreau has effectively maintained the power in the hands of the male and diminished the threat of the female. Here, the "impotency of the asexual being"[64] or the socially disengaged transcendent body which the androgyne often signified in the Symbolist period has been figured so as to regain its power while abolishing its "filthy" sexuality. The particular crisis of masculinity at the fin de siècle, which the abandonment of the sexual through the androgyne so clearly presupposed, has been resolved here through a construction of dominance and power. The gazes of the two figures reinforce this power relationship. Medea pays allegiance to Jason's victory, while he looks upward, his arm triumphantly raised.

Closer to our time period, Armand Point created a much less elegant and even awkward image (despite the Leonardesque face) of the asexual androgyne in *Angel at the Pillars* (c. 1890s; figure 5.26). The belted sheath (or quiver) hangs on the angel's otherwise nude body directly over the genitals in a comically overt suggestion of the phallus. Khnopff, in *The Meeting of Animalism and An Angel* (1889; figure 5.27), depicted a similar contrast between androgynous (that is, masculine) power and female sexuality. The stoic, androgynous male figure[65] places a controlling hand on the head of the female sphinx who almost purrs under his touch. These images expose a softer side of masculinity, but not without implicit

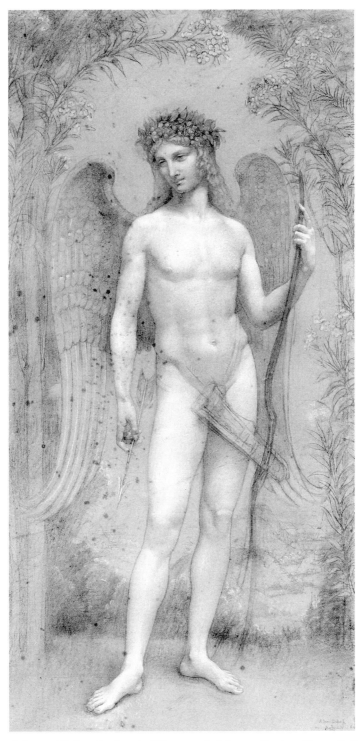

5.26 Armand Point, *Angel at the Pillars,* pastel. Private collection. Photo: Bulloz.

5.27 Ferdnand Khnopff, *The Meeting of Animalism and An Angel (L'Ange)*, 1889. Bibliothèque Royale Albert Ier, Brussels.

power relations inherent in them. The Symbolist androgyne, then, is an example of masculinist manipulation of gender categories to express male needs while maintaining the dominant mythology of male privilege and power.

Moreau's *Jason* also suggests a potential but hidden sensuality and eroticism in the image of the androgyne. As Professor of French A. J. L. Busst put it, "In the work of Gustave Moreau, . . . sexlessness and lasciviousness are often characteristically fused in androgynous-looking figures."[66] The masculine figure here is sensual rather than sexualized, and thus not entirely undesirable (if not desiring). Péladan envisioned the androgyne as just such an innocent figure eliciting desire: "Jeune homme aux longs cheveux et presque désirable, que le désir n'a pas encore touché . . ." ["A young man with long hair and almost desirable, that desire has not yet touched"].[67] However, the type of desire Jason figures was not normative masculine sexuality but rather the homoerotic.[68] By no means is this figure as homoerotic as Girodet's *Endymion*, but the suggestion of the provocative body is present. In Moreau's *Study for Jason* (c. 1865; figure 5.28), desire becomes more manifest. The male body is much more eroticized; the pose more feminized; the genitals explicit and the nipples erect. Even the expression is seductive with eyes closed and mouth slightly open. The artist's love of the male body is present in every caressing chalk line. Here, homoeroticism must be acknowledged. The displacement of male/male desire onto an image of ambivalent sexuality may have provided a way to legitimately represent such desire by encoding the homoerotic body as supposedly desexualized.[69] Responses to the body of *Jason* would range, then, from the representation of a feminized, erotic male figure to an idealization of masculine spirituality. Both extremes could be read in this image.

The appropriation of sexuality into the androgynous body in order to control the sexual served several purposes. It represented a viable defense against the castrating femme fatale, and a passive if overt stratagem to defuse the power of "dirty" (hetero)sexuality altogether through disembodiment. To maintain the phallic at the expense of the sexual is to privilege power over one's own instinctive urges and to sacrifice one's own sexuality (at least in representation) in order to diminish and devalue even further the status of woman as body and as nature.[70] The very instability and ambivalence of images of androgynous sexuality also suggest the volatile construction of masculinity during the period, and perhaps as well a fear of impotency in the face of modern culture's attack on the self.

This triad of sexual uncanniness—from the monsterized woman to the negation of both masculine and feminine sexuality—represented a

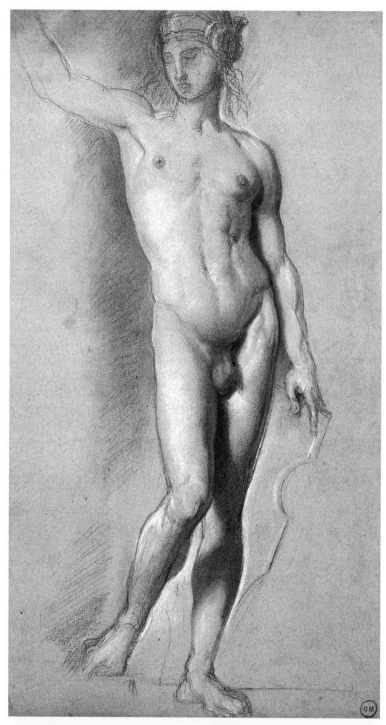

5.28 Gustave Moreau, *Study for Jason,* c. 1865, red and white chalk on grey paper, 16¼" × 8⅞", Musée Gustave Moreau, Paris.

terrain where various struggles to define and assert masculine identity and power could be enacted. By casting female sexuality as aberrant and its lack (exemplified by the pure woman) as the ideal, artists could temporarily alleviate their own and their culture's anxieties about sexuality and masculinity by displacing their dread onto images of women while maintaining masculine authority through constructions of the androgyne as a form of asexual but still phallic manhood. The androgyne, splitting off the self from sexuality, connoted loathing and blame for both women and sex and at times pathetically represented the ideal male as disembodied. At the same time, many of these feminized male figures suggest a more complete rejection of woman and strengthening of ties within the male brotherhood by their covert homoeroticism.

The role of homoeroticism in Symbolism is not fully explored here. Certainly, there seems to have been a large homosexual population of artists and aesthetes who participated in this milieu, although little research has yet been done in this area. However, homosocial bonding also played a significant role in the use of the erotic male androgyne, since it appears in the art of both heterosexual and homosexual men. The wavering boundaries between the homoerotic and the asexual in images of the androgyne reflect the constant negotiation of masculinity at the fin de siècle.

Such a splitting of the sexual and the spiritual, relentless in its logic, was repeatedly imaged during the Symbolist period. Indeed, there could never be enough repetition, because such representations were not a resolution, but an expression of the anxieties they embodied. These representational strategies illustrate the desperate need to constantly reinforce, stabilize, and reify the perpetual shifts in masculine and feminine identity and sexuality.

Through allegorization and idealization of woman, and aestheticization of the body, artists produced cathartic images intended to safely negotiate or erase woman's threat to masculine power, dominance, and potency at a time when disruptions in social formations and the feminization of culture[71] intensified the fin-de-siècle crisis of masculinity. Women were defined in these representations by their earthly bodily urges or lack of them, while men's bodies signified the transcendent, spiritual self, often in the guise of the homoerotic. The muteness of the female body in intellectual discourse made it eminently available for such interpretive manipulation.

6.1 Joséphine Houssaye, *The Lesson*.

Symbolist Women Artists

PRACTICE AND RECEPTION

. . . elle [the woman artist] menace de déchaîner à courte échéance sur l'art
un véritable fléau, une confusion affreuse, un règne
de médiocratie qui épouvante.
Déjà nous voyons une armée de peintresses envahissant les ateliers, les
Salons annuels, ayant même formé une exposition
des *Femmes peintres et sculpteurs* . . .

[. . . the woman artist threatens to unleash shortly on art a veritable flood,
a frightful confusion, an appalling reign of mediocrity.
Already we see an army of women painters invading the studios, the
annual Salons, and even forming an exhibition group,
Women painters and sculptors. . .]
(Octave Uzanne, 1910)[1]

It is [woman], with the aid of that faculty, *intuition,* for which men, even the
most unjust, recognise her, who should give back to the world the light that will
regenerate intellectual life which has gone away, morality which has
disappeared, faith in supreme truth, enthusiasm for
great and holy causes.
(Mme Renooz, 1888)[2]

Uzanne's vision of a flood of mediocre women artists exemplified the
by-now familiar arguments for gender difference as the foundation of
creativity. Mme Renooz's view of women, in accordance with that of
many women artists, expressed this difference more positively. A number
of women artists embraced it as their mission to create a feminine art
of the future,[3] while others sought to work either within the frame estab-
lished by male artists or to negotiate a place for themselves within the
interstices of various discourses on art.

Despite obstacles, more women than ever before in late-nineteenth-
century France chose the profession of artist, securing for themselves a

range of artistic positions from academic to avant-garde. Critical approaches to their art, however, situated them within the bounds of femininity either as threat to it or function of it. For some women this was natural and proper; for others it was frustrating. In either case, their "genius" was considered to be related to their womanhood.[4]

Critical reception indicated the discursive boundaries of "women's art" and thus the limits of what was acceptable in art by women. It therefore influenced the way women artists experienced themselves—as working within their cultural circumstances or resisting those circumstances—and thus affected the artistic choices they made.

Not surprisingly, few women directly engaged the Symbolist model of art production, based as it was in masculinist notions of genius and isolation. Most women artists looked elsewhere for areas in which to position their artistic enterprise. Yet critics often interpreted the work of avant-garde women artists through the predominant paradigm of Symbolism. This conflicted relationship of women artists and their critics to Symbolism indicates the unstable and fluid nature of this model despite critical defense of its absolute authority.

Notwithstanding the variety of niches women carved out for themselves in the art world, they were most commonly received through the dominant topos of the "femme-artiste." Determined by the ideology of femininity and the discourse of masculine genius, specific subject matter, styles, and sensibilities were considered either appropriate or inappropriate to this "femme-artiste." When confronted with work that might reveal the space of contradiction and disjunction existent but normally suppressed in the ideology of gender, critics tended to fall in line with dominant notions of the "femme-artiste" seemingly out of blind belief in the ideology of femininity or out of confusion as to how to approach such work.[5]

"Femmes-artistes" were expected to live out their "natural" femininity, their gender difference, through their art.[6] Whether or not one's artistic production actually remained within the ideological confines of proper womanhood, it might nevertheless be interpreted as doing so. Recent publications have shown that Berthe Morisot was widely praised during her lifetime and later, in her person and in her art, for remaining within the bounds of acceptable femininity. She did not threaten male hegemony.[7] The reception of her work provides an example of the numerous critics who strained to maintain gender categories and therefore misrecognized disruptive, idiosyncratic, subversive elements in women's art. In contrast to Mary Cassatt, who, as Renoir described her, "carried her easel like a man," or her colleague Rosa Bonheur, who deliberately affected the dress and mannerisms of male artists, Morisot was, according

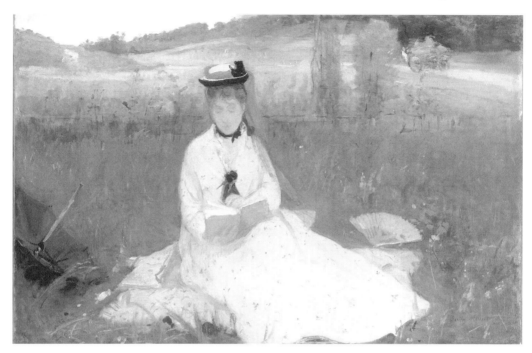

6.2 Berthe Morisot, *Reading,* 1873, o/c, 45.8 × 71.5 cm., Cleveland Museum of Art, Gift of the Hanna Fund, 1950-89.

to Renoir, "so feminine she would make Raphael's *Virgin with the Rabbit* jealous."[8] Her Impressionist technique itself, in its transitory, capricious effects, rapid execution, and emphasis on sensual surface effects (figures 6.2 and 6.3), was also regarded as an appropriately feminine expression of the female temperament, whereas critics maintained that Mary Cassatt's more linear style usurped a male mode.[9]

Aurier characterized Morisot's 1892 exhibition as an expression of her move from a more masculine art influenced by Manet to a feminine art. In the process, she lost "the beautiful male qualities" of Manet, his "precise and synthetic vision of forms and colors," and his "horror of the sentimental 'joli.'" Aurier further complained that she unfortunately added a little "rice powder" to her boaters at Argenteuil, indicating that they had been too cosmetically feminized for his taste. Even so, her work remained interesting to Aurier because she was, he said, unexpectedly able to interpret the most masculine genius that ever was (Manet) through a "legitimate and savory femininity."[10] Again, Morisot's femininity was considered to be her gift, and though Manet was clearly the superior artist in Aurier's eyes, he considered her to play her feminine role with élan.

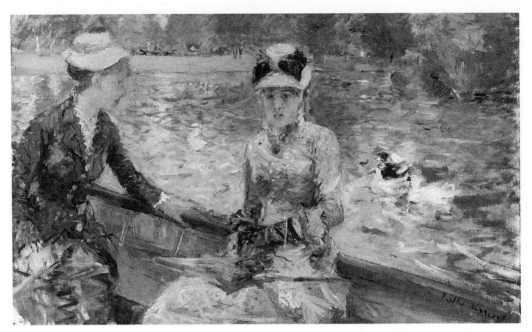

6.3 Berthe Morisot, *Summer Day,* 1879, oil on canvas, 18″ × 29½″, National Gallery, London.

In actuality, Morisot was among those independent women artists aligned with the avant-garde art movements who exhibited in the numerous specialized exhibition groups that had sprung up in Paris, from the *Salon des Independents* to the Impressionist exhibitions.[11] These women artists were more idiosyncratic and maneuvered within the avant-garde models, such as Impressionism and Symbolism, which privileged individuality. These independent women artists worked more within the contradictions and gaps of their social positioning than within its strictures as their more conservative colleagues did. Consequently, they often felt the pressures and constraints of their position all the more strongly.

Tamar Garb has demonstrated how certain critics were disappointed when they did not find an inherent "female nature" expressed in art by women.[12] Their expectations that women would express their "difference" from men reveal the extent of their indoctrination into gender difference and the creed of separate realms. Such expectations also indicated the inequities and intolerance against which women artists had to struggle in order to create art that was not limited to the "feminine."

Even though it affected the artistic choices women made, such strict

gender differentiation among the majority of critics overdetermined and circumscribed the criticism of women artists much more than it did women's artistic practice. Indeed, women artists in varying degrees were able to exploit the rifts and inconsistencies as well as the norms of gender discourse to create viable practices. Thus there was often a gap between the way women artists were positioned critically during the Symbolist period and their actual creative process and cultural production.

A number of more traditionally minded women artists assumed for their art the power of morality and purity so often attributed to women, thereby gaining power in the social arena on its own terms. The leaders of the *Union des femmes* espoused a program of social betterment through aesthetic reform.[13] They embraced the position of women as protectors of traditional values and set themselves against the "excesses" of avant-garde art.[14] In keeping with this conservative agenda, they also refused to shirk their domestic duties and promoted the separation of spheres for women and men as a healthy social arrangement.[15] Their position was not simply a reactionary complicity with the ideology of femininity. Rather, they created for themselves out of the dominant ideology a site that allowed them cultural agency and (limited) power.

Although the art exhibited at the Salons of the *Union des femmes* was quite varied, the works of the leaders, such as its second president, Virginie Demont-Breton, illustrated their agenda quite well. Demont-Breton's *Husband at Sea* (Salon of 1889; figure 6.4) portrayed a young mother with sleeping, sated child waiting longingly by the fire in her properly domestic sphere. Adhering to conventional gender roles, Demont-Breton valorized the domestic role and the patience and stoicism it entails, even while imparting a sense of melancholy and remaining squarely within the acceptable bounds of the ideology of femininity.

Women artists working in the highly polished, illusionistic, conservative Academic style, such as American artist Elizabeth Gardner, wife of the esteemed Academic *pompier* William-Adolphe Bouguereau, also worked within a narrow definition of the feminine artist. Gardner was well received in the Salon des Beaux-Arts. Her painting, *The Judgment of Paris* (figure 6.5), a genre scene of children playing, overwhelmingly figures traditional gender roles.[16] The male child, Paris, with classical features and body type (note his feet with the long second toe in particular) sits in masterful control before three young girls and gazes seductively while offering the prize to the innocent, blonde, most femininely dressed and modest of the three. Already, her role as object of beauty and desire for a male gaze is demonstrated. Here there is no attempt to posit feminine values as civilizing; strict gender difference is preserved.

6.4 Virginie Demont-Breton, *Husband at Sea,* Salon of 1889, whereabouts unknown.

Yet Gardner's conventional approach and success should not mask her struggles or the significance of her choices as a woman artist. As Madeleine Fidell-Beaufort points out, Gardner found creative ways around traditional obstacles. Although excluded from the prestigious École des Beaux-Arts because of her gender, she was part of a women's cooperative atelier that, as Gardner wrote to her sister, hired their own models and did "just as we please."[17] She also dressed in men's clothing so that she could attend all-male life-drawing classes at the Gobelins tapestry

6.5 Elizabeth Gardner, *The Judgment of Paris,* whereabouts unknown.

school in 1873. Unlike Rosa Bonheur, however, Gardner abandoned such cross-dressing as soon as the Académie Julian opened.[18]

Gardner's choice to work within the Academic venue was not just a collusion with Academic ideals. It was rather a successful, though hard-won, attempt to position herself within the most publicly esteemed mode of art-making. As Gardner said about the extremely close relation

between her work and that of her husband, she "would rather be known as the best imitator of Bouguereau than be nobody."[19]

Although academic women artists and members of the *Union des femmes* did fashion a position for themselves in the established art world, the repressive force of dominant discourses marked the way they created and the range within which they could comfortably exist as creative women. Terry Eagleton termed the acquiescence of the marginalized to their repression a "performative contradiction."[20] They internalize and thus act out of the social codes that structure their cultural position.[21]

Nevertheless, as Eagleton pointed out, even performative contradictions can be manipulated. As Judith Butler observed, ideologies are only maintained through individual repetition and, within that continual enactment, resistance and transformation are possible.[22] The leaders of the *Union* embraced the ideology of femininity, yet in their repetition of it, they also opposed it through their professional status, their insistence on having a cultural voice, and their reclamation of the right to resist. They carved out active lives based in intellectual and artistic activity normally allowed only to men. Even though they may not have been recognized by dominant forces for these mutations of the ideology of femininity, nevertheless they modeled and made available to other women a cultural resistance that had potential to effect social change, and they were part of a growing pressure from a number of groups to allow women into professional domains.

Marie Bashkirtseff, a bourgeois Russian artist working in Paris in a Realist manner during the late nineteenth century, forcefully articulated the contradictions for women artists between experience and ideology.[23] Over and over again in her unexpurgated journal, she expressed frustration at the limitations placed on late-nineteenth-century women artists in France.[24] Bashkirtseff argued for gender equity in terms of institutional access in an article written under a pseudonym: "women who want to be artists should be allowed to do so on equal terms with men and not have inadequate education used as proof of innate inferiority." Speaking of the critiques of "femmes-artistes" at the Académie Julian, she stated: "These gentlemen despise us and it is only when they come across a powerful, even brutal piece of work, that they are satisfied; this vice is very rare among women. It is the work of a young man, they said of mine."[25]

Within the category of Symbolist women artists, only a very few women can be identified. The most prolific and best known among them is Camille Claudel. Like the majority of women artists working within avant-garde models, Claudel was male-identified. Her circle, by and large, was constituted of avant-garde males, and both the reception and, to a lesser degree, the aesthetic of her work was enabled by those

male colleagues. As a result, her female "respectability" was not so crucial to her, so she was less constrained by bourgeois propriety. Nevertheless, she was still confined by the ideology of femininity on a number of levels. Her later art, however, was representative of a woman's sphere unusual in avant-garde work.

Despite her personal and professional problems, Camille Claudel enjoyed critical acclaim during her lifetime. She exhibited regularly at various Salons and galleries from 1888 until 1905,[26] and was quite well received, especially relative to the reception of women's art generally.[27] Gabrielle Réval, in *Fémina,* 1913, referred to her as the greatest French sculptor.[28] From 1893 onwards, a number of the major Symbolist critics of the epoch praised her: Claude Roger-Marx, Octave Mirbeau, Henri de Braisne, Gustave Geffroy, Gustave Kahn, Camille Mauclair, Louis Vauxcelles, and Charles Morice.[29]

Although the complexity of Claudel's art was recognized to some extent by the variety of critical perspectives used to interpret it, critical models such as those described below were all circumscribed by their anxiety over her gender. Those who saw her art as Symbolist displaced it into an aberrant form of masculinity arising from a rigid delineation and containment of gender difference; those who read her biography as determining and delimiting her art relied on the ideology of femininity. These critical strategies have clouded more than illuminated understanding of her artistic production, especially that of her years without Rodin.

Frequently critics resorted to the predominant avant-garde model of the Symbolist aesthetic to describe Claudel's work.[30] Women artists whose work did not fall into the category of the "feminine" artist or whose work critics admired for its "masculine" qualities often found their art interpreted from a Symbolist viewpoint. This model was more appropriate for some than others, but for Claudel it fit particularly well. She was a solitary, original artist whose work had an interiority and a symbolic force common to the Symbolist aesthetic.

Critic Mathias Morhardt was among Claudel's strongest supporters; in 1898 he wrote what is generally seen as one of the most authoritative and significant articles on her. He knew her well and much of the article comes from conversations with her. Her grandniece and biographer Reine-Marie Paris even claimed that it was a disguised interview of sorts.[31] Claudel had the "eyes of the poet," according to Morhardt, and "une passion véhémente, qui la possède toute entière, . . ." ["a vehement passion which possessed her entirely, . . ."] from childhood on.[32] More specifically, Morhardt characterized the woman in *The Prayer* or *Psalm* (1889; bronze, Musée Boucher de Perthes, Abbeville) as in a state of *extase.*[33] Yet Morhardt, who knew Claudel so well and perhaps spoke

through her to some degree, took pains to say that her artistic nature took precedence over her gender. Morhardt's distinction between woman and artist illustrates the gulf that separated women from creative activity and the mutually exclusive nature of the discourses of creativity and women.

Symbolist critic Octave Mirbeau expressed real enthusiasm, praising such works as *The Waltz* (see figure 4.5) and *Clotho* (figure 6.6) for their strange compositions, their passion, their invention, their emotion through decorative arrangement, and their profound poetry.[34] Claudel was, according to Mirbeau, "one of the most interesting artists of our time," and her work "uproots our innermost self."[35] In 1893, *The Waltz* was again described using Symbolist language in a journal sympathetic to Symbolism:

> Et qu'est-ce que l'art en somme si ce n'est une prise perpétuelle, inassou-
> vie de l'humanité sur le mystère, le mystère, réservoir inëpuisable et som-
> bre de toutes les beautés du possible. . . . Voici ce qu'ils [les corps des
> valseurs] m'ont semblé dire, de la voix pénétrante, inextinguible des chefs-
> d'oeuvre: "Pris de dégout pour la vie plate et la planète morose nous
> sommes partis pour les espaces dans une danse d'amour et d'espoir."

> [And what is art in sum if it is not humanity's perpetual, never-satiated
> desire to grasp and hold on to mystery, mystery, inexhaustible and somber
> reservoir of all possible beautiful things. . . . Here they [the bodies of the
> waltzers] seemed to speak to me, with the penetrating, inextinguishable
> voice of masterpieces: "Taken with disgust for mundane existence and
> the morose planet, we left for other places in a dance of love and hope."][36]

Strangeness, mystery, passion, invention, meaning through synthetic (decorative) composition, deep, subjective response, and disgust for the mundane are all attributes of the Symbolist aesthetic. However, what most impressed Mirbeau to the point of astonishment was what he twice referred to as the masculinity of her conceptions and execution.[37] Such masculine traits led him to call her a "genius," even though a woman of genius was "contrary to nature" in his view.[38] Her works "dépassent par l'invention et la puissance d'exécution tout ce qu'on peut attendre d'une femme" ["go beyond anything one can expect from a woman in invention and power of execution"].[39] Although Mirbeau was strongly supportive of Claudel's work, he could only grasp its power in stereo-typic forms of gender difference.

Here we encounter the opposite extreme of the "femme-artiste," the perversely "masculine" woman artist, characterized by virility and force-fulness. Discussion of this "type" cut across disciplines and was common

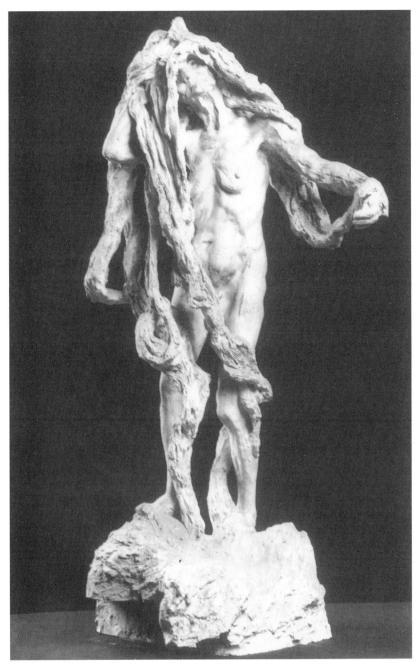

6.6 Camille Claudel, *Clotho (The Fate),* 1893, plaster, Musée Rodin. ©1999 Artists Rights Society (ARS), New York/ADAGP, Paris.

at the time. Uzanne's Lombrosian approach to women's ambition mas-culinized the woman artist in ways reminiscent of the excessive response to the New Woman. Although the male artist was encouraged to isolate himself and remain in seclusion unrecognized in order to create great art, Uzanne described the woman artist as selfishly obsessed rather than professional in her commitment to her work:

> [la peintresse incomprise luttant pour la notoriété] s'en croit énormément, est insupportable à vivre, et fait souffrir mort et passion à son marie ou à ses amants. Elle est irritable, inquiète, égoïste, et l'art, dont elle parle trop, "son art," comme elle dit, a fini par dévorer en elle toutes ses grâces féminines, ses gamineries, ses enfantillages, ses nonchalances amoureuses, tout ce qu'il y a d'exquis dans la femme. . . . Chez elle, à son atelier, on la trouve encore plus insaisissable; elle ne se préoccupera que de ses toiles, de ses pochades, de ses futures expositions, des cadres à trouver, des dé-marches pour obtenir la *cimaise,* de la *presse* à préparer; c'est une terrible *raseuse* pour qui la courtise, car elle oublie son sexe et ses qualités innées; elle évolue vers l'affreuse androgyne; et elle affecte des airs de supériorité intolérables que ne justifient pas toujours ni son esprit naturel, ni son talent acquis.

> [[the unknown woman painter fighting for recognition] thinks a great deal of herself, is impossible to live with, and makes her husband or her lovers suffer cruelly. She is irritable, restless, an egoist, and the art of which she too often speaks, "her art" as she calls it, devours in the end all her feminine graces, her playful girlishness, her childishness, her amorous nonchalances, all that is delicate and refined in woman. . . . In her studio, she is even more incomprehensible; she will preoccupy herself only with her canvases, her sketches, her future exhibitions, finding frames, how to obtain la *cimaise* [to have one's work placed "on the line" at the Salon], preparing for the *press;* it is a terrible bore for anyone who courts her, because she forgets her sex and her innate qualities; she evolves toward the dreadful androgyne; and she affects airs of intolerable superiority that never render justly her natural spirit or her acquired talent.][40]

Even when avant-garde critics praised rather than condemned women artists for their "maleness," an artist's difference from her own gender was emphasized; that is, she was elevated to a condition of "honorary" maleness without ever really attaining the true status of that gender. While such an artist never entirely escaped the categories of *femme-artiste,* she was nonetheless seen as other than female.

Like most avant-garde critics dealing with women artists they ad-mired, Mirbeau inverted the aversion to masculine traits in women to

claim their "masculinity" as the highest value. Yet the construct of "masculine" woman artist was a conflicted and uneasy one that was continuously interrupted by male anxiety over its character and the necessity of its existence. At the same time that Mirbeau commended Claudel's work for its masculine qualities, he reinforced gender difference by accusing her work of being unfeminine. He critiqued *The Waltz* for "pas assez féminisé le bras de la femme, . . . Je lui aurais voulu plus d'abandon, de mollesse, moins de muscles accusés" ["not feminizing enough the woman's arms, . . . I would have liked more surrender, softness, fewer muscles acknowledged"].[41] To transpose gender categories while insisting on gender norms was a typical pattern in criticism of the "masculine" woman artist.

Gender difference was such a central structuring tenet of the social order in which critics were embedded that their admiration of Claudel's work was always tempered by her otherness as a woman producing strong, expressive, intellectual art. Most critics' enthusiasm for Claudel's work showed the same astonishment at her gender and anxiety over her "masculine" traits.[42] There was a constant conflict in the discussion of her work between its expressive power and the gender of the artist who made it. Accustomed to the exaggerated emotional sensibilities of male expressionists such as Rodin, expression and emotion in art by "masculine" women artists such as in Claudel's sensual *Waltz* generally mystified critics. The forceful grip of the ideology of gender can be felt on these critics as they struggle to make sense of expressive art by women that contradicts their normalized notions of gender. If Claudel's work had been more Academic or Impressionist, they could have easily placed her even if only by misplacing her as "femme-artiste," as they did Morisot. But her Symbolist art came too close to notions of "natural" female emotional sensibilities while at the same time frustrating that stereotype by its "virile" qualities. She confounded gender stereotypes in a most disturbing way for her critics. Such female traits were privileged by Symbolists, as noted in the case of the feminization of their artistic personae and their art, but these same traits could not be transposed back onto a woman artist even though she had been "masculinized" by the critics. The inability of discursive structures to contain all forms of practice is evident here, while at stake was the necessity to claim that they could.

This anxiety revealed some of the unresolved contradictions in the discourse of women artists: that "masculine" women theoretically were considered perverse anomalies while masculine traits in women's art practice received the highest praise. The slippage between masculine woman as deviant and masculine woman artist as superior demonstrates that social categories were not hard and fast but constituted an elastic,

dynamic economy of norms that sometimes became schizophrenic. Certain values had general currency but they could fluctuate according to specific circumstances. Since behavioral rules are dependent on their continual repetition by individuals, social codes of behavior are constantly shifting, although only within certain limits.[43]

The masculinization of women artists by critics shifted gender borders just enough to place women outside of their gender, but without allowing them to enter the other. Critics quite consistently found often subtle ways to reposition masculine women artists just outside of the realm of real masculinity. Mirbeau, for example, bridged the gap between the degraded "masculine" woman and her strength as an artist by his criticism of Claudel's work as lacking feminine features. Such women artists belonged neither to the category of "male" artist nor to that of "femme-artiste" but resided in a limbo between the two. A hierarchy of art and gender would thus read: male artists, masculine women artists, feminine women artists. In the strategies of masculinization and feminization, the elasticity of the economy of norms was limited by the need to maintain gender boundaries on some level.

Claudel's fiercest advocates, such as Morhardt and Mirbeau, supported her to the extent of their capabilities. Their gender-based astonishment, their waverings, their qualifications and disclaimers emphasized here were signs of the power of gender discourse, signs that were magnified in the larger culture which objectified such strong women artists as unnatural and anomalous.

The issue of sexuality in Claudel's work unsettled the critics for reasons similar to their unease with its masculine qualities. Recently, Claudine Mitchell demonstrated that the conjunction of intellectuality and sexuality was central to Claudel's art, yet critics consistently disassociated the one from the other.[44] Symbolist critics lauded the intellectuality of her art but did not acknowledge its sexual connotations except in (purist) intellectual terms.[45] Mirbeau perceived both "voluptuousness and chastity" in *The Waltz*,[46] recalling the Symbolist ideal of the erotic but pure passion for the Absolute. Paul Claudel, who placed her among Symbolists of the stature of Van Gogh, Rimbaud, and Verlaine, also read her work as spiritual and pure. He contrasted its melancholy chasteness to Rodin's material and coarse sexuality.[47] Nevertheless, the Symbolist critics' emphasis on Claudel's intellectuality was a tribute rarely offered women artists and a tenet that was central to the Symbolist aesthetic.

Those critics who did not link her art to intellectuality or the Symbolist aesthetic often read sexual passion in works such as *The Waltz* but saw it as originating in "female instinct." By uncoupling the conjunction of intellectuality and sexuality in her work, such positions assured it

would not be read as sexual in any threatening way and thus silenced Claudel's voice in the debate on sexuality.[48] Like her "masculine" traits, the intellectuality and the sexuality of her images both attracted and troubled her critics, and they dealt with their conflicted responses by recognizing the prowess of her work but blinding themselves to certain aspects of its significance, such as sexuality.

In a recent text, Jeanne Fayard hailed Claudel as a "poète maudite," aligning her with those great mad visionaries from Nietzsche to Artaud who, as Fayard described it, were consumed by an amorous passion that could only lead to madness or suicide.[49] Fayard's attempt to rescue Claudel from invisibility by claiming her for the Symbolist model of mad genius obscured the gender implications of inserting a woman into this or any male model. Yet she offered Claudel a more positive historical role than most contemporary writers, who consider her suffering to be confined to her relationship to a man.

Although Claudel always kept her own studio and remained independent of Rodin, he was seen to be the motivation for and the limit of possible meanings in Claudel's art for a great number of critics. Themes that might have been read as seeking a more universal significance were displaced into the ideology of femininity. Émile Dacier in 1905 and Pierre Moisy in 1971 positioned Claudel as model and muse to Rodin rather than collaborator and artist in her own right. Both described *Sakountala* (1888–1905; see version entitled *Vertumnus and Pomona,* figure 6.7), among her most celebrated works, as no more than a paraphrase of Rodin.[50]

Paris, in particular, reduced the meanings of Claudel's works to a singular and lifelong response to her passionate and thwarted love affair with Rodin. *The Waltz* and *Sakountala,* for example, "reflect[ed] the precarious happiness of the couple, or their short-lived reconciliation." Paris's analysis of *Fortune* (1900–1905; bronze, private collection) is a caricature of the image of this strong-bodied woman balancing on a wheel: she "stumbles on the road of destiny, waltzing without a partner, a princess without a prince, her weary head no longer leaning on a man's cheek but on her own arm."[51] Paris transformed this powerful figure of human destiny into a figure of feminine dependency. *The Little Châtelaine* (c. 1893; figure 6.8), *Aurora* (1905; marble, private collection), and *The Little Châtelaine with Doves* (1898; oil on canvas, private collection) "reflect[ed] the child she could not bear." *Clotho* (see figure 6.6) and *The Beseecher* (1894–1905; figure 6.9) "capture[d] the unhappiness of a deserted woman."[52] Despite its rational clarity, emotional coolness, and fine craftsmanship, Paris claimed that *Perseus and the Gorgon* (1898–1902; plaster, marbles, bronzes; now attributed to Pompom), "with its empha-

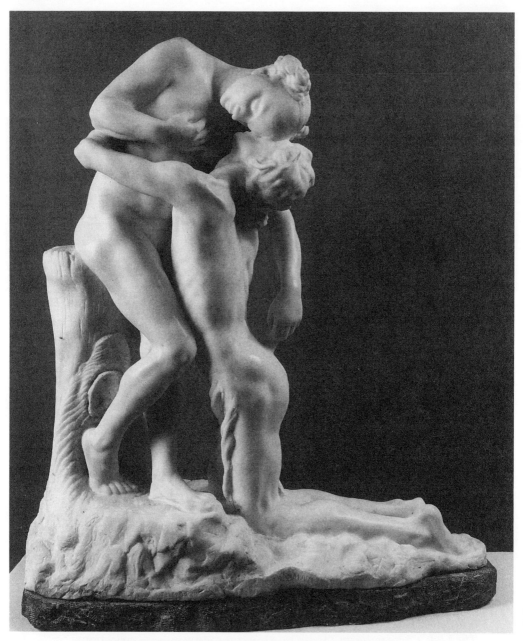

6.7 Camille Claudel, *Vertumnus and Pomona,* 1888–1905, marble, 91 × 80.6 × 41.8 cm. s.1293. Musée Rodin, Paris. Photo: A. Rzepka. ©1999 Artists Rights Society (ARS), New York/ADAGP, Paris. Other versions include *L'Abandon,* 1888–1905, bronze, Fondation Pierre Gianadda, Martigny, and *Sakountala,* 1888, private collection.

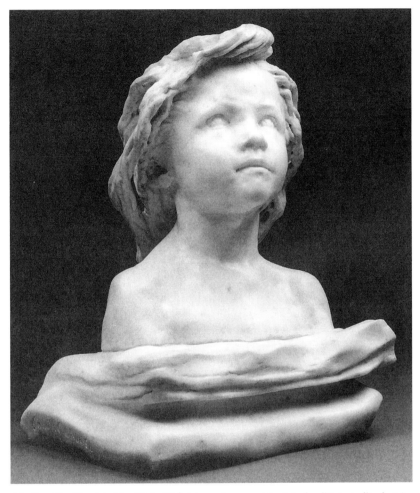

6.8 Camille Claudel, *The Little Châtelaine,* 1893, marble, Musée d'Art et d'Industrie, Roubaix. Photo RMN: Michèle Bellot. ©1999 Artists Rights Society (ARS), New York/ADAGP, Paris.

sis on crawling serpents, signal[ed] her emerging madness."[53] Paris referred to the decapitated head of this sculpture as "her response to [Rodin's] torment."[54] The notion of Claudel's life and art as centered in her deep anguish over the loss of her passionate relationship with Rodin was reinforced by her brother Paul: "Elle avait tout misé sur Rodin, elle perdit tout avec lui" ["She had staked everything on Rodin, she lost everything with him"].[55] The quite popular romanticized epic French film, *Camille Claudel* (1989), exploited and further reinforced this myth by representing the sculptor as a gifted young woman brought down

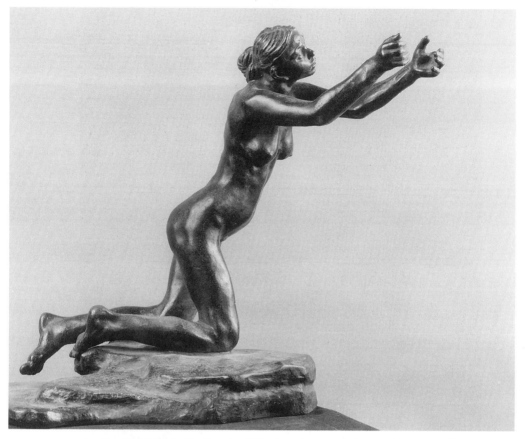

6.9 Camille Claudel, *The Beseecher* (*L'Implorante*), c. 1894, bronze. S.1377. Musée Rodin. Photo: Bruno Jarret. ©1999 Artists Rights Society (ARS), New York/ADAGP, Paris.

by her insane passion for the man whom she could not have. In this characterization of Claudel as obsessed by a painful passion for Rodin, her "douleur" was not construed as giving her access to the Absolute; rather, she was institutionalized for it. In this romanticized myth of her despair, her energizing artistic force was stereotyped as emerging from an overexcited and overemotional female sensibility dependent on her relationship to her great male master.

Such a conflation of life and art was typical of Modernist art criticism and history; however, gender emphatically inflected the way in which this Modernist critical mode was used. Rodin's work was often read through his biography, but even though Rodin was extremely upset at losing Claudel,[56] texts on this virile genius did not assume that the body

of his later works focused on that loss. Moreover, works that *were* per-
ceived as based on his passion for and loss of Claudel inevitably were
understood to go beyond that emotionally draining experience to create
something more universally meaningful. Rodin could transcend his de-
spair while Claudel disintegrated into hers.[57]

Yet, in the face of such gendered interpretations, including her own,
Paris claimed that there was no proof that Claudel suffered a great passion
for Rodin. Her affection for him was always "reasonable and measured,"
she says, despite Claudel's fiery temperament, and "ambition was not
absent from it."[58] A recently discovered contract between Rodin and
Claudel, which assured her of his complete and exclusive attention as
her mentor and her lover, supports Paris's conclusion. Claudel wanted
Rodin entirely for herself and seemed to have schemed to accomplish
her desire, but her motives were as much professional as personal.[59]

For the most part, the possibility that Claudel might have been in-
spired by concerns beyond her passion for a "great" and therefore irre-
sistibly desirable man was beyond the imagination of very many writers.
Few considered that Claudel had the strength of intellect or character
to have wanted more than to purge her own feelings and regrets about
Rodin through her art, even though she wrote to her brother that her
new work had nothing of Rodin in it. Indeed, she produced a remark-
able body of independent and innovative work in the twelve years after
their relationship ended. By channeling the meaning of passionate work
produced by a woman into normative notions of gender relations, critics
were absolved from repositioning and rethinking gender.

During the last twelve years of her creative life (c. 1893–1905), Ca-
mille Claudel worked consciously to develop a new aesthetic separate
from that of Rodin and outside the bounds of other established models
as well. These most remarkable works are small-scale, multimedia sculp-
tural tableaus such as *The Gossipers* (1893–1905; plate 4), *The Wave*
(1897–98; plate 5), and *Profound Thought* (1900–1905; figure 6.10).[60]
They are not directly linked to traditional artistic conventions and have
a conceptual ambiguity that Claudel seemed to cultivate. They open a
space in which women, neither idealized nor eroticized, act, think and
speak.

Nevertheless, those who dealt with these works tended to place them
within traditional art historical categories. Although claiming that *The
Wave,* for example, was "free of any Western influence," Paris referred
to the female figures as water nymphs and mermaids. Such personifica-
tion offers little insight into the work's meaning; it even confuses it, for
why would three nymphs place themselves under such a threatening
force? Instead of grappling with content, Paris traced it formally to the

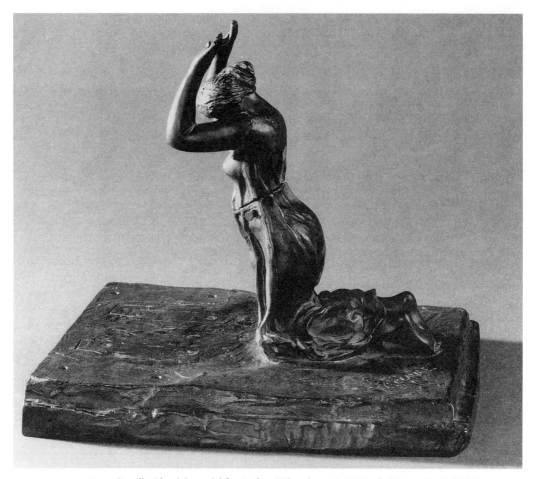

6.10 Camille Claudel, model for *Profound Thought,* c.1898, Musée Sainte-Croix, Poitiers.
© Photo RMN: Michèle Bellot. ©1999 Artists Rights Society (ARS), New York/
ADAGP, Paris.

popular passion for Japanese art among artists at the time, specifically that
of Hokusai.[61] Claudel did see Hokusai's *The Wave* at the 1889 Exposition
Universelle, and the wave's crest resembles that work, but her image
deviates significantly from it as well.[62] Her focus is as much on the wave
as on the response to it by the three very Western young women who
are holding hands, beginning to crouch, and looking up at the menacing
form above them. Such attempts to place these sculptures within tradi-
tional frameworks rob them of their forcefulness and stifle potentially
more evocative readings.

 If we compare Gauguin's *In the Waves (Ondine)* (1889; figure 6.11),

shown in Paris that same year, with Claudel's *The Wave,* Claudel's inter-
ests come into better focus. Both works portray the ocean as a tumultu-
ous force. In Gauguin's painting, the sense of ocean swell is more subtle,
but the nude woman seems to look up at the threatening wave in front
of her and holds her arm up in a protective gesture. She is unstable in
the water, tipping to the right. In the work by Claudel, the wave rises
far above the heads of the three women, but unlike *Ondine,* these women
prepare for the impact, rather than let themselves be taken by surprise,
by hunching down and holding hands. There is a sense of play and an
apprehensive pleasure rather than the instability of Gauguin's image. The
three women wait for the fall of the wave, anticipated by the long pull
of water from the shore as it gathers into the wave. To examine these
images from a totally different perspective, Gauguin's painting does not
necessarily demand a narrative mode at all. The gestures, unsteady posi-
tion, and strangely upturned face of the woman could be the product
of Gauguin's Symbolist distortion and reductive, synthetist style. These
oddities create a sense of the mysterious and the uncanny when no narra-
tive is assumed. Gauguin's Symbolist language of art—an exaggerated
use of color, reductive form, contracted spaces, outlines as ciphers of
universal significance—intentionally obscures without obliterating his
narratives. Claudel's figures, even if surprised and frightened by the
wave, still prepare themselves for it, as their bodily positions indicate.
These women act; *Ondine,* if read narratively, reacts or remains a cipher
of suggestivity. In Claudel's work, the female nude body locates itself
in a context of agency; the Gauguin nude remains a sign.

Aristide Maillol, under the influence of Gauguin and the Nabis,
painted *The Wave* in 1898 (figure 6.12). His work lacks the mystery of
Gauguin's image, and the figure is even more unstable than *Ondine.* The
nude figure cuts diagonally across the canvas here as in the Gauguin, but
the subtle, "decorative" body found in *In the Waves (Ondine)* becomes, in
the Maillol work, simply another voluptuous female body as spectacle
with her large female hips and buttocks and her taut breast. This painting
is an even greater contrast to the Claudel piece than that of Gauguin's.
The three female bodies in Claudel's sculpture possess strong thigh mus-
cles and slender, unexaggerated bodies, unlike the soft pliancy of the
Maillot. Again, the emphasis in the Claudel is on preparedness and group
effort, not on the display of seductive bodies.

The materials used by Claudel are central to the narrative focus of
her work. The sensually carved onyx appears a heavy material for water
and the bronze a great contrast to the onyx if one interprets only for-
mally. Once read narratively, however, this combination seems ideal:
materially grounded bodies face an accelerating but transitory force. The

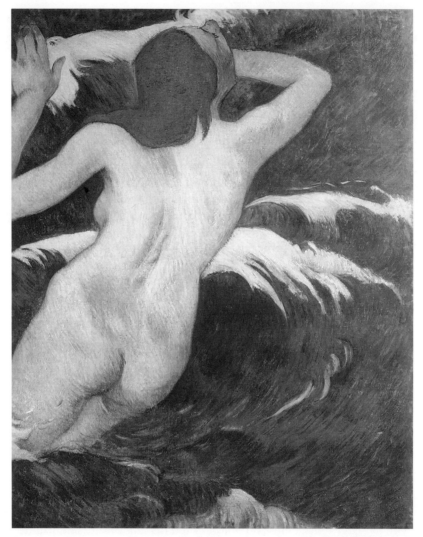

6.11 Paul Gauguin, *In the Waves (Ondine)*, 1889, oil on canvas, 92 × 72 cm. © Cleveland Museum of Art. Gift of Mr. and Mrs. William Powell Jones, 1978.63.

onyx not only has the transparency and variation of sea water but its density evinces the buoyancy of salt water, heavier than clear water. The fluid character of the onyx lends itself perfectly to Claudel's flowing carving of it. Its weight is balanced by the grounded stances and the denser bronze of the women. The stone and bronze are essential to a reading of this work as the immoveable object in the face of the unstoppable force.

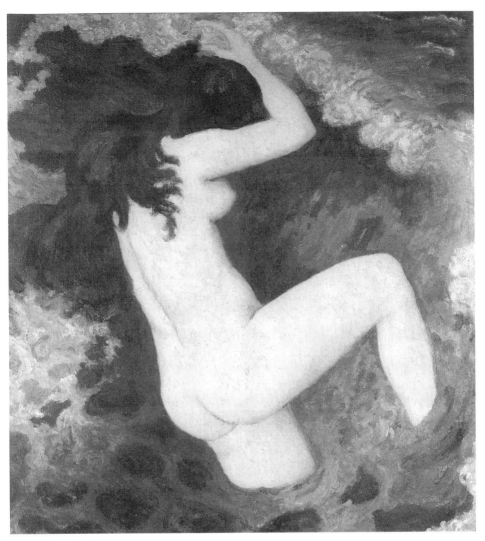

6.12 Aristide Maillol, *The Wave,* Ville de Paris, Musée du Petit Palais. © Photothèque des Musées de la Ville de Paris. ©1999 Artists Rights Society (ARS), New York/ ADAGP, Paris.

The Flute Player (1900–1905; bronze, private collection), her favorite work according to Eugène Blot, bears the mark of ecstasy and interiority prominent in so much Symbolist art and theory. The young woman, dressed only in an energized length of cloth which seems to respond to her music, plays her flute with an uncommon joy and abandon. Her body arches and lifts rapturously, suggesting not the sexualized woman

but the power of music to lift the soul. Claudel used the bronze effec-
tively; the light reflected off of it seems to emanate from the flute player's
body, an effect very unlike the materiality of the women in *The Wave*.
The young woman has transcended to heights beyond the mundane and
worldly. To let go so completely demands an instinctive sense of free-
dom; for a woman to do so would generally imply pathological excess.
Instead, the flute player's light touch on her instrument and her concen-
tration conveys passionate engagement.

Claudel's tableaus from the last years of her productive life are all
scenes of women, and recently several critics have read them as the prod-
uct of a female sensibility: "Ce sont ses obsessions amoureusement déve-
loppées, l'aventure d'une âme féminine: les siens, l'amour et l'enfance.
. . . [ces oeuvres] exprimeront pour eux . . . la saveur douce-amère
du vivre telle qu'une femme la goûta" ["They are lovingly developed
obsessions, the adventure of a feminine soul: friends, love and childhood.
. . . [these works] will express for them . . . the bittersweet flavor of
life such as a woman tasted it"].[63] Anne Rivière similarly described *The
Gossipers* and *The Wave* as "parmi les plus emouvantes, les plus vivantes,
les plus 'féminines' de notre sculpture" ["among the most moving, the
most lively, the most 'feminine' of our sculpture"].[64] However, one must
be wary of attributing these works to Claudel's female sensibility defined
as some essential feminine soul to be expressed and recognized by other
women. This series of genre works, however, does seem to relate partic-
ularly to a woman's sphere. Its protagonists are creative and inspired
women (*The Flute Player*), women together who participate in ambigu-
ous narratives (*The Gossipers, The Wave;* see plates 4 and 5), women who
are deeply engrossed in each other (*The Gossipers*), or a woman in con-
templation (*Profound Thought;* see figure 6.10). As images of women ab-
sorbed in their own world, Claudel's figures do not necessarily transgress
notions of the feminine but they do assert the existence of women's
experiences not acknowledged in the ideology of femininity.

These genre scenes also seem to reflect a gendered stance in their
treatment of the female body. Unlike the chaste Venuses or the seductive
nudes that crowded the Salon year after year, Claudel's women in *The
Gossipers* and *The Wave* seem to be comfortable in their nudity, even
unaware of it, and their bodies are not presented to be viewed eroti-
cally.[65] Rather, they appear to be nude in order to avoid any temporal
historical connection.

Claudel may have sought something more than the expression of a
woman's experience in these late works. Yet she claimed to be totally
uninterested in theory. Asked about her thoughts on Impressionism, she
responded: "Je ne comprends rien aux questions théoriques en matière

d'art. Je me borne à la pratique. Je laisse à autres—qui n'y comprennent pas plus que moi—le soin de discuter ces points oiseux. Croyez à ma parfaite ignorance" ["I understand nothing of theoretical questions in matters of art. I am content with practice. I will leave to others—who understand no more than me—the trouble of discussing these idle points. Believe me, I am completely ignorant [of such things]"].[66] Her work was grounded in her love of materials. Sculpture, she said, was born of the "besoin de toucher, de la joie presque maternelle de la terre plastique entre ses mains" ["need to touch, of the almost maternal joy of the material earth between one's hands"].[67] However, her denial of any interest in theory and her love of the material would not have precluded a desire to express something more than the personal or the experiential.

Not only Symbolist critics but perhaps Claudel as well saw her art to some extent within a Symbolist model. Symbolism, as the most daring, innovative and avant-garde model available at the time, would have attracted the ambitious Claudel. More important, its expressive, spiritual bias and its emphasis on individualism would also have appealed to her. In fact, she may have been seeking a form of Symbolist universal significance beyond the surface narrative of the work. "According to a private statement made by the artist to art critic Mathias Morhardt, it does not really matter that the origin [of *The Gossipers*] comes from the observation of four gossips sitting in a narrow compartment of a railroad car, except as a measure of the genial transfiguration of a scene of daily life into a timeless rite of initiation."[68] The speaking woman in *The Gossipers,* to which all the others give their rapt attention, may well be initiating these women into her secrets, female or otherwise.[69] The original and unusual content of *The Gossipers* was praised at the time.[70] Morhardt recognized it as a new form of art, a poem, like nothing seen before, and credited its power to Claudel's strength and freedom.[71] Claudel has given voice to women in this work, and the language they speak comes from a realm unavailable to men. One woman speaks to others in a ritual of initiation into the language of women's sphere. Rather than the mute nudes of Gauguin, Claudel's women break the silence with their rapt listening and voice. Woman exists not simply as a spectacle of male desire as in the Lacanian Symbolic Order, but as a voice situated in meanings that belong to a language of women—socially constructed, certainly— the words of which remain within the Symbolic Order, but still a language initiated and used by women to voice their concerns.[72] In these genre works, Claudel may have attempted to establish an art of higher significance related to the Symbolist aesthetic but based in the experience of women.

This series of genre works is difficult to place within the critical cate-

gories used to position Claudel's other works. They are small and inti-
mate, so they do not fit the category of virile masculine art. They are
about women but not specifically about bourgeois experience. Her other
works from the last decade or so of her creative life also highlighted
women, again as more than objects of male fantasies. In *The Waltz* (see
figure 4.5) and in *Vertumnus and Pomona* (figure 6.7), the partners are
both equally erotically engaged. Claudel's late works may have incorpo-
rated an attitude toward women which she herself lived: women could
be independent even in a world that cast their individuality and indepen-
dence as deviant, and their experiences, too, could lead to larger mean-
ings.

The expressive force of Claudel's work, especially that done after her
breakup with Rodin, and her friendship with several art critics, assured
her, even as a woman, the praise if not the recognition her work de-
served. She had some success among critics who acknowledged ideas in
her work. Yet her gender kept even those critics from recognizing or
accepting the realm of experience she was addressing in these late works.
Her gender also hampered her financial and therefore her artistic success
in a medium in which women were not trusted to accomplish large
commissions.

Claudel's work has begun to be placed intellectually, but even now
it is often read through the filters of gender difference. It was her female
passion and her fall into madness that were in large part responsible for
her recuperation from history. These have been romanticized and ob-
scure the significance of her real life's work.

The majority of critics writing on Claudel described her as a Symbolist
and were themselves Symbolist critics. Claudel in many ways can be
claimed for Symbolism. Indeed, a tentative category for Symbolist
women artists can be constructed based on the work of Claudel and that
of two other artists working directly within the Symbolist realm.

Elisabeth Sonrel (1874–1951) exhibited paintings and large watercol-
ors from 1893 until 1941 at the Salon des Artistes français. As a very
young woman, she arrived in Paris at the height of Symbolism. She
worked in a literary if not completely academic style, perhaps influenced
by the English Symbolist Burne-Jones. Her subject matter consisted of
Symbolist, mystical images and, in greater number, idyllic visions of
higher realms including mythological and religious scenes. She was sup-
posedly well known during the late nineteenth century and also painted
portraits, flowers, and scenes of Brittany. Of interest for this study of
Symbolist art are several works, such as *Errant Souls* (Salon de 1894;
whereabouts unknown) and *Spirits of the Abyss* (Salon de 1899; figure
6.13).[73] The latter, one of few available illustrations of her work, is an

6.13 Elisabeth Sonrel, *Spirits of the Abyss* (Salon de 1899), Photo: ND-Viollet.

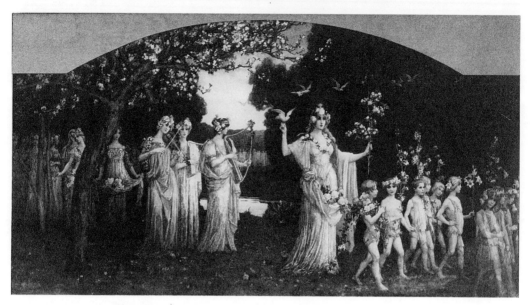

6.14 Elisabeth Sonrel, *The Procession of Flora,* 1897, watercolor, 100 × 200 cm, Musée de l'Impression sur Etoffes, Mulhouse. Photo: Roger Viollet.

eccentric mix of Pre-Raphaelite as well as Academic style and Symbolist content.

The group of women in *Spirits of the Abyss,* with identical headdresses, swords, and varying forms of armor, descends away from the light and toward the chasm below. Their armor and winged helmets suggest a Wagnerian theme such as the Valkyries, which would also account for the overly dramatic facial expressions. Each figure responds differently— some in almost burlesque exaggeration—to what lies beyond the canvas. Some are angry, some sad; several turn away as if in sorrow. Wagnerianism was a strong presence among Symbolist artists and critics. Sonrel's subject here places her well within the Symbolist camp. The figures, however, do not rise to the level of the brooding landscape; they are too harshly drawn, at least according to what one can see from the photograph.

She is more successful at painting the Symbolist trope of the innocent woman. Sonrel's *The Procession of Flora* (1897; figure 6.14), a very large watercolor on paper (100 x 200 cm), establishes her technical prowess. The flowering trees, the glowing pond, and the accomplished figures indicate the range of her skills. The mannered grace of the women, the dreamy landscape, and the group format recall the similar purist images of "innocent" women by Le Sidaner, Puvis de Chavannes, and Osbert

discussed in chapter 5. However, these women do not perform domestic or intimate duties such as caring for children or bathing. They play instruments or pick and carry flowers. The children here, seemingly male and female although the genitals are covered and gender difference is not emphasized, are part of Flora's entourage as signs of innocence. Nor are the women partially or completely nude. They do not wear the loose dresses seen in Maurice Denis's *April* (see figure 1.3) or in the works of Le Sidaner. Flora is neither eroticized nor defeminized. She wears a fitted but unrevealing bodice; her hair is loose but does not dominate her image. The mythological subject does not account for the presence of such details. Rather than bodiless icons of the pure woman, the women in this procession subtly undermine that category.

The Procession of Flora is not a radical work. It conforms in most respects to modes of Symbolist fantasy seen in the work of those nostalgically invoking the harmonious golden age. Within this genre, Sonrel's work is successful; she has evoked a mythical world of serene rhythms and bounty. However, the discrete differences outlined above reveal a different gender performance from the parodies found in the works of her male colleagues. Neither sterile Classical bodies nor female phantoms, Sonrel's women are embodied, functioning women.

The same can be said of Sonrel's *Design for a Diploma* (exhibited in 1892; figure 6.15). In this allegory of peace and labor ("Pax et Labor"), Sonrel depicted several of her allegorical figures as professional women—an artist to the right and a geometer who looks out at us to the left. Once again, the figures have grace and bodiliness without eroticism. The style is a somewhat academic romanticized Classicism, but the sense of presence conveyed by each woman bestows dignity to the work.

Women artists also at times imaged the femme fatale. Not surprisingly, however, such works generally lacked the aggressive sexuality so common in representations by male artists. In American painter Ella Ferris Pell's *Salome* (1890; figure 6.16), for example, exhibited at the Salon des Artistes français, Salome turns away from the viewer. She also places her arm somewhat defensively across her body and appears more melancholy than aroused. Despite her exposed breasts and flowing hair, she does not emanate the sexual charge of most femmes fatales. This work neither celebrates nor degrades woman or her sexuality.[74]

The works of Mme Jeanne Jacquemin, a Symbolist artist described in recent literature as "a mysterious woman who dabbled in the occult and influenced Huysmans," do not pose the extremes presented here.[75] Images of serenity and despair appear, but in forms more subtle and moving than most of those by her male or female colleagues. A small pastel, *Daydream* (c. 1892–4?; plate 6), assumes properties of the "innocent

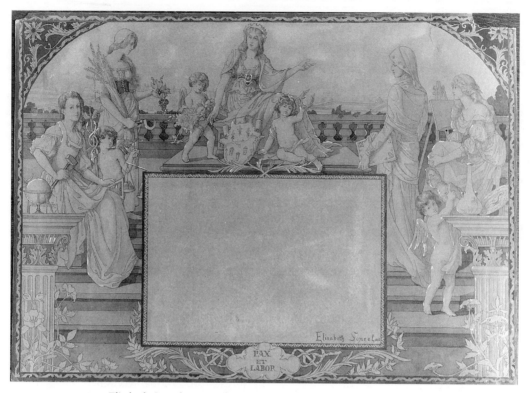

6.15 Elisabeth Sonrel, *Design for a Diploma,* exhibited in 1892, Musée des Beaux-Arts de Tours. Photo: Patrick Boyer.

woman": in a garden before massive, eroded rock arches on the beach, a Pre-Raphaelite-esque young woman dominates the foreground.[76] With flowers in her hair, itself silhouetted in gold, and medieval dress, she touches her hand to her tilted head and looks dreamily inward. Aglow with youth and beauty, her body closed from the viewer by gesture and dress, a deep pleasure radiates from her expression. Sweeter than longing yet verging on melancholy, her countenance conveys a depth of feeling and even intelligence and maturity unlike other, more frigid images of innocence presented earlier. Indeed, innocence can only be inferred here by a lack—of sexual innuendos and of a female gaze.

On the other hand, the garden setting, the medieval clothing and the meditative, almost mystical silence are reminiscent of the medieval motif of the Virgin in the enclosed garden as symbol of Mary's sacred isolation, her fecundity and her need for protection against impurity. This interpretation would allow those so inclined to place Jacquemin's daydreamer into normalized, passive categories such as "woman as nature."

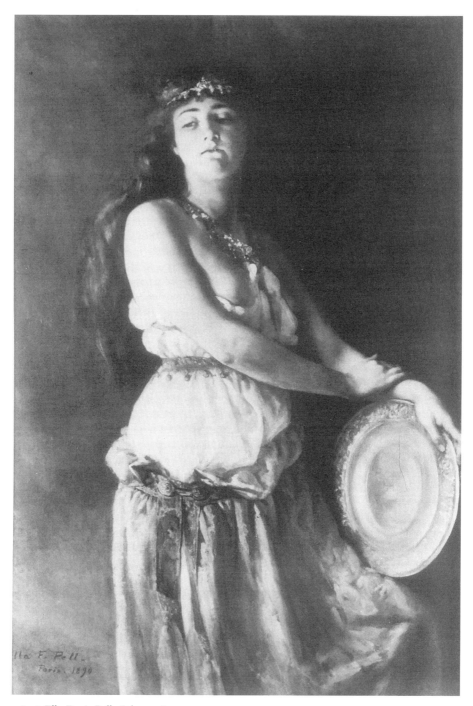

6.16 Ella Ferris Pell, *Salome*, 1890.

Yet the image does not easily hold such conventional meaning. The fact that a woman made this work—her signature, neatly printed across the robe of the woman, is hard to miss—certainly would have encouraged the majority to read it in a customary mode. However, for others more conscious of women's issues, from independent women and even Academic women artists to men with awareness, this image might have signified the isolation, otherworldliness, and mysticism of the (female) Symbolist artist, possibly Jeanne Jacquemin herself. Certainly for contemporary feminists today, and perhaps for the artist as well, this reading is plausible. Her avant-garde style also supports a less orthodox interpretation. In this pastel, she used a vibrating, vertical stroke reminiscent of the backgrounds of many Gauguin paintings, among others, with variously drawn outlines of shapes and vibrant yet subtle combinations of color.

In contrast to Jacquemin's image of the serene and secluded *isolé,* her drawing, *Anguish* (whereabouts unknown; figure 6.17), suggests another Symbolist fundamental, *la douleur.* It was reproduced in Aurier's review of the "Deuxième Exposition des peintres impressionnistes et symbolistes," held in 1892 at the gallery of Le Barc de Boutteville, Paris.[77] He spoke of its "sorrowful springs of bitterness," a fitting description for this plaintive image of suffering. The naked figure, shown only from the shoulders up, seems to hug herself in a huddled gesture of protective closure; the head turns toward the viewer with a gaze of profound despair. The style is more *synthétique* than in the *Daydream.* Again, the artist employed narrow strokes (of charcoal?) throughout, but now they create a more consistent and overall surface vibration; outlines are more distinct; and the composition is compressed and flattened by the high horizon line that cuts across the image in a curve reminiscent of Gauguin's visionary landscape in *Vision After the Sermon* (1888). The figure stands close to the front of the picture plane, in the lower half of the image, with tree trunks immediately behind and vertically traversing the composition. This compact, forceful and compelling design effectively invokes isolation and loss of self.

The sex of the figure is ambiguous. There are no clues in the body; the hands are utterly abstract, neither thick nor fine; the body is slightly boyish with the breast area carefully concealed. The sensuous mouth, high cheekbones with narrow chin and wide, luminous eyes allude to feminine characteristics, but the barely shoulder-length hair and the longish, sensitive, flattened face suggest a male figure, if an androgynous one. If Jacquemin has represented the androgyne, its spirituality and *douleur* are more commanding and vivid than in other images discussed. Is it possible that the artist has appropriated the Symbolist androgyne to

6.17 Jeanne Jacquemin, *Anguish*.

construct a figure truly without sex or gender in order to signify that *la douleur* is not confined to masculine sensibilities? Has she presented us with a female androgyne after all or a more universal image of anguish that does not participate in the power struggles of gender representation? However we or the Symbolists experienced this image, it is an intense work with clear Symbolist attachments in both style and content.

Claudel, Sonrel, and Jacquemin establish the spirited participation of women in the Symbolist aesthetic. Perhaps others will surface in the future. From the work of these three artists, it appears that women Symbolists approached the movement from a variety of stylistic perspectives, as did male Symbolists. However, gender is enacted differently in these works by women. Instead of the abstract manipulation of the sign, woman, to articulate masculine desire or fears, these three women grounded their works, even if at times unconsciously, in their own experiences, so that their female characters enacted their difference with dignity and authority. In order for a woman to create the vapid or vicious creatures painted by Symbolists from Moreau to Gauguin, she would have had to deny the reality of her intimate life knowledge. Work by women Symbolists does not suggest an essentialized female sensibility but, rather, the impact of those socially generated experiential differences that arise from separate spheres.

Gendered Bodies II

PAUL GAUGUIN

A conflict between masculine spirituality and sexuality as lack, excess or homoeroticism, in a form similar to the triad of femme fatale, androgyne, and pure woman discussed earlier, appeared in the work of Paul Gauguin throughout his artistic career. However, rather than radically splitting spirituality from sexuality, he attempted to reconcile them using escapist discourses such as the mythic harmony of nature and exotic primitivism. Gauguin pursued a desire to merge spiritual purity with sexual freedom in his depictions of Tahitian women and androgynous young men. He, too, sublimated the threat of the female body, by deferring it into notions of "woman as nature" and into primitivism while imaging the androgyne in a constantly disturbed accord with his female bodies.[1] Also like other Symbolists, his own masculine and sexual identity was at stake in this effort.

The social status and sexuality of women was a recurring motif in the art of Paul Gauguin. In works such as his bas-relief, *Be In Love, You Will Be Happy* (1889; figure 7.1), Gauguin sympathized with the dependence of contemporary Western bourgeois women on marriage as one of the few and certainly the most respectable of roles available to them. He described himself in *Be In Love* as a monster, grabbing the hand of the resisting and despairing woman and ironically "encouraging" her to "be in love and you will be happy."[2] She moves to stop him with her left hand, on which a wedding band is prominent. By equating love with marriage and both with symbols of wailing women, a lascivious male, and the "symbol of sexual perversity"—the fox—Gauguin specified

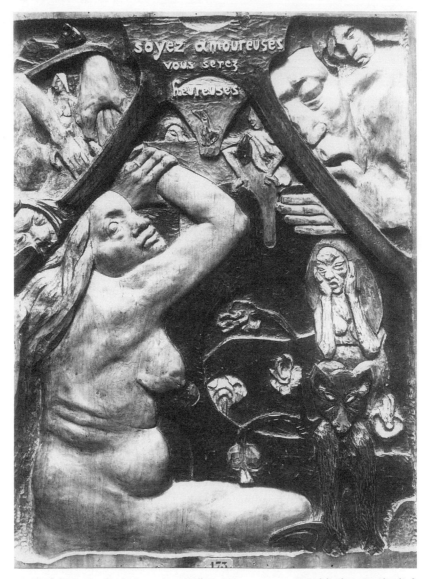

7.1 Paul Gauguin, *Be In Love, You Will Be Happy,* 1889, painted linden-wood relief, 37½″ × 28½″, Arthur Tracy Cabot Fund, courtesy, Museum of Fine Arts, Boston.

forced submission as the subtext of love and marriage for women. He recognized that the institution of marriage compelled women to be dependent on men, and even characterized Western men as the corrupters and exploiters of women and of civilization. Yet he himself played the role of the corrupted male in this work, the demonic tempter who repre-

sents the lascivious nature of civilized man. Soon to go to Tahiti (1890), Gauguin substituted the features of "primitive" women seen in books and at the World Fair for those of Western woman. Nevertheless, the wedding band indicated a form of Western bondage.

Gauguin's understanding of the Western (bourgeois) woman as in effect forced to prostitute herself in marriage was a relatively rare but not unknown mode of comprehending the plight of women during the nineteenth century. It was common to a number of liberal thinkers, especially feminists, among them Gauguin's grandmother Flora Tristan. Tristan (1803–44) was an ardent feminist and socialist, calling for the working class to emancipate itself five years before the *Communist Manifesto* was written.[3] She argued vehemently against the enslavement of women in marriage and campaigned for women's rights to education and equal wages.[4] Tristan, like other socialists and feminists, perceived prostitution not only to be the result of "prejudice, poverty and serfdom," but also of the oppression of women:

> Yes, if you had not made chastity a virtue and required it of women but not of men, women would not be spurned by society for having yielded to their hearts, and young girls who have been seduced, deceived and abandoned would not be reduced to prostitution.[5]

Rather than blaming prostitution on women's aberrant sexual desires or evolutionary degeneracy, Tristan reproached the social order and its laws:

> Indeed, if you did not force women to submit to the abuses of paternal despotism and the indissolubility of marriage, they would not be confronted with the only alternative: to submit to oppression and infamy!
>
> Virtue and vice imply the freedom to do good or evil. But what kind of ethical notions can be expected of a woman who is not her own woman, who owns nothing and whose life-long training has taught her to counter arbitrariness with deceit and coercion with seduction? Brought up in the art of seduction, is she not, when tormented by poverty and seeing all wealth in the hands of men, inevitably driven to prostitution?
>
> Put the blame therefore on the social order and let women be exonerated.[6]

Tristan herself had married to escape poverty and was finally granted legal separation from her husband after he was accused of incest with her daughter Aline (Gauguin's mother).[7] She was thus attuned to the realities of women's existence and was not interested in idealizing their lives.

Gauguin was no doubt proud to be the offspring of such an indepen-

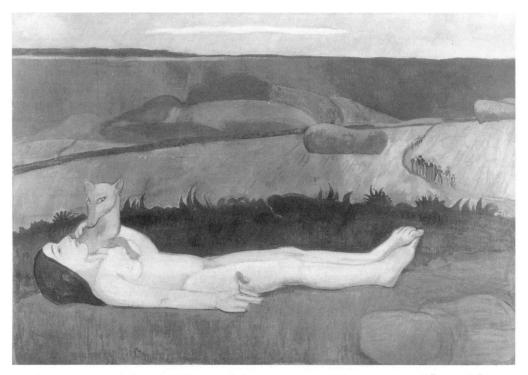

7.2 Paul Gauguin, *The Loss of Virginity*, 1890–91, oil on canvas, 35½″ × 51¼″. The Chrysler Museum of Art, Norfolk, Virginia. Gift of Walter P. Chrysler, Jr. 71.510.

dent, fiery woman,[8] and she may well have influenced his compassion for the Western woman's plight as prostitute to her husband.[9] However, Gauguin's ideal resolution to this plight was not that of his grandmother's—woman liberated from such domestic prostitution, but rather woman's passive and even heroic submission to her "natural" role. Biologically bound to the regeneration of the human race, and serving man's needs, woman inevitably and willingly must sacrifice herself to that greater end. In his painting, *The Loss of Virginity* (1890–91; figure 7.2), Gauguin equated the fall of woman, represented through the possessive fox and the plucked and wilting flower she holds, with the harvested grain behind her. Her crossed feet and prostrate position alluded to the sacrifice of Christ.[10] Woman's surrender to the body as an act of nature—of female nature—corresponds to the equally inevitable process of Nature itself through the cycle of the harvest. Both her loss of virginity and the harvest of the grain are cast as beneficial signs of regeneration. She embraces the fox, a symbol of sexual perversion,[11] though with a melan-

choly air, signaling her submission to suffering at the hands of lustful men in order to regenerate life. In this stereotype—woman's creativity idealized as regenerative life force—Western woman was denied her own sexuality. Forced into the rigid role of the standard bearer of purity and virtue, she submits, though always reluctantly, to the debasement of sex only for the higher purpose of procreation. Moreover, woman's primarily reproductive function in this painting aligned it with other conservative reactions to the falling birth rate in France.

Gauguin's philosophy of women, as expressed in *Be In Love, You Will Be Happy* and *The Loss of Virginity,* thus combined an apparent sympathy for "civilized" (that is, European bourgeois) women's plight with an oppressive belief in woman's duty to regenerate. Although his images were at least superficially more compassionate than the representations of women as engulfing femmes fatales or vapid innocents, Gauguin's Western women remained confined to the timeless world of nature outside of culture and the intellect and were creative only through their bodies.

Both of these images contain references to Gauguin's own and his culture's attitudes about masculine sexuality. Through images of the fox in *The Loss of Virginity* and of Gauguin (with lolling tongue) in *Be In Love,* the figure of masculine desire and sexuality is represented as base, but also as inevitable, proprietary, and controlling. Although Gauguin claimed to disparage masculine sexual impulses, in reality the dominating presence of masculine power and exaggerated masculine sexual potency was naturalized and covertly admired at the same time that it was self-righteously condemned. The artist's sympathy for, yet possessive sexual authority over, woman in these works sent just as equivocal if not as threatening a message as did the conflict between dread and desire implicit in the femme fatale.

In his book *Noa Noa,* Gauguin more directly expressed ambivalent and conflicted feelings about his own sexuality, now through the body of the androgyne, in his attraction to an "androgynous" and "quite young" Tahitian man.[12] Although Gauguin's texts, such as *Noa Noa,* functioned to construct his persona as a "savage" rather than revealed his "true" self,[13] he nevertheless exposed in such passages culturally formed attitudes toward sexuality, masculinity, and his own desires.

Gauguin recounted a trip through the forest with a "faultlessly handsome" young man described as a friend (p. 23). At first, Gauguin perceived the youth walking in front of him as the asexual, if feminized, androgyne—"His lithe animal body had graceful contours, he walked in front of me sexless. . . ." (p. 24)—and felt a sort of ideal love toward the figure. But then he "had a sort of presentiment of crime, the desire

for the unknown, the awakening of evil" and was sexually aroused by the young man. Gauguin's arousal was a strange mixture of homoerotic lust and feminine passivity. The "weariness of the male role" overcame him, and he yearned "to be for a minute the weak being who loves and obeys" a woman (p. 24).[14] He acted on his feelings—"I drew close, without fear of laws, my temples throbbing,"—only to be dramatically halted and his desire turned cold when the youth suddenly turned, "me présentant la poitrine. L'androgyne avait disparu: ce fut bien un jeune homme" ["his chest towards me. The androgyne had vanished; it was a young man after all . . ."].[15] The artist seems to have constructed a scene to portray his evolution into a savage, by first inscribing and then purging his civilized self. It was only after recognizing his own "evil" thoughts in the face of the young man's innocence that he was able to find the savage in himself.

The "evil" desire that Gauguin felt was perhaps the civilized decadent urge to defile the innocent, although the entire passage also evokes homosexual longing. Gauguin's association of his sexual desire with a longing for female passivity suggests an urge to be dominated by a male rather than an ungendered or degendered, asexual androgyne, and it is perhaps this homoerotic longing that makes him experience such guilt at his own desire, blaming such illicit urges on his education in the evils of civilization. Yet when he described his actions based on his arousal, they were put in aggressive terms, indicating either male prerogative, homosexual desire, or the unacceptable aggressiveness of female lust: "I drew close, without fear of laws, my temples throbbing."[16] Whatever Gauguin's intentions, his overly aggressive response to his feelings assured his savage masculinity, a masculinity *not* found in the androgynous Tahitian, as he himself noted.

Gauguin's representation of androgynous figures of both sexes was sanctioned by the widespread notion of Tahitian culture as feminized but, in his art, the eroticism of these bodies is located more in the male figures than in the female. That Gauguin sexualized the male figures instead of the female cannot be attributed solely to the myth of a feminized Tahitian "race." The feminized bodies of Maohi culture represented in narrative and visual form by Gauguin also convey a desire to succumb to "ungendered" (that is, homoerotic/androgynous) sexual encounters.

A telling mistranslation in Griffin's edition of *Noa Noa* indicates a misunderstanding of the term "androgyne." Both Gauguin and Morice (in the supplemented edition of *Noa Noa*) consistently use "l'androgyne," and Griffin translated the term as androgyne early in the passage cited. However, when Gauguin recognized that it was only a young

man in front of him, Griffin translated "L'androgyne avait disparu" as "The hermaphrodite had vanished."[17] Griffin thus accepted the late-nineteenth-century notion of the hermaphrodite as perversely sexualized and assumed the androgyne to be asexual in his translation. He seemingly did not have knowledge of the (homo)eroticized male androgyne. In the original French version, however, the passage on Gauguin's desire indicates a more ambivalent and possibly more homoerotic sexuality than Griffin suggested, and perhaps than Gauguin meant to reveal.

Man with an Axe (1891; plate 7), described in a passage of *Noa Noa* shortly before the story of his erotic adventure, again resembles a feminized male androgyne rather than an asexual young man. Art historian John House suggested that Gauguin transposed his experience described above onto this axe-man with his "nipples and vestigial breasts."[18] Although Gauguin may well have meant to suggest his belief in the "androgynous aspect of the savage"[19] in order to signal his rejection of Western civilization as House suggested,[20] this figure's body in pose and contour—with its small waist, breasts, curving hips, and sensuous mouth—is inscribed with a seductive allure uncommon in Gauguin's images of Tahitian women.[21] Earlier, the artist had expressed an interest in pubescent boys, such as his image of a *Naked Breton Boy* of 1889 (figure 7.3), over whom the viewer stands and whose sultry expression, awkward, adolescent body, and prepubescent genitals seem to charge rather than detract from his erotic appeal.[22]

Gauguin's adventure indicated what he considered to be Western impure desires—for the homoerotic, for relief from the burden of masculinity, and for "dirty" sexual desire. According to Gauguin's idealized vision of the Tahitians, they remained pure in their sexual relations—"Vice [was] unknown among savages"—because they did not feel the perverse urges of Western sexuality; "the purity involved by the sight of the nude and the easy morals between the two sexes" (p. 24) remained uncontaminated. By overcoming his "perverse" sexual impulse, he felt cleansed and purified. His moment of weakness gave way to a rejuvenated masculinity:

> Fiercely I thrust my way with energy into the thicket, [which had] become more and more wild; the boy went on his way, still limpid-eyed. He had not understood. I alone carried the burden of an evil thought, a whole civilisation had been before me in evil and had educated me. . . . Savages both of us, we attacked with the axe a magnificent tree which had to be destroyed to get a branch suitable to my desires. I struck furiously and, my hands covered with blood, hacked away with the pleasure of sating one's brutality and of destroying something. (p. 24)

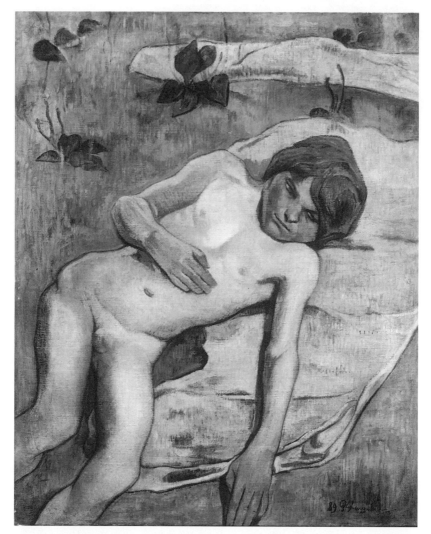

7.3 Paul Gauguin, *Naked Breton Boy*, 1889, Wallraf-Richartz Museum, Cologne. Photo: Rheinisches Bildarchiv, Cologne.

He had become a Maohi, a "savage," freed of "all the old remnant of civilised man in me" (p. 24). He now perceived the young man's "curves" as "robust," rather than lithe, that is, as masculine rather than feminized.[23]

Yet Tahitian native culture accepted without proscription a form of homoeroticism in the *mahu*. Unlike the representation of the homosexual in Western culture as perverse, the *mahu*, a male "third sex" who

has attributes of femininity in appearance and dress and often performs women's work as well as sexual acts with other men, is not so stigmatized.[24] Perhaps Gauguin did not attempt to act on his desire for this androgynous figure because the *mahu,* although an integral actor in certain social contexts, was less respected in other contexts of power.[25] At least in this passage of *Noa Noa,* Gauguin preferred for himself the more aggressive masculinity typical of his Western culture and present in Tahiti as well.[26]

Gauguin's parable of the ritual purging of his Western ways and initiation into the primitive almost certainly was calculated to construct for the European public an image of the noble, "savage," and vital artist.[27] At the same time, it secured his identity as masculine according to Western naturalized social codes of gender embedded in his narrative. These codes at first bring his masculinity into question by the form of his desire for the "sexless" youth: the "weariness of the male role" and "the desire to be for a moment weak, a woman." Once he had purged these Western character flaws, however, he became—not a "savage"—but the more conventional, rugged ideal of Western masculinity. His primitivism did not liberate him from the rigid prototype of Western heterosexual masculinity but rather reconciled him to a guilt-free version of that ideal.

Gauguin's struggle to define his own sexuality continued to be played out in his images of Tahitian women. In this instance, his ideal that sexual relations remain pure in a savage state was tainted by his colonial mentality and its model of female sexuality.

In contrast to the Western bourgeois woman,[28] Gauguin theorized a "primitive" woman who freely and naturally accepted her role in the life cycle, including sexual availability. In a letter to August Strindberg, Gauguin described his theory of the two Eves—the civilized one and the primitive one. The Western Eve, as we have seen, was necessarily warped by civilizing influences such as the institution of marriage. The primitive Eve, founded in the discourse of the "noble savage" and in Gauguin's dreams of Tahiti as an earthly paradise, embodied the ultimate masculine fantasy of the period—unfettered by the polluting effects of Western culture, she offered no threat to masculine domination of the cultural sphere and remained at once both innocent and pure *and* sexual and willing.

> The Eve of your [Strindberg's] civilized conception makes misogynists of you and almost all of us; . . . [Only the Primitive Eve] can logically remain nude before our gaze. In such a simple state, yours could not move without being indecent, and, being too pretty (perhaps), would be the evocation of evil and pain.[29]

Gauguin described an encounter between two such women, one an actual French woman, the wife of a gendarme, and the other his Tahitian "fiancée": "[the Frenchwoman's] eye undressed the impassive girl, now grown haughty: decrepitude was staring at the new flowering, the virtue of the law was breathing impurely upon the native but pure unashamedness of trust, faith. . . . I felt ashamed of my race, and my eyes turned away from that mud—quickly I forgot it—to gaze upon this gold which already I loved . . ."[30]

In *When Will You Marry?* (1891; figure 7.4), a similar contrast exists. The voluptuous, wide-eyed "primitive Eve," dressed in native clothing, is opposed to the Westernized Tahitian woman, recognizable by her high-necked collar, missionary garb, and sly, thin face. This Westernized woman represents the corruption of purity that comes with knowledge through education. She raises her hand in a teaching gesture toward the still innocent primitive Eve, pure in her ignorance, and asks her the question, "When will you marry?," that initiates Western women into fettered sexuality, the corrupt form of marriage as prostitution. In this image, Gauguin acknowledged that the Fall had entered Tahiti and was at pains to establish the peoples' original purity.

Gauguin also rendered the idealized sensual innocent from a more patronizing perspective—as naively superstitious. A fearful young Tahitian woman hallucinates a vision of death in the *Spirit of the Dead Watching* (1892; plate 8). In *Barbaric Folk Tales* (1902; oil, Museum Folkwang, Essen), two young women recount folk stories to the point of hallucinating the presence of the devil. Gauguin both idealized these women's "naive" response to their fears and beliefs and at the same time evoked a sense of civilized, superior difference from them. In *Noa Noa,* his condescending attitude toward the superstitious Tahitians is cloaked in the guise of tolerant indulgence. Sleeping in the open one black night, he described how

> Close to my head a [sort of] phosphorescent dust intrigued me, and I
> smiled as I thought of those kind Maoris who had told me beforehand
> those stories of the *tupapau* [spirits]. I found out later that this luminous
> dust was a small mushroom that grows in the damp places on dead
> branches like the ones which had served me for my fire. (p. 26)

Here we find the same dividing practice at work as in the polarity that characterized dominant notions of woman: the "primitives" were understood to be childlike, wondrous and innocent, but at the same time superstitious, ignorant, and uncivilized.[31] The Western European male, however, had the rational analytical tool of science (here, knowledge of mushrooms) to overcome superstitions. This is a very revealing passage because at the same time that Gauguin presented himself as a savage—

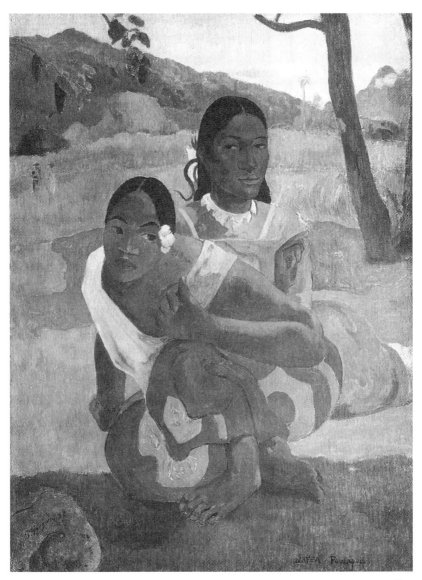

7.4 Paul Gauguin, *Nafea Faa Ipoipo (When Will You Marry?)*, 1892, oil on canvas, 40″ × 30½″, Rudolf Staechelin Family Foundation, Basel.

sleeping outdoors—he also could not resist asserting his Western, learned knowledge and thus his superiority over the "primitive," more intuitive Tahitians. Even in a text in which he sought to champion the "primitive" over the learned, Gauguin reverted (unconsciously?) to his Western bias by privileging rationality over intuitive knowledge.

In *Spirit of the Dead Watching* (plate 8), the superstition of the sensual innocent woman is not only patronized but becomes a site for a "civilized" form of sexual domination. Gauguin wrote of coming home to find his mistress lying in the dark afraid of the night spirits. He painted her passively and fearfully lying on her stomach, with the viewer standing over her, suggesting the sexual availability and submissiveness so common in the genre of the female nude. Her position overwhelmingly conditions our response to the painting. So strong are these sexual associations that Gauguin felt the need to refute them.

> . . . it is a slightly indecent study of a nude, and yet I wish to make of it a chaste picture and imbue it with the spirit of the native, its character and tradition. . . . What can a young native girl be doing completely nude on a bed, and in this somewhat difficult position? Preparing herself for making love? That is certainly in character, but it is indecent, and I do not wish it to be so. Sleeping? The amorous activity would then be over, and that is still indecent. I see here only fear. What kind of fear? Certainly not the fear of Susanna surprised by the elders. That kind of fear does not exist in Oceania.[32]

Her passive nature, indeed her "primitive" fear of imagined spirits rather than of licentious real men, mark her as submissive to the colonizing male gaze, a gaze that both patronizes and diminishes, that exploitatively weakens and then prides itself on protecting.

In Gauguin's writings, the tension between the two extremes of disdain and idealization which characterized his primitivism were also charged by sexual desire.

> The Tahitian Eve is very subtle, very knowing in her naiveté . . . She is Eve after the Fall, still able to walk naked without shame, possessing all of her animal beauty of the first day . . . Enigmatically she looks at you.[33]

Gauguin saw the primitive Eve as sexual without shame, a state certainly preferable to the Western dichotomy between the asexual and the oversexed, the pure woman and the femme fatale. However, the significance of the innocent, "animal beauty" of his Tahitian Eve was not as an alternative role model for Western women but, rather, symbolized for a masculinist culture the ideal woman to be taken freely, without guilt. Free love was part of Gauguin's vision of the barbaric primitive life which he sought in Tahiti, as he wrote to his estranged wife, Mette Gauguin:

> There in Tahiti I shall be able to listen to the sweet murmuring music of my heart's beating in the silence of the beautiful tropical nights. I shall be in amorous harmony with the mysterious beings of my environment. Free at last, without money trouble, I'll be able to love, to sing, to die.[34]

Yet his own experiences with Tahitian women were consistently col-
ored by his Western attitudes. In a passage of *Noa Noa,* their sexual
desire, even in its passive form, threatened Gauguin.

> Je voyais bien des jeunes femmes à l'œil tranquille, je devinais qu'elles
> voulaient être prises sans un mot—prise brutale. En quelque sorte désir
> de viol. Les vieux me disaient en parlant d'une d'elles: Mau tera—*Prends*
> celle-ci. Timide je n'osais me résigner à cet effort.

> [I saw plenty of calm-eyed women, I surmised that they wanted to be
> taken without a word—brutally. In a way [a] desire for rape. The old men
> said to me, speaking of one of them: Mau tera—*Take* this one. Timid, I
> dared not abandon myself to that endeavor.][35]

The various editions and translations of Gauguin's Tahitian journal
Noa Noa have caused some serious misreadings of the artist's self-
constructed myth and of this passage in particular. Most significantly,
Solomon-Godeau's recent, shocking unearthing in a feminist context of
Gauguin's statement that he had a longing to rape Tahitian women is
actually the product of a poor translation. In her otherwise highly sophis-
ticated revisionist essay, she uses Griffin's translation of Gauguin's origi-
nal manuscript—only rediscovered by Jean Loizé in 1951 and done prior
to the modification and elaboration of the text by Charles Morice:

> I saw plenty of calm-eyed women. I wanted them to be willing to be
> taken without a word, brutally. In a way [it was a] longing to rape.[36]

Moreover, Solomon-Godeau left out the next sentence of Griffin's
translation which contextualizes her citation differently: "The old men
said to me, speaking of one of them [women]: '*Mau tera* (take this one).' I
was timid and dared not resign myself to the effort—" (Wadley/Griffin,
p. 23).

Morice's reworked version of the original manuscript, this time in
the French edition (Crès), earlier thought to be the original, represented
Gauguin as much less aggressive, even gentlemanly:[37]

> Je voyais bien des jeunes femmes à l'œil tranquille, de pures tahitiennes
> et quelqu'une d'entre elles eût volontiers *peut-être?* partagé ma vie. Mais
> toutes veulent être prises, prises à la mode maorie (mau, saisir) sans un
> mot, brutalement; toutes ont en quelque sorte le désir du viol.

> [I saw plenty of calm-eyed young women, pure Tahitians, and perhaps
> one of them would willingly share my life. But all of them want to be
> taken, in the maohi mode (mau, saisir), without a word, brutally; in a
> way, they have a desire for rape.][38]

In this version, as in Gauguin's original French version, it is not Gauguin who longs to rape, but the women who are described as longing to be brutally taken. Moreover, Morice ascribed their desire to a Tahitian custom—"la mode maorie." The critic more faithfully captures Gauguin's meaning than did Griffin, even though Morice has changed substantially the overall text, whereas Griffin has only translated Gauguin's original version. Both of these translations, however, differ from Gauguin's original manuscript, cited earlier.

A different Gauguin emerges from the original manuscript, one who does not boldly assert a desire to rape (Griffin's translation), nor seeks a woman simply to "share his life" (Morice edition), but rather one whose masculinity seems threatened by such overt female sexual desire (or at least one who did not feel capable of attempting such a "rape"). The women in this encounter possessed agency and Gauguin decidedly did not, suggesting a much less aggressive and lascivious Gauguin than is implied in Griffin's translation. Indeed, Stephen Eisenman has recently pointed out Gauguin's difficult position within Tahitian culture. He did not fit native conceptions of either masculinity or sexuality, so the boldness of the Tahitian women may well have threatened him on social levels as well.[39]

Given Gauguin's vulnerability in this public encounter with the sexuality of Tahitian women, his reversion to a Western model of women's sexual behavior—that is, his assumption that Tahitian women long to be raped—is not surprising. Their supposed come-on read as a desire for a violent and brutal act surely emerged from Gauguin's cultural bias that when women desire, they also overwhelm, and that their seeming tranquility was actually a passive masochism he felt unable to serve. Despite Gauguin's philosophical construction of female sexuality as natural, and aberrant only in the context of a decadent culture, when he was faced with the reality of Tahitian sexuality, he was unable to fully acknowledge its differences. His ideal of sexual freedom and pleasure without shame gave way to conventional Western notions of sexual relations.

Immediately after his narration of this emasculating experience, Gauguin asserted his rightful position as sexual aggressor and his disdain for Western ways in favor of the primitive.

> Je fis savoir à Titi que je voulais qu'elle vienne. Elle vint. Mais déjà civilisée, habituée au luxe du fonctionnaire, elle ne me convint longtemps. Je m'en séparai.

> [I let Titi know that I wanted her to come. She came. But being already civilized, used to an official's luxury, she did not suit me for long. I parted from her.][40]

Gauguin desired mastery in the Western sense of masculine dominance, over an innocent rather than a desiring woman. He was too timid to take on the latter, yet he was unsatisfied with what he considered to be the jaded, Westernized Titi. In both cases, his response was Western rather than "primitive." The Tahitian women were neither innocent (that is, sexually naive) enough for his taste, nor evil enough to arouse his lust.

His timidity before the bold Tahitian women also sprang from a certain respect he had for them. Although his writings are full of degrading and patronizing remarks about his relationships and his knowledge of these women, he also praised them for their intelligence: "Like Eve, the body of [the Tahitian Eve] is still an animal thing. But the head has progressed with evolution, the thinking has acquired subtlety . . ."[41] Nevertheless, Gauguin was unable to reconcile himself to women as different as these in their sexuality and in their intellect. His dealings with them as individuals were either patronizing or sexualized. In these passages, Gauguin seemed to lose control of the image he desired to create as masculine savage and retreated into European patterns of belittling others (Tahitian women) and aggrandizing oneself (as Titi's superior).

Charles Morice, and possibly Gauguin in collaboration with him, understood full well the threat to masculinity embedded in this passage on the sexuality of Tahitian women in Gauguin's original manuscript. He rewrote the text to diminish the sexual threat by portraying the desire of these women to be brutally taken as a Maohi custom rather than an act of female desire. He also added a sentence that made the women appear somewhat more aggressive and thus legitimized Gauguin's anxious response:

> . . . je me sentais vraiment intimidé tant elles nous regardaient, les autres hommes et moi, avec franchise, avec dignité, avec fierté.

> [. . . They looked at us, the other men and me, with so much frankness, dignity and pride, that I felt really intimidated.][42]

Finally, Morice rescued Gauguin's masculinity from the artist's admitted lack of "audacity or confidence" to take these sexualized "primitive" women by characterizing them as syphilitic from their contact with Europeans. In this light, their lust arose from their Westernization rather than their natural state.[43]

Regardless of Gauguin's supposed desire that Tahitian women be innocent yet sexually available, in the majority of his works they do not flaunt and only barely emit sexuality. Gauguin was unable to collapse

the distinction in the ideology of the dichotomized female body between innocent and sexual. Innocence and naiveté, sometimes nobility as in the image of *Two Tahitian Women* (1899; plate 9), preempts the erotic. Despite the sexual domination implicit in *Spirit of the Dead Watching,* the woman's body is not overtly eroticized (unless one is aroused by her act of submission). Typical of many of Gauguin's images of Tahitian women, her body is thick, with oversized hands and feet. In this work, there are not even signs of her femininity—if one discounts the long hair as attributable to an "other" primitive race. Her posture hides her breasts and genital area. Indeed, when one imagines this figure as a young boy, the raised and highlighted buttocks imply a very different kind of sexual act—sodomy.[44] Such a gender change produces, at least from my perspective, a greater erotic charge than if the figure is seen as a woman.

Tahitian Women, although among Gauguin's most sensual paintings, also carries a low erotic charge. The women have a serene beauty and "hauteur" that lends them an air of nobility and distinction, yet none of these characteristics create the sensuality of the painting. The bodies are not in themselves either pure or sexual, but appear almost wooden, as though of a material other than flesh. Rather, the displacement of the sensual from the body to the luscious fruit (or flowers) and tropical colors gives the work whatever air it has of physical seductiveness. As an operating principle, displacement of the erotic was a peculiar practice for an artist so intent on creating a self-image as virile "savage."[45] Nevertheless, his own self-portraits, his written statements, and his images of young men were often more smoldering than his nude female figures. Gauguin's style is in part responsible for this. His at times consciously awkward female bodies and reductive style cause these figures to appear flat. Such a technique is not conducive to erotic representation. However, other factors are at work in the de-eroticization of his nudes.

Solomon-Godeau characterized the lack of sexuality in Gauguin's Tahitian women as follows:

> . . . there is . . . something in their wooden stolidity, their massive languor, their zombielike presence that belies the fantasy they are summoned to represent.[46]

In her judgment, Gauguin's images of Tahitian women were left impoverished in large part due to his plagiarism of so many sources for his art—photographs and images, both recent and historical, from the West and from a number of other civilizations, but issues of masculinity and Western constructions of sexuality are at work here as well.[47]

Perhaps the guilt-free sexual woman sought by Gauguin was impossible to image because the female body had become so dichotomized into

the vapidly innocent and the malevolently sexual that the coexistence of sexuality and innocence was outside of the range of imagination for the artist and his culture.[48] The very innocence of his "exotic" women preempted their eroticism in a culture that connected innocence with asexuality.[49] They could not be endowed with the power of the sexual because sexuality usually deferred to the discourse of sexual domination, a masculine domain unless co-opted by the threatening femme fatale. Women who offered their bodies could not be taken in a free exchange of love but only as wanton temptresses, forcefully. And as Gauguin said, he was too timid and could not abandon himself to the task of satisfying the sexually assertive Tahitian women. Ultimately, in the majority of his images of Tahitian women, Gauguin's daydream of the harmonious life of the "primitive" took precedence over his sexual fantasies.

Gauguin transferred the threat of women's sexuality into an escapist discourse outside the body—the earthly paradise situated in the primitive woman—at the same time making the bodies and the primitive available and safe for delectation through the masculine hetero or homoerotic gaze.

In the context of such an earthly paradise, the beguiling women, in *Tahitian Women* for example, may also evoke in Gauguin a desire for the maternal as a comforting source of pre-Oedipal plenitude.[50] His sturdy, rarely sensual but never erotic women placed in a fecund, lush nature would have served well the artist's need for comfort and care in a world in which he had to fight unceasingly for his livelihood and which became increasingly hostile toward the end of his life. In his ideal, self-constructed world, he could deny the corruption of Tahiti and its people, he could play the savage, he could pretend that sex was his for the taking and that love could permeate all bodies and all life forms—thereby transcending his sexual guilt. The pre-Oedipal continuity between all beings that informs his paintings and his sculptures is present in the body of the mother. Gauguin's Tahitian women are images without passion that nonetheless provoke desire—for the primitive, for the maternal.

The women in Gauguin's images willingly submitted to their biological fate, and their bodies were either conceptualized as sacrifice for the benefit of the race, diminished by conflicting ideologies of sexuality and a purist primitivism, or affirmed as the return of the nurturing maternal. His androgynes were the site of his struggle to become a primitive himself and exposed his illicit homoerotic desires at the same time as they facilitated his construction of his own aggressive masculinity.

EIGHT

Gendered Bodies III

SUZANNE VALADON

Suzanne Valadon (1865–1938[1]), who worked within the Symbolist period and beyond it, did not conform to any of the notions of the "femme-artiste" discussed so far. She grew up on the streets of Montmartre, worked as an artist's model, and taught herself to paint by watching others paint her body. She had little ambition to enter the mainstream art world and allied herself with the avant-garde, bohemian artists of Montmartre.[2] Nor did she strive for heroic, Symbolist, or passionately engaged subject matter like Claudel, but chose rather to make the male-dominated genre of the female nude a central theme of her work.[3] She painted from a perspective of her working-class status that imbued her images with a very different sensibility from that of the bourgeois women artists discussed above. Moreover, she developed a very personal, material aesthetic out of the lessons not only of Gauguin, but of Degas, Renoir, Courbet, and Cézanne. This brief study of Valadon examines her outsider status as it affected both her work and its reception and outlines her renegotiation and reconceptualization of the Symbolist territory of "woman as nature." Both of these areas were influenced by the ideology of gender. Valadon's work exemplified the way in which the Symbolist aesthetic served some critics as a paradigm and some women artists only tangentially.

Valadon forged for herself a personal aesthetic out of conventions both traditional (the genre of the female nude) and avant-garde (stylistic innovations such as the materiality of her brushwork and the free use of color). She, like Claudel, claimed to disdain theorizing: "Au fond je crois

que le [*sic*] vraie théorie c'est la nature qui l'impose: la nature du peintre d'abord, celle de ce qu'il représente ensuite" ["In essence, I believe that the true theory is imposed by nature: the nature of painting first, that which it represents next"].[4] Yet her statement embodied the Modernist (and Symbolist) theory that style and formal elements ("the nature of painting") were of primary concern and subject matter followed from it. Indeed, similarly to Claudel, Valadon seemed to have been well aware of current avant-garde artistic trends and theories. She spent hours in cafes with colleagues, where there were endless arguments over "Rosicrucianism, the virtues and faults of Seurat's Pointillism, or Symbolism, of Degas's 'keyhole nudes,' of Zola's *L'Oeuvre*."[5] Typical of a number of women artists who looked to the avant-garde for their models, Valadon gave no strong allegiance to any particular style or movement but chose an independent path based on a negotiation with several modes. She was familiar with and influenced by the work of Gauguin, for example,[6] but "dismissed" the "Symbolist ideal." Although she had been "impressed much by the techniques of Pont-Aven," she had decided "to pursue them, but without the vestiges of aestheticism or artiness,"[7] and applied them to naturalistic subjects.[8]

Valadon diluted and fragmented the Symbolist Aesthetic just as did Claudel, according to her own needs. Valadon's path was based in a materiality and realism that addressed a particularly concrete experience of the world. "Je ne serais pas capable de déssiner de mémoire un sucrier" ["I would not be capable of drawing a sugar bowl from memory"].[9] A major characteristic of her nude women, for example, are their very physical embodiment. Nevertheless, critics generally placed her work within a model of gender and class difference that channeled its meanings into carefully circumscribed categories. Yet her experiences as model and artist, and as bohemian, working-class woman were crucial to her choice, interpretation, and adaptation of artistic conventions.

The importance of class in the formation of Valadon's artistic aesthetic cannot be overstressed. Rather than assert her independence from the social realm and its capitalist discourse as the Symbolists aspired to do, Valadon seems to have engaged class issues directly in her series of nude working-class women. The often large, unidealized bodies of her nude figures, their heavy features, relaxed postures, and the ease they display toward their nudity were all signs within the political economy of class that would mark them as working-class women for a late-nineteenth-century French audience.[10] Plate 10, *Catherine Nude Seated on a Panther Skin* (1923), figure 8.1, *Catherine at Her Bath* (1895), and figure 8.2, *Catherine Nude, Brushing Her Hair* (1895) illustrate such bodies. Indeed, one major signifier of their class was their difference from the unspoken norm

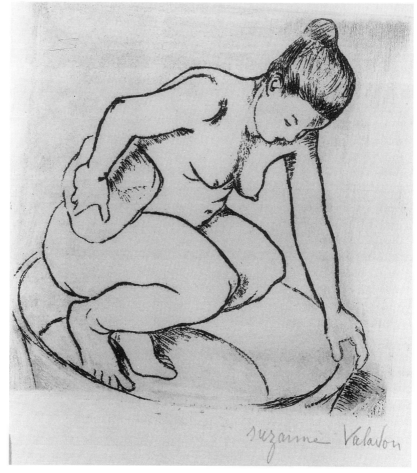

8.1 Suzanne Valadon, *Catherine at Her Bath,* 1895, etching, Musée National d'Art Moderne, Centre Georges Pompidou, Paris. ©1999 Artists Rights Society (ARS), New York/ADAGP, Paris.

of idealized bourgeois womanhood that silently but relentlessly dominated images of the Academic female nude. Valadon's nudes lacked the feminized features and slender, idealized, and often antiseptic bodies of Salon nudes, traits that indicated their proper bourgeois status. Even those Academic nudes meant to elicit arousal or covertly suggest the courtesan, such as Cabanel's *Birth of Venus* (1865; figure 8.3), did so only within the limits of a dimpled, pink, hairless, and nonthreatening version of the erotic.[11]

The social coding of the working-class woman was fueled by the same

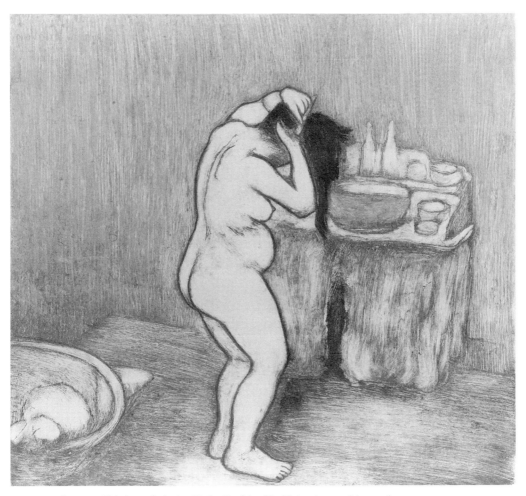

8.2 Suzanne Valadon, *Catherine Nude, Brushing Her Hair,* 1895, etching and monotype, Musée National d'Art Moderne, Centre Georges Pompidou, Paris. ©1999 Artists Rights Society (ARS), New York/ADAGP, Paris.

polarities that structured the discourse of primitivism. They were "noble savages" of Western civilization, either idealized as naive and therefore pure ignorants close to nature and some originary realm of truth or debased as signs of sexual excess because of their "naturally" base instincts or their degenerative condition.[12] The Realist avant-garde often portrayed the working-class woman through this polarity, as sentimentalized or noble creature accepting her fate (Daumier, *The Laundress,* c. 1863; figure 8.4), as haggard workhorse (Degas, *Woman Ironing,* c. 1884–86; figure 8.5), or as part of the degenerate spectacle of Parisian night life

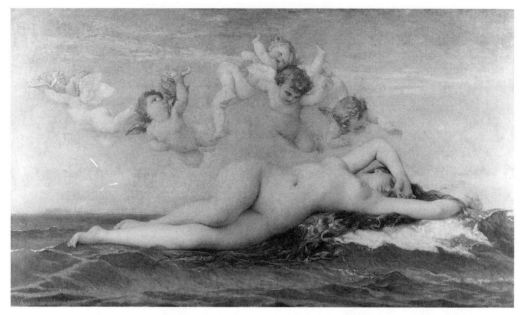

8.3 Alexandre Cabanel, *Birth of Venus,* 1863, Musée d'Orsay. Photo: RMN.

in the role of prostitute (Degas, *Women on the Terrace of a Café in the Evening,* 1877; figure 8.6).[13]

The Symbolist avant-garde, in keeping with their asocial position, tended to avoid such overt representations of class in their images of the female nude, even though their models were most often of the working class.[14] Gauguin's small print, *Washerwomen in Brittany* (1889; figure 8.7), is so abstract that it is difficult at first to discern the figures. When subject matter is considered, the two women washing clothes in a pastoral landscape with a cow munching contentedly in the foreground, there is no clear reference to working-class labor. Rather, the anonymous women appear as solid as the rocks which they resemble and participate in the myth of the "happy peasant." The Symbolists performed an erasure of class in favor of a purist, primitivist idealization of "woman as nature" or represented the essentialized sexuality of the femme fatale as discussed in chapter 5. In the early twentieth century, the avant-garde reduced "woman as nature" to a primitive raw sexuality as in the nudes of Amedeo Modigliani (*Nude with Coral Necklace,* 1917; figure 8.8). All of these categories paralleled the discourse of primitivism, presenting woman as a natural force for good or evil. Instead of openly directing the viewer to class, however, the discourse of primitivism was employed to obscure inferences of class.

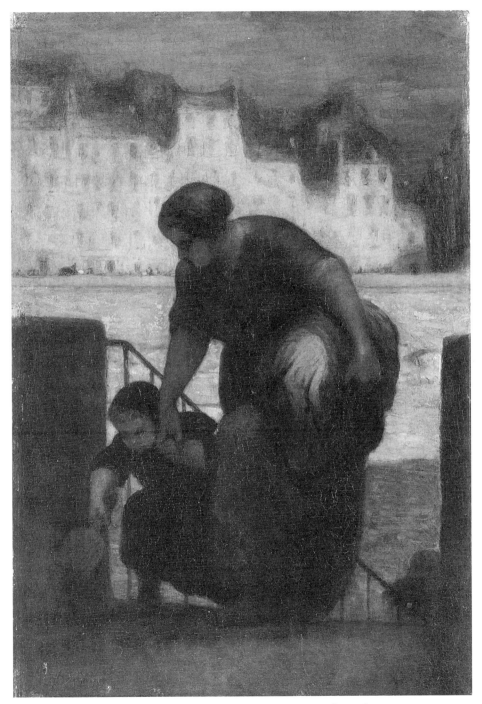

8.4 Honoré Daumier, *The Laundress,* c. 1863, oil on wood, 19¼″ × 13″. The Metropolitan Museum of Art. Bequest of Lillie P. Bliss, 1931. (47.122)

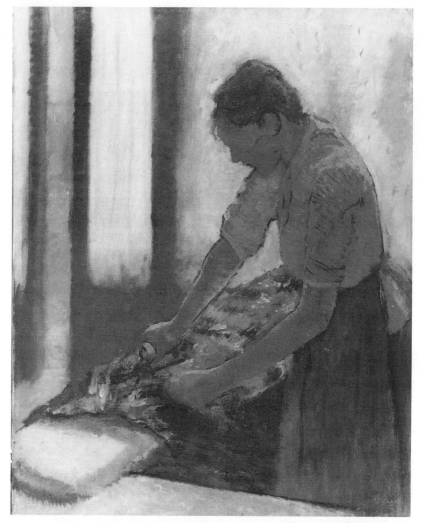

8.5 Edgar Degas, *Woman Ironing*, c. 1884–86. Board of Trustees of the National Museums and Galleries on Merseyside. Walker Art Gallery, Liverpool.

Yet class was implicated, if not forthrightly represented, in all of these Symbolist tropes, just as class was conveyed through the propriety of Academic nudes. The class valence of a female nude was never neutral. The level of titillating sexuality in the "primitive" woman marked these images as belonging to one class or another. Sexuality was very much a classed concept during the period.

Primitivism, as a discourse of escape from cultural engagement, could produce the darker, more threatening side of woman's sexuality without

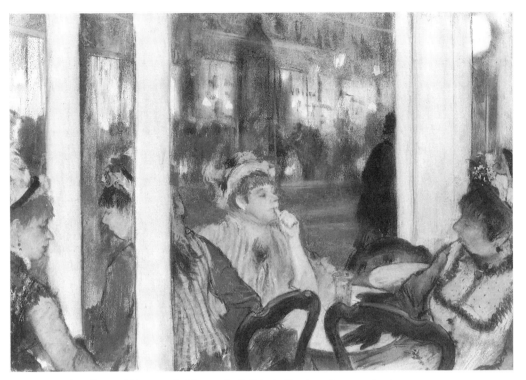

8.6 Edgar Degas, *Women on the Terrace of a Café in the Evening,* 1877, pastel on monotype, Musée d'Orsay, Paris. Photo: RMN.

consciously arousing the anxiety of class difference in the viewer. When confronted with an image of a prostitute dressed as a proper bourgeois woman in a Paris café, the breakdown of class distinctions could not be ignored. When faced with a representation of a vociferously sexual femme fatale situated in a realm outside of the social, her threat was essentialized and distanced from daily experience, and the transgression of class boundaries was obscured. Renoir's bathers (*Blonde Bather,* 1881; figure 8.9) did not present a sexual threat and so remained "properly" seductive; the femme fatale and Modigliani's nudes belonged to the "class" of women who were depicted as oversexed and dangerous, an impropriety generally coded as working class but displaced into the discourse of the primitive.[15] Primitivism may have been used as a camouflage for class difference, but the codes for class were implicit in primitivism's own polarities of ennobled or debased behavior.

The signs for class and the polarities of primitivism were equivalent, but they were received very differently; the discourse of class functioned as potential threat, the discourse of primitivism was manipulated to di-

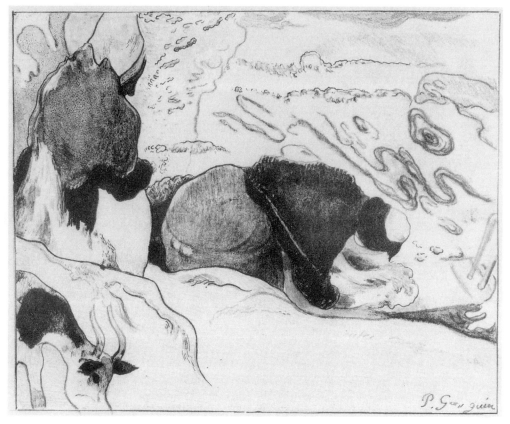

8.7 Paul Gauguin, *Washerwomen in Brittany,* Guérin 6, zincograph, 1889, 21.3 × 26.3 cm. William McCallin McKee Memorial Collection, 1943.1023. © The Art Institute of Chicago, all rights reserved.

minish and contain threat. Primitivism allowed the ciphers of the working class to be not only palatable, but pleasurable. The middle-class audience could take pleasure in that which they denied themselves and attributed to the working class, such as excessive sexual desire, if the threat of that class had been removed through a distancing mechanism such as primitivism.

Women artists, too, participated in the primitivizing of class, but in the form of romanticized peasant rather than sexualized force. The *Union des femmes* leader, Virginie Demont-Breton, represented an idealized working-class woman in *Husband at Sea* (see figure 6.4), identified by her simple dress, her poor surroundings, and her bare feet. She is an attractive and buxom, though not overly large, wife and mother who awaits her husband with a melancholy air. Although represented neither

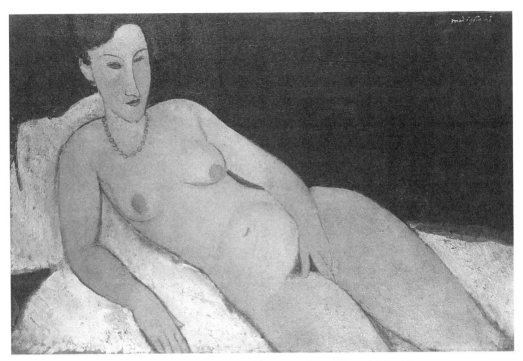

8.8 Amedeo Modigliani, *Nude with Coral Necklace,* 1917, Allen Memorial Art Museum, Oberlin College, Oberlin, OH. Gift of Joseph and Enid Bissett, 1955.

as vamp nor as "noble savage," she is still an idealized image of working-class womanhood who keeps her place and expresses her "lower" class, in opposition to bourgeois womanhood, through her bodiliness, her dress, and her humble surroundings. Even the renegade Marie Bashkirtseff turned to stereotypes of the "country girl" or the urban poor to express "sexual and bodily license . . . imagined as a return to Nature, an escape from cultural femininity."[16] Both of these artists relied on a primitivized notion of class that maintained safe boundaries and class distinctions.

Valadon's female nudes conformed neither to the bourgeois propriety of Academic nudes nor to the depictions of working-class women as vulgar caricatures, purist primitivist idealizations, or signs of sexual excess. Their working-class status is obvious rather than covert, and it is asserted through their bodies. Their class is embedded in their bodies "naturally"; that is, it is central to their condition, rather than an ideological force that drives the image from outside. Valadon's women are not images of difference, even though they were often read as such, but of self-containment, self-absorption, and concrete bodily awareness.[17]

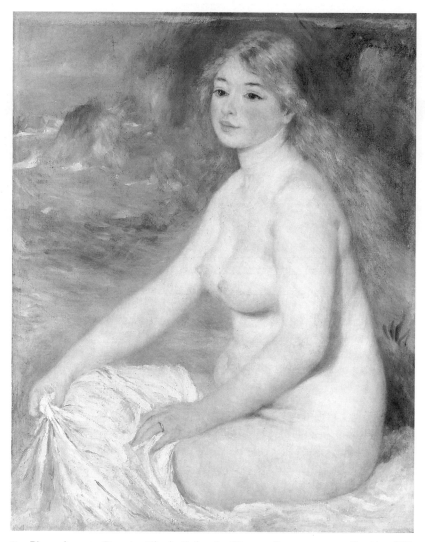

8.9 Pierre-Auguste Renoir, *Blonde Bather I,* 1881–2, oil on canvas, 32³/₁₆ × 25⁷/₈″. 1955.613, © Sterling and Francine Clark Art Institute, Williamstown, MA.

The stereotypic expectations of the working-class woman as coarse and loose as well as the realities of Valadon's working-class existence actually worked in her favor. They freed her to work in a genre dominated by male artists, to carouse with the avant-garde, and to live without the repressive constraints of propriety that plagued bourgeois women artists such as Claudel and Bashkirtseff.[18] As a result of her classed bodies and her avant-garde status outside of the concerns of the official bour-

geois art world, Valadon entered the debate on sexuality from a very different position than did Claudel, who had to contend with the bourgeois demand for purity and chastity in nudes by women. Valadon related rather to libertine attitudes toward the female body, attitudes she encountered among her avant-garde friends in Montmartre, as well as through the discourse on working-class women.[19]

Valadon thus had more freedom to work as she pleased, but she also paid the price of her class by being reduced to a stereotype in the literature. Her bravado, her feistiness, and her sense of herself as a free agent were certainly more acceptable in a woman outside of the bourgeois structure, but accounts of her life sensationalized these aspects and ignored evidence of her more "proper" behavior such as her long-term monogamous relationships and her labor-intensive care for her mother and alcoholic son.[20] The conflicting discursive demands of class and gender determined the reception of her art.

Despite their attention to Valadon's lifestyle, critics were ill-equipped to deal with the relation of her work to her class. They only acknowledged her class identity and the representation of class in her works through veiled attitudes toward her person and the bodies of her female nudes. Dorival subsumed her class into her avant-gardist aesthetic: "these most vulgar creatures," were chosen, he suggested, for their heavy, thick bodies and their vulgar ("canaille") aspect to enhance Valadon's vigorous and harsh aesthetic. He reacted to Valadon's unidealized women's strong-featured faces as ugly, "wasted by misery, pleasure or vice"[21] in works such as her *Catherine Reclining Nude on a Panther Skin* (1923; figure 8.10) and her *Reclining Nude with Red Drape* (c. 1914; figure 8.11). Jean Vertex, too, interpreted the lack of idealization in Valadon's nudes as ugliness and lack of charm and accused Valadon of hating women.[22]

Valadon's images do not contain the extremes of vulgarity and degeneration described in these texts. These writers' repugnance toward Valadon's women is a classic example of the divisive practices of class difference, here intersecting with the equally classed discourse of the ideal female nude. Their feelings of disgust for class difference demonstrate how bourgeois identity forms itself through differentiation from and rejection of what is other to the self. Their attraction to an art that explores such "disgusting" material may reflect the desire for that which is repressed and excluded.[23] These writers have unwittingly disclosed their inability to deal with class on any level but the stereotypical.

Valadon's class, manifested in her bohemian lifestyle, also encouraged some writers to characterize her as the embodiment of the primitive. As we have seen, primitivism was a familiar category for veiling class status

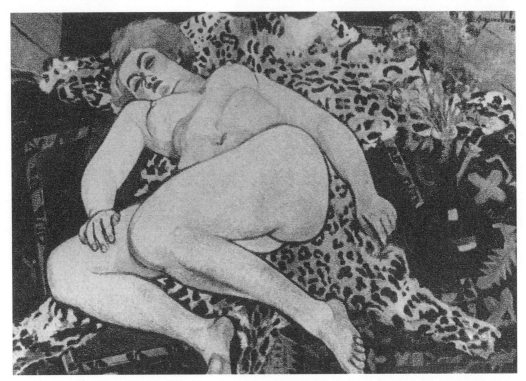

8.10 Suzanne Valadon, *Catherine Reclining Nude on a Panther Skin*, 1923. ©1999 Artists Rights Society (ARS), New York/ADAGP, Paris.

to which both artists and critics could refer in their production of or response to the female nude. Critics spoke of Valadon's wildness and her promiscuity and found corresponding "primitive" characteristics in her art as well. Storm, for example, described her work as "[s]avage and extremely personal, unconnected with any 'school' of the past or present, . . . It is primitive, strong, and frank, abounding in health and vigorous color . . ."[24] He went on to report that the refined atmosphere of the milieu of Puvis de Chavannes, with whom he claimed she lived during the early 1880s, "threatened to destroy creative powers which sprang from her savage and unsophisticated way of life."[25] Yet according to Jeanine Warnod, a family friend and one of her biographers, this supposedly unsophisticated savage read Nietzsche.[26]

Further, her "primitivism" accommodated the critics' attraction to her as a bohemian woman of supposedly loose morals. Her hypersexuality, almost certainly mythical, was understood in the context of the naive and "natural" sexual urges of the primitive so promoted by Gauguin.

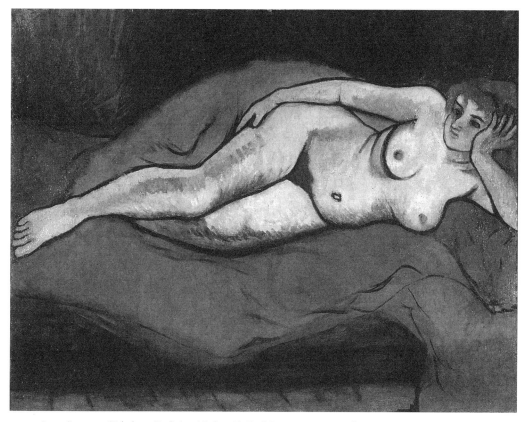

8.11 Suzanne Valadon, *Reclining Nude with Red Drape,* c. 1914, oil on canvas, private collection, Paris. Photo: Giannada Foundation. ©1999 Artists Rights Society (ARS), New York/ADAGP, Paris.

Yet only Valadon's class position allowed her, as a woman, to be seen as "primitive," "savage," and sexual, all traits unacceptable for a bourgeois woman (but coveted by the bourgeois avant-garde male artists). Indeed, it was *only* within these ideological constructs of the working class and primitivism that the sexual woman could exist.

Despite the characterization of Valadon as "primitive" and promiscuous, her nudes were rarely discussed in terms of their sexuality. The class of these women in the context of the nude would normally have sexualized them. However, most critics avoided issues of sexuality or its lack in Valadon's nudes. Several reasons suggest themselves for this evasion. To objectify her women not only would compromise the role of "artist" as virile producer of provocative nudes, but also would be an inappropriate attribution of sexual charge for the majority of Valadon's nudes. The

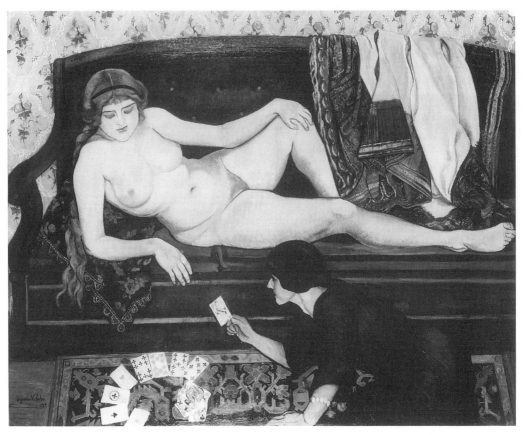

8.12 Suzanne Valadon, *The Fortune Teller (The Future Unveiled),* 1912, oil on canvas, 130 × 163 cm. Musée Petit Palais, Geneva. ©1999 Artists Rights Society (ARS), New York/ADAGP, Paris.

classed bodies of her nudes allowed no idealized interpretation either. Moreover, it was one thing to praise the seductive power of women painted by men; it was another if the artist was herself a woman and supposedly a promiscuous one.

When sexuality in Valadon's images was assumed, critics deferred to the discourse of the female nude as object of the male gaze. The discourse on the female nude ranged from sanctimonious euphemisms about the female body as the representation of some higher ideal, to recognition of the Academic nude as prostitute in disguise,[27] to outright (if unconscious) sexualized objectification in discussions of avant-garde nudes. According to critic André Warnod, the nude in *The Fortune Teller (The Future Unveiled)* (1912; figure 8.12), offers herself to the viewer as voluptuous ob-

ject: "Quelle puissance sensuelle évoque ce bassin large, ce ventre lisse, cette femme, enfin, offerte et qui attend" ["What sensual power is evoked by the broad hips and smooth belly, by this woman who is offered and lies waiting"].[28] This reading exaggerates the sexual passivity of the woman and ignores the central narrative element of two women together performing the act of fortune telling.

Another position suggests itself—that of a subject. Valadon's nudes were not seductive or attractive in conventional terms, and nudity is not central but incidental to their condition as "subject." The lack of modesty in Valadon's nudes placed them in the working-class category of vulgar bodies, despite the fact that Valadon did not imbue her nudes with other orthodox signs of the stereotypical degenerate working-class woman, such as vulgarity and coarse or exaggerated sexuality. Rather, these women relax into their bodies, read books while their bodies are models to be painted, or look back at the gaze of the viewer. Notice the attitude of the models in *Catherine Nude Seated on a Leopard Skin* (plate 10) and *Nude with Striped Coverlet* (1922; figure 8.13).

Valadon's "shameless" but unavailable nudes derailed the representation of class whether they were intended to do so or not. Their class valence could not be located in the prescribed social hierarchy of class types, so they were thrown into available categories that exposed the limited and categorical nature of that order. Critics defused the potential rent in the social fabric provoked by Valadon's renegotiation of class, gender, and sexuality by rerouting the conventional hierarchy onto the safer ground of the "unclassed" and naturally sexual "primitive" artist. Despite the fascination Valadon's life held for male writers, her class remained invisible in their discussions of her work. This was an especially eloquent omission considering how reviewers of women's art tended to comment as much on the artist as on her artistry.

Similarly to Claudel's reception, both contemporary and later critics of Valadon respected her art for its "male" qualities. Male critics, a number of whom wrote entire treatises on her art and especially her life, consistently read her work as powerful and thus masculine. Using terms of combat, Claude Roger-Marx praised Valadon as the only woman artist who had been able to attack and subdue the engraving and etching processes.[29] Robert Beachboard admired her cold and unfeminine lucidity and her work's "virility" in relation to that of other women painters.[30] According to poet and critic Francis Carco, her nudes had the rigor of a masculine vision, but the humanizing line of a woman artist.[31] Dorival argued that her work had nothing in common with other women painters,[32] and few feminine qualities at all except her disregard for logic and consistency:

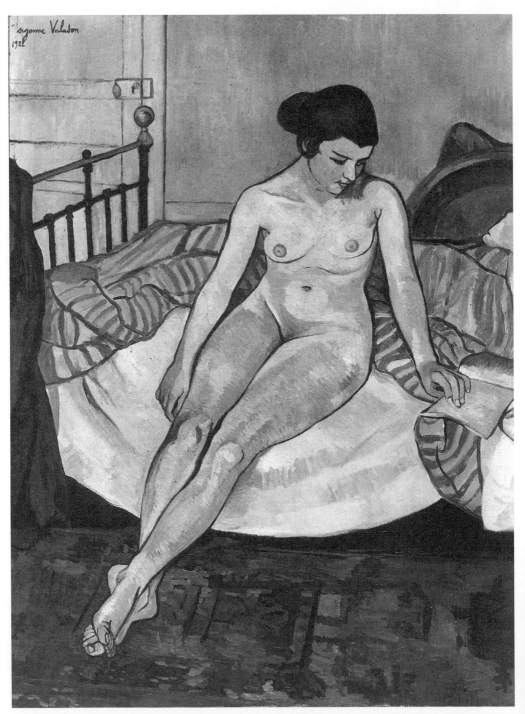

8.13 Suzanne Valadon, *Nude with Striped Coverlet,* 1922, Musée d'Art Moderne de la Ville de Paris. Photo: Giraudon. ©1999 Artists Rights Society (ARS), New York/ ADAGP, Paris.

... dans ce dédain de la logique, dans cette inconséquence et cette indif-
férence aux contradictions, [est] le seul trait féminin que présente l'art de
Suzanne Valadon, la plus virile—et la plus grande—de toutes les femmes
de la peinture.

[. . . the only feminine trait present in the art of Suzanne Valadon, the
most virile—and the greatest—of all women painters [is] in this disdain
for logic, in this inconsistency [disregard for] and indifference to contra-
dictions.][33]

Jacometti also characterized her strengths as unexpectedly virile, ener-
getic, and spirited for a woman.[34]

Statements on the "virility" of Valadon's work issued not only from
the inability of critics to read strong work by women as anything but
male, but also from her primitivizing avant-garde style. Unlike the more
"aristocratic," elegant, well-crafted sculpture of Claudel, Valadon's work
belonged to a Symbolist stylistic tradition which privileged awkward-
nesses, reductive, coarse form, bright color, and loose brushstrokes as
signifiers of sincerity and Truth. This form of "rugged" and "primitive"
avant-gardism, especially in its early-twentieth-century manifestations,
but found among Symbolists as well, was considered to be the most
masculine and virile of art modes, so that Valadon's participation in it
reinforced critical tendencies to interpret her art as "male."

Yet all of these critics, among them her greatest supporters, situated
Valadon's "masculinity" as well as her avant-gardism against the pre-
sumed ground of the "femininity" of "women's art." Just as in the case
of Claudel, Valadon may have been considered superior to her gender,
but her work was rarely equated with the power of male artistic virility.[35]
The discourse of gender difference supported the caveat that the superior
category of the "masculine" woman artist was still inferior to that of the
male artist.

The subtext of gender difference in the topos of the "masculine"
woman artist was nowhere more evident than in the critics' attention
to Valadon's appearance. She was fascinating to writers as an attractive
bohemian woman artist and patronizingly praised for her "gamine" qual-
ities and her passionate, robust sensuality. Storm, who never met Vala-
don and wrote twenty years after her death, described the "ripened vigor
of her spirit" that was "in her walk, in the long unfaltering stride so
strangely incongruous to her size, *in the lift of her breasts.*" His depiction
paralleled that of the femme fatale: "She at once exuded fine sensuality
and robust grandeur. She was far too subtle, too complicated, too dan-
gerous to fire the desires of the callow."[36] Her lifestyle, too, preoccupied

critics. Biographers spent much more time dramatizing her life than they did discussing her art.[37] A number of critics and historians effaced her identity as an artist altogether. In R. H. Wilenski's book, *Modern French Painters* (1940), Valadon was introduced as the mother of Utrillo and identified as "friend and model of Renoir and Degas."[38] As late as 1985, McMullen expressed surprise at Degas's interest in the work of this "Montmartre model."[39]

For many other writers as well, Valadon's more conventional roles as mother and model conflicted with and displaced her identity as an artist. Even though Valadon taught Utrillo to paint, had both critical and financial success,[40] and by many accounts was the more interesting and certainly the more diverse artist of the two, Utrillo's star continued to rise while his mother's faded after her death. Valadon's lived experience integrated her various roles, but critics tended to align themselves with one of her personae at the expense of the others. Critics deferred either to the topos of the masculinized woman artist or relegated her to her conventional place as a woman.

Her role as artist's model also contradicted the characterization of Valadon as a virile, masculine artist. The masculine virility of male avantgarde artists was sexualized as erotic force, and the artist's model, as muse and mistress, represented the ground on which the artist's creative lust could be enacted. Bulliet described the male artist as "both lover and creator" and the female model as both "his mistress and his muse." He goes on:

> Genius is creative, and our guardians of morals, professional and amateur, rightly (even if ignorantly) sense a connection between the lusts of the body and this creative energy of the mind and emotions.[41]

Abetting and justifying the desire for the artist's model to be sexually available, models, like working-class women, were characterized as prostitutes.[42]

In Valadon's case, the role of the model in the construction of sexualized male artistic identity overshadowed and eventually, in many historical accounts of Valadon, displaced the tenuous and conflicted concept of the strong, "masculine" woman artist. The two roles could not exist simultaneously except in the concept of the sexualized but unsophisticated primitive, since the position of model helped construct the artist as virile male, while that of the strong woman artist threatened that same construction. Her career as a model no doubt was largely responsible for assumptions of her promiscuity as well. A number of writers chose to favor the identity that did not disrupt the real subject of art historical texts—art by men. Despite the number of critiques

that substantiated her artistic achievement, her gender took priority in defining her historically, just as it had with Claudel. The "masculinity" of their art was only a fragile veneer created by critics as a strategy both to mark their difference from the general run of women artists, so that there could be no doubt that they were only exceptions to the rule, and to contain them within the bounds of gender difference by marking these "masculine" women artists as better than women but still lesser than men. The ideology of gender roles continually erupted in contemporary accounts of their art and, in most cases, predominated over the more threatening category of the masculine woman artist in later histories, even though that category still maintained gender difference.

Valadon's strongest and most astute support came from Montmartre avant-garde artists. Toulouse-Lautrec was a close friend and supporter, and she became a regular at his weekly soirées. He introduced her to Degas in 1887,[43] a meeting she referred to as "the wonderful moment of my life."[44] Storm described Degas's respect for her work, when during their first meeting, he took a long time over her drawings, and said, "Yes. It is true. You are indeed one of us." Degas called her his "ferocious Maria," "illustrious Valadon," and spoke of her "wicked and supple drawings."[45] But he too stereotyped her by these very appellations as a wild and wicked bohemian woman. Male artists of the caliber which Degas suggested Valadon had attained would not have been so patronizingly treated.

Critics of Valadon also exemplified the both pervasiveness and breakdown of Symbolist categories. Some critics, unable to place Valadon, described her and her work in terms of Symbolist revelation, excitation, *la douleur,* and excessive life force. Reminiscent of Aurier's eulogy of Van Gogh, Adolphe Tabarant spoke of her "sibylline agitation" before a canvas, and of her passion.

> Mme Suzanne Valadon est tout bouillonnement et tout nerfs. Devant la toile qu'elle peint elle doit connaître la pathétique agitation d'une sibylle. . . . [Everything] s'anime, vit et palpite, cette femme extraordinaire est la passion même, et l'on cherche vainement à qui la comparer.

> [Mme Suzanne Valadon is all ebullience and nerves. Before the canvas she must know the compassionate agitation of the sibyl . . . [Everything] is animated, lives and throbs, this extraordinary woman is passion itself, and one searches in vain to compare her to someone.][46]

Similarly, Jacometti described her in terms of *la douleur* and as an *isolé,* whose creative process was one of virtual ecstasy.

C'est dans son art que Suzanne Valadon trouve le réconfort à tant de
malheur.

Pendant les éclaircies qui s'ouvrent dans le ciel orageux de sa destinée,
elle se renferme dans son "manoir" de la "Butte," pour composer ces
hautes fanfares colorées qui l'arrachent au quotidien et la soulèvent vers
les sommets les plus purs.

Elle y va de sa peinture, les nerfs tendus, le cœur battant; elle s'y livre
tout entière en une lutte verticale: ses forces conjuguées se mesurent, avec
une virile crânerie, aux forces mystérieuses qui émanent des choses qu'elle
affronte.

[It is in art that Suzanne Valadon finds relief from so much unhappiness.

During the clearings which opened in the stormy sky of her destiny,
she shut herself up in her "manor" on the "Butte" to compose these lofty,
colorful fanfares which wrest her from the quotidian and raise her toward
the most pure summits.

She goes to her painting, nerves taut, heart beating; she surrenders
entirely to an upward (vertical) battle: her joined forces, with a manly
daring, vie with mysterious forces which emanate from the things that
she confronts.][47]

Once again, the myth of the artist as wild bohemian now read within
a Symbolist aesthetic obscured other effects of the works.[48] Unlike
Claudel, Valadon's work related only tangentially to the Symbolist aes-
thetic.[49] Her art hardly expresses Symbolist-derived concepts of "pure
summits" or "mysterious" emanating forces, nor does it "throb" with
passion. It is much more concrete and worldly than it is spiritual, ephem-
eral, or expressionistic.

These various strategies to critically place Valadon's art illustrate the
predominance of discourse in structuring meaning. They convey more
about the way criticism forced artistic practice into preconceived catego-
ries, especially those based in gender and class, than about Valadon's art.
Such critical strait-jacketing became most obvious when dealing with
those artists that did not often fit existing paradigms, such as Valadon
and indeed most women artists. Conventional periodization and catego-
rization is generally not even appropriate for women artists and others
working on the margins of culture, since such distinctions and structures
were designed by and intended for white middle-class males.

Moreover, none of these critiques came to grips with what is of great-
est interest in Valadon's art. Let us look at a work that engages the dis-
course of "woman as nature," a theme with which male Symbolists were

concerned, in order to characterize more particularly some of the gen-
dered aspects of her art.

Most of Valadon's single-figure nudes relate to avant-garde traditions
than that of the Symbolists, but her image of "woman as nature" in *The
Joy of Life* (1911; plate 11) might be fruitfully considered in light of our
earlier study of this theme. Male Symbolists used this trope to express
various desires and fears about women or the forces of nature, but Vala-
don's image is much less conceptually directed and consequently more
contradictory.

The women in Valadon's image both reflect and disrupt the construct,
woman as nature, as we have seen it manifested in fin-de-siècle mascu-
linist art. On the one hand, *The Joy of Life* makes obvious the function of
such scenes of woman and nature as objects of the male gaze by actually
materializing the male spectator in the image itself. Valadon has created
a contemporary *Judgment of Paris* by displaying the female body in a vari-
ety of poses and by including her new lover André Utter as a sort of
Paris, the traditional figure of male voyeurism. He stands separate from
the objects of his gaze, at ease, arms crossed, in control, and seems delib-
erately to stare at the figures. His dominating stance, the exaggerated
wiriness of his musculature and concealed genitals keep his body from
becoming sexually objectified. He has no other role in the painting ex-
cept as this near-caricature of the dominating male gaze.

On the other hand, the four women in *The Joy of Life* destabilize this
reading. All seem to be at once oblivious to his look and self-consciously
attendant to it. These women are embedded in nature, yet they are self-
absorbed as well. In contrast with Gauguin's *Tahitian Women,* in which
the bodies of women are equivalent to the rest of nature, their breasts
analogous to the fruit or flowers they carry, or Rubens's *Three Graces*
(c. 1638; figure 8.14) who unashamedly display themselves, Valadon's
figures, placed in an idyllic landscape, are not totally integrated into any
of the narratives of "woman as nature." They could not readily be feared
for their sexual voracity as in the femme fatale, forced into submission
as in the work of early-twentieth-century Expressionists,[50] "revered" for
their "primitive" ability (supposedly) to enjoy sexuality without shame
as in Gauguin's Tahitian "primitive Eves," nor admired as the intermedi-
ary for nature's flowing life energies and forces as in Matisse. They are
somewhat closer to Renoir's corpulent bathers, but they do not embody
the voluptuousness of Renoir's figures (compare with *Blonde Bather,* in
figure 8.9). The large-bodiedness of Valadon's women do not display
the deferential attitudes endemic to the art historical tradition stemming
from Rubens of an abundance of sexualized flesh in which Renoir's

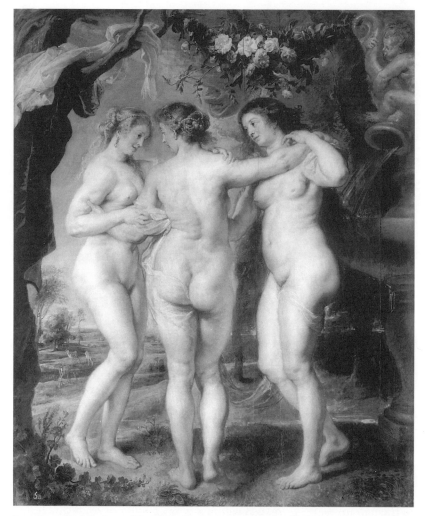

8.14 Peter Paul Rubens, *The Three Graces,* c. 1638, Prado, Madrid.

images are rooted. Most significantly, Valadon's work does not create a coherent narrative that so clearly dominated masculinist images. Masculine dreams of exotic or harmonious paradises are replaced by a disjunct web of contradictory narratives[51] in this otherwise prototypical scene of woman as embedded in nature.

Unlike the cool sensuality of Gauguin's image, or the fleshy wantonness and seductive posing of Rubens's women, attitudes that allow one to speak of pleasure and desire when viewing these works, Valadon's *The Joy of Life* is particularly impassive.[52] The woman arching her body

might even be seen to be expressing grief rather than ecstasy. Paris/Utter takes no pleasure in his viewing; the intensity of his directed gaze appears stern and severe rather than desirous. There is none of the playfulness so often associated with scenes of *The Judgment of Paris*. Indeed, the figures do not interact with each other at all, and a cool but self-consciously charged distance is maintained between observer and observed. The actors in this drama belie our expectations.

Most disruptive of the voyeuristic narrative is the range of positions these women take. The painting represents four very different stances. On the far left, the nude figure stands with her back to us, a robust body so typical of Valadon's types and, here, reminiscent of Courbet's hefty female bodies, with a drape in front of her and one leg casually crossed over the other at the knee. She is hardly interested in exciting the viewer and is looking out into the forest. One can imagine her as a model in Valadon's studio, somewhat bored and preoccupied, holding the drape to her for warmth, and totally relaxed. The second figure standing next to her is in a very different, more exaggerated pose. She bends her body at the knee, head back and arms dramatically placed. Of the four women, her body is the most seductive and present as object. The lines of her body are repeated in the sinuous, Gauguin-like tree to the left, and in the much cooler body of the woman to her right. Just below her, another half-draped woman bends forward to pick up a white cloth, and the effect is very similar to uneroticized images of Valadon's *femme de ménage*, Catherine, at her bath (see figures 8.1 and 8.2). Again, the woman seems self-absorbed and offers little for the voyeur except a bared breast. The fourth figure, possibly Valadon herself because of the facial features and the dark hair, is the only one that could be construed as actively aware of and engaged in the scene, rather than absorbed in the self. Her darker skin also makes her distinct from the others, although she may be in shadow. She looks toward the bending woman while in the act of turning her body, and she too seems to reach for her drape. Her body, however, is seen only from behind, seated, and it cannot easily be read as voluptuously seductive.

These figures move in and out of the construct, "woman as nature," depending on the role that the viewer assigns to them at the moment. Certain of the figures seem incredibly disjunctive from each other and appear to be images of studio models only montaged into the narrative. Others appear to be placed specifically for the male viewer's pleasure, a reading supported by the sinuous and sensuous Gauguinesque trees on the left that emphasize their poses. In yet another disruptive narrative, the figures seem to be part of a contemporary picnic or "déjeuner sur l'herbe," just finished, in which they rise, stretch, gaze for one last mo-

ment at the landscape, and gather their things to go, a Realist vision or even a contemporary "embarkation from Cythera." Betterton emphasized such a reading of the painting when she praised Valadon's women for being active and, as such, actively disrupting the traditional codes for painting the female nude: "in her treatment of the theme ["woman as nature,"] women are not shown to be instinctual and natural beings, but individuals engaged in social relationships and activities. . . . What Valadon tried to capture . . . was the intensity of a particular moment of action rather than a static and timeless vision."[53] But this image seems to reveal a less coherent intention on the part of Valadon, one that incorporates several visions—that of active women, objectified women, and women as represented in traditional genres accompanied by a male gaze, with obvious influences from Gauguin, Matisse, and Cézanne, among others. More important, these various narratives do not form a unified and static message, but seem rather to defer meaning to and across fragments of each other in a perpetual play of meaning. Multiple narratives interrupt the continuity of the singular narrative, "woman as nature," and expose its assumptions about universal woman. This painting and the problematics of reading many of Valadon's nudes reveal the way in which various narratives intersect in her work in often uncomfortable ways to dislodge and destabilize conventional gendered interpretations.

Gardner's *Judgment of Paris* (see figure 6.5) might profitably be compared with Valadon's image. The male figure in both is in a position of power and just as self-assured, but the female figures react very differently. Gardner's little girls are either diminished or elated by the boy's choice, whereas Valadon's women are more indifferent, though no less under the sway of the male figure's controlling gaze. The relation to gender categories in Valadon's work is much more flexible than in Gardner's rigid encoding. Gardner's class allegiance and the concomitant demand for propriety was a powerful force in her work, just as Valadon's disregard for bourgeois respectability and its rigid gender roles was in hers.

Valadon's aesthetic reflects the contradictions of her own position as a relatively free "woman of the people" within a bohemian society, yet a woman nonetheless not immune to the prevailing ideology of femininity of her time. To be sure, her inversions of the norms may be more a result of her unusual background than a conscious effort to deconstruct and subvert the male tradition of the female nude. Nonetheless, Valadon brings to her works of the female nude a series of positions that have the potential to alter radically the conventional perceptions of the genre. Her nudes pose numerous problems and raise issues related to constructed femininity and the potential role of diverse female gazes in slip-

ping through that construction. Valadon's interruptions in the conventions of the nude must be seen as extraordinary, however far they do or do not go.

The critics did not recognize the disruptive narratives present in so many of her nudes, such as in *The Joy of Life*. Her biographer Jeanine Warnod, for example, described these women as disporting themselves before a young athlete.[54] Dorival, we recall, briefly mentioned the "contradictions" in Valadon's art, but criticized them as "female" traits, and perhaps they are if we consider them in opposition to the universalizing narratives of Symbolism and other masculine-dominated avant-garde theory and practice. Possibly only those such as women artists, doubly marginalized as both woman and woman artist, who often lived contradictory roles of artist/model/wife/mother, and so on, could portray the contradictions that riddled both their own lives and the meta-narratives of Modernism.

Valadon's images of young girls also contradicted and disrupted Symbolist constructions of women. Her images of puberty show very different attitudes toward it than that of male Symbolists, and the nature versus culture debate takes on totally different parameters when the two are compared.

Puberty was a very charged moment in the life of the bourgeois woman. Contemporary discussions of it exposed ambivalent attitudes and fantasies about the sexuality of women of that class. Edvard Munch's *Puberty* (1894–95; plate 12)[55] supports the Symbolist view of the disruptive effects of the natural process of puberty on both young girls and their unfortunate male prey. In Munch's image, puberty as the onset of the vociferous, frightening sexuality of the femme fatale is charged with phallic sexual innuendoes, such as the shadow behind the subject. Here the young girl's sexual awakening is depicted as oppressive, subsuming, and terrorizing. Whether one reads the girl as terrified by or embracing her newly found sexuality, it is visited upon her and subsumes her. This image justified and enforced a male identity that must guard itself against vociferous women; puberty here represents the birth of the femme fatale. Obviously, when one chooses to play these kinds of logical semiotic games, as intellectuals in the nineteenth century were wont to do, the results are predictable; if a young girl is the cipher of sexual innocence and passivity, then the post-pubescent woman *must logically be* the opposite (predatory and carnal). Puberty then becomes the threshold of the metaphysical transformation between these two extremes. Gauguin's *Loss of Virginity* (see figure 7.2) proposes another "natural" outcome of puberty: woman as necessary sacrifice for the regeneration of the race. Gauguin's figure does not pose the threat of the sexualized woman; in-

stead she resignedly accepts her biologically determined role along with male dominance and male sexual needs. Gauguin embeds her in mythic cycles of regeneration such as the harvest ritual to indicate the universal and inevitable nature of her role.

Valadon's *The Abandoned Doll* (1921; plate 13) offered a very different formulation of puberty from the mythic ciphers of Gauguin and Munch, one perhaps closer to lived experience in a culture in which respectable womanhood was culturally coded as appearance rather than sexual urge. It envisions puberty from the young girl's perspective as a socially constructed process that is as much enculturated as biologically determined. Whether this image represents bourgeois or working-class women, it is concerned with respectability. In *The Abandoned Doll*, a discarded toy symbolizes childhood which the young girl is throwing off. The subject turns away from her mother's nurturing attention to concentrate instead on her own appearance in a mirror. The bow in the hair, also present in the doll's hair, might be seen as early training for her later role as attractive woman (woman who "appears"), conveyed through the object of the doll itself. Indeed, the bow could represent both a sign of childhood innocence as well as the necessary "dressing up" of the woman in order to attract the male, a role conditioned already in childhood to which the pretty doll as model for young girls attests. The mirror, too, signals a preoccupation with appearance. Its history as a sign of "vanitas"[56] revolves largely around beautiful women narcissistically self-absorbed in their beauty, as in Rubens's *Toilette of Venus* (1615; oil). Such women admire and present themselves as objects for a male gaze, with only a tangential reference to the ephemerality of life.

Experientially, this focus on appearance has resulted in women's anxieties about their "looks," and the mirror in Valadon's painting may represent woman both taking pleasure in her appearance and awakening to its ensuing anxieties. The mother here is presented as either benevolent through her pleasantly plump body and her expression, and thus either unaware of or unconcerned about her daughter's shift of focus; or as melancholy over the soon to occur separation between the two. In either case, her role seems to be the traditional one of caretaker, here drying her daughter's body, that very body soon to enter the economy of reproduction, regeneration, and representation that will define her social position as woman. Indeed, the role of mother here seems even to initiate the daughter into the realm of appearances. Her attention to her child's body sets an example for the attention women give their own bodies as vessels of attraction and seduction. This work elucidates the way in which a young girl's indoctrination into the order of womanhood inevi-

tably implied an induction into the order of appearing and the assumption of the masquerade of femininity.[57]

The daughter turns away from the mother's serene supervision, psychologically rejecting her childhood attachment to the mother. There is no sense of crisis here, rather of impatience (perhaps) on the part of the daughter and tender acceptance on the part of the mother. It is indeed surprising how little anxiety or negative tension is present in this work. It all seems so "natural." Valadon's work exhibits none of the essentialized sexual power or sense of sacrifice evident in images of women and puberty by artists such as Munch and Gauguin. Her young girls remain firmly within the realm of the social. The social position of woman is defined by her gender conditioning rather than by some inherent physiological difference. Two different models of meaning are exhibited in these examples. One is based in the notion of biological determination, the other in the lived experience of women's social positioning. Even before it was culturally acknowledged, gender was present in Valadon's painting as a construction and a process rather than an inherent given.

The young woman in *The Abandoned Doll* seems too self-absorbed to perform as the stable ground of woman as passive vessel or femme fatale through which male identities were partially structured. She experiences her own entry into the social order, rather than playing her "proper" role in representation. It is an image of the *experience* of the ideology of femininity, not of its ideal. Yet, despite the signs of this girl's youth in her hairdo and bow, Valadon confronted the viewer with the young girl's ripening body in a way that might have offered voyeuristic pleasure if one overlooked other ideological implications of the image. Indeed, such a nude body was expected to elicit desire as part of its role in the economy of appearance. Such "ignorance" of content was a common strategy in criticism of women artists, as we have seen. Nevertheless, by so constructing her image, Valadon both participated in the ideology of femininity and exposed, albeit unwittingly, one of its mechanisms. The conflicted narratives in this work express the subterranean contradictions concerning female sexuality versus social roles with which women had to grapple.

The mythic, even archetypal, nudes often found in the work of Gauguin contrast in similar ways with the mundane bodies and contemporary types found in Valadon's images. The passive, submissive pose of the nude in Gauguin's *Spirit of the Dead Watching* (see plate 8), and the gaze of colonialism inherent in it, differs in every particular from Valadon's image of an "odalisque," *The Blue Room* (1923; plate 14). Whereas Gau-

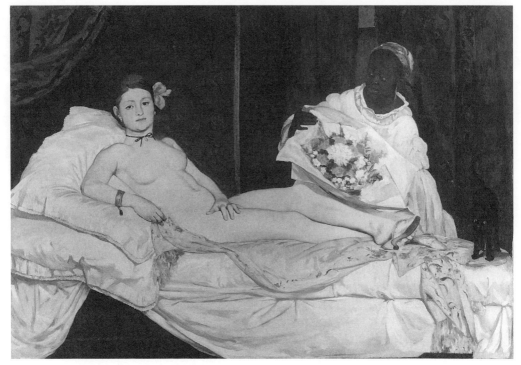

8.15 Edouard Manet, *Olympia,* 1863, Musée d'Orsay, Paris. Photo: RMN: Gérard Blot.

guin's nude was praised as the "Black Olympia," in reference to Manet's
Olympia (1863; figure 8.15; of which Gauguin did a close copy), Vala-
don's independent woman, a "nu habillé," was described as vulgar, with
a thick and common body.[58] And yet, her body has as much in common
with Manet's courtesan as Gauguin's Tahitian woman, but from a very
different perspective. Neither *Olympia* nor Valadon's woman is mute,
passive or vulnerable, and certainly not fearful. Class is inscribed in both
bodies in a way that threatened Manet's critics[59] and repelled Valadon's;
neither woman is idealized and both possess a self-assurance and a bold-
ness that distressed their audiences. The mute fear of Gauguin's nude
offers no such resistance. Manet and Valadon both disrupted conven-
tional genres with the impertinent presences of their women: *Olympia*
deploys the long tradition of the seductive nude laid out on the canvas
for the pleasure of the male gaze; Valadon's painting invokes the conven-
tions of the odalisque with its decorative setting and its lounging (usually
"oriental") woman, itself merely a subgenre of the category of the female
nude.

 Both women derive their brashness and independence from their sta-

tus as outsiders, but of different sorts. Manet's nude asserts both her out-siderism as a courtesan at the same time as she insists on the importance of her role in the gendered economy of capitalism. She challenges the viewer and implicates *his* participation through her gaze. The woman in the *Blue Room,* however, does not derive her independence from a cultural position of service but rather chooses to live a bohemian lifestyle. The presence of books on the bed indicate education and mental activity and replace the usual exotic accoutrements of the hookah, or the cat, that hissing sign of sexual promiscuity in Manet's *Olympia.* These signs, along with her cigarette, her unfeminine clothing, and her hair pulled back contradict the suggested representation of lower-class woman as a cipher of sexuality within the context of the odalisque format. The strong presence of a lesbian community in Paris with which Valadon had at least some ties, suggests the possibility that this is a representation of a lesbian intellectual, along the lines of a Gertrude Stein, although there is little proof of this in the image except her boldness and her refusal to play to a male gaze.

Representations of women of color by Gauguin and Valadon also manifested distinct differences—for example, Gauguin's *Two Tahitian Women* (see plate 9),[60] and Valadon's *Nude Black Woman* (*Vénus Noire ou La Négresse Nue,* 1919; plate 15). Both Valadon and Gauguin positioned their figures in a lush, green landscape, and both relied on the trope of "woman as nature." Both avoided the hideously distorted stereotype of the black woman as the embodiment of pathological sexuality.[61] Gau-guin's Tahitians are serenely beautiful with a sense of dignity that comes from their silent stillness, symmetrical, "exotic" features and flowing hair. Their relation to nature is emphasized by the flowers of one and the fruit or petals of the other, as well as by their exposed breasts. They are among the most effective evocations of Gauguin's ideal of the "prim-itive Eve." However, they are also strangely passive. Rather than meet-ing the viewer's gaze seductively, one averts her eyes and the other sub-missively turns her head to look indirectly into the viewer's space, or perhaps only gazes downward. Gauguin, again, had trouble imaging Ta-hitian women as both sexual and innocent. Despite their strange gazes (perhaps they are both listening as Brettell suggested, but to what? to something threatening?), these women have become affirming signs of Gauguin's paradise.

Although Valadon's image shares the same prototype ("woman as na-ture") and the same (Gauguinesque) background, her woman is the an-tithesis to Gauguin's Tahitian beauties. Images of black women within the genre of the nude are rare in themselves, except in representations of the colonized, idealized Other, and this one is unusual for a number

of other reasons. Valadon's *Nude Black Woman* is neither passive, silent, nor still, but gazes consciously and almost confrontationally out at the viewer.[62] She seems to be in the act of moving rather than posing for the roaming eye of the viewer, despite the accoutrements of modeling such as the white drape. She covers herself not in the traditional manner of seductive modesty, which calls attention to what is not seen, but with a more aggressively defensive gesture, as though to block our view. Her features are heavy, her body muscled; she, like all of Valadon's women, contradicts conventional ideals of beauty. She wears earrings and possibly makeup. She is aware of herself as an enculturated, social being, and as a body under the gaze. Such consciousness of body and mind disrupts the normative psychological process of the male gaze. Her specificity and individuality dominate (but do not obscure) stereotypes of "woman as nature" and the sexualized black woman. She refuses to willingly perform these roles. Valadon, because of her realism, or her consciousness, or her interaction with this woman, recorded her refusal, or perhaps constructed it.

The tangible body and self-consciousness of this nude shields her from being completely incorporated into the roles she plays. Her reality as a woman rather than a sign, a physical reality which Valadon never entirely released even in her grand allegories, unsettles the coherence of the depicted narrative. Valadon's women are never quite enmeshed in the myth of the feminine. Symbolists such as Gauguin, on the other hand, maintained the mythic, symbolic dimension of woman and manifested it through their masculinist positions.

Although the number of women artists increased exponentially during the late nineteenth century and there was much written on them, they all, from Academic to avant-garde, encountered gender bias in the interpretation of their art and consequently in their placement in history. Critics, faced with the anomaly of women artists within a discourse of creativity that denied their existence, sought ways to place them that would not disrupt the masculine hegemony of the creative venture. Most women artists were channeled into the category of the "feminine" artist, which kept them safely within their proper sphere. Even those who worked more radically, such as Claudel and Valadon, were finally subsumed by the ideology of gender. Such "exceptions" were placed within the ambivalent topos of "masculine" woman artist. The mental distress endured by women who tried to negotiate the conflict between their lived experience and their ideological positioning paralyzed many.

Both Valadon and Claudel created a powerful aesthetic from their own perspectives that differed from those of their male colleagues, yet neither was fully acknowledged in their lifetime, and both were eventu-

ally written out of art history. The reception of their works was trapped in the codes of gender difference, and despite the artists' negotiations with male constructs of creativity, from Claudel's Symbolism and Expressionism to Valadon's woman as nature, critics and historians could not move outside of gender boundaries to recognize their real innovations.

Claudel wanted to enter the establishment on her own expressive terms and on equal footing with male colleagues. She did not receive the necessary commissions to continue her art, and evidence suggests that her gender played an important role on many levels in this failure.[63] She had some critical success, but the ideology of gender again biased the meanings attributed to her art. Her state of mind and the events surrounding her institutionalization epitomized the frustration as well as the medical and legal restraints such strong women could suffer during the period. After her internment, history cast Claudel out of her creative role altogether, cloaking her in the conventional role of muse and lover to the great white male.

Valadon suffered a similar fate. She did not care to establish herself through traditional routes and exhibited regularly in alternative spaces. Gradually, she had some financial success. But the aspects of her work that make it live for us today, her imaging of working-class women and her alternative vision of the nude female body, were misread by her critics. Valadon became better known as the mother of Utrillo and the model of "great" male artists than as an artist herself.

In both cases, the model of creativity as masculine virility was applied to their art. As such, they could never be more than second-class males. Herein lies the problematic for interpreting art by women and writing them into an already given history. Once placed in secondary categories of feminine art or second-class male art, they were easily culled from historical surveys, giving place to the "real" artists and "first-class" art. When women were not omitted altogether from history, they were given lesser status because they could not possibly attain the heights of male creative force. It did not really matter what these women artists did in practice, they were theoretically circumscribed. The best they might hope for was limited success during their lifetime. In this way, the stranglehold of the ideology of gender as it was manifested in notions of creativity had material effect on the practice of art by women.

The invisibility of Valadon and Claudel in the literature took a great deal of historical editing, as did the presentation of Claudel's work as parasitically dependent on her relationship to Rodin and the ascension of Valadon's son Utrillo's work over her own. Both women were active and respected participants in the milieu of late-nineteenth- and early-twentieth-century avant-garde art, however ambivalently they were crit-

ically received. Their erasure from history, as those of most women artists, derived not just from a lack of information, but from a willful ignorance, the "privilege of unknowing"[64] that was the foundation of artistic hierarchies of creativity, hierarchies dominated by white, middle-class, masculine privilege. Of course, the omission is empirically self-perpetuating, for once someone has been overlooked in the literature, they can be legitimately overlooked thereafter. Theories of creativity and genius excluded women and thus writers could legitimately efface them from their studies of art by ignoring evidence to the contrary. This refusal historically to acknowledge women artists such as Valadon and Claudel as artists at all, much less as significant ones, was part of the tactic of ignorance that deferred to the "regime of truth" in which women do not produce or create except on a biological level, thereby structuring the aesthetic creative field as exclusively masculine.

Women artists were forced to work within such codings of ignorance even if merely by reacting against them. Only a minority of women—feminists—recognized and acted upon the full measure of their oppression as women. Many acted out of the "ignorance" of their repression, an "unknowing" which allowed them to produce despite being theoretically written out of creative models. The more conservative women artists worked within the ideology of femininity and achieved a modicum of success, even though the more transformative agendas of those such as the leaders of the *Union* were distorted by critics to support an even more traditional notion of bourgeois womanhood than their own. Such artists who accepted their social place and worked out of it may have been free to create, but they suffered the consequences of their "privileged" ignorance by being absorbed into the discourse of woman.

Despite the lack of recognition in the past of the true gender difference that images by avant-garde women artists represented, we can now acknowledge the radical undermining of normalized versions of gender in such works. By indicating a site where women resisted their assigned positions, the work of these women artists created a counterdiscourse to the dogma of gender roles. Such women did not consciously choose these spaces, but rather existed in them. Their experience, as that of most women at the time, was necessarily different from the rigid ideology of femininity that constituted the ground on which masculine desires and fantasies were played out. As a result, works by women artists, even the more conservative ones, often reveal the space of women almost despite themselves. Independent women artists such as Claudel and Valadon lived their lives as a form of resistance to their proper positioning as women. Their art does not necessarily express that resistance, since art is not a direct reflection of biography, but their lived position as both

women and artists was inscribed through their production of art, just as it was for male artists.

Both Valadon and Claudel worked within the "privilege of unknowing" to some degree.[65] They were socialized as women in their culture at least to the extent that they did not imagine women as revolutionizing culture or even particularly as expanding its boundaries. Although they created images that questioned the ideology of femininity, they did not really transgress the boundaries of gender. Neither tried to create alternative roles for women or fought for women's rights.

What we do see in their art that differs from work that more wholeheartedly embraced the ideology of femininity and the "privilege of unknowing" is the representation of woman's sphere from the perspective of women. Both expressed otherwise invisible roles that women did experience. Claudel envisioned women as having experiences in a realm of their own. Valadon destabilized the masquerade of feminine appearance in her images of puberty and of feminine posing and the male gaze in *The Joy of Life*. However, these visions were not recognized as such by their (mostly male) critics, who forced their work into categories which helped formulate and sustain masculine creative hegemony.

Thus two women artists, very different in interests, class, and artistic direction, were placed in very similar critical categories largely because critics were ill-equipped to handle the power of their work and its underlying subtext of women's sphere. As a result, they were ambivalently touted as virile women artists and then dropped from sight.

Women artists threatened the structuring and stabilizing function of "woman" within the homosocial fabric. Although their practice was diversified and redolent with cultural significance, the reception of their art and the theorizing of their social position were riddled with the ambiguities and contradictions that attended any attempt to create or enforce strict gender difference. These women artists reveal a scarcely explored living realm of creative women that contradicts the social position of woman as "other" to masculine needs.

Conclusions and
Contiguous Connections

Creativity in late-nineteenth-century France was not a static and mono-lithic entity within which the artist operated, but a discursive site in which competing voices from various social groups vied for dominance within the cultural arena. Each faction represented itself as the sole locus of truth and attempted to repress difference and surmount opposition from other points of view, but no group achieved absolute hegemony. As Foucault described it, discourse

> does not operate in a uniform, stable way; there is not an accepted dis-course and an excluded discourse, a discourse of the dominant and a dis-course of the dominated. It is made up of a multiplicity of elements that intersect in a complex, unstable way, as instruments and effects of power, but also as points of resistance.[1]

This conclusion brings together the contiguous issues from throughout the book so as to summarize the effects of their interactions and analyze their strategies of otherness and inversion.

Symbolists and scientists alike manipulated the concept of madness-as-insight to produce different social positions for the genius. Such ma-nipulation exemplifies the way in which a set of culturally circulating terms might be restructured within an economy of norms according to different needs but without having absolute transformative impact on the culture as a whole in any of its manifestations. Certain voices did have more authority than others, according to their position within the fragile but constantly reinforced and buttressed regime of truth. Because

the discourse of science commanded considerable cultural authority, the version of mad genius as creative but without control put forward by an influential segment of the scientific and medical establishment was most persuasive. Art and artists were rapidly and unhappily losing the prestigious position as cultural commentator to the authority of science and industry, but the Symbolists mounted a heroic effort to reestablish the artist as a metaphysical authority in opposition to what they considered to be the crass and vapid objectivity and empiricism of their scientific adversaries. In their interpretation, the mad genius—characterized as enlightened visionary rather than irrational force—was the only hope for social transformation and the establishment of a utopian future.

The Symbolist moment represented the conscious crystallization of the stances of transgression and opposition so central to avant-gardism.[2] Their loudly proclaimed antagonism toward bourgeois regulations and beliefs, despite their participation in some of those values, rallied a strong oppositional force of cultural voices to create a space for alternative (masculine) representations to exist. Escape or retreat into the Ideal such as that of the Symbolists, even in the guise of advance, rarely leads to substantive change. Nevertheless, the Symbolists' separatist gesture remained oppositional in its overt antagonism, aspiring nihilism, and messianism. Such a space of opposition serves to prevent culture from becoming static and overadministered and to fuel hope for change in the future.

Although the Symbolists' formulation of mad genius enjoyed an appreciative audience, ironically it also contributed to the disempowerment of their aesthetic in the culture at large. By subscribing to the necessity of pain and suffering and the ecstatic nature of inspired creativity, the Symbolists laid themselves open to appropriation and distortion of their aesthetic. Scientific and medical discourses acknowledged these aspects as inherent in creativity but framed them as debilitating and thus ineffectual and unthreatening in the cultural realm since genius was represented as operating without rational control. From this perspective, science and creativity were wed in a metaphoric and teleological communion in which the former (the "objective" partner) justified, legitimized, and represented the other (the "irrational" of the pair), while the latter was left to speak only in a voice predetermined through heredity, evolution, degeneration, and the violent, excessive emotion which supposedly characterized it.

The critical effectiveness of the Symbolist aesthetic was further undermined by its relation to capitalism and its disinterested aesthetic. Capitalism, manifested as materialism, cultural loss of refined taste and distinctions, and the democratization of culture, was the force against which the Symbolists railed, but Symbolist methods of innovation and transgression

meant to overcome the agents of capitalism only served to further the progress of consumerism. The disinterested aesthetic of Symbolism left it vulnerable to appropriation by capitalist interests.

The Symbolist aesthetic's ability to effect social change was most diminished by its complicity with the bourgeois regime of truth. The hierarchical distinctions and elitism of the Symbolist aesthetic were based in the same dividing practices as those of the social order they supposedly despised. In the artistic and literary communities, the desire to oppose the authority of institutional discourses such as science led Symbolists to embrace difference and offer alternative and positive value to the marginal. By reversing the hierarchy of difference, they meant to impose their own authority over the structuring of social and cultural values. Yet those values and their "difference" were still based in middle-class white Western masculinist values, despite their claim to value the truly "other." Their very privileging of the other assumed the right to represent it and thus to control it. The critics' refusal (or inability) to acknowledge class in Valadon's works except as otherness or by displacing it into the discourse of primitivism elucidates the mechanism of exclusion on which hierarchical social distinctions were founded. The Symbolists' strategic employment of primitivism as an escape from history and from the present into a purified, idealized originary past was also contaminated by their participation in the bourgeois social order. The fantasy of a timeless moment when humanity lived in a state of purity depended on a colonialist mentality which characterized the dominant social order as well.

Creativity in late-nineteenth-century France was a discourse of and about masculinity. Dividing practices served as social mechanisms that established social order and assured masculine hegemony by absorbing and converting any threat to male privilege into self-serving representational forms—*femmes-artistes,* hysterical women, naive and ignorant "primitives." Discourses such as gender difference and primitivism accordingly repressed women and others, but over and above a desire to "keep women in their place," the primary function of such discourses was to produce sites of ideologically stable otherness on which the struggle for cultural hegemony could be enacted and against which the unstable category of masculinity could be established and maintained. "Woman" was one of the necessary others onto which the male homosocial establishment displaced its fears and desires, and through which it defined its superiority. The topoi of the "feminine" and the "masculine" woman artist were shaped by this naturalized production of otherness. Gender difference marked the category of avant-garde artists as decidedly male.

The images of women by male avant-garde artists demonstrated how

important the discourse of woman was in structuring male fantasy and desire. Speaking of the cultural hierarchy of "high" and "low," Peter Stallybrass and Allon White described a recurrent pattern that illuminates the role of woman as a site of the construction of masculinity:

> the "top" attempts to reject and eliminate the "bottom" for reasons of prestige and status, . . . but also . . . the top *includes* that low symbolically, as a primary eroticized constituent of its own fantasy life. The result is a mobile, conflictual fusion of power, fear and desire in the construction of subjectivity: a psychological dependence upon precisely those Others which are being rigorously opposed and excluded at the social level. It is for this reason that what is *socially* peripheral is so frequently *symbolically* central . . .[3]

The covert desire for illicit sexuality embedded in images of the femme fatale illustrated such psychological dependence. Women were presented as sexually vociferous animals both to insure their lack of cultural agency and to allow men to indulge their fantasies while safeguarding their gender boundaries. Less virulent images of "woman as nature" secured and protected notions of gender difference, the availability of female bodies, and the primacy of utopian ideals. Symbolist images of women exemplify how vital the construction of woman as other was to the identity of the Symbolist as virile artist. They also reflect the continual disempowerment of women.

Inversion was one of the Symbolists' most common counterdiscursive strategies to express their opposition to capitalist and bourgeois values. They asserted the priority of spirituality, anarchism, nihilism, antagonism, and antimaterialism as antidotes to the materialism and empiricism characteristic of their culture. Cultural values assigned to madness and rationality were inversely reassigned, so that knowledge and wisdom in the Symbolist aesthetic were posited as emanating from the former rather than the latter. This inversion had such cultural resonance amidst the crises of late-nineteenth-century society that even some scientists, such as the philosophers of degeneracy, granted authority to the irrational as long as it was controlled.

Inversion functioned only for privileged men, however. The link between madness and genius was severed when considering women artists, for example. Their "madness" was transposed into the discourse of woman and madness. The masculinist muse of madness provided an ordered perception, albeit an other-worldly order, that could reveal Truth. Madness in women, such as the ideologically convenient and timely reinstatement of the category of hysteria, implied a disorganization, a frenetic, wild, unstructured and random behavior, a short-circuiting of the

nervous system. The ramblings of mad genius were interpreted as profound; similar utterings of hysterical women were conceived of as gibberish and without semiotic content except as symptoms of illness. The Symbolist inversion of madness bled through into bourgeois orderings of meaning but was considered by neither avant-garde Symbolist nor establishment scientist to function for women.

The Symbolists also inverted gender categories by feminizing their aesthetic but insured that women could not participate in the fluctuation of gender boundaries that they had set in motion. Symbolists extolled the "feminine" traits of intuition, expression, and emotion, and even feminized their own personae accordingly. At the same time, an aggressive virility unacceptable in bourgeois women necessarily accompanied such feminization; as a result, most women artists could not benefit from the privileging of female emotionality. Once again, mental illnesses such as hysteria redirected any creative potential that such emotionality in women might contain. Forceful expression in art by women was defused by rerouting it into the category of "masculine" woman or collapsing it back into the feminine. Such masculinization was itself a form of gender inversion. Yet despite the supposed superior status of those women artists who qualified as masculine, historically and critically they were positioned in a limbo located between both genders. The inversion of gender traits was thus kept safely within the parameters of masculine identity.

The discourse of primitivism and history represented another instance of value inversion. For the Symbolists, in contrast with bourgeois norms, knowledge was immanent and originary rather than learned and accumulated. However, the power of primitivism, similarly to that of gender inversion, was limited to its use in the construction of male avant-garde identity rather than as a more widespread liberatory tool. When "primitives" or women displayed traits of the primitive, such a threat was contained by diverting its meaning into the negative pole of the discourse of primitivism. Such others were seen as dangerous and in need of control. In the case of Valadon, the threat of her class and her classed subjects was channeled into primitivism, so that she became the desired other praised for her lack of propriety. Such lack trespassed against the social contract of "reasonable behavior" and therefore signified a dysfunctional, marginalized, and unthreatening social position.

The Symbolists' inversion of margin and center also typified their complicity with the social order. While claiming to work in the margins of society to create a new center, they manipulated the marginal to their advantage. They constituted their own personae as marginalized but joined the conventional center by excluding the truly marginalized from their aesthetic.

The tactic of inversion, therefore, did not empower the Symbolist aesthetic to transform social values. Foucault has argued that a strategy of opposing positions is doomed to fail because both positions remain within the same set of terms as those they resist. Simply to reverse the terms leaves intact the social codes and institutions that construct those terms. The Symbolists' practice of inversion did not unmask the mechanisms of social power and authority but, rather, assumed and reorganized them. Indeed, male artists had much to lose by a true restructuring of the social order; women artists and other subgroups had a great deal to gain.

The Symbolists' tactic of inversion produced a binary opposition between margin and center; it did not acknowledge the more complex condition—a cacophony of voices each struggling to assert its own center. The level of power and authority garnered by each group was dependent on the level of ideological consensus attained for its position and the authority of conflicting or mirroring discourses with which it interacted. Culture as a site of the proliferation of conflicting voices vying for dominance corresponds more closely to cultural conditions, to actual social practices, and to the elusive and contingent nature of discursive formations than does the reductive notion of oppositional discourses that rise up against repressive and dominant forces.

Although flawed in its ability to represent the multiplicity of social discourse and thus of social transformation, inversion was effective as a tactic of regulation and control. Founded in polarities, it served as a central organizing principle not only of avant-garde oppositional discourses but also of socially dividing practices. Polarities structured hierarchically the categories produced by dividing practices—the noble or ignorant savage, the honest or debased woman, the naive or dangerous working class. The Symbolists' use of inversion thus paralleled one of the most effective tools of power used by the homosocial establishment: the construction of otherness through dividing practices.

Polar opposites are by their very nature interconnected; each exists only in reference to the other. The privileging of the primitive, for example, depended for its significance and the intense loyalties to it on a bourgeois order that was synonymous with primitivism's binary opposite—the civilized. Yet even the hierarchy of inversion is not totalizing. In the fabrication of otherness, whether it be the working class or the noble savage, the structuring polarities hold an ideological place, as meaning constantly slips and slides between purportedly opposite poles according to the dictates of individual experience and the demands of discourse. Conflicting voices, such as that of Valadon, destabilized simplistic polarities and exposed their absences and exclusions. Ideological

polarities existed in tension with practices that tended to establish a range
of positions between the poles.

Despite the seemingly oppositional stances between the avant-garde
and its antagonists, their positions were much less polarized than either
imagined. Both scientific and artistic constructs of creativity and genius,
for example, relied on faith in the root metaphors of madness and genius.
The ideological correspondences between these scientists and Symbolists
produced social and cultural representations of white, middle-class, het-
erosexual masculinity as the norm, even when seen as mad, and ex-
cluded—even denigrated—all others as deficient. Indeed, both groups
represented staunch bastions of the powerful homosocial establishment.

The discourse of the creative woman further illuminated the parallels
between bourgeois and avant-garde value systems. Although multiple
masculine voices opined about the potential for woman's creativity, the
large majority agreed that it was meager at best. Woman's structuring
role was too important to the maintenance of normativity and her trans-
gressive potential too threatening to the regime of truth for women's
rights to attract a critical mass.

The homosocial fabric of privilege and difference did not keep
women from creating, but it did have a significant influence on their
practice. Women had to struggle much harder than male artists to find
sites in which to negotiate their creativity, and they generally situated
their creative practice in the fractures, obfuscations, and absences within
and between discourses. As a result, women artists worked differently
than their male colleagues. Yet even feminists could not completely es-
cape the regime of truth, nor transgress its boundaries. One cannot think
totally beyond one's time and still be visible and heard within it, but
the ever increasing number and diversity of women artists suggested the
limitations of discursive power to determine identity and practice abso-
lutely. Some worked within the interstices of Academic creative models
and artistic professionalism and of normative ideologies of femininity and
gender difference. These masculinist sites restricted their voices to vary-
ing degrees but nonetheless did allow them to produce. Others, such
as Valadon and Claudel, found freedom to create in the disjunctions,
contradictions, and absences of masculinist artistic practices, such as the
expression of a world of women.

The gendered nature of creativity at the fin de siècle reveals the con-
struction of gender to be contingent and fluid. Not only feminized male
artists but also women artists occupying interstitial sites of artistic produc-
tion reenacted gender as an insubordinate performance whose shifting
boundaries destabilized and challenged normalized gender roles.

The predominant masculinist discourse of creativity controlled to a

much greater degree the reception of women's art than it did their prac-
tice. Critics tended to contain any threat to the position of the male
artist and to cultural notions of gender difference by strait-jacketing art
by women—bracketing their work within a framework of caveats and
exceptions. Yet critical attempts to find a place for strong women artists
at the fin de siècle, such as Valadon and Claudel, indicated that although
ideologies comprising the regime of truth may be rigid and monolithic,
the enactment of social norms is elastic and dynamic. There is a slippage
between the ideals applied to society as a whole, such as the a priori
models for women who were characterized as either strictly conforming
to them or as misfits, and the dynamic practice of the application of
those models—a slippage within which women could work and to an
extent find at least provisional acceptance in the art world.

Women artists such as Claudel and Valadon worked within estab-
lished artistic categories, yet their art went beyond representations of
predominant notions of gender and creativity. Their experiences as
women, even those conditioned by gender difference, were so unlike
the dominant ideology of femininity that the gap between their experi-
ence and its ideological equivalent could not be bridged. That gap often
appeared in their work as content—for Valadon, the working-class
nude; for Claudel, the world of women.

The resistance of women artists such as Claudel and Valadon, then, if
it may so be termed, did not take place in the space of opposition produced
by Symbolism but through ongoing negotiations with the ideologies
within Symbolism, feminism, and science that confined or affirmed
them, and with the contradictions and disjunctions in those ideologies so
integral to their own experience. Experience is not meant to imply here
an inherent, legitimizing authority, since it too is biased by ideological
assumptions as demonstrated in the discussion of "performative contradic-
tions."[4] However, when an ideology so narrowly limits experience as did
that of the ideology of femininity in late-nineteenth-century France, the
subjects of that ideology are bound to encounter its inadequacy daily in a
thousand ways, much as they may strive to behave according to its rules.
Moreover, other discourses such as the New Woman or individual sexual-
ity would have interacted and conflicted with the ideology of femininity,
so that it could never have been experienced purely. Such norms and con-
tradictions formed the fabric of bourgeois women's lives and, as such, have
much to tell us. Even in the most conservative cases such as that of Elizabeth
Gardner, when her art is examined from the perspective of her position as
a bourgeois woman artist in late-nineteenth-century France, we learn a
great deal about sites of resistance and artistic identities available to women
and thus of the authority or lack of it in the discourses of gender difference.

Such counterdiscursive practices were hardly equivalent to the self-conscious, aggressive program of opposition that characterized the Symbolist aesthetic. A renegade group of male artists could inscribe its voice within culture as long as it remained within the domain of masculinist values and did not challenge the foundations of the social order. The subordinate position of women, on the other hand, was more fundamentally interwoven into the cultural fabric. Their roles as generators and caretakers of the human race were the essential ground on which the male homosocial fabric was elaborated. They were not free to drop out of society as were men such as the Symbolists, and when they attempted to do so as in the case of the eccentric, asocial Claudel, they paid a heavy price. Yet women's artistic practices ultimately were more disruptive of the social fabric than the Symbolist tactics.

Capitalism and bourgeois values have increasingly dominated Western culture, whereas the grip of the ideology of femininity, though still prevailing, has slowly eroded as images of women have undergone transformation over the course of the twentieth century. Male avant-garde artists sought to change society without fundamentally restructuring its underlying assumptions. Women artists sought to express themselves even within the confines of gender ideology and in doing so helped to undermine, however unwittingly, the gendered foundations of society by revealing the limits of its discursive formations. Ironically, the renegotiation of gender has also served bourgeois capitalism's desire for the ever-new.

Women artists' passive resistance has only begun to be studied in images. Its first interpretations in the literature of the 1970s as the expression of a "female sensibility" tended to overlook the variety of women's experiences. But if conceptualized within the specificity of history, the representation of women's particular contributions and identity constructions in their art opens avenues to rewrite not only the historical role of women artists but the history of art itself.

Creativity as an historicized construct in late-nineteenth-century France was not a stable and static concept that underlay and determined the attitudes and practice of the period, but a shifting and unstable matrix of interactive strategies and knowledges. At issue in this construct were the authority of science and art; the nature of woman; the identity of men; the definition of Truth; the conflict between primitivism and history; the cultural role of the counterdiscursive; and women's acceptance of or resistance to gender difference. This book has attempted to describe both the multiplicity and the ideological boundaries of late-nineteenth-century French notions of the creative while at the same time exploring the sites and the significances of its exclusions.

Notes

INTRODUCTION

1. Édouard Vuillard and Pierre Bonnard were early members of the Nabis, and Henri Toulouse-Lautrec also encountered them. All three exhibited the influence of the Nabis' synthetist style but focused on scenes of modern life rather than Symbolist ideals. The style was quite important for poster art of the 1890s as well.

CHAPTER ONE

1. Friedrich Nietzsche, *The Will to Power,* edited by Walter Kaufmann, and translated by Walter Kaufmann and R. J. Hollingdale (New York: Random House-Vintage, 1968), section 794, p. 419.

2. Symbolism was actually a pan-European movement, especially strong in Belgium and Germany. This book focuses on Paris, with some exceptions.

3. The first part of this chapter is a much revised and expanded version of "Passionate Discontent: The Creative Process and Gender Difference in the French Symbolist Period," *Allen Memorial Art Museum Bulletin* 43, no. 1 (Summer 1988): 21–30. For the Symbolist aesthetic, I have relied particularly on three very influential Symbolist art and literature critics: Albert Aurier, Charles Morice, and Téodor de Wyzewa. See my book, *Aurier's Symbolist Art Criticism and Theory* (Ann Arbor: UMI Research Press, 1986) for a more detailed explication of the creative process and the Symbolist aesthetic, the critics and artists participating in the movement, and Symbolism's intellectual milieu.

4. Enid Starkie, *Baudelaire* (Norfolk, CT: New Directions, 1958), p. 118. Baudelaire was such a powerful influence on both artistic and literary Symbolists that they virtually appropriated his work for their movement.

5. G.-Albert Aurier, "Le Symbolisme en peinture: Paul Gauguin," in *Oeuvres posthumes,* edited by Remy de Gourmont (Paris, 1893), p. 210.

6. Aurier, "Les Peintres symbolistes," in *Oeuvres posthumes,* p. 299.

7. See Paul Sérusier, *ABC de la Peinture* (Paris: Librairie Floury, 1950), pp. 12–13, for statements on the ability of simple folk and savages to grasp the universal language.

8. Aurier, "Gauguin," p. 217; Mathews, *Aurier,* chapter 3, "The Creative Process"; Aurier, "Gauguin," p. 213, and "Les Peintres symbolistes," p. 301.

9. Perhaps the very nature of the goals of much Symbolist art and literature to "go beyond the habitual limits of the human spirit and establish new rapports with the hidden forces of the universe" demanded a form of intense self-nihilism, as Alain Mercier suggested. Their goal, he said, "can be realized not through the romantic exaltation of the 'moi,' but the fusion, the 'death' of the individual in the harmonious *Grand Tout;* the interior initiation" (Alain Mercier, *Les Sources ésotériques et occultes de la poésie symboliste, 1870–1914,* vol. 1, *Le Symbolisme français* [Paris: Nizet, 1969], p. 182). Mercier is referring specifically to Mallarmé, Villiers de l'Isle-Adam, Rimbaud, and Lautréamont.

10. The latter is Aurier's terminology; see "Gauguin," p. 217. Many others speak similarly of the Absolute as a form of vibrating radiation. See Charles Morice, *La Littérature de tout à l'heure* (Paris: Perrin, 1889), p. 295, for example, where he speaks of "the shiver of life that Art eternalizes" and the necessity of the symbol to condense and suggest the intensity of life. Nietzsche, who had limited direct influence on the Symbolists but articulated many of the same views, described such an emotional, revelatory experience in terms very similar to Aurier's and others' concept of ecstasy. (Nietzsche's work was not commonly read in France until the late 1890s, but he was "known and felt as a presence in France long before his work was translated into French." See Karl Frederick, *Modern and Modernism: The Sovereignty of the Artist, 1885–1925* [New York: Atheneum, 1985], p. 66.) In a famous passage from *Ecce Homo,* Nietzsche recounted the onset of inspiration and its physical and emotional repercussions on the subjectivity of the writer. See Gretchen R. Besser, *Balzac's Concept of Genius: The Theme of Superiority in the "Comédie humaine"* (Geneva: Librairie Droz, 1969), p. 264.

11. Aurier, "Gauguin," pp. 217–18.

12. Camille Mauclair, "L'art en silence," in *Esthétique de Stéphane Mallarmé,* p. 87, quoted by A. G. Lehmann, *The Symbolist Aesthetic in France, 1885–1895* (Oxford: Basil Blackwell, 1950), p. 105, n. 2. Mauclair, a second-generation Symbolist, was often on the verge of conservatism but, in a number of texts written in the early 1890s, he echoed the voice of Idealist Symbolist theorists such as Aurier. As the representative of the follower rather than the initiate, Mauclair's appropriated ideas indicate their larger acceptance within the Symbolist milieu.

13. As Maurice Denis put it, "Symbolism is the art of interpreting and evoking the conditions of the soul by means of colors and lines" (cited by Geurt Imanse, "Occult Literature in France," in *The Spiritual in Art: Abstract Painting 1890–1985,* edited by Edward Weisberger; exhibition organized by Maurice Tuchman; exhibition catalog, Los Angeles County Museum of Art [New York: Abbeville Press, 1986], p. 356). The Symbolist reification and heroization of the formal elements were the precursors of early twentieth-century abstraction. For the connection between Symbolists and later Abstractionists, see Mark Cheetham, *The Rhetoric of Purity: Essentialist Theory and the Advent of Abstract Painting* (Cambridge, U.K.: Cambridge University Press, 1991).

14. Some Symbolists respected certain Realists and traditional Idealists for their ability to capture essences. See Mathews, *Aurier,* chapter 5.

15. Inscribed on the back of this work is "Fait en Octobre 1888 sous la direction de Gauguin par P. Sérusier Pont-Aven."

16. Maurice Denis, "L'Influence de Paul Gauguin," in *Du Symbolisme au classicisme: Théories* (Paris: Hermann, 1964; originally published in 1912), p. 50; originally in *L'Occident* (October 1903).

17. Ibid. Upon his return to Paris and the Académie Julian, Sérusier enthusiastically and with due ceremony showed the painting to his friends there: Pierre Bonnard, Édouard Vuillard, Denis, Félix Vallotton, and Paul Ranson. See John Rewald, *Post-Impressionism from Van Gogh to Gauguin,* 3d ed., rev. (New York: Museum of Modern Art, 1978), pp. 252–55. By 1890, all of these artists were part of the group calling themselves the Nabis (Hebrew for "prophet"), along with K.-X. Roussel, Willibord Verkade, Georges Lacombe, René Piot, and József Riple-Ronai.

18. Sérusier, *ABC de la Peinture,* pp. 12, 23. He noted that the artist's faculty to perceive correspondences resides in the memory (p. 23). This statement incorporates the synthetic and abstract basis of the expressive theory of Symbolist art as well, and one sees here how closely intertwined are the formal and intellectual aspects of Synthetist/Symbolist art.

19. See the quite popular work of occultist Eliphas Levi [Alphonse Constant], *Histoire de la magie* (Paris: Germer-Baillière, 1860), and *Fables et symboles avec leur explication où sont révélés les grands secrets de la direction du magnétisme universel et des principes fondamentaux du grand oeuvre* (Paris: Germer-Baillière, 1862). See also Imanse, "Occult Literature in France," pp. 355–60, for the Symbolists', especially Péladan's, interest in the occult. Another important text on the Symbolists' connection to the occult is Filiz Eda Burhan, "Visions and Visionaries: Nineteenth-Century Psychological Theory, the Occult Sciences and the Formation of a Symbolist Aesthetic in France," Ph.D. diss., Princeton University, 1979, esp. chap. 2.

20. The Nabis in particular, including Sérusier, Denis, Ranson, Vuillard, as well as Gauguin, used esoteric symbols in some of their works. See Robert P. Welsh, "Sacred Geometry: French Symbolism and Early Abstraction," in *The Spiritual in Art: Abstract Painting 1890–1985,* pp. 63–78. For a discussion of the deterioration of faith in science more generally, see Kathleen Mary McDougall, "Sexuality and Creativity in the 1890s: Economy of Self in the Social Organism," Ph.D. diss., Dept. of English, University of Toronto, 1995, Introduction and chap. 1. I would like to thank Dr. McDougall for sending me a copy of her dissertation and allowing me to cite it.

21. For artists' specific references to mystic and occult ideas, including those used by Gauguin, Sérusier, and Denis, see Judi Freeman, "Chronologies: Artists and the Spiritual," in *The Spiritual in Art: Abstract Painting 1890-1895,* pp. 393–419.

22. Interview with Mallarmé, Jules Huret, *Enquête sur l'evolution littéraire* (Vanves: Les Éditions Thot, 1982), p. 77. Originally published as part of a series of interviews with contemporary figures in *L'Echo de Paris,* 3 March–5 July, 1891.

23. See, for example, Morice, *La Littérature,* pp. 178–79; Paul Bourde, "Les Poètes décadents," pp. 21–22, and Jean Moréas, "Les Décadents," pp. 28–34, both in *Les Premières Armes du symbolisme,* ed. Léon Vanier, (Paris: Léon Vanier, 1889). Gauguin, in a response to André Fontainas's review of his exhibition in 1899, quoted Mallarmé on his work: 'the essence of a work . . . consists precisely of "that which is not expressed; it flows by implication from the lines without color or words"' (Herschel B. Chipp, *Theories of Modern Art: A Source Book by Artists and Critics* [Berkeley: University of California Press, 1973], p. 75).

24. See Mathews, *Aurier,* pp. 26–28. Denis, 1909, called art "the *subjective deformation* of nature," as had Aurier (Chipp, *Theories,* p. 106).

25. Morice, *La Littérature,* pp. 368, 371.

26. In an interview with Huret, *Enquête sur l'evolution littéraire,* p. 78. Critic Téodor de Wyzewa considered isolation to be a safeguard for artistic creation: "ceux qui survivent encore des maîtres de cet art poursuivent, dans la solitude qui désormais est leur sauvegarde, loin des salons et loin de la foule, leur haut travail de création artistique" ["those masters of this art who still survive pursue their lofty work of artistic creation in the solitude which henceforth is their protection, far from the salons and the crowd"] (Téodor de Wyzewa, *Nos Maîtres: Études et Portraits Littéraires* [Paris: Perrin et Cie, 1895], from an essay written in 1886, p. 24.) De Wyzewa was a great admirer of Wagner, as were a number of Symbolists.

27. G.-Albert Aurier, "Essai sur une nouvelle méthode de critique," in *Oeuvres posthumes,* pp. 187–88.

28. Charles Morice, *Le Christ de Carrière* (Paris: Édition de la Libre Esthétique, 1899), p. 7: "l'oeuvre d'art est un être, organisé, personnel et à jamais vivant."

29. Aurier, "Les Peintres symbolistes," p. 303; "Essai," p. 201.

30. De Wyzewa, *Nos Maîtres,* p. 246, spoke of removing the viewer from the mundane cares of the material world. Because of their social purpose, the Symbolist artists did not espouse "art for art's sake," as did some of their literary colleagues.

31. Camille Mauclair, "Note sur l'Idée Pure," *Mercure de France* 6 (September 1892): 43–44, among many others, made this connection of art to life, although in his case he was arguing for a connection as well between art and "la morale."

32. Philosopher and psychologist Gabriel Séailles, *Essai sur le Génie dans l'art* (Paris: F. Alcan, 1883), pp. 271–72. De Wyzewa also believed that the task of art was to recreate the world "au-dessous de ce monde des apparences habituelles profanées, bâtir le monde saint d'une meilleure vie: meilleure, parce que nous la pouvons créer volontairement, et se voir que nous la créons" ["below this world of profaned everyday appearances, to build the sacred world of a better life: better, because we can create it intentionally and see for ourselves that we create it"] (*Nos Maîtres,* p. 14).

33. Weber on capitalism: "Man is dominated by the making of money, by acquisition as the ultimate purpose of his life. Economic acquisition is no longer subordinated to man as the means for the satisfaction of his material needs. This reversal of what we should call the natural relationship, so irrational from a naive point of view, is evident as definitely a leading principle of capitalism as it is foreign to all peoples not under capitalistic influence" (*The Protestant Ethic and the Spirit of Capitalism* [1904], translated by Talcott Parsons [Los Angeles: Roxbury Publishing Co., 1998], p. 53).

34. Richard Terdiman, *Discourse / Counter-Discourse: The Theory and Practice of Symbolic Resistance in Nineteenth-Century France* (Ithaca, NY: Cornell University Press, 1985), p. 337; Aurier, "Chronique," *Le Moderniste,* no. 19 (31 August 1889): 147; Aurier, "A propos des trois Salons de 1891," *Oeuvres posthumes,* pp. 345–53, and "Deuxième Exposition des peintres impressionnistes et symbolistes," exhibition catalog, Le Barc de Boutteville, Paris (July 1892), reprinted in *Mercure de France* 5 (July 1892): 260. The disdain for commercial dealings has a long history in modern art. See Patricia Mainardi, *Art and Politics of the Second Empire: The Universal Expositions of 1855 and 1867* (New Haven, CT: Yale University Press, 1987), Introduction, chaps. 1 and 2.

Rémy G. Saisselin, *The Bourgeois and the Bibelot* (New Brunswick, NJ: Rutgers University Press, 1984), p. 152, notes how disinterested aesthetics maintain art's distance from the realm of business and money and thus retain an elite status since art is not created for sale. "For by this distinction of action and contemplation, the artistic remains pure, untainted by practical considerations or by the market, separate from the practical world and from business." He further cynically notes that "Intelligence, work, and knowledge were safely left out of this picture of the artist since these were associated with the practical, everyday, workaday world of action, business, purpose."

35. Aurier, "Deuxième Exposition," p. 261. By 1892, the Salon was no longer sponsored by the state. Aurier's use of the term most likely was meant to differentiate the original Salon now in the hands of a society of artists from the many other Salons and exhibitions that had cropped up in the 1880s. See Aurier, "Les Peintres symbolistes," p. 296. Critics of many persuasions wrote disparagingly of the official Salon.

36. Morice, *La Littérature,* p. 291. He continues, "l'autocratie turbulente et bruyante du commerce a supprimé, dans les préoccupations publiques, la préoccupation de la Beauté, et l'industrie a tué ce que le politique laisserait subsister de silence" ["the rowdy and clamorous autocracy of commerce has suppressed the preoccupation with Beauty among the public, and industry has killed whatever politics left remaining of silence"] (pp. 272–73).

37. Morice, *Le Christ de Carrière,* pp. 12–13.

38. Aurier also spoke in similar terms of those true artists who care nothing for material gain. See "A propos des trois Salons de 1891," in *Oeuvres posthumes,* p. 347. Remy de Gourmont, "L'art et le peuple," *Style* (July 1899): 197, noted that all genius is at first ignored or contested by the masses.

39. Camille Mauclair, "Pour l'idéalisme," *Essais d'Art Libre* 1 (July 1892): 257.

40. Besser, *Balzac's Concept of Genius,* p. 19, wrote an entire book on Balzac's concept of genius as it relates to *la douleur*. She cites Balzac's *Oeuvres complètes, Illusions perdues,* XII, p. 70, for this quote. Balzac is one of the links between Romantic concepts of genius as suffering and the Symbolist conception of it. The Symbolists particularly admired Balzac's *Seraphita* and *Louis Lambert*. Aurier praised him. H. de Brisne dedicated a poem to him in Aurier's journal, *Le Moderniste,* no. 5 (4 May 1889): 38.

41. Charles Baudelaire, *Les Fleurs du mal,* translated by Richard Howard (Boston: D. R. Godine, 1982), pp. 12–13.

42. For a discussion of these two portraits and Gauguin's self-portrayal as Christ, see Ziva Amishai-Maisels, *Gauguin's Religious Themes* (New York: Garland Publishing, Inc., 1985), chap. 2.

43. Aurier, "Vincent Van Gogh," in *Oeuvres posthumes,* p. 261. See also Aurier, "Les Peintres symbolistes," p. 305. Plato's cave, a metaphor often invoked during the Symbolist period, epitomized the notion of the "norm" as the inability to see Truth. See Aurier, in Chipp, *Theories,* p. 90; and Schopenhauer, in Cheetham, *Rhetoric,* p. 18. Those who remained inside the cave believed the flickering of the fire on the cave wall to be reality. Those who went out into the sun saw the true reality of Ideas and were aligned with the *poète-voyant* in the literature of the period. The enlightened ones were not only seen as outside the norm but were also considered mad by the majority.

44. Aurier, "Van Gogh," pp. 261–62. See Mathews, "Aurier and Van Gogh: Criticism and Response," *The Art Bulletin* 68, no. 1 (March 1986): 94–104; reprinted in *The*

Spiritual Image in Modern Art, edited by Kathleen J. Regier (Wheaton, IL: Theosophical Publishing House, 1987), pp. 13–39.

45. Morris Berman, *Coming to Our Senses: Body and Spirit in the Hidden History of the West* (New York: Bantam Books, 1990), p. 321, and citing Freud.

46. Alfred de Vigny (1797–1863), in his *Journal,* cited in Besser, *Balzac's Concept of Genius,* p. 215, n. 2, from *Oeuvres complètes,* II, edited by F. Baldensperger, "Bibliothèque de la Pléiade" (Paris: Gallimard, 1948), p. 888.

47. Aurier, "Les Peintres symbolistes," p. 303; Aurier, "Essai," p. 202. This translation is from Chipp, *Theories,* p. 88; see Mathews, *Aurier,* pp. 89–90; Aurier, "Essai," p. 201. He argued that the material "hardly exists" in the artwork also in order to assert the artwork's ability to contain the Immaterial Ideas. Mark Cheetham, *The Rhetoric of Purity,* noted that adherents of Neo-Platonism had to argue that art can contain the Immaterial in light of Plato's condemnation of art as too material.

48. See Julia Kristeva, *Powers of Horror: An Essay on Abjection,* translated by Leon S. Roudiez (New York: Columbia University Press, 1982), on one aspect of the abject as disgust for the bodily waste that allows us to live and yet at the same time shows us (rather than signifies) our mortality. See also Peter Stallybrass and Allon White, *The Politics and Poetics of Transgression* (Ithaca: Cornell University Press, 1986), p. 191.

49. See Mathews, *Aurier,* pp. 33–34, 46–47. Quote in Aurier, "Les Peintres symbolistes," p. 303.

50. The autonomy of art as an entity of its own is directly related to its status as a religion, because it preserves Utopia. See Max Horkheimer, *Critical Theory,* translated by Matthew J. O'Connell (New York: Seabury Press, 1972), p. 275. The composer Richard Wagner had suggested a connection between art and religion early on: "La musique n'est pas un art seulement, mais un art sacré, une Religion" ["Music is not only an art, but a sacred art, a Religion"] (from de Wyzewa's translation of Wagner's *Ecrit sur Beethoven,* in *La Revue Wagnérienne,* 1934, pp. 38–39, cited in Elisabeth Puckett, "The Symbolist Criticism of Painting: France, 1880–1895," n.d., Ph.D. diss. Bryn Mawr, p. 32). Morice, *La Littérature,* pp. 65–68, 366, described the passionate metamorphosis of art into the "religion suprême." Similarly, art critic Jules Laforgue referred to the Ideal, "la Loi," as a "principe mystique universel," and "le dernier divin," of a humanity finally "débarrassée" of its old gods. Médéric Dufour, *Une Philosophie de l'impressionisme. Étude sur l'esthétique de Jules Laforgue* (Paris: Léon Vanier, A. Messein, 1904), p. 23, and Jules Laforgue, *Oeuvres complètes. Mélanges posthumes,* 7th ed. (Paris: Société du Mercure de France, 1919), "Allemagne," p. 199.

51. Cited in Cheetham, *Rhetoric,* p. 32, and Rewald, *Post-Impressionism from Van Gogh to Gauguin,* p. 255.

52. Sâr Joseph Péladan, *La Queste du Graal,* 1892, cited in John Milner, *Symbolists and Decadents* (London and New York: Studio Vista/Dutton, 1971), p. 75.

53. Camille Mauclair, "L'art en silence," in *Esthétique de Stéphane Mallarmé,* p. 87, quoted by Lehmann, *The Symbolist Aesthetic,* p. 105, n. 2.

54. That is, the intelligentsia sensitive to avant-garde art. Most Symbolist writers expressed their elitism quite overtly. Morice, *La Littérature,* pp. 16, 19, distinguished between the superior intelligences and the boors: "Il y a toujours les aristocrates et les manants, ce sont les dilettanti et les autres . . . Ecrivez du moins pour Quelques Uns, pour les rares esprits capables d'élévation: écrivez pour les grandir" ["There are always

aristocrats and peasants, dilettantes and others . . . Write at least for Certain Ones, for the rare spirits capable of elevation: write to exalt them"].

55. Aurier, unpublished letter to his sister Suzanne, 20 April 1886, *Aurier Archives,* family chateau, near Moulins, France. Aurier wrote that he had just finished a volume of decadent poetry that called for revolutionizing the literary world and stupefying the bourgeoisie.

Symbolists tended to use "public," "masses," and "bourgeoisie" interchangeably as an opposition to their own "superior" audience. Aurier develops a whole hierarchy of audiences, equivalent to his hierarchy of artists (see Mathews, *Aurier,* chaps. 3 and 5) with the bourgeois at the bottom (they care only for money), then the peasants and workers who can appreciate art on an unsophisticated level, next amateur art lovers who can grasp the Impressionists and "pointillistes," and finally the "intellectual elite," who are themselves "penseur/poètes" [thinker/poets] and aesthetes, capable of appreciating the highest levels of avant-garde art such as that of Gauguin. Aurier's own agenda in favor of Idealist over Neo-Impressionist art is in evidence here.

See "Chronique," *Le Moderniste,* no. 19, 31 August 1889, p. 147; "Les Peintres symbolistes," p. 296.

56. Raymond Williams, *Culture and Society, 1780–1950* (London: Chatto & Windus, 1958), pp. 32–48, traces the beginning of the notion of antagonism toward the public within the Romantic period and coinciding with the rise of the market, with its emphasis on originality and notions of the artist as genius.

57. Mauclair, "Pour l'idéalisme," 256.

58. Morice, *La Littérature,* pp. 9, 3. See also pp. 4–12.

59. Aurier, "À propos de l'Exposition universelle de 1889," pp. 335–36. Aurier was appalled at the overt nationalism of this exposition and the use of art to support it.

60. As Mauclair indicated: "à ces âmes amoindries par les soucis sociaux, il [poète] dévoile une âme d'homme libre en qui toutes contemplent ce qu'elles pourraient être et prennent conscience d'elles-mêmes" ["to those souls withered by social cares, the poet unveils the soul of a free man in whom all contemplate that which they could be and become conscious of themselves"]. In Mauclair, "Note sur l'Idée Pure," p. 45.

This audience most likely was drawn from the liberal professions (doctors, lawyers) and the salaried professionals (engineers, civil service, teachers). See Patrick H. Hutton, editor-in-chief, *Historical Dictionary of the Third French Republic, 1870–1940* (London: Aldwych, 1986), p. 963.

61. De Wyzewa, "Notes sur l'oeuvre poétique de M. Mallarmé" (1886), in *Nos Maîtres,* pp. 104–5, cited in Paul Delsemme, *Téodor de Wyzewa et le Cosmopolitisme Littéraire en France à l'époque du symbolisme* (Brussels: Presses Universitaires de Bruxelles, 1967), p. 145, n. 3. De Wyzewa is speaking of Mallarmé and poetry here, but Aurier and others said the same of art. Aurier's theory of the aesthetic experience was very similar. See Mathews, *Aurier,* chap. 4.

62. Aurier explicitly used the term lover, with all its erotic overtones, but others also invoked the importance of love in the aesthetic experience. See Mathews, *Aurier,* pp. 89–90, for a discussion of his use of this notion. De Wyzewa, *Nos Maîtres,* p. 246; Sérusier, *ABC de la Peinture,* p. 9; Eugene Véron, *L'Esthétique* (Paris: C. Reinwald et Cie., 1878), p. 464, tells us that the perfection of the Platonic Ideal can be realized through love.

63. Gabriel Séailles, *Essai sur le Génie dans l'art,* 2d ed. (Paris: F. Alcan, 1897), p. 257.

64. Aurier, "À propos de l'Exposition universelle de 1889," p. 342; primitivism has

its roots in the eighteenth century. It has been recently studied in depth: Marianna Tor-govnick, *Gone Primitive: Savage Intellects, Modern Lives* (Chicago: University of Chicago Press, 1990); Sally Price, *Primitive Art in Civilized Places* (Chicago: University of Chicago Press, 1989).

65. "History as science is interfused and interwoven with history as myth." In Ste-phen Bann, *The Clothing of Clio: A Study of the Representation of History in Nineteenth-Century Britain and France* (Cambridge: Cambridge University Press, 1984), p. 177.

66. Michael Allen Gillespie, *Hegel, Heidegger, and the Ground of History* (Chicago: University of Chicago Press, 1984), pp. 12–13. In the early part of the century, this ideal was sought through historical models and revivalism; later through evolutionary models and the Modern.

67. Charles Baudelaire, "L'Art Philosophique," in *Critique d'Art,* vol. 2, edited by Claude Pichois (Paris: Librairie Armand Colin, 1965), p. 385; G.-Albert Aurier, "À propos de l'Exposition universelle de 1889," p. 342; Charles Morice, *La Littérature,* p. 52. "Le sens historique est—fatalement et comme par définition . . .—le signe de la vieillesse d'une race, une marque de décadence."

68. Aurier, "Essai," pp. 180, 195, 196. My emphasis.

69. Friedrich Nietzsche, "On the Uses and Disadvantages of History for Life" (1874), translated by R. J. Hollingdale, in Friedrich Nietzsche, *Untimely Meditations* (Cambridge: Cambridge University Press, 1983), pp. 78, 123. Nietzsche's ideas on history were re-markably similar to those of Symbolists such as Aurier. However, the Symbolist model of "primitive" cultures is not Nietzsche's, although his idealization of ancient Greece has similar overtones of originary purity. He, too, calls for a rejection of tradition in favor of a return to inherent vital impulses that will reinstate meaning to life and culture.

Nietzsche further characterized history as a series of disembodied and meaningless signs that overwhelm any attempt to make sense of them. He described its accumulation of facts as a burden of knowledge: "Historical knowledge streams in unceasingly from inexhaustible wells, the strange and incoherent forces its way forward, memory opens all its gates and yet is not open wide enough . . . In the end, modern man drags around with him a huge quantity of indigestible stones of knowledge" (ibid., p. 78). In this formulation, history as an objective science is ridiculed. So conceived, it cannot teach, but can only confuse and enfeeble humanity with its interminable facts. A simpler, purer, and therefore more profound state of knowledge was desired.

70. See Gillespie, *Hegel, Heidegger, and the Ground of History,* p. 16.

71. Gauguin, speaking in opposition to Impressionism. See J. de Rotonchamp, *Paul Gauguin, 1848–1903* (Paris: G. Crès, 1925), p. 243.

72. As Aurier said, "education has atrophied that faculty in us" ("Les Peintres sym-bolistes," p. 301).

73. Elisa Evett, *The Critical Reception of Japanese Art in Late Nineteenth-Century Europe* (Ann Arbor: UMI Research Press, 1982), p. 58.

74. Charles Baudelaire, "Victor Hugo" (1861), in *Art Romantique,* in a passage ex-cerpted in Guy Michaud, *Message poétique du symbolisme* (Paris: Librairie Nizet, 1947), p. 722.

75. Morice, *La Littérature,* p. 52; paraphrase of Nietzsche, "On the Uses and Disad-vantages of History," p. 106; see also pp. 75, 83 and passim.

76. See Mathews, *Aurier,* pp. 22, 30–33, for the relation of Hegel to the Symbolist aesthetic.

77. Alan Colquhoun, "Three Kinds of Historicism," *Oppositions* 26 (Spring 1984): 33.

78. Brent C. Brolin, *The Failure of Modern Architecture* (New York: Van Nostrand Reinhold Co., 1976), p. 57.

79. Morice, *La Littérature,* pp. 71–80, especially p. 79. He saw both artistic and apolitical evolution as caused by the "law" of the spirit, but evolving separately. On Balzac, see p. 195, n. 1. Morice greatly admired Balzac otherwise. See pp. 167–95.

80. See especially Aurier's introduction to "Les Peintres symbolistes," p. 293; see also Mathews, *Aurier,* pp. 20–23, for his relation to science.

Moréas, *"Les Poètes decadents,"* pp. 31–32. Cyclical theories of art and history existed earlier as well. See Mainardi, *Art and Politics of the Second Empire,* for example, pp. 163–64. Morice also put forth an evolutionary theory of art, with Symbolist synthesis as its culmination (Morice, *La Littérature,* p. 356). He, like Aurier, wholeheartedly condemned science for its empiricist viewpoint. It had simplistically reduced everything to $A = B,$ and most offensively, "supprimé la Grâce de l'Esprit" (p. 7).

De Wyzewa, *Nos Maîtres,* pp. 16–18, 31–34, 59–61. "Et dès le premier jour j'ai détesté la science, moins encore pour la fausseté que pour l'inutilité des soi-disant connaissances dont elle nous encombre l'esprit" (introduction, II). Such knowledge, in his view, denied mystery, imagination, and fantasy (pp. 273–95).

81. Terry Eagleton, *The Ideology of the Aesthetic* (Oxford: Basil Blackwell, 1990), chap. 9, esp. 252–59.

82. See Gauguin, "Notes Synthétiques," in Chipp, *Theories,* pp. 60–64; and his letter to Charles Morice, Tahiti, July 1901, in which he asserted, "Emotion first! understanding later" (ibid., p. 66).

83. Charles Morice in *Paul Gauguin* (Paris: H. Floury, 1919), cited in Richard Brettell, Françoise Cachin, Claire Frèches-Thory, Charles F. Stuckey, *The Art of Paul Gauguin,* catalog (National Gallery of Art, Washington; The Art Institute of Chicago, 1988), p. 173.

84. Ibid., pp. xx, xxi; also p. xxii.

CHAPTER TWO

1. Terry Eagleton, *Ideology of the Aesthetic* (Oxford: Basil Blackwell, 1990), p. 9, referring to the aesthetic more broadly and historically.

2. This refers to the last decades of the century, approximately from 1880 until 1900, during the early Third Republic. The Third Republic dates from 1870 to 1940.

3. Philip G. Nord, *Paris Shopkeepers and the Politics of Resentment* (Princeton, NJ: Princeton University Press, 1986), pp. 4, 143ff. For the economic crisis generally and the conservative reaction to it by the French petit bourgeois, see especially chapter 4, and passim. Patrick H. Hutton, editor-in-chief, *Historical Dictionary of the Third French Republic, 1870–1940* (London: Aldwych, 1986), "Economy," pp. 316ff., described the 1880s and 1890s to 1896 as a period of economic depression, slowdown, and stagnation. For the effect of foreign trade on the French economy, see Hutton, pp. 321ff. Roger Magraw, *France, 1815–1914: The Bourgeois Century* (New York: Oxford University Press, 1986), p. 363, suggested the importance of the economic crisis for social unrest: "Post-1896 economic growth had, clearly, dulled the edge of social protest."

4. Hutton, *Historical Dictionary,* p. 321. The depression was due to a drop in wheat prices between 1872 and 1879 and then again between 1892 and 1896; a decline in output

from 1874 through 1878 and from 1889 until 1883; and a vine epidemic that did great damage to the wine industry. This crisis also "diminished the capacity of the agrarian population to buy industrial products."

5. Magraw, *France, 1815–1914*, p. 226; Hutton, "Aging," pp. 8ff., "Economy," p. 319, "Family," p. 355, "Marriage," pp. 606–7, "Population Trends," pp. 793–96 in *Historical Dictionary*.

6. Eugen Weber, *France, Fin de Siècle* (Cambridge, MA: Belknap Press, 1986), pp. 104–9ff., outlined the constant threat of war, including several very close calls in 1887 and 1898; he also noted the fear of revolution after the Commune.

A number of artists and critics, including some Symbolists, were involved with these movements, especially anarchism. The first French socialist party was founded at the Congress of Marseilles in 1879 (see Hutton, *Historical Dictionary*, p. 206). For a brief history of laborers and collectivism in the Third Republic, see ibid., p. 206. During the 1890s, anarchists were responsible for dynamite explosions in Paris and the assassination of French President Sadi Carnot (ibid., p. 21). See Richard D. Sonn, *Anarchism and Cultural Politics in Fin-de-siècle France* (Lincoln: University of Nebraska Press, 1989).

See Nord, *Paris Shopkeepers*, passim, and Michael Marlais, *Conservative Echoes in Fin-de-Siècle Parisian Art Criticism* (University Park: Pennsylvania State University Press, 1992), passim. Nord described the change in political climate in Paris at the end of the century as follows: "Once a radical republican city, . . . it became a right-wing stronghold, a citadel of the middle classes besieged by left intellectuals and proletarian *banlieusards*" (p. 478).

Gordon Wright, *France in Modern Times: 1760 to the Present* (Chicago: Rand McNally & Co., 1960), pp. 297ff.

7. "Accounts of the Third Republic which mark only its major crises lose sight of the fact that its existence, practically to the First World War, was one long crisis, every lull overshadowed by disbelief that it could last, every relaxation of tension flouted by some new alarm" (Weber, *France, Fin de Siècle*, p. 107).

8. Hutton, *Historical Dictionary*, pp. 960–61. "During the Third Republic the traditional world that was passing and the modern one in the making coexisted. Each had its own social hierarchy within which there was only limited opportunity for upward mobility" (p. 961).

9. The hierarchy of wealth protected the bourgeois from the flattening effect of democracy. Sanford Elwitt, *The Making of the Third Republic: Class and Politics in France, 1868–1884* (Baton Rouge: Louisiana State University Press, 1975), interpreted the *seize mai* crisis (1877)—when the president replaced the republican cabinet with an oligarchy of *haut bourgeois*—and the resolution of the crisis over monopolies and the construction of the railroad in the Freycinet Plan as the triumph of industrial capitalism (see chapter 4, pp. 136ff.).

10. Georg Simmel, "The Metropolis and Mental Life," in Richard Sennett, ed., *Classic Essays on the Culture of Cities* (Englewood Cliffs, NJ: Prentice-Hall, 1969), pp. 58–59. On p. 59, he referred specifically to the impersonal spirit of the metropolis as inculcating this alienation from the self: "Here in buildings and educational institutions, in the wonders and comforts of space-conquering technology, in the formations of community life, and in the visible institutions of the state, is offered such an overwhelming fullness of crystallized and impersonalized spirit that the personality, so to speak, cannot maintain itself under its impact."

11. Ibid., pp. 52–54.

12. "It is likely that this increasing focus on the inner, psychological realm was at least in part due to the rise of scientific psychology at this time, a field which often 'pitted against the confinement of mass man . . . the liberation of psychological man' " (Mark Cheetham, *The Rhetoric of Purity: Essentialist Theory and the Advent of Abstract Painting* [Cambridge, U.K.: Cambridge University Press, 1991], p. 2, quoting Deborah Leah Silverman, "Nature, Nobility, and Neurology: The Ideological Origins of 'Art Nouveau' in France, 1889–1900," Ph.D. diss., Princeton University, 1983, p. 149 [Ann Arbor: UMI]).

13. I defer to Nicholas Green's definition of subjectivity as a historicized concept: "To talk of subjectivity is not to appeal to some general or universal level of formation but to historically distinct modes of identity forged by ideologies and discourses. It is to see *subjectivities* as multiple and heterogeneous in form, in accordance with complex and changing historical conditions. But, at the same time, it is to argue for a certain mode of address, a certain interpellative mechanism that comes into play in the shaping of *personal* as of public identities" (*The Spectacle of Nature: Landscape and Bourgeois Culture in Nineteenth-Century France* [Manchester, U.K.: Manchester University Press, 1990], p. 129).

14. Walter Benjamin, "Paris, Capital of the Nineteenth Century," in his *Reflections: Essays, Aphorisms, Autobiographical Writings,* ed. Peter Demetz (New York: Harcourt Brace Jovanovich, 1978), p. 151. François Caren, in *An Economic History of Modern France* (New York: Columbia University Press, 1979), p. 27, stated that "Industrial growth in France during the nineteenth century and up to 1929 took place in three stages. From the 1830s, growth was steady; it accelerated until the 1860s; then it gradually slackened until the end of the century."

15. *Dialectic of Enlightenment,* translated by John Cumming (New York: Herder and Herder, 1972 [orig. ed. 1944]), pp. 138, 167. Adorno and Horkheimer defined the culture industry as the film, radio, television, and advertising industries which now dominate society. Through "control of the individual consciousness. . . . industry robs the individual of his function" (pp. 121, 124). "The culture industry tends to make itself the embodiment of authoritative pronouncements, and thus the irrefutable prophet of the prevailing order. It skillfully steers a winding course between the cliffs of demonstrable misinformation and manifest truth, faithfully reproducing the phenomenon whose opaqueness blocks any insight and installs the ubiquitous and intact phenomenon as ideal" (p. 147).

16. Art historian T. J. Clark, *The Painting of Modern Life: Paris in the Art of Manet and His Followers* (New York: Alfred A. Knopf, 1985), p. 9, outlines the effect of capital on the structuring of individual experience as "the progressive shift within production towards the provision of consumer goods and services, and the accompanying 'colonization of everyday life.' The word 'colonization' . . . points to a massive *internal* extension of the capitalist market—the invasion and restructuring of whole areas of free time, private life, leisure, and personal expression which had been left . . . relatively uncontrolled."

17. Ibid., chap. 4; Charles Bernheimer, "Degas's Brothels: Voyeurism and Ideology," *Representations* 20 (1987): 158–86.

18. Thomas Crow, with reference to Meyer Schapiro, asserted that the "one remaining domain of relative freedom" for members of the bourgeoisie politically disempowered during the Second Empire was "the spaces of public leisure" (Thomas Crow, "Modernism and Mass Culture in the Visual Arts," in *Modernism and Modernity,* The

Vancouver Conference Papers, edited by Benjamin H. D. Buchloh, Serge Guilbaut, and David Solkin [Halifax: Press of the Nova Scotia College of Art and Design, 1983], p. 230). Not all of the bourgeois class was powerless, of course. Many of those who held power and money through industry or other big business were deeply involved in the political agenda during the Second Empire and beyond. For the resemblance between avant-gardes and subcultures, see Stuart Hall and Tony Jefferson, eds., *Resistance through Rituals: Youth Subcultures in Post-War Britain* (London: Hutchinson, 1976), p. 50.

19. G.-Albert Aurier, "À propos de l'Exposition universelle de 1889," in *Oeuvres posthumes,* edited by Remy de Gourmont (Paris, 1893), p. 342.

20. The dandy and the aesthete really belong to two separate epochs—the former in the Napoleonic era and again with different emphases in the Realist 1860s and 1870s, and the latter in the Symbolist 1880s and 1890s. Some of the literature does not always make such distinctions clear.

21. John Milner, *Symbolists and Decadents* (London and New York: Studio Vista/Dutton, 1971), pp. 70–75. Péladan had first worked with the well-known occultist Stanislas de Guaïta to found the Ordre de la Rose + Croix Kaballistique but went on to found his own group.

22. Max Nordau, *Degeneration,* translated from the 2d edition of the German [no name given] (New York: D. Appleton and Co., 1896), pp. 219–20. Despite his belief that mysticism was a sign of degeneration, Nordau showed a certain respect for Péladan. He referred to him as the "only one of all these master-sorcerers . . . to be taken in good faith" (p. 219) and praised his novels: "He pursues with ardent hatred all that is base and vulgar, every form of egoism, falsehood, and thirst for pleasure; and his characters are thoroughly aristocratic souls, whose thoughts are concerned only with the worthiest, if somewhat exclusively artistic, interests of humanity. It is deeply to be regretted that the overgrowth of morbidly mystic presentations should render his extraordinary gifts completely sterile" (p. 224). Nordau's regard for Péladan is even more surprising when one reads his bitter denunciation of Symbolism in this same text.

23. Such Idealist aesthetes differed from Symbolists such as Aurier or Gauguin primarily in their much greater emphasis on occultism, the extremely exaggerated aestheticism of their lifestyle, their preference in art for content over form, and the intensified role that appearance and accoutrements played in their construction of an identity distinct from the norm.

24. Stephen F. Eisenman, *Gauguin's Skirt* (London: Thames and Hudson, 1997), p. 98.

25. Rosalind Williams, *Dream Worlds: Mass Consumption in Late Nineteenth-Century France* (Berkeley: University of California Press, 1982), pp. 133, 129.

26. "Of all the paradoxes of dandyism [*sic*], none is more striking than the way the loftiest theories of spiritual superiority all depended on the vulgar act of shopping" (ibid., p. 119).

27. Benjamin, "Paris," p. 155.

28. Thorstein Veblen, *The Theory of the Leisure Class* (New York: Dover Publications, 1994), p. 47.

29. Ibid., chapters 5 and 7; pp. 24, 81.

30. George L. Mosse, in *Nationalism and Sexuality: Respectability and Abnormal Sexuality in Modern Europe* (New York: Howard Fertig, 1985), outlined the modern history of respectability. See Pierre Bourdieu, *La Distinction: Critique social du jugement* (Paris: Les

Éditions de Minuit, 1979), for the importance of respectability to social positioning and for the concept of "distinction" as an ordering social force.

31. Hutton, *Historical Dictionary*, pp. 961–62; this group "dominated both finance and heavy industry" and comprised "some two hundred entrepreneurial families that created the dynasties of a bourgeois aristocracy." Elwitt, *The Making of the Third Republic*, p. 305, noted, however, that in the early Republic, "republicans took ideological positions against those big bourgeois and 'aristocrats' whose exercise of political power appeared to thwart entrepreneurial freedom and had produced . . . an explosive 'class antagonism' " (see also chapter 4). Magraw, *France, 1815–1914*, p. 364, noted that "the *grande-bourgeoise* survived the transition to 'democracy' remarkably unscathed."

32. Green, *The Spectacle of Nature*, p. 135, mentions the coexistence of such different strategies at midcentury. See also Hutton, *Historical Dictionary*, p. 963, and Wright, *France in Modern Times*, pp. 358ff.

33. With the expansion of industries, their numbers grew during the 1880s. Women entered the workforce in unprecedented numbers as well. Women worked mainly as domestics, secretaries, and elementary school teachers and were paid far less than their male counterparts (Hutton, *Historical Dictionary*, pp. 963–64).

34. Ibid., pp. 512–14. This ideology and mentality was central to the early Third Republic and, after the Amiens Charter of 1906, was a cornerstone of French labor confederations. However, infighting and strong tensions characterized the relation between labor and socialism in the early Third Republic.

35. Elwitt, *The Making of the Third Republic*, p. 307. Magraw (*France, 1815–1914*, chap. 8, pp. 285ff.) analyzes the republican policy of integration as well. He claimed that the "attitude of workers towards the Third Republic was consistently ambivalent." Government "propaganda emphasized the alliance of the 'people'— . . . against 'parasitic' clergy and aristocrats," but a bourgeois elite actually dominated the capitalist regime "behind a façade of parliamentary democracy and progressive rhetoric."

36. The first department stores in Paris were established in the 1850s and 1860s. Department stores had individual reputations, as they do today. The clientele for La Belle Jardinière, for example, was primarily part of the working class (Nord, *Paris Shopkeepers*, p. 78). During the 1880s, the clientele in general broadened tremendously, and "women who ventured into the department store did so at their peril" (ibid., p. 165; see pp. 161ff. for democratization of the department stores' buying public). For the rise and success of department stores and their social and economic importance, see ibid., chap. 2, pp. 60ff., and Rémy G. Saisselin, *The Bourgeois and the Bibelot* (New Brunswick, NJ: Rutgers University Press, 1984), passim. Magraw (*France, 1815–1914*, p. 262) referred to the great success and influence of department stores: "The twelve largest Parisian department stores employed 1,700 in 1881, 11,000 three decades later." He described (p. 367) the department store as a manifestation of bourgeois power: "As [M.] Miller [*The Bon Marché*, 1981] emphasizes, the store's mixture of managerialism and paternalism, its flaunting of appearances, its celebration of materialism and leisure, its strike-free workforce and its encouragement of petty-bourgeois consumerist fantasy make it a potent symbol of the bourgeois hegemony of the *Belle Epoque*." For the anxiety of wavering class boundaries, see Clark, *The Painting of Modern Life*, pp. 109ff., 258, and 259ff., and Hollis Clayson, *Painted Love: Prostitution in French Art of the Impressionist Era* (New Haven: Yale University Press, 1991). See Richard Terdiman, "The Paradoxes of Distinction:

The Prose Poem a Prose," chap. 6 in *Discourse/Counter-Discourse: The Theory and Practice of Symbolic Resistance in Nineteenth-Century France* (Ithaca: Cornell University Press, 1985), for a discussion of the anxiety about distinguishing oneself from the masses among both the avant-garde and the other bourgeois.

37. Magraw, *France, 1815–1914*, pp. 289–90. These shopgirls were a "far cry from nasty, unwashed proletarians. Their petty-bourgeois aspirations were flattered by well-publicized courses on etiquette and music, . . ." (p. 367).

38. See Clayson, *Painted Love*, chap. 3.

39. As Williams, *Dream Worlds*, p. 12, put it, the French "were witnessing an historical collision as longstanding cultural traditions of enlightened consumption slammed into material and social changes that directly challenged those traditions."

40. Simmel, "The Metropolis and Mental Life," pp. 48, 51. For a discussion of writers such as Mallarmé's and Baudelaire's awareness of the intrusion of capital even into literature, see Terdiman, *Discourse*, pp. 302ff., and chap. 6. Nord, too, contended that "the market and its values penetrated every sphere of life, certainly in nineteenth-century Paris" (*Paris Shopkeepers*, p. 479).

41. Not only the Symbolists but also a number of the Impressionists moved in the direction of greater stability during this period: Monet toward more subjective and abstract work from the 1880s on; Renoir toward classical harmony; Berthe Morisot toward a more synthetic and less transitory style.

42. Terdiman, *Discourse*, p. 322. "What faced the avant-garde as the condition of their crisis was the progressive absorption of the world into the market economy, of all discourse into practical discourse" (pp. 337–38).

43. This impulse in psychoanalytical terms describes a return to the unity of all things existent in the pre-Oedipal period. For this period as the experience of the mother's bodily rhythms continuous with the self, see, for example, Julia Kristeva, "About Chinese Women," in *The Kristeva Reader*, edited by Toril Moi (New York: Columbia University Press, 1986), pp. 148–51.

44. Jochen Schulte-Sasse, in his foreword to Peter Bürger, *Theory of the Avant-Garde*, trans. Michael Shaw, vol. 4, *Theory and History of Literature* (Minneapolis: University of Minnesota Press, 1984), p. xiv.

45. Aestheticism can represent the "distance from the degradation of the social whole," in the words of Terdiman (*Discourse*, p. 283). In a discussion of Mallarmé, he states, "For if 'modernity' is the name for a society increasingly regulated by discursive dominance, paradoxically the counter-discourse emerges as its crucially repressed secret, as the alternative [that] . . . redefines the ground upon which contestation—the conscious foregrounding of otherwise repressed alternatives in the discursive realm—might state its struggle and attempt its subversion. . . . the counter-discursive can be conceived as the present and scandalous trace of a historical potentiality for difference, as the currently realizable sign of a transformed future" (pp. 342–43).

46. Schulte-Sasse, in foreword to Bürger, *Theory of the Avant-Garde*, p. xxxviii. Francis O'Connor described a different model of the avant-garde as a counterdiscourse, one in which the artists emerged as heroic. In a culture such as modern France, which had lost its fundamental "informing myths," the avant-garde artists might be seen as attempting to reinvent meaning. See Francis V. O'Connor, "The Psychodynamics of Modernism: A Postmodern View. Part I. Baudelaire and the Elementalism of Melancholy," *Psychoana-*

lytic Perspectives on Art 2 (1987): 80. According to O'Connor, cultures themselves may show conditions of depression, etc., that is, "not . . . psychopathological conditions, but . . . general configurations of temperament which influence artistic behavior and cultural patterns . . . "(p. 78 and passim).

47. Elwitt, *The Making of the Third Republic,* p. 310; chap. 5, pp. 170ff. After the harsh repression of the Commune, the first governments of the Third Republic (during the 1870s) were reactionary and even included monarchists. The more liberal governments of the 1880s and 1890s proclaimed a program of reform that included universal education, abolishment of class difference and privilege, and the betterment of the entire population. In actuality, they supported capitalist principles and values as well as the entrenchment of the middle class and the integration of the working class into it. (See ibid., pp. 305–7, and Katherine Auspitz, *The Radical Bourgeoisie: The Ligue de l'enseigne-ment and the Origins of the Third Republic, 1866–1885* [Cambridge: Cambridge University Press, 1982].) These policies "ruthlessly excluded any radical social content that challenged the fundamentals of the existing order" (Elwitt, *The Making of the Third Republic,* pp. 305–7). Wright (*France in Modern Times,* p. 305) did not assign such conscious intention to the Republicans, but he did stress the indoctrinating aspects of the new educational program. "[T]here is good reason to believe that [this new public educational system] was a major shaping force over the next half-century" for French "attitudes and behavior" such as "materialism and positivism" and militant patriotism.

48. Aurier suggested in "Vincent Van Gogh," *Oeuvres posthumes,* p. 265, that the "petit peuple" could understand Van Gogh better than the bourgeois because they escape the teachings of the Laity. In "Théâtre Libre: 'Le Canard sauvage' d'Ibsen," *Mercure de France* (June 1891): 364, he claimed that education kept the Latin races from seeing beyond set limits. In "Les Peintres Symbolistes" (April 1892): 301, education is blamed for atrophying in Westerners the ability to grasp Ideas behind appearances.

49. Havard, *Lettre sur l'enseignement des beaux-arts* (Paris, 1879), pp. 8, 23, cited in English translation in Michael R. Orwicz, "Anti-Academicism and State Power in the Early Third Republic," *Art History* 14 (December 1991): 588, n. 33. Orwicz cites a number of officials on the role of art and art education. See also Albert Boime, "The Teaching of Fine Arts and the Avant-Garde in France During the Second Half of the Nineteenth Century," *Arts Magazine* (December 1985): 46–57.

50. Aurier, *Le Moderniste,* no. 1 (April 1889). Aurier, as stated in the discussion of the Symbolist aesthetic, preferred the "uselessness" of art—"the grandeur of unnecessary things"—to what he considered to be a degraded form of utilitarianism ("Chronique," *Le Moderniste,* no. 19 [31 August 1889]: 147).

51. Benjamin, "Paris," p. 155.

52. Hutton, *Historical Dictionary,* pp. 207ff., describes the colonial expansion policies of the Third Republic between the 1870s and the First World War and its relation to the accelerating nationalism of the period. The entry on nationalism discusses its roots in the eighteenth century and its diversion into these two types of nationalism (p. 677).

53. Aurier, "À propos de l'Exposition universelle de 1889," especially pp. 338–43. The League of Patriots was a conservative political organization founded in 1882 which stood for "military strength, patriotic education, and *revanchard* nationalism" (Hutton, *Historical Dictionary,* pp. 536–38). Although by 1889 the state no longer sponsored the "official" Salon, it continued to sponsor exhibitions such as the international exhibi-

tions of 1879, 1889, and 1900. The Symbolists were not alone in their critique of official and academic art. Critics of all persuasions satirized and criticized much of this kind of work.

54. Téodor de Wyzewa, "La Peinture Japonaise" (July 1890), in *Peintres de jadis et d'aujourd'hui* (Paris: Perrin et Cie, 1903), pp. 223–71.

55. Aurier, "Van Gogh," pp. 260–63. Paul Sérusier, *ABC de la Peinture* (Paris: Librairie Floury, 1950), pp. 11–12, compared the importance of nationality and race for the temperament of lesser artists with the genius who strikes out on his own. Nationality and race influence the artist on an inherited level; contemporary society does not. Although relatively benign in the cases presented here, such racial determinism during the period was also directed toward establishing the inferiority of races other than the Caucasian.

56. Wright, *France in Modern Times,* pp. 309, 382–84; Elwitt, *The Making of the Third Republic,* p. 14, and chap. 7, "Social Imperialism," pp. 273ff.; Hutton, *Historical Dictionary,* p. 677.

57. Aurier described Symbolist Georges Darien's novel, in "Biribi," *Mercure de France* (1890): 137–38, as showing "the French army to be at once judge, overseer and executioner of South Algeria." In this review, Aurier suggested that the Army was equivalent to "la Patrie" for many.

58. Paul Gauguin, *Noa Noa: Gauguin's Tahiti,* edited and with an introduction by Nicholas Wadley, translated by Jonathan Griffin (Oxford: Phaidon, 1985), p. 13.

59. Aurier, speaking of the degeneration of academic art, speaks of exiling oneself, "loin, trés loin, à nous réfugier en ces lointains pays d'Orient, fermés aux influences malsaines de l'Europe, en ces pays de lumière et de génie où l'art a conservé l'intégrité de sa pureté originelle, au Japon, en Chine!" ["far, quite far, to take refuge in the distant countries of the Orient, closed to the unhealthy influences of Europe, in those countries of light and of genius where art preserves the integrity of its original purity, in Japan, in China"] (Aurier, "À propos de l'Exposition universelle de 1889," p. 342).

Hutton, *Historical Dictionary,* p. 677, wrote that Prime Minister Jules Ferry often spoke to the "advantages of Empire," while Moroccan High Commissioner Hubert Yautey lauded France's "civilizing mission" abroad.

60. See Eugenia W. Herbert, *The Artist and Social Reform: France and Belgium, 1885–1898* (New York: Books for Libraries, Arno Press, 1980 [1961]), pp. 184ff. I call the "Neo-Impressionists" Symbolists because their aims were similar. Paul Adam, for example, said of them: "To render the major aspect of a visual sensation without allowing the understanding to be misled by the evil influence of the eye . . . ; to learn to serve this vision and fix it—this is the aim of these analytical painters" (1886). Cited by Herbert, in ibid., p. 73. Félix Fénéon, "The Impressionists in 1886," in *Nineteenth-Century Theories of Art,* edited by Joshua C. Taylor (Berkeley: University of California Press, 1987), p. 482, referred to Seurat's "hieratic design" of figures "rigidly standing, like a Puvis in modern dress." Seurat himself, in a letter to Maurice Beaubourg, 28 August 1890 (Taylor, p. 542), speaks of the necessity of synthesis. Fénéon was an early admirer of Gauguin and wrote about him, although later they had a falling out. See Joan Ungersma Halperin, *Félix Fénéon: Aesthete and Anarchist in Fin-de-Siècle Paris* (New Haven, CT: Yale University Press, 1988), pp. 213ff. The critic even favorably compared Gauguin and Seurat (p. 216).

61. He was acquitted. See Halperin, *Félix Fénéon,* chap. 12.

62. Sonn, *Anarchism and Cultural Politics,* pp. 182–83 and passim.

63. Herbert, *The Artist and Social Reform,* pp. 105-6.

64. Herbert's remarks about earlier Romantic artists hold true for Symbolists as well: "the artist saw two possible avenues open to him. He might react to the hostile environment by allying himself with radical social movements aimed at changing the status quo, or he might retreat into the regions of pure art, attempting to ignore the crassness about him" (*The Artist and Social Reform,* p. 46). See also pp. 126ff. for the synthesis of social ideals and art practice among the Symbolists.

65. Pierre Quillard, "L'Anarchie par la littérature," *Entretiens* (April 1892): 150. He continues: "whoever communicates to his brothers in suffering the secret splendor of his dreams acts upon the surrounding society in the manner of a solvent and makes of all those who understand him, often without their realization, outlaws and rebels" (p. 151). Also cited by Herbert in *The Artist and Social Reform,* p. 129.

66. Remy de Gourmont, "Le Symbolisme," *La Revue Blanche,* 6 (June 1892): 322, and cited in Sonn, *Anarchism and Cultural Politics,* p. 218.

67. Max Nordau, in *Degeneration,* pp. 19ff.

68. In "Impressionistes et révolutionnaires," cited in Stephen F. Eisenman, *The Temptation of Saint Redon: Biography, Ideology, and Style in the "Noirs" of Odilon Redon* (Chicago: University of Chicago Press, 1992), p. 168. Sonn, *Anarchism and Cultural Politics,* pp. 148-49, cited a similar statement by Signac. For anarchism and the visual arts during the Symbolist period, see Sonn, *Anarchism and Cultural Politics,* chap. 6.

69. A. Elias, *Plato's Defence of Poetry* (Albany: State University of New York Press, 1984), p. 135, cited in Cheetham, *Rhetoric of Purity,* p. 2. According to Elias, it has been "*the* central theme of Platonism." For more information on this tradition, see Cheetham, passim. Baudelaire's desire to be "anywhere out of this world" is also apt here. Cheetham further notes that "Neoplatonic thinking offered metaphysical *security,* an antidote to and escape from the relativity of the everyday world" (p. 24). Terdiman speaks of a "determined structure of historical arrest" with which many of the period were concerned (*Discourse,* p. 283).

70. See Marlais, *Conservative Echoes,* pp. 13ff. Also see Nord, *Paris Shopkeepers,* p. 8 and passim. The novelist, writer, and important right-wing figure, Maurice Barrés, was elected to parliament as a boulangist in the last decades of the century.

71. See Michael Paul Driskel, *Representing Belief: Religion, Art and Society in Nineteenth-Century France* (University Park: Pennsylvania State Press, 1992), p. 7, speaking of Roman Catholicism; also see Hutton, *Historical Dictionary,* pp. 678-79, on the right-wing nationalism of Barrés.

72. Cited in Patricia Mainardi, *The End of the Salon: Art and the State in the Early Third Republic* (Cambridge: Cambridge University Press, 1993), p. 133.

73. Wright, *France in Modern Times,* p. 294. Wright also stated, however, that antagonists of the republican regime were not always antirationalist as were the Symbolists. See Marlais, *Conservative Echoes,* chap. 1 and passim. He argued that by the late 1890s, Symbolist criticism was generally conservative.

74. See Michael Marlais, "Conservative Style/Conservative Politics: Maurice Denis in Le Vésinet," *Art History* 16 (March 1993): 143. Griselda Pollock, *Avant-Garde Gambits 1888-1893: Gender and the Color of Art History* (New York: Thames and Hudson, 1993), p. 53, characterizes this abandonment in terms of conservative movements. She asserts that the "rash of reactionary cultural formations in the 1890s—symbolism, idealism, Catholic revivalism, primitivism and so forth . . . are indicators of a radical betrayal of

the realist projects of the 1850s to 1860s." The Realists' engagement with modernity was abandoned in favor of a "referent or reference point for art other than that of a *social* modernity," and "the avant-garde defines itself thereafter through its almost religious preoccupations with art's own procedures and process."

75. Green claims that "dealing in contemporary art had emerged by the end of the 1860s as a highly distinctive economic practice with clear-cut business codes and financial protocols. The biggest operators were becoming entrepreneurial capitalists, based internationally and backed by considerable financial resources." Green does not deal with the Symbolists directly, but with certain market values that the Symbolists helped to create. See his discussion of the rise of individualism and its relation to market forces. From the late nineteenth century on, the notion of "progress" in art was also encouraged and facilitated by entrepreneurial capitalism (*The Spectacle of Nature,* pp. 60, 61, 69, 72–73ff.) See also Wagner's statement, cited earlier in chapter 1, in which he mentioned the punishment for those who "dare to traffic in sublime art."

76. See Aurier's review, "Deuxième Exposition des peintres impressionistes et symbolistes," in *Mercure de France* (July 1892): 261, regarding his criteria of the true artist. Also see Green, *The Spectacle of Nature,* pp. 71–72.

77. Green discusses the careful maintenance of distinctions between the market and other cultural sites during the early Third Republic, despite the role of such sites in developing capital. He further suggested that economic positions do not necessarily "prescribe political and cultural attitudes"; the latter may even have an impact on their economic actions. He offers as evidence the case of several art dealers (ibid., pp. 73–74). Thomas Crow proposed another way of looking at the relation of oppositional philosophy to economic necessity: "To accept modernism's oppositional claims, we need not assume that it somehow transcends the culture of commodity; we can see it rather as exploiting to critical purpose contradictions within and between different sectors of that culture" ("Mass Culture," p. 244).

78. Robert Jensen, *Marketing Modernism in Fin-de-Siècle Europe* (Princeton: Princeton University Press, 1994), p. 10, believes such strategies were more conscious. The Symbolists and their critics perceived their privileging of aesthetics as a very radical dimension of their philosophy. See Renato Poggioli, *The Theory of the Avant-Garde,* translated by Gerald Fitzgerald (New York: Harper & Row-Icon Editions, 1971; originally published in 1962).

79. Eagleton, *The Ideology of the Aesthetic,* p. 9. Eagleton sees a potential in the aesthetic for oppositional force as well. Bürger argued that contrary to what these artists believed, aesthetics are incapable of standing outside of culture and history, since aesthetics are not universal but specific to location and historicized moment (Schulte-Sasse, foreword to Bürger, *Theory of the Avant-Garde,* p. xxxvii, and Bürger, *Theory of the Avant-Garde,* passim). Anthony Vidler described such utopian dreams as returning "to earth as the consumable dreams of the middle classes losing in the process any implied critical qualities" ("After Historicism," *Oppositions* 17 [Summer 1979]: 5). Speaking of artistic social critiques, Schulte-Sasse (p. xi) noted that "The mode of reception undermines the critical content of the works." The dialectical resolution to the contradiction of a politically motivated art that is nonetheless dissociated from the material world is the utopian teleology that underlay their aesthetic. To be disinterested meant to have transcended worldly decadence for a greater realm that was the only salvation for future culture. Their politics stood outside and above "realpolitik." The relation of the disinterested

status of the Symbolist aesthetic to its political agenda in their formulation of it is further clarified when one remembers that the Symbolists insisted on remaining free of the social, and that "life" for them meant not the mundane world of events but the higher realm of static truths. See also Remy de Gourmont, *Chemin,* Fragments IV, "Sur le rôle de l'art," 1899, p. 292, for art as a refuge. Theodor Adorno (cited in Schulte-Sasse, p. xviii) takes up a similar position, in which art becomes "the medium of hibernation in bad times" and resists "the conformity to society."

80. For a discussion of the avant-garde's inadvertent complicity with the actions of capital, see Hal Foster, "For a Concept of the Political in Contemporary Art," *Recodings: Art, Spectacle, Cultural Politics* (Port Townsend, WA: Bay Press, 1985), p. 147. Even today, any attempts to remain "avant-garde" are so quickly commodified that it appears that the market is there before the artist, awaiting the next innovation. As Pierre Bourdieu points out, subversive acts such as avant-garde artists engage in "are immediately converted into artistic 'acts,' recorded as such and thus consecrated and celebrated by the makers of taste" ("The Production of Belief: Contribution to an Economy of Symbolic Goods," *Media, Culture and Society* 2, no. 3 [July 1980]: 263, cited by Victor Burgin, "Some Thoughts on Outsiderism and Postmodernism," *Block* 11 [Winter 1986/86]: 21).

81. Although some Symbolist artists did suffer financial stress, many also fit Saisselin's description of them: "On the whole this aesthetic was that of rentiers living off unearned income and having nothing to do but contemplate" (Saisselin, *The Bourgeois and the Bibelot,* p. 152).

82. This is typical of a subculture such as Symbolism—in this case, a subculture within the larger subculture of the bourgeoisie (Hall and Jefferson, *Resistance,* p. 13).

CHAPTER THREE

1. Pauline, Lambert's fiancée, did not believe that Louis was insane but, rather, that he had access to a higher spiritual realm. "Il a réussi à se dégager son être intérieur de son corps, et nous aperçoit sous une autre forme . . ." ["He has succeeded in separating his interior self from his body and perceives us in a different form . . ."] (Honoré Balzac, *Louis Lambert,* edited by Marcel Bouteron and Jean Pommier [Paris: Librairie José Corti, 1954], I, p. 202. See also pp. 202–4).

2. Balzac, *Louis Lambert,* cited in Gretchen R. Besser, *Balzac's Concept of Genius: The Theme of Superiority in the "Comèdie humaine"* (Geneva: Librairie Droz, 1969), pp. 65–66. Besser related this position to the concept of the "mad genius" as well. Her book has been very helpful to this discussion.

3. The narrator of the novel described Lambert's excessive sensitivities: "Déjà ses sensations intuitives avaient cette *acuité* qui doit appartenir aux perceptions intellectuelles des grands poètes, et les faire souvent approcher de la folie" (Balzac, *Louis Lambert,* p. 64). Balzac's *Louis Lambert* and *Séraphita* were widely read and referred to by the Symbolists. See Charles Morice, *La Littérature de tout à l'heure* (Paris: Perrin, 1889), pp. 190–93 for example. Gauguin comes to Swedenborg's writings on correspondences and Neo-Platonism through Balzac's *Louis Lambert* and *Séraphita*. He mentions these novels in his *Cahier pour Aline* immediately after citing Swedenborg. Sérusier, too, often mentioned Balzac's *Séraphita* (Mark Cheetham, *The Rhetoric of Purity: Essentialist Theory and the Advent of Abstract Painting* [Cambridge, U.K.: Cambridge University Press, 1991], pp. 14, 15). Robert P. Welsh noted that both Gauguin and Sérusier read *Louis Lambert* ("Sacred Geometry: French Symbolism and Early Abstraction," in *The Spiritual in Art: Abstract*

Painting 1890–1985, exhibition catalogue, Los Angeles County Museum of Art, edited by Edward Weisberger, exhibition organized by Maurice Tuchman [New York: Abbeville Press, 1986], pp. 67–68). In certain of their works, Balzac, Baudelaire, and Flaubert were heirs to the Romantic tradition and thus appealed to the Symbolists' reworking of that tradition. See Rosalind H. Williams, *Dream Worlds: Mass Consumption in Late Nineteenth-Century France* (Berkeley: University of California Press, 1982) on the connections between Romanticism and the fin de siècle.

4. See chapter 1 of this volume and my article, "Aurier and Van Gogh: Criticism and Response," *The Art Bulletin* 68, no. 1 (March 1986): 94–104. For another example of the failed genius, see Émile Zola, *L'Oeuvre* (Paris: Bibliothèque-Charpentier, 1902).

5. Including psychology. The boundaries between disciplines were not so finely drawn in the nineteenth century as they now are. Researchers in psychology were quite often philosophers. I will refer to psychologist/philosophers as well as doctors as "scientific writers" because of the nature of the work they did.

6. Stephen Jay Gould, *The Mismeasure of Man* (New York: W. W. Norton & Co., 1981), p. 20.

7. Sir Francis Galton, *Hereditary Genius: An Inquiry Into Its Laws and Consequences* (London: Macmillan and Co., Limited, 1914 [1869]), "Prefatory Chapter to the Edition of 1892," p. vii. Galton was influential in France. Henri Joly (*Psychologie des grands hommes,* 2d ed. [Paris: Librairie Hachette et Cie, 1891], pp. 128–29) felt the need to refute Galton's *Le Génie héréditaire.*

8. Th. Ribot, *L'Hérédité psychologique,* 2d ed. (Paris: Librairie Germer-Baillière, 1882), pp. 142, 414. Ribot was director of *La Revue philosophique,* but wrote on psychology as well as philosophy.

9. Cynthia Eagle Russett, *Sexual Science: The Victorian Construction of Womanhood* (Cambridge, MA: Harvard University Press, 1989), pp. 66–68.

10. B. A. Morel first put forth the connection between degeneracy and genius in the 1850s. See Christine Battersby, *Gender and Genius: Towards a Feminist Aesthetics* (Bloomington: Indiana University Press, 1990), p. 117. See also Daniel Pick, *Faces of Degeneration: A European Disorder, c.1848–c.1918* (Cambridge: Cambridge University Press, 1989), pp. 44ff., for Morel, and passim.

11. Max Nordau, *Degeneration,* translated from the 2d edition of the German (New York: D. Appleton and Co., 1896), pp. 16–17.

12. See Battersby, *Gender and Genius,* pp. 117–18, and George Becker, *The Mad Genius Controversy: A Study in the Sociology of Deviance* (Beverly Hills, CA: Sage Publications, 1978), pp. 37–38.

13. See Russett (*Sexual Science,* pp. 67–68) for the widespread influence of these theories. See Barbara Spackman for a discussion of degeneracy as a strategy to marginalize and defeat political antagonists (*Decadent Genealogies: The Rhetoric of Sickness from Baudelaire to D'Annunzio* [Ithaca, NY: Cornell University Press, 1989], pp. 1–32, especially pp. 7–9).

Genius and illness had been connected at least since Romanticism, but their congruence at the end of the century was more closely tethered to biological determinism. For the influence of Romanticism on concepts of mad genius, see Becker, *The Mad Genius Controversy,* pp. 75ff.

14. Gould (*The Mismeasure of Man,* pp. 123–43), noted Lombroso's manipulation of evidence, which caused certain scientists to reject his method. Although he cited statis-

tics, they were often from historical rather than scientific evidence. Dr. Édouard Toulouse was the "Chef de Clinique des Maladies mentales de la Faculté de médecine de Paris, Médecin de l'Asile Sainte-Anne."

15. Lombroso's book was originally written in 1863. According to Robert A. Nye in *Crime, Madness, and Politics in Modern France* (Princeton: Princeton University Press, 1984), pp. 103ff., Lombrosian theory on atavism and criminality was at its height in 1885 and suffered a major setback at a Paris Congress in 1889.

16. Césare Lombroso, *L'Homme de génie* (Paris: F. Alcan, 1889), pp. 2–3, 197. After all, the genius did not possess "ordinary intellectual health." Lombroso says that hyperaesthesia, "an exquisite, and sometimes perverted, sensibility," is a common trait of genius, whereas "the savage and the idiot feel physical pain very feebly; they have few passions" (*The Man of Genius,* translated from Italian [London: Walter Scott, 1898], p. 26). See also Lombroso, as translated by Spackman (*Decadent Genealogies,* p. 31) from the Italian edition of *Man of Genius.*

17. Defined as "the association of audacious and unexpected ideas." Although neurologist Charles Richet claimed that the genius was able to judge his own ideas, Lombroso suggested otherwise. See Richet, in Lombroso, *L'Homme de génie,* Preface, pp. xi–xiii.

18. Lombroso, *Man of Genius,* p. 22.

19. Richet, Preface to Lombroso, *L'Homme de génie,* pp. v–vii. Madness freed the imagination from rational constraint, Lombroso wrote, and so encouraged an originality (like that of genius) a more calculating mind would consider absurd (ibid., p. 290). Like the madman, the genius was immoderate and spontaneous. Patience, according to Richet, in the preface to Lombroso's book (p. ix), produced only honorable and conservative work (modérée), never that of genius.

20. Ibid., p. 29.

21. Lombroso, *Man of Genius,* pp. 6–14.

22. Ibid., pp. viii, vi, and p. 19, where Lombroso is citing Hagen.

23. Ibid., pp. 20, 22, 24. Inspiration is often described by geniuses, he said, as "a sweet and seductive fever, during which their thought has become rapidly and involuntarily fruitful, and has burst forth like the flame of a lighted torch." Spackman similarly concluded that Lombroso's "study of genius is colored by admiration of, and self-identification with, greatness and artistic achievement, no matter how degenerate" (*Decadent Genealogies,* pp. 22–23).

24. Nordau's book on degeneration brings to bear Lombroso's research and method and applies it to art and literature. He gives almost obsequious credit to Lombroso in his preface, in the form of a letter to him, and dedicates the book to him (Nordau, *Degeneration,* pp. vii–ix).

25. See Max Nordau, *Psycho-Physiologie du génie et du talent,* translated by Auguste Dietrich (Paris: Félix Alcan, 1898).

26. Ibid., p. 546. The link Nordau made between modern art and degeneracy was influential in developing the notion of "degenerate art" so important to Hitler (see Sander Gilman, *Difference and Pathology: Stereotypes of Sexuality, Race, and Madness* [Ithaca, NY: Cornell University Press, 1985], p. 236).

27. Nordau noted that "the degenerate and insane are the predestined disciples of Schopenhauer and Hartmann" (Nordau, *Psycho-Physiologie du génie,* p. 20). Lombroso chastised Nordau for this position. "[Nordau's] ostracism struck down the highest peaks,

from Wagner to Ibsen to Tolstoy, while it left intact mediocre creation because they were truly less sick" (*Man of Genius*, p. xii of the Italian; in Spackman's translation, *Decadent Genealogies*, p. 31).

28. Nordau, *Psycho-Physiologie du génie*, pp. 3, 24, viii. He noted that these degenerates in literature, music, and painting are "revered by numerous admirers as creators of a new art, and heralds of the coming centuries" (pp. vii–viii). Nordau condemned other practices central to Symbolism as degenerate, such as the "predilection for inane reverie," the search for universals, *la douleur*, neurasthenia, ecstasy, eccentricity, and particularly mysticism ("a cardinal mark of degeneration"). See pp. 19, 21, 22.

29. Ibid., p. 19. This passage is also reminiscent of Balzac's *Louis Lambert*.

30. Galton, *Hereditary Genius*, "Prefatory Chapter to the Edition of 1892," pp. ix–x.

31. Joly, *Psychologie des grands hommes*, p. 243. "C'est encore l'erreur d'une vieille rhétorique que de considérer l'inspiration comme inséparable d'une effervescence violente des sentiments et d'une sorte de délire" ["It is still an error of an old rhetoric to consider inspiration as inseparable from a violent effervescence of feelings and from a sort of delirium"]. The phrase, "an old rhetoric," seems to refer to the Romantics— Byron—seemingly without cognizance of, or perhaps criticizing as old-fashioned, the Symbolist aesthetic. See also pp. 245–47.

32. Ibid., p. 151, and passim.

33. Édouard Toulouse, *Enquête médico-psychologique sur les rapports de la supériorité intellectuelle avec la névropathie* (Paris: Société d'Éditions Scientifiques, 1896), pp. 73ff., esp. p. 76. Nevropaths are "des individus chez lesquels les réactions émotives sont exagérées et certains troubles d'évolution et actuels, . . . sont manifestes" ["individuals in whom emotional reactions are exaggerated and certain evolutionary and present day troubles . . . are manifest"] (p. 49). He argued that nevropathy and intellectual superiority may be different expressions of the same conditions. He is in agreement with Réveillé-Parise here, he says, but suggests that rather than nevropathy causing genius, it is possible that genius may cause nevropathic troubles (p. 50). Besser (*Balzac's Concept of Genius*, pp. 248–49, n. 3) also notes this attitude.

34. Toulouse, *Enquête médico-psychologique*, p. 52.

35. Ibid., pp. x, 53. Toulouse received help from artists, including Rodin, in writing this book.

36. Moreau's thoughts on this subject especially influenced positivists. Joly (*Psychologie des grands hommes*, p. 94), for example, still argued against Moreau's principles as late as 1891. Toulouse based much of his argument about genius on Moreau de Tours.

37. He claimed that genius was "seulement une *névrose*." J. Moreau de Tours, *La Psychologie morbide dans ses rapports avec la philosophie de l'histoire, ou de l'influence des névropathes sur le dynamisme intellectuel* (Paris: V. Masson, 1859), p. 59, cited in Jackie Pigeaud, "Le Génie et la folie: Étude sur la 'Psychologie morbide . . .' de J. Moreau de Tours," in *Art et Folie*, in *Littérature, Médecine, Société*, no. 6, edited by Jackie Pigeaud (Nantes: Université de Nantes, 1984), p. 12.

38. Pigeaud, "Le Génie," p. 16, citing Moreau: "L'excitation manique prédispose éminemment les facultés de l'esprit à une *association d'idées imprévues, à rapprochement singulier qui frappent l'attention, éveillent fortement les passions*" ["Manic excitation eminently predisposes the faculties of the spirit to an *association of unexpected ideas, to the singular rapprochement which grabs attention, forcibly awakening the passions*"].

"L'état d'inspiration est précisément celui qui offre le plus d'analogie avec la folie réelle. Ici, en effet, *folie et génie* sont presque synonymes à force de se rapprocher et de se confondre" ["The state of inspiration offers quite the best analogy with actual madness. Here, in effect, *madness and genius* are almost synonymous by dint of approximating each other and confounding each other"] (Pigeaud, "Le Génie," p. 14, citing Moreau).

39. Moreau de Tours, *La Psychologie morbide,* p. 447; *"surcrôit d'esprit, de sentiment"* and "avec une fougue chaleureuse," p. 448. *Any* signs of superior intellectual faculties, according to Moreau de Tours, especially if such faculties had attained an exceptionally high energy level, were evidence of the influence of the neuropathic state on thought (p. 463).

40. Becker, *The Mad Genius Controversy,* on Moreau de Tours, pp. 79–80.

41. Nor is he so bound to physiological causes and to heredity. "L'extase" he said, is "un fait morbide, extra-physiologique, dû à la concentration des forces vitales dans l'organ de la pensée, à l'exaltation de la sensibilité. Les causes, soit physiques, soit morales, sont faciles à apprécier: on les retrouve à l'origine de tous les désordres cérébraux." ["Ecstasy is a morbid [in relation to illness] fact, extra-physiological, due to the concentration of vital forces in the organ of thought, to the exaltation of the sensibility. The causes, either physical or moral, are easy to appreciate: one finds them again in the origin of all cerebral disorders.] In Moreau de Tours, *La Psychologie morbide,* p. 236.

42. Loss of control over one's self or one's world was understood as a primitive "regression into this dark past, a degeneracy into the primitive expression of emotions, in the form of either madness or unbridled sexuality. Such a loss of control was, of course, viewed as pathological and thus fell into the domain of the medical model." Gilman, *Difference and Pathology,* p. 99.

43. G.-Albert Aurier, "Henry De Groux," in *Oeuvres posthumes,* edited by Remy de Gourmont (Paris, 1893): "Puisque c'est la tête qui guide la main, qu'y a-t-il d'étonnant à ce que la tête d'un rêveur guide sa main de façon à traduire son rêve, et la force, pour cela, à des combinaisons, à des modifications de lignes et de couleurs, mystérieuses, inconscientes, presque inanalysables . . ." (p. 273). See also G.-Albert Aurier, "Le Symbolisme en peinture: Paul Gauguin," in *Oeuvres posthumes,* p. 213; and Patricia Mathews, *Aurier's Symbolist Art Criticism and Theory* (Ann Arbor: UMI Research Press, 1986), chap. 3, especially p. 64.

44. Spackman, *Decadent Genealogies,* pp. x, 33. She was referring to Decadents rather than Symbolists here, but they both employ metaphors of illness.

45. Plato speaks of a form of "divine madness" to describe the state of ecstatic inspiration available to a select few. See Roy Porter, *A Social History of Madness: The World Through the Eyes of the Insane* (New York: Weidenfeld and Nicolson, 1987), p. 60.

46. Some nineteenth-century occultists used scientific method to support their metaphysics, and such scientific legitimization of one's mystically or spiritually oriented position was common among Symbolists. See Edouard Schuré, *Les Grands initiés* (Paris, 1889; rpt. Paris: Perrin, 1960), p. 34; and Alfred Fouillée, "Le Mouvement idéaliste en France," *Revue des Deux Mondes* 134 (1896): 289, 294.

47. F. Brunetière, a conservative art critic not particularly sympathetic to Symbolism but an Idealist with similar attitudes toward science and art, spoke strongly against the biological determinism and hereditary notions of genius, championing the individuality of the artist instead. In the process, he supported the artist-genius as structuring force in the discourse of the Modern artist beginning with Romanticism and reified in Sym-

bolist theory. Despite his attraction to the science of heredity, he never relinquished his commitment to individualism. See his "Revue Littéraire: Le Génie dans l'art, à l'occasion d'un livre récent," *Revue des Deux Mondes* 62, no. 2 (15 April 1884): 938–42.

48. Published in *Le Décadent* 1, no. 11 (19 June 1886): n.p. "His story . . . describes a hypnotizer, an enthusiast of Mesmer, Cagliostro, and Charcot, who determine that man is not free because hypnotism has the power to control the subject's will. However, when he tries to hypnotize a young girl, she only pretends to fall into a trance. When he turns his back she sticks out her tongue, to the merriment of all her companions" (Mathews, *Aurier,* p. 24).

49. Aurier refuted Taine's sociological theory of art as presented in *Philosophie de l'art* (Paris, 1865), in a lengthy exegesis in "Essai sur une nouvelle méthode de critique," *Oeuvres posthumes,* pp. 176–201.

50. See Michel Foucault, *Madness and Civilization: A History of Insanity in the Age of Reason,* translated by Richard Howard (New York: Vintage Books, 1973), chap. 9, "The Birth of the Clinic," for a history of the institutionalization of madness. Foucault specified a chronological and discursive break in the *scientific* discourse of psychopathology at the beginning of the nineteenth century (see his *The Archaeology of Knowledge and the Discourse on Language,* translated by A. M. Sheridan Smith [New York: Pantheon Books, 1972], p. 40.). Just as with genius, the psychopathological domain became delimited, describable, definable, its lineage traceable through specific ideas to specific forerunners. Medicine, with its own authorized body of knowledge and practice, was the authority that "established madness as an object," but not without the help of law, religion, literature, and art criticism (ibid., pp. 40–42).

51. See Foucault, *Madness and Civilization,* pp. 259–60, relating madness to class fear: "Henceforth, the essential madness, and the really dangerous one, was that which rose from the lower depths of society" (p. 260). Such fears of class, as well as gender and race, certainly fueled the social darwinists, as well as advocates of degeneracy and of physiological determinists such as Lombroso.

52. This was also true of Romantics and Surrealists.

53. See Aurier, "Gauguin," p. 212, for example. Jules Bois, *L'Eve Nouvelle* (Paris: Léon Chailley, 1896), pp. 268–69, described the mad as misunderstood avant-garde visionaries working against society. See also Arthur Schopenhauer, *The World as Will and Representation,* translated by E. F. J. Payne, 2 vols. (New York: Dover, 1969), 1:190–91. Schopenhauer was a very strong influence on the Symbolists, particularly in his doctrine of subjectivity, "the world is my representation." See Mathews, *Aurier,* pp. 31–32, 43–44, and chap. 2 generally.

54. In Slavoj Zizek's use of the term "form"—not formal elements or composition, but the configuration which contains and structures meaning. See *The Sublime Object of Ideology* (London: Verso, 1989), pp. 11ff. Nordau denigrated mystical and spiritual experiences, for example. The concrete social effects of the division of these two states were the marginalization, institutionalization, surveillance, and control of the insane. See Foucault, *Madness and Civilization,* Preface, and passim for further explication.

55. Gilman, *Difference and Pathology,* p. 27, likewise speaks here of interlocking "systems of stereotypical representation" (p. 26).

56. Foucault, *Madness and Civilization,* chap. 9, "The Birth of the Asylum," especially pp. 251ff., speaks of the rise of rational authority versus more overt forms of repression to control the mad.

57. Medical authorities had the power to define and institutionalize the "mad." They placed "deviates" and especially women in asylums. Foucault defined "dividing practices" in terms of the subject as "either divided inside himself or divided from others. This process objectivizes him" (Foucault, "The Subject and Power," *Art After Modernism: Rethinking Representation,* edited by Brian Wallis [New York: The New Museum of Contemporary Art, 1984], p. 417).

58. Gilman, *Difference and Pathology,* pp. 24–25: "the idea of the pathological is a central marker for difference" (p. 23).

59. See Patricia Mainardi, *The End of the Salon: Art and the State in the Early Third Republic* (Cambridge: Cambridge University Press, 1993), Introduction and chap. 1, for the loss of art's power.

60. Aaron Sheon, "Van Gogh's Understanding of Theories of Neurosis, Neurasthenia and Degeneration in the 1880s," *Van Gogh 100,* edited by Joseph D. Masheck (Westport, CT: Greenwood Press, 1996), pp. 183–84, 177. Van Gogh had been told that he had a form of epilepsy by Dr. Rey in 1889 and related it to Lombroso's theories. Van Gogh knew Lombroso's work in French translation (p. 183).

61. According to a talk given by Sheon at the annual meeting of the College Art Association Conference in Seattle, 1993. Griselda Pollock's *Avant-Garde Gambits 1888– 1893: Gender and the Color of Art History* (New York: Thames and Hudson, 1993) also argued that such strategies were self-consciously employed by fin-de-siècle artists to promote themselves. (She focuses particularly on Gauguin.) However, Sheon considers Van Gogh as both caught in and making use of these discourses.

62. Cited in Sheon, "Van Gogh's Understanding," p. 175, from Van Gogh letter L481. Sheon's very informative article described Van Gogh's acceptance of the theories of Lombroso and Moreau de Tours, as well as his references to his own neurosis and his interest in artists and illness.

63. Letter to Aurier, n.d. (ca. February 1890), St. Rémy, Vincent Van Gogh, *The Complete Letters of Vincent Van Gogh,* translated by J. Van Gogh-Bonger, (Greenwich, CT: New York Graphic Society, 1958), vol. III, letter 626a, p. 256. See also Patricia Mathews, "Aurier and Van Gogh," pp. 94–104.

64. There was a tremendous revival of mysticism and the occult at the end of the century. Researches of spiritual subjects such as hypnotism and séances were widely conducted. Aurier even dabbled in alchemy. See Mathews, *Aurier,* pp. 26, 23–39.

65. Another example comes to mind. Lombroso and his followers embraced pathology and suffering as part of the human condition through scientific discourses on heredity and evolution. Yet, just as with mad genius, they disempowered pathology and suffering at the same time by situating them as degenerate and perverse in relation to the healthy norm, identified by science's dividing practices. See Gilman, *Difference and Pathology,* p. 27.

66. As Lombroso said of degenerate genius, according to Nordau, *Degeneration,* p. 24.

67. Foucault, interview with Chomsky, in "Noam Chomsky and Michel Foucault. Human Nature: Justice Versus Power," *Reflexive Water: The Basic Concerns of Mankind,* by A. J. Ayer et al., edited by Fons Elders (London: Souvenir Press, 1974), pp. 168ff.

68. Gould recorded Tolstoy's "frustration with the Lombrosians" because they used science to "avoid the deeper question that called for social transformation." See *The Mismeasure of Man,* pp. 21, 143. He noted, p. 140, that the Lombrosian criminal anthro-

pologists "tended toward liberal, even socialist, politics and saw themselves as scientifically enlightened modernists."

CHAPTER FOUR

1. Friedrich Nietzsche, *The Will to Power,* edited by Walter Kaufmann and translated by Walter Kaufmann and R. J. Hollingdale (New York: Random House, 1968), sec. 817 (Spring–Fall 1887; rev. Spring–Fall 1888), pp. 432–33.

2. For a discussion of representations of woman as a construction of masculinity, see Mary Jacobus, "Is There a Woman in This Text?" in *Reading Woman: Essays in Feminist Criticism* (New York: Columbia University Press, 1986), pp. 83–109.

3. Judith Butler, *Gender Trouble: Feminism and the Subversion of Identity* (London: Routledge, 1990), p. x.

4. For a general discussion of these changes and their effects on masculinity, see Peter N. Stearns, *Be a Man! Males in Modern Society* (New York, London: Holmes & Meier, 1990), 2d ed., chap. 3, "Manhood and the Challenge of Industrialization."

5. For a summary of the debate during the Third Republic, see K. M. Offen, in Patrick H. Hutton, editor-in-chief, *Historical Dictionary of the Third French Republic, 1870–1940* (London: Aldwych, 1986), pp. 1068–79.

6. On radical feminism, see Claire Goldberg Moses, *French Feminism in the Nineteenth Century* (Albany: State University of New York, 1984), pp. 198, 218. After the Third Republic was well established, from 1881 on, restrictions on meetings and freedom of the press were lifted, so that feminist groups survived long enough to develop and their leaders were not repressed or banished. See also Debora Silverman, "The 'New Woman,' Feminism, and the Decorative Arts in Fin-de-siècle France," in *Eroticism and the Body Politic,* edited by Lynn Hunt (Baltimore: The Johns Hopkins University Press, 1991), p. 148; and Anne-Marie Sohn, in the introduction to Auguste Bebel, *La Femme dans le passé, le présent et l'avenir* (Paris: Ressources, Slatkine Reprints, 1979; originally published in 1891), p. III.

7. See K. M. Offen, in Hutton, *Historical Dictionary,* p. 1075; also, "full civil rights to women married . . . and the removal of the other legal inequities . . . were achieved only in 1965" (p. 1076). Women were only allowed full voting rights in April, 1944, by the decree of General Charles de Gaulle rather than by the parliamentary republic (p. 1079). See also Antony Copley, *Sexual Moralities in France, 1780–1980* (London: Routledge, 1989), chap. 5.

8. Michelle Perrot, "The New Eve and the Old Adam: Changes in French Women's Condition at the Turn of the Century," Helen Harden-Chenut, trans., in *Behind the Lines: Gender and the Two World Wars,* edited by Margaret Randolph Higonnet, Jane Jenson, Sonya Michel, Margaret Collins Weitz (New Haven: Yale University Press, 1987), p. 57. The discussion of women's condition is indebted to Perrot's article, pp. 51–60.

9. Debora Leah Silverman, "Nature, Nobility, and Neurology: The Ideological Origins of 'Art Nouveau' in France, 1889–1900," Ph.D. diss., Princeton University (Ann Arbor, MI: University Microfilms International, 1983), p. 124.

10. See Perrot, "The New Eve," especially p. 59; Carroll Smith-Rosenberg, ed., *Disorderly Conduct: Visions of Gender in Victorian America* (New York: Knopf, 1985), pp. 245–96; Debora Silverman, "The 'New Woman,' " p. 150. For an analysis of the role of the bourgeois women in the home in late-nineteenth-century France, see Anne

Martin-Fugier, *La Bourgeoise, Femme au temps de Paul Bourget* (Paris: Bernard Grasset, 1983), passim, especially pp. 154–55. "Ménagère ou courtisane," in Proudhon, *Système des contradictions économiques,* t. II, p. 280, edit. 1867. V, cited in Edmée Charrier, *L'Evolution intellectuelle féminine. Le Développement intellectuel de la femme. La Femme dans les Professions intellectuelles* (Paris: Librairie du Recueil Sirey, 1937), p. 83. Proudhon argues that men represent power, moral faculties, and conscience, while women represent beauty. For Proudhon's attack on feminists and his linkage of freedom for women with prostitution, see P.-J. Proudhon, *La Pornocratie ou les femmes dans les temps modernes* (Paris: A. Lacroix, 1875), p. 2–3, 12. Frederick Engels, for one, disagreed with Proudhon on this in *The Origin of the Family*. He believed that bourgeois marriage was a form of prostitution. See Khalid Kishtainy, *The Prostitute in Progressive Literature* (London, New York: Allison & Busby, 1982), p. 47.

11. Proudhon, *La Pornocratie,* p. 224. V. , cited in Edmée Charrier, *L'Evolution intellectuelle féminine,* p. 83.

12. Silverman, "The 'New Woman,' " p. 149. Perrot, "The New Eve," p. 54, discussed the threat of this decline as well.

13. Clarisse Bader, *La Femme française dans les temps modernes,* 2d ed. (Paris: Perrin, 1885), pp. 470–77.

14. For support of feminism among men, see Susanna Barrows, *Distorting Mirrors: Visions of the Crowd in Late Nineteenth-Century France* (New Haven: Yale University Press, 1981), pp. 51–52. See also Flavia Alaya, "Victorian Science and the 'Genius' of Woman," *Journal of the History of Ideas* 38 (1977): 261–80.

15. Moses, *French Feminism,* pp. 186, 198–99. The paper was established in 1869 and ran for twenty-three years. Their strategy of moderation and compromise focused on morality rather than equal rights; it supported the family structure but did demand equality in marriage. James F. McMillan, *Housewife or Harlot: The Place of Women in French Society, 1870–1940* (New York: St. Martin's Press, 1981), pp. 84–89.

16. Louis Frank was a lawyer and advocate of women's rights, including their freedom to work outside the home and to be better educated. With remarkable insight, he stated that prolonged idleness could lead to nervous disorders, including hysteria (Louis Frank, *L'Education domestique des jeunes filles ou la formation des mères* [Paris: Larousse, 1904], and *Essai sur la condition politique de la femme: Étude de sociologie et de législation* [Paris: Arthur Rousseau, 1892], XIff.). However, he believed that there was no more elevated and noble mission for a woman than to produce male geniuses and heroes and to be enthroned in the "foyer domestique," but he also recognized that not all women could fulfill this "idéal radieux" (*L'Education domestique,* pp. VII–VIII, XII–XIII, and *Essai,* p. 76). He wrote a number of works on women's rights, etc. (see pp. XII–XIII, VII and passim). In 1900, the more radical Jacques Loubert, member of "La Société de Sociologie de Paris," used evolutionary, scientific, and social arguments *for* woman's freedom. He argued that social restrictions kept a woman from developing her capabilities. See Jacques Lourbet, *Le Problème des Sexes* (Paris: V. Giard et E. Brière, 1900), p. 296. The German marxist Auguste Bebel, although an evolutionist who believed in hereditary characteristics, also argued in his book of 1891 (immediately translated into French) that the flaws in a woman's character, as defined by antifeminists such as Lombroso and Proudhon, were socially constructed rather than biologically inherent. Such radical writers with visions of social justice and equality were in the minority at the time, although their oppositional voices were an important source of support for feminists and others

resistant to dominant forces. See Auguste Bebel, *La Femme dans le passé*, pp. V, VI, X–XI, and passim.

17. "La Femme moderne par elle-même," *Revue Encyclopédique*, no. 169 (1896): 841–95.

18. "les qualités intellectuelles" were directly linked to brain size according to the doctor and many others as well. See Marya Chéliga, "Les Femmes et les Féministes: Les Hommes Féministes," *Revue Encyclopédique*, no. 169 (1896): 825–31.

19. See Chéliga, "Les Femmes," pp. 825–31. Writer Armand Sylvestre expressed his fantasy when he called woman "qu'un objet de mystérieuse et profonde admiration," and "Elle est, par essence, faite pour traiter l'homme en esclave, et c'est par condescendance qu'elle le traite quelquefois en ami. . . . La femme est, par nature, susceptible d'héroïsme" ["only an object for mysterious and profound admiration . . . She is, essentially, meant to treat man as a slave and only condescends to treat him as a friend. . . . Woman is by nature capable [susceptible] of heroism"].

20. Jules Bois, "La Femme nouvelle," *Revue Encyclopédique*, no. 169 (1896): 832–33.

21. Gustave Geffroy, in "Le Travail des femmes. Opinions sur les aptitudes, l'éducation et les occupations féminines," *Revue Encyclopédique*, no. 169 (1896): 909.

22. Opposing discourses of the nineteenth century, whether Left, Right, or Center, artist or scientist, most typically met on common ground over the "woman question." See Martin-Fugier, *La Bourgeoise*, pp. 8–9.

23. An extreme example of the desire to know "woman" was the dissection of the female body as a form of unveiling, of discovering the mystery and otherness of women. Much was written and imaged on this common practice in the nineteenth century. See Ludmilla Jordanova, *Sexual Visions: Images of Gender in Science and Medicine between the Eighteenth and Twentieth Centuries* (Madison: University of Wisconsin Press, 1989), chap. 5.

24. The role of the state is particularly clear with its laws and regulations concerning prostitution as based in biologically determinist notions of the nature of women. For women's entry into the École, see Tamar Garb, *Sisters of the Brush: Women's Artistic Culture in Late Nineteenth-Century Paris* (New Haven: Yale University Press, 1994).

25. The literature on this subject is vast. Some texts that have been useful for this study include Anne Fausto-Sterling, *Myths of Gender: Biological Theories About Women and Men* (New York: Basic Books, Inc., 1985); Donna Haraway, *Primate Visions: Gender, Race, and Nature in the World of Modern Science* (New York: Routledge, 1989) and *Simians, Cyborgs, and Women: The Reinvention of Nature* (London: Free Association Books, 1991); Nina Auerbach, *Woman and the Demon: The Life of a Victorian Myth* (Cambridge, MA: Harvard University Press, 1982); Cynthia Eagle Russett, *Sexual Science: The Victorian Construction of Womanhood* (Cambridge, MA: Harvard University Press, 1989); Ludmilla Jordanova, *Sexual Visions;* McMillan, *Housewife or Harlot;* Sander L. Gilman, *Difference and Pathology: Stereotypes of Sexuality, Race, and Madness* (Ithaca, NY: Cornell University Press, 1985); David Rubinstein, *Before the Suffragettes: Women's Emancipation in the 1890s* (New York: St. Martin's Press, 1986); Cynthia Fuchs Epstein, *Deceptive Distinctions: Sex, Gender, and the Social Order* (New Haven; New York: Yale University Press; Russell Sage Foundation, 1988); Elaine Showalter, *Sexual Anarchy: Gender and Culture at the Fin de Siècle* (New York: Viking, 1990) and *The Female Malady: Women, Madness, and English Culture, 1830–1980* (New York: Penguin Books, 1987).

26. Christine Battersby, *Gender and Genius: Towards a Feminist Aesthetics* (Bloomington: Indiana University Press, 1990).

27. Philosopher Alfred Fouillée, who wrote on psychology, among other things, says as much: "La femme eût-elle la puissance d'effort cérébral nécessaire à ces conquêtes, il y a une retenue, une modestie, une timidité naturelle qui l'arrêtent: elle sent que ce n'est pas son rôle" ["Had woman the power of cerebral effort necessary for these conquests, a certain natural discretion, modesty, timidity stops her: she feels that this is not her role"]. Cited in Jacques Loubert, *Le Problème des Sexes,* p. 98, from *Tempérament et caractère selon les individus, les sexes et les races,* edited by Félix Alcan (pp. 241–42 of 1901 edition, Paris: Germer-Baillière).

George Moore, a nineteenth-century writer and sometime art critic who spent a great deal of time in Paris, cites women's superficiality in "Sex in Art," *Modern Painting* (London: Walter Scott, Ltd., 1898), p. 226.

G. Devillier, in "Le Travail des femmes: Opinions sur les aptitudes, l'éducation et les occupations féminines," *Revue Encyclopédique,* no. 169 (1896): 909, defined female creativity:

Sans dépenses excessives elle saura s'habiller avec goût, s'arranger un intérieur aimable exactement approprié à sa destination et créer pour l'orner mille et un objets délicats et charmants.

Et c'est ainsi que du rôle de simple copiste elle s'élèvera à la dignité de *créatrice* capable de réaliser pour son plaisir et pour le nôtre de véritables oeuvres d'art.

[Without excessive expense [woman] will know how to dress tastefully, arrange a pleasant interior exactly appropriate to her intention and create a thousand and one delicate and charming objects to ornament it.

And it is thus that the role of simple copyist will elevate her to the dignity of female *creator,* capable of realizing true works of art for her pleasure and for ours.]

28. Saisselin saw these "attributes" as linked to a burgeoning consumerism: "Woman became the rival of the work of art. She turned into a bibelot herself, surrounded by bibelots, an expensive object of desire, to be possessed and cherished, but also exhibited. . . . But in the capitalist sublunar world, woman was also a consumer and as such she represented an extraordinary market" (Rémy G. Saisselin, *The Bourgeois and the Bibelot* [New Brunswick, NJ: Rutgers University Press, 1984], p. 55; 62).

29. Césare Lombroso, *The Man of Genius,* translated from Italian (London: Walter Scott, 1898), pp. 138–39. Lombroso's attitude was made more significant in that women's professions—such as teaching and nursing—at the turn of the century were received through stereotypes such as mother and devoted and sacrificing woman, so that women's work, too, was seen as inferior. See Perrot, "The New Eve," p. 57.

30. Fausto-Sterling, *Myths of Gender,* pp. 17, 18, deals at length with the way in which scientific evidence, despite other proof to the contrary, was used to defend, or was biased by, social policy.

A "political regime of the body" as Michael Feher refers to it, functioned to maintain hierarchy among races, classes, and genders through more and more rigid forms of differentiation that were theorized and developed in every discipline. See his "Of Bodies and Technologies," *Discussions in Contemporary Culture* no. 1, edited by Hal Foster (Seattle: Bay Press, 1987), p. 160; see also Allan Sekula, "The Body and the Archive," *October* 39, (1986): 3–64.

31. Flavia Alaya argued this point cogently in "Victorian Science and the 'Genius' of Woman," pp. 261–80.

32. Charles Darwin, *The Descent of Man* (1871; rpt., Princeton: Princeton University Press, 1981), pp. 326–27. Cited in Showalter, *Female Malady,* p. 122. Alaya, "Victorian Science and the 'Genius' of Woman," p. 265, demonstrated how little evidence Darwin offered for his thesis.

33. Henri Joly, *Psychologie des grands hommes,* 2d ed. (Paris: Librairie Hachette et Cie, 1891), pp. 68–69. He seemed to be promoting a form of potent masculinity here as well, of "robust and virile qualities."

34. Lombroso, *Man of Genius,* p. 138.

35. Otto Weininger, *Sex and Character,* translated from German (London: William Heinemann, [1903] 1975), pp. 189, 265ff., and passim. See Gilman, *Difference and Pathology,* p. 55, for Weininger's influence.

36. "He considers women as being close to nature, far closer than the simplest man could ever be, and considers sensuality as their chief distinguishing characteristic. Echoing Schopenhauer, this means that woman is incapable of abstract thought and necessarily precluded from direct participation in any spiritual life." Gudrun Schubert, "Women and Symbolism: Imagery and Theory," *The Oxford Art Journal* 3, no. 1 (April 1980): 32.

37. *Paul Gauguin's Intimate Journals,* translated from *Avant et après,* by Van Wyck Brooks (New York: Liveright, 1949), p. 18.

38. Cited in Thomas Craven, *Famous Artists and Their Models* (New York: Pocket Books, 1949), pp. 104, 106.

39. The "phallus," as "signifier" for Lacan, represents more than the penis; it refers rather to the "assertion of male privilege." Women's relation to the phallus is "described essentially in terms of masquerade." See Juliet Mitchell and Jacqueline Rose, eds., *Feminine Sexuality: Jacques Lacan and the École freudienne,* translated by Jacqueline Rose (New York, London: W. W. Norton & Co., and Pantheon Books, 1985), Introduction II, Rose, pp. 40, 43; and, in the same volume, Jacques Lacan, "The Meaning of the Phallus," pp. 74–85.

40. Eve Kosofsky Sedgwick, "The Beast in the Closet: James and the Writing of Homosexual Panic," in *Sex, Politics, and Science in the Nineteenth-Century Novel,* edited by Ruth Bernard Yeazell (Baltimore: The Johns Hopkins University Press, 1986), p. 152. Male homosocial bonding was a strategy to create an illusion of stability in the face of the always unstable categories of maleness and authority (p. 150). "The emerging pattern of male friendship, mentorship, entitlement, rivalry, and hetero- and homosexuality was in an intimate and shifting relation to class; and . . . no element of that pattern can be understood outside of its relation to women and the gender system as a whole" (Eve Kosofsky Sedgwick, *Between Men: English Literature and Male Homosocial Desire* [New York: Columbia University Press, 1985], p. 1). See this book, especially the Introduction, for a more extensive analysis of the homosocial. Although the "homoscial" may refer to social bonds of either sex, it will be used here (and most often is elsewhere) to refer to males.

41. Jules Michelet, *Woman (La Femme),* translated by J. W. Palmer (New York: Rudd & Carleton, 1860). According to K. M. Offen, in Hutton, *Historical Dictionary,* p. 1070, Michelet as well as Auguste Comte "greatly influenced the founders of the Third Republic" with their "biologically based reformulation of old arguments for women's subordination in the patriarchal family." Michelet consistently portrayed woman in rela-

tion to the masculine. He pitted a derelict masculinity—"The man no longer wishes to marry, no longer wishes to protect the woman. He lives greedily alone" (Michelet, *Woman,* p. 24)—against a helpless femininity—"Everything is difficult for the solitary woman, everything a barrier or a precipice. . . . The worst destiny for woman is to live alone" (pp. 31–32). In addition, Michelet distinguished between a man with a "genuine masculine character" and a "woman's man." The latter was defined as one whom women could govern (p. 149). Women needed, we are told, a real man who would provide "a strong arm, to uphold her, and smoothe her way of life." He would have a rich and loving heart, an "active faith," and power—that is, he would be "full, strong, productive, a creator and a generator," with "an imperial spirit and noble will" (pp. 149–52). Man, "fanatic of toil and intoxicated with enthusiasm and struggle," was intended by nature to be proud (p. 207).

42. Alfred Fouillée, *Tempérament et caractère,* chap. 3, especially pp. 202–15. Fouillée allowed for a mingling of these traits across genders, and opposed those social darwinists who claimed that women had no "douleur" or other talents. However, he did maintain that a woman's finer sensibilities were interior and suited to her role as mother and wife rather than culturally productive. His position that women were not inferior was typical of most moderate positions in which women were given some due but still characterized as domestically bound. See also Michael Marlais, *Conservative Echoes in Fin-de-Siècle Parisian Art Criticism* (University Park, PA: Pennsylvania State University Press, 1992), p. 11. Fouillée rejected symbolism, mysticism, and positivism and embraced science, as Marlais noted, but he, like the philosophers of degeneracy, also had much in common with the Symbolists.

43. Jessica R. Feldman, *Gender on the Divide: The Dandy in Modernist Literature* (Ithaca: Cornell University Press, 1993), p. 11.

44. See Jennifer Shaw, "The Figure of Venus: Rhetoric of the Ideal and the Salon of 1863," *Art History* 14, no. 4 (December 1991): 562, for the impact of effeminacy in the nineteenth century.

45. "A-t-elle même un sexe? Oui, mais qu'on devine stérile et seulement propre à nos puériles amusailles" (G.-Albert Aurier, "Renoir," in *Oeuvres posthumes,* edited by Remy de Gourmont [Paris, 1893], pp. 228–29.

46. Jacques Loubert, *Le Problème des sexes,* discussed a range of such positions. The connection between madness and genius did not always exclude women, but it was never posited in any consistent manner. Lombroso, for example, cites several women in his discussion of examples of temporary genius among the mad during bouts of madness and excitation (*Man of Genius,* pp. 161ff.).

47. Michel Foucault, *The History of Sexuality, Volume I: An Introduction,* translated by Robert Hurley, (New York: Vintage Books, 1980 [1976]), p. 104, spoke of the "hysterization of women's bodies": "whereby the feminine body was analyzed—qualified and disqualified—as being thoroughly saturated with sexuality; whereby it was integrated into the sphere of medical practices, by reason of a pathology intrinsic to it . . ." Medicine had to provide two views of women: working class and middle (or upper) class: "It was as if there were two different human species of females. Affluent women were seen as inherently sick, too weak and delicate for anything but the mildest pastimes, while working-class women were believed to be inherently healthy and robust. The reality was very different. Working-class women, who put in long hours of work and received inadequate rest and nutrition, suffered far more than wealthy women from contagious

diseases and complications of childbirth" (Barbara Ehrenreich and Deirdre English, *Complaints and Disorders: The Sexual Politics of Sickness* [Old Westbury, NY: Feminist Press, 1973], p. 12).

48. Although male cases did exist, hysteria was generally considered a female malady. The term is derived from the Greek word for womb, *hysteron*. The definitions and parameters of hysteria and its rate of occurrence shifted over different time periods and even within the same time frame. See Ilza Veith, *Hysteria: The History of a Disease* (Chicago: University of Chicago Press, 1965). According to Showalter (*Female Malady*, p. 129), "[C]ases of classic hysteria peaked in frequency" from c. 1870 to WWI, whereas by the twentieth century, "the clinical incidence of the dramatic episodes had greatly declined." Showalter also notes that hysteria "stood for all extremes of emotionality" at the end of the century. The characteristics of hysteria as described by doctors in the early nineteenth century are outlined by Showalter (p. 130). See also Barbara Ehrenreich and Deirdre English, *For Her Own Good: 150 Years of the Experts' Advice to Women* (Garden City, NY: Anchor Books, 1979), p. 137; and Veith, *Hysteria*, pp. 211–19, for often contradictory attributes of hysterics according to different doctors.

49. Harriet E. Lerner, "The Hysterical Personality: A Woman's Disease," *Women and Mental Health*, edited by Elizabeth Howell and Marjorie Bayes (New York: Basic Books, Inc., 1981), citing psychologists Chodoff and Lyons (1958), p. 197. This article suggested the importance of social and cultural factors in the development of hysteria.

50. Prior to the rise in cases of female hysteria in the late nineteenth century, the disease had been in decline. Its revived status as a legitimate disease in medical circles is due largely to the efforts of Charcot. According to Gerard Wajeman, *Le Maître et l'hystérique* (Paris: Navarin, 1982), p. 174, cases of hysteria multiplied when Charcot was interested in it and declined rapidly afterwards. Charcot also demonstrated that hysteria occurs in men, but it remained for him "symbolically, if not medically, a female malady" (Showalter, *Female Malady*, p. 148). His conception was extremely influential. Freud's early work on hysteria was based on Charcot, for example. Charcot seemed to have overlooked a great number of obvious factors in his "objective" categorization of the phases of hysteria. "Contrary to all previous observers, Charcot described the attacks as being quite uniform in all his patients" (Veith, *Hysteria*, p. 233). A flood of materials concerning hysteria and Charcot have appeared in the last decade. These studies overwhelmingly suggest that Charcot constructed the period's particular manifestation of the disease himself. Wajeman, *Le Maître et l'hystérique*, p. 152, noted the importance of the doctor as master in the description of hysteria. Georges Didi-Huberman, *Invention de l'Hystérie, Charcot et l'Iconographie photographique de la Salpêtrière* (Paris: Macula, 1982), pp. 4–5, 16, 76, and passim, stated outright that hysteria was invented, that is, constructed, at the Salpêtrière by Charcot and described the entire staging and photographing of hysteria as a spectacle, a fabrication of images. He further suggested, p. 82, that the construction of hysteria in Charcot's clinic, especially as it was manifested in photography, inscribed feminine traits, sexuality, and implications of prostitution into its structure. Alain Corbin, *Les Filles de noce: Misère sexuelle et prostitution aux 19e et 20e siècles* (Paris: Aubier Montaigne, 1978), p. 440, noted that there were various opinions, but a thriving literature, especially toward the end of the century, claimed a relation between prostitution and hysteria. Charcot did not directly link hysteria and female sexuality, yet he interpreted "hysterical gestures as sexual," called one of its stages "eroticism" and

another "amorous supplication," and concluded that the ovarian region was an "hystero-genic zone" (Showalter, *Female Malady,* p. 150).

51. Ehrenreich and English, *For Her Own Good,* pp. 4–5.

52. See, for example, Gilbert Ballet, *Rapports de l'hystérie et de la folie* (Clermont-Ferrand: G. Mont-Louis, 1894), pp. 18–30. Jan Goldstein, *Console and Classify: The French Psychiatric Profession in the Nineteenth Century* (Cambridge: Cambridge University Press, 1987), p. 370, noted that the Charcot school related the stage of the "attitude passionnelle," in which the patient might remain "motionless and absorbed in silent contemplation" for hours or even days, with accompanying visual hallucinations and visions, to "the religious ecstasy of the mystics." Hysterical women were also character-ized as *névroses* (Dr. Albert Deschamps, *La Femme nerveuse: Essai de psychologie et de psycho-graphie* [Clermont-Ferrand: G. Mont-Louis, 1892], p. 3). In addition, women were widely considered to be prone to a "hyperaesthesia of the senses," and hysteria was seen as the means of giving vent to it (Bram Dijkstra, *Idols of Perversity: Fantasies of Feminine Evil in Fin-de-Siècle Culture* [New York: Oxford University Press, 1986], p. 243).

53. Aurier, "Vincent Van Gogh," in *Oeuvres posthumes,* p. 265.

54. Sigmund Freud, *The Standard Edition of the Complete Psychological Works of Sigmund Freud,* translated and edited by James Strachey (London: Hogarth Press and The Insitute of Psycho-Analysis, 1953-74), from *Totem and Taboo,* vol. 13, p. 863. Freud's quote was pointed out to me by Richard Spear. Didi-Huberman notes the connection between *la douleur* and hysteria throughout the book. Charcot refers to "une douleur complexe et spécifique à l'hystérie" (Didi-Huberman, *Invention de l'Hystérie,* p. 99). Even when women were seen to be ecstatically creative, this was considered to be related to the inherently unstable nature of their "nervous organization" and to hysteria. For example, women were thought by many to have "an uncontrollable urge to dance" wildly, and this urge was "the outcome of a nervous organization affording a suitable soil for hysteria" (Harry Campbell, *Differences in the Nervous Organization of Man and Woman,* p. 169, cited by Dijkstra, *Idols of Perversity*). Repression is an essential mechanism in Freud's concept of creativity. Ellen Handler Spitz, "A Critique of Pathography: Freud's Original Psycho-analytic Approach to Art," *Psychoanalytic Perspectives on Art,* edited by Mary Mathews Gedo, vol. 1, 1985, p. 10, noted that "the conception of the artist implicit in Freud's term [pathography] grows solidly out of the Romantic tradition in which artistic creativity is variously associated with moments of intense emotion, altered states of consciousness, and pain." Steven Z. Levine, "Monet, Fantasy, and Freud," *Psychoanalytic Perspectives on Art,* edited by Mary Mathews Gedo, vol. 1, 1985, p. 43, noted that Freud correlates neurosis and artists despite himself: "In spite of frequent disclaimers that the artist is not a neurotic, Freud's correlation of art and neurosis is nevertheless very close . . ."

55. Showalter, *Female Malady,* pp. 131–32, considered that reasons for hysteria's real manifestations lay in "women's intellectual frustration, lack of mobility," lack of "auton-omy and control," and that they were "unsatisfied and thwarted in other aspects of their lives." The ideological denial of their sexuality and social prohibition against it created "un malaise" among "des femme honnêtes," according to Anne Martin-Fugier, which could have resulted in hysteric manifestations (Martin-Fugier, *La Bourgeoise,* p. 15). Some doctors also connected it to sexual frustration due to the repression of sexual feelings placed on women at puberty (Showalter, *Female Malady,* pp. 130–32). Others, however, related it to sexual excess (Alex Owen, *The Darkened Room: Women, Power and Spiritualism in Late Victorian England* [Philadelphia: University of Pennsylvania Press, 1990], p. 148).

Georges Guinon, *Les Agents Provocateurs de l'hystérie* (Paris: Delahaye et Lecrosnier, 1889), pp. 371–72, who worked with Charcot, cited a number of reasons for hysteria's occurrence, but ultimately said it was the result of heredity.

56. Slavoj Zizek, *The Sublime Object of Ideology* (London: Verso, 1989), pp. 111–12, related this "split between demand and desire" to Lacanian notions of the "logic of the hysterical." "[I]n the last resort, what is hysteria if not precisely the effect and testimony of a failed interpellation; what is the hysterical question if not an articulation of the incapacity of the subject to fulfill the symbolic identification, to assume fully and without restraint the symbolic mandate? Lacan formulates the hysterical question as a certain 'Why am I what you're telling me that I am?' " (p. 113).

57. Showalter, *Female Malady*, p. 145. The use of hysteria to put feminists in their biological place can be seen in attitudes toward the radical activist feminist Hubertine Auclert who, "in the eyes of the police, was written off as 'suffering from madness or hysterics which made her think of men as equals' " (James F. McMillan, *Housewife or Harlot*, p. 82).

58. Goldstein noted that Charcot's "hysteria concept was a powerful interpretive device" that "served as an instrument in the politics of gender" (Goldstein, *Console and Classify*, p. 375, and citing C. R. [Mme C. Renooz], "Charcot dévoilé," *Revue scientifique des femmes* 1 [1888], esp. p. 245).

59. Some of this material is indebted to my article, "The Gender of Creativity in the French Symbolist Period," in *Women and Reason,* edited by Elizabeth D. Harvey and Kathleen Okruhlik (Ann Arbor: University of Michigan Press, 1992), pp. 163–85.

60. Rodin met the young Claudel in 1883 when he came to teach at the Académie Colorassi where she was studying sculpture. She entered his studio in 1885 as his model and assistant, and an ardent eight-year affair began. Claudel broke with Rodin in 1893, seemingly because he would not marry her but instead chose to remain faithful to the much older Rose Beuret. However, she continued to see him until 1898 when the final break came. According to Jacques Cassar, *Dossier Camille Claudel* (Paris: Librairie Séguier, 1987), pp. 167–74, the break resulted from Rodin's "theft" of Claudel's marble work, *Clotho,* 1899.

61. Reine-Marie Paris, granddaughter of Claudel's brother Paul, who has access to unpublished material and correspondence between Paul and Camille Claudel, said in *Camille Claudel, 1864–1943* (Paris: Éditions Gallimard, 1984), p. 25, that her illness was still an unexplored mystery. Letters to her father and Rodin are lost. Medical records were published and discussed in this volume by François Lhermitte and Jean-François Allilaire, "Camille Claudel malade mentale," but still do not absolutely clarify the circumstances of her internment or the nature of her illness.

62. She was a precocious child, and a self-taught and talented sculptor by the age of twelve. According to Reine-Marie Paris, *Camille Claudel,* exhibition catalogue (Washington, DC: The National Museum of Women in the Arts, 1988), pp. 19 and 41, many of the figures on the *Gates of Hell* were probably by Claudel. She saw several very pronounced "consonances claudeliennes": *la Danaïde, la nymphe, Les Sirènes.* Claudel's plaster of 1885, *Study for Rodin's "Greed and Lust"* from his *Gates of Hell* reveals their collaboration and "casts doubt upon the attribution of the massive work exclusively to Rodin." See also Paris, *Claudel,* pp. 14–15. Paris said that "Rodin often asked Claudel to sculpt the hands and the feet of his works" as in this "elegantly crafted" piece from about 1885 (p. 22, illustration 20). Mathias Morhardt, "Mlle Camille Claudel," *Mercure de France*

(March 1898), reprinted in Cassar, *Dossier Camille Claudel,* p. 467, also mentioned the hands and feet done by Claudel while she was in his studio. Cassar noted her work on the study for *Les Bourgeois de Calais* "où s'assemblent son masque et la main de Pierre de Wissant" (p. 75). Paris also noted the influence of Claudel on Rodin (*Claudel, 1864– 1943,* p. 41). Robert Wernick, "Camille Claudel's Tempestuous Life of Art and Passion," *Smithsonian* 16 (September 1985): p. 59: "You have only to compare the Brobdingnagian *Le Penseur,* whose thoughts do not appear to go much beyond, say, his next wrestling match, with *La Pensée,* with its tender delicacy, its veiled sadness, which he did a few years later and which is a portrait of Camille."

63. Paris, *Claudel,* p. 19, and *Claudel, 1864–1943,* p. 83.

64. Rodin, for example, did not support *L'Age mûr* (begun 1894) before the administration of the Beaux-Arts (Cassar, *Dossier Camille Claudel,* p. 157). In a recently discovered contract written by Rodin to Claudel in 1886 (Musée Rodin archives), he promised her complete support for exhibitions, for training, for critical support; however, he also promised to marry her. This contract was never strictly adhered to. Rodin did help Claudel somewhat, but after their separation, he was more concerned with his own career. This document is cited in Odile Ayral-Clause, "Camille Claudel, Jessie Lipscomb and Rodin," *Apollo* 145, no. 424 (1997): 25. Rodin signed his name on the neck of *Giganti* (on one of three casts of it); Claudel was furious when she found out. Reine-Marie Paris and Arnaud de la Chapelle, *L'Oeuvre de Camille Claudel* (Paris: Adam Biro, 1991), pp. 34, 109. See Ursula Heiderich, "The Muse and her Gorgon's Head: On the Problem of Individuation in the Work of Camille Claudel," translated by John Ormrod, in *Rodin: Eros and Creativity,* edited by Rainer Crone and Siegfried Salzmann (Munich: Prestel-Verlag, 1992), p. 222 and n. 1: she noted the reattribution of this work to Camille Claudel in 1967.

65. Some of their works are virtually identical, and Rodin may well have taken not only her ideas but her forms. Paris, *Claudel,* p. 22, noted how little difference there is between *Jeune fille à la gerbe* and Rodin's *Gala.*

66. See Cassar, *Dossier Camille Claudel,* pp. 221–31, for a description of both material and psychological reasons for her decline. Claudel broke away from Rodin financially in 1893; he had rented an apartment for her (Paris, *Claudel,* pp. 14, 61).

67. This financial help was hidden from her sister and mother. Certainly some of her mother's resentment came from her father's attachment to Camille and his willingness to promote her work sometimes at a high cost (Reine-Marie Paris, *Camille: The Life of Camille Claudel, Rodin's Muse and Mistress,* translated by Lilian Emery Tuck [New York: Arcade Publishing, 1988], p. 61). Camille probably agreed to furnish "maquettes d'objets utilitaires" in order to live—such as "lampes et cendriers." They are not signed and have not been identified (Paris, *Claudel, 1864–1943,* pp. 77–78).

68. Cited in Anne Rivière, in Gaudichon, *Camille Claudel (1864–1943),* exhibition catalogue (Paris: Musée Rodin, 1984), p. 21.

69. Jeanne Fayard in her preface to Cassar, *Dossier Camille Claudel,* p. 17.

70. Claudine Mitchell, "Intellectuality and Sexuality: Camille Claudel, the Fin-de-siècle Sculptress," *Art History* 12, no. 4 (December 1989): 436ff. The figures in *The Waltz* were originally unclothed. Paris says the critics were so shocked that they demanded she clothe the figures (*Claudel,* p. 22).

Although she did receive a commission from the state in 1895 for *L'Age Mûr,* the money was withdrawn before the work could be cast into bronze (Rivière, *Camille*

Claudel (1864–1943), p. 19). This work was recommended to the state by Armand Sylvestre and commissioned in plaster in 1895. A marble was commissioned, but then recalled.

71. Several writers blame Rodin for her loss of the *L'Age Mûr* commission. Cassar, *Dossier Camille Claudel*, pp. 158–60: "Rodin, au sommet de sa gloire ne tient nullement à ce que sa vie intime soit exposée sur la place publique." Later Cassar (pp. 233, 236) says that Rodin did not support the commission for the bronze of this work and that his supposition was confirmed by M. Bruno Gaudichon, Conservateur-Adjoint du Musée de Poitiers. The young woman in the sculpture pleads with the older man who is led away by an old woman. Rivière calls the work an "allégorie de sa rupture avec Rodin" (*Camille Claudel (1864–1943)*, pp. 19–20) as does Paul, *Journal II* (Paris: Gallimard, 1968), p. 463; see Cassar, *Dossier Camille Claudel*, pp. 363–64. Whether this work was directly related to Rodin's relationship with Claudel is questionable, although he might have suspected that it was. Claudel may have lost another commission due to her pride and antagonism toward Rodin (Gaudichon, *Camille Claudel (1864–1943)*, exhibition catalogue [Paris: Musée Rodin, 1984], pp. 12–13).

72. Paris, *Claudel*, p. 15. According to H. Asselin, she destroyed works each summer that she had made during the year (Cassar, *Dossier Camille Claudel*, p. 210). Claudel wrote to Marguerite Thierry (Mme Fauvarque) in 1912 that she had broken her plaster models and burned what she could to "se venger" her enemies who had poisoned and killed her father (p. 231).

73. Cited in Wernick, "Camille Claudel's Tempestuous Life," p. 62. Paul writes in 1909: "A Paris, Camille folle [. . .] énorme et la figure souillée, parlant incessamment d'une voix monotone et métallique" (*Journal I* [Paris: Gallimard, 1968], pp. 103–4). It is difficult to say how accurate this description is.

74. Asselin, whom Cassar thought exaggerated Claudel's condition, wrote around 1905 that "Elle passait de la mélancolie la plus sombre à des excès de gaieté délirants" (Cassar, *Dossier Camille Claudel*, p. 221; Rivière, *Camille Claudel (1864–1943)*, p. 21). Asselin said she also drank with unknown people she gathered together when she had the funds (Paris, *Claudel, 1864–1943*, p. 84).

75. Cassar, *Dossier Camille Claudel*, pp. 363–64; Paul Claudel, *Journal II*, p. 463.

76. "Although a reform bill on asylums had been passed in 1838, the laws on committal permitted gross abuse, as witnessed by the account of a woman unjustly interned in 1854 at Charenton and then at the Salpêtrière at the instigation of her family. She spent the next fourteen years in French insane asylums, never flagging in her efforts to be released" (Martha Noel Evans, *Fits and Starts: A Genealogy of Hysteria in Modern France* [Ithaca: Cornell University Press, 1991], p. 23).

77. Paris, *Claudel*, pp. 143, 82. Doctors twice, in 1920 and again in 1923, suggested that Camille Claudel would be better off near or with her family, as stated in the medical records (Paris, *Claudel, 1864–1943*, pp. 200–202).

78. Paul was very close to Camille, and statements in his letters and by his granddaughter, Reine-Marie Paris, suggest that complex psychological anxieties and desires accompanied his love for her (Paris, *Claudel*, p. 4). In Anne Pingeot, ed. *"L'Age mûr" de Camille Claudel*, exhibition catalogue, Musée d'Orsay (Paris: Éditions de la Réunion des Musées Nationaux, 1989), p. 47, Paul is described as jealous of Rodin.

79. In a letter to Dr. Michaux of 25 June 1918, Camille claimed that "my sister has

gotten hold of my inheritance and she is determined that I never leave prison" (Paris, *Claudel,* p. 78).

80. Camille's sister, too, no doubt played a role in all of this, but she was never as close to Camille as was Paul.

81. In a letter to Judith Cladel, Rodin's biographer, in 1954; cited in Pingeot, *"L'Age mûr,"* p. 66.

82. Wernick, "Camille Claudel's Tempestuous Life," p. 63.

83. She wrote clear and coherent letters to her cousin Charles immediately before and after her internment (Paris, *Claudel,* pp. 92ff.); Wernick tells us that "it is characteristic of paranoia that it entails no impairment of the mental processes" ("Camille Claudel's Tempestuous Life," p. 64).

84. Ibid.

85. She was interned the 10th of March, and this article appeared 19 September 1913 in *L'Avenir de l'Aisne* (Chateau-Thierry) (Paris, *Claudel,* p. 72).

CHAPTER FIVE

1. Friedrich Nietzsche, *The Will to Power,* edited by Walter Kaufmann and translated by Walter Kaufmann and R. J. Hollingdale (New York: Random House, 1968), sec. 864 (March–June 1888), p. 460.

2. Not all Symbolist artists created the types of bodies discussed in this chapter. These images are signifiers of the extremes typical of Symbolist representation; in this case, the extremes of gendered sexuality.

3. Reinhold Heller, "Some Observations Concerning Grim Ladies, Dominating Women, and Frightened Men Around 1900," *The Earthly Chimera and the Femme Fatale: Fear of Woman in Nineteenth-Century Art* (Chicago: University of Chicago Press, 1981), p. 11, noted that the term *femme fatale* was not used until after this period.

4. See Abigail Solomon-Godeau, "Male Trouble: A Crisis in Representation," *Art History* 16, no. 2 (June 1993): 286–312, for a discussion of the disappearance of the male nude as an object of representation in the early nineteenth century.

5. Sexualized women and degraded sexuality had been characteristic of the Idealist tradition for centuries. The Symbolists' revival of Plotinus is significant in this respect.

6. See Kimberley Reynolds and Nicola Humble, *Victorian Heroines: Representations of Femininity in Nineteenth-Century Literature and Art* (New York: New York University Press, 1993), for an attempt to define that audience for Great Britain.

7. See Charles Rearick, *Pleasures of the Belle Epoque: Entertainment and Festivity in Turn-of-the-Century France* (New Haven: Yale University Press, 1985), pp. 185, 99, for images of women wrestlers, posters, and so on.

8. Franz von Stuck was one of the founders of the Munich Secession in 1892, which was influenced by French developments.

9. Baudelaire praised Rops. The Goncourt brothers praised his portrayal of the femme fatale as early as 1868: "Rops is truly eloquent in depicting the cruel aspect of contemporary woman, her steel-like glance, and her malevolence towards man, not hidden, not disguised, but evident in the whole of her person." Cited in John Milner, *Symbolists and Decadents* (London, New York: Studio Vista/Dutton, 1971), pp. 115–17.

10. For an excellent study of the split between mind and body, culture and nature, male and female, see Susan Bordo, *Unbearable Weight: Feminism, Western Culture, and the*

Body (Berkeley: University of California Press, 1993), especially the Introduction. As Jessica R. Feldman, *Gender on the Divide: The Dandy in Modernist Literature* (Ithaca: Cornell University Press, 1993), p. 6, pointed out, Baudelaire saw the "natural" woman as abominable, especially in relation to the elegant artificial existence of the dandy.

11. Women were seen as more sensitive than men and therefore more easily overpowered by animal (sexual) instincts. See Mary Poovey, "'Scenes of an Indelicate Character': The Medical 'Treatment' of Victorian Women," *Representations,* no. 14 (Spring 1986): 146, and passim.

12. G.-Albert Aurier, "Henry De Groux," in *Oeuvres posthumes,* edited by Remy de Gourmont (Paris, 1893), p. 276.

13. Charles Baudelaire, "The Painter of Modern Life," in *The Painter of Modern Life and Other Essays* (written 1859–60; first published in 1863), translated and edited by Jonathan Mayne (New York: Da Capo Press, 1986), pp. 32–33.

14. Friedrich Schiller, *Lettres sur l'education esthétique,* letter XXVII, in *Oeuvres de Schiller,* 8 vols., edited and translated by Ad. Regnier, (Paris: Hachette, 1859–62), p. 303. Aurier makes note of this passage, as well as others by Schiller.

15. For example, see Julien Lejay, "L'Economie politique et la méthode synthétique," in the Symbolist journal *La Plume* 3, no. 78 (15 July 1892): 325. Quote from Aurier, "J.-F. Henner," *Oeuvres posthumes,* p. 289.

16. Janet Wolff, *Feminine Sentences: Essays on Women and Culture* (Berkeley: University of California Press, 1990), p. 129. Wolff discusses Kristeva (*Powers of Horror*) on the maternal body.

17. Julia Kristeva, "Females Who Can Wreck the Infinite," in *Powers of Horror: An Essay on Abjection,* translated by Leon S. Roudiez (New York: Columbia University Press, 1982), pp. 159, 161 (on the representation of women by the writer Louis Céline).

18. Woman as material nature was too close to her body, and her sexuality was understood to be pathological and perverse, whereas proper women had no sexuality according to the ideology of femininity of the time. See Sander L. Gilman, *Difference and Pathology: Stereotypes of Sexuality, Race, and Madness* (Ithaca, NY: Cornell University Press, 1985), part 1, and especially chap. 3, for female sexuality as pathological. Robert Goldwater, *Symbolism* (New York: Harper and Row, 1979), p. 67, among many others, noted a fear of female sexuality among Symbolists at the time.

19. Sigmund Freud's readings are culturally appropriate in the Symbolist context not because the artists or writers knew his work but because he came out of a fin-de-siècle culture, had worked in Paris, and thus had personal insights into the possible motivations for such imagery. His essay, "The Medusa's Head" (1922; in *The Standard Edition of the Complete Psychological Works of Sigmund Freud,* 24 vols., translated from the German and edited by James Strachey [London: Hogarth Press and the Institute of Psycho-Analysis, 1953–74], vol. 18, pp. 273–74) for example, explained the fear of women's sexuality in terms that apply quite readily to Symbolist images of the femme fatale.

20. See Karen Horney, "The Dread of Woman," in *Feminine Psychology,* edited by Harold Kelman (New York: W. W. Norton, 1967). Georges Bataille later voiced this notion of erotic desire for the abject as a conquering of the grotesque, beastly female genitals which degraded beauty ("Beauty," in *Eroticism: Death and Sensuality,* translated by Mary Dalwood [San Francisco: City Lights Books, 1986]). See also Julia Kristeva, "Females Who Can Wreck the Infinite" and "Approaching Abjection," in *Powers of Horror.*

21. Andreas Huyssen, "Mass Culture as Woman: Modernism's Other," in *Art Theory and Criticism: An Anthology of Formalist Avant-Garde, Contextualist, and Post-Modernist Thought,* edited by Sally Everett (Jefferson, NC: McFarland and Co., 1991), p. 231.

22. Kristie Jayne, "The Cultural Roots of Edvard Munch's Images of Women," *Woman's Art Journal* 10, no. 1 (Spring/Summer 1989), pp. 28–34, describes Munch's adherence to a philosophy which asserts that we are all caught in a biological process beyond our control.

23. Originally called *Love and Pain,* Munch adopted the title *Vampire* on the advice of a friend. He later disclaimed this title, however, when he was accused of being "too literary" and "asserted that the motif merely represented a woman kissing a man on the neck." See Arne Eggum, "The Major Paintings," in *Edvard Munch: Symbols and Images* (Washington, DC: National Gallery of Art, 1978), p. 42.

24. The "phallic mother" in psychoanalytic terms refers either to the desire for the mother whom the child sees as having the phallus because the father (phallus) desires her, or to the dread of the castrated mother who has the power to castrate. See Julia Kristeva, "Revolution in Poetic Language," in *The Kristeva Reader,* edited by Toril Moi (New York: Columbia University Press, 1986), p. 101.

25. J. K. Huysmans, *Against the Grain,* translated by John Howard with an introduction by Havelock Ellis (New York: Lieber & Lewis, 1922 [1888]), p. 95.

26. Huysmans's language to describe Moreau's *Salome* resembles quite closely Kristeva's elaboration of a "wild, obscene, and threatening femininity" in the works of the writer Céline (Kristeva, "Females Who Can Wreck the Infinite," *Powers of Horror,* p. 167).

27. Mario Praz, *The Romantic Agony,* 2d ed., translated by Angus Davidson (New York: Oxford University Press, 1954), pp. 307ff., discussed the reception of Moreau's paintings of women during the Symbolist period as well as works from that period in terms of the femme fatale. He also cited Moreau's own statement on woman as "Fatality, . . . Evil and Death" (p. 309).

28. Such as Alphonse Germain, *La Plume* (1895).

29. See Freud, "Medusa's Head," *Complete Psychological Works of Sigmund Freud,* vol. 22, pp. 273–74.

30. Julia Kristeva, "Females Who Can Wreck the Infinite," *Powers of Horror,* discussing Céline's writing, p. 169. In "Approaching Abjection," ibid., Kristeva defined the "loathsome" abject as that which we must put outside of ourselves—what is "radically excluded from 'I' "—because it threatens our personal and cultural boundaries.

31. Francette Pacteau, "The Impossible Referent: Representations of the Androgyne," in *Formations of Fantasy,* edited by Victor Burgin, James Donald, Cora Kaplan (London and New York: Routledge, 1989), pp. 68–70. Pacteau spoke here of the search for unity of the self and saw the unsettled self as potentially able to reconstitute a sense of coherent self-image.

32. See Alain Corbin, *Filles de noce (Women for Hire: Prostitution and Sexuality in France after 1850),* translated by Alan Sheridan (Cambridge: Harvard University Press, 1990).

33. Freud's "Medusa's Head" makes this point: "If Medusa's head takes the place of a representation of the female genitals, or rather if it isolates their horrifying effects from their pleasure-giving ones, it may be recalled that displaying the genitals is familiar in other connections as an apotropaic act" (p. 274). Freud further suggested that simply to represent one's fears is to mitigate them.

34. This refusal of bodiliness through representation of the excessive body of the femme fatale also stems from the alienation of the male body forced to submit to the machine culture of industrial, urban, and technological developments. See Mary Ann Doane, *Femmes Fatales: Feminism, Film Theory, Psychoanalysis* (London: Routledge, 1991).

35. Ibid., pp. 1–3. "Her power is of a peculiar sort insofar as it is usually not subject to her conscious will, hence appearing to blur the opposition between passivity and activity. She is an ambivalent figure because she is not the subject of power but its *carrier* (the connotations of disease are appropriate here)." Heller, in "Some Observations," described the femme fatale as one who "fused the sensual charm of women with the intellectual capabilities of men into a sterile union capable only of generating death" (p. 11). I disagree that the femme fatale was represented with the "intellectual capabilities of men," although she certainly was understood to be co-opting male characteristics such as sexual aggression.

36. E. Ann Kaplan, "Is the Gaze Male?" in *Powers of Desire: The Politics of Sexuality,* edited by Ann Snitow, Christine Stansell, Sharon Thompson (New York: Monthly Review Press, 1983), p. 311, noted: "The sexualization and objectification of women is not simply for the purposes of eroticism; from a psychoanalytic point of view, it is designed to annihilate the threat that woman (as castrated, and possessing a sinister genital organ) poses." See also Kristeva, *Powers of Horror,* pp. 168–69, for a similar argument in her interpretation of a text by Céline.

37. Indeed, around 1900, a number of society women, in Germany, for example, had themselves painted as femmes fatales. See Bram Dijkstra, *Idols of Perversity: Fantasies of Feminine Evil in Fin-de-Siècle Culture* (New York: Oxford University Press, 1986), p. 252. One wonders whether this indirect identification with the femme fatale was only a form of collusion with patriarchal stereotypes, or if it could possibly have represented for such women at least a minor site of resistance to the male gaze and to male power of which they were eager to take advantage, even if in the diminished form of the fashionable, or whether the masquerade of the femme fatale offered a vicarious access to the public realm of the sexual, which was otherwise denied to bourgeois women during the period. I thank Jennifer Flock for this suggestion. The role-playing of the powerful sexualized woman is problematic but still not thoroughly theorized. See for example, Belinda Budge, "Joan Collins and the Wilder Side of Women: Exploring Pleasure and Representation," and Shelagh Young, "Feminism and the Politics of Power: Whose Gaze Is It Anyway?" in Lorraine Gamman, and Margaret Marshment, eds., *The Female Gaze: Women as Viewers of Popular Culture* (Seattle: The Real Comet Press, 1989).

In Linda Williams's essay, "When the Woman Looks," in *Re-Visions: Essays in Feminist Film Criticism,* edited by Patricia Mellencamp, Mary Ann Doane, Linda Williams (Frederick, MD: University Publishers of America, 1984), pp. 83–99, women protagonists are punished for looking at the monster but nevertheless often recognize themselves because both woman and monster are positioned as images of difference. Williams suggests that the mutual recognition of monster and woman might also contain a more subversive recognition of the power of nonphallic sexuality.

38. Nina Auerbach, *Woman and the Demon: The Life of a Victorian Myth* (Cambridge, MA: Harvard University Press, 1982), chapter 1, discusses the complex relationship between the Victorian cultural imagining of dangerous women and the potential of such representations to empower women.

39. See Kari Weil, *Androgyny and the Denial of Difference* (Charlottesville: University

Press of Virginia, 1992), chapter 3, "The Aesthetics of Romantic Androgyny." Weil described how the androgyne, from the Renaissance to the present, has focused on male transcendence and avoided issues of female sexuality (pp. 63–64). However, the androgyne had connections to other discourses during the century as well, such as mystical philosophies (themselves often Idealist) and alchemy. See A. J. L. Busst, "The Image of the Androgyne in the Nineteenth Century," *Romantic Mythologies,* edited by Ian Fletcher (New York: Barnes and Noble, 1967), pp. 4ff. The androgyne represented both origins and utopian endings in philosophical, historical, and social theories, that is, it stood for the original human condition and the end of human progress.

40. Weil, *Androgyny,* p. 70, including the citation to Barthes, *Michelet.*

41. "Pre-Oedipal sexuality is undifferentiated—a common ground in the history of the libido in which passive and active instinctual aims alternate in both male and female subjects; the dissolution of the Oedipus complex marks the passage from a disseminated sexuality to a heterosexual organization under the primacy of the genitals" (Pacteau, "The Impossible Referent," p. 64). According to Pacteau, Pontalis considered the representation of the "positive" androgyne to be "an impossibility because it would evoke a double castration" (p. 81).

42. Thomas Crow, "Patriotism and Virtue: David to the Young Ingres," in Stephen F. Eisenman, *Nineteenth Century Art: A Critical History* (London: Thames and Hudson, 1994), attributed the androgyny of this figure to the "narrowing of a total ideal of human beauty into an exclusively male realm, a move which pays homage not only to the homoerotic bias of ancient Greek culture but also to the bonds of exclusively masculine fellowship within the studio itself" (p. 30). Abigail Solomon-Godeau, "Male Trouble: A Crisis in Representation," *Art History* 16, no. 2 (June 1993): 295, claimed that the "feminized masculinities of post-revolutionary culture" in France represented, among other things, "the ultimate flight from sexual difference" and were "if anything, the logical extension of the 'real' historical event of women's expulsion from the public sphere." In *Male Trouble: A Crisis in Representation* (London: Thames and Hudson, 1997), chap. 4, she agreed with Crow that the eroticized androgynous male nude was incorporated into a revolutionary ideal of masculinity, but further suggested that such representations of the "ephebic body" stood as alternative feminine masculinity within a regime of masculine power. Weakness was only another side of strength, as long as both remained within the bounds of an empowered masculinity, and the ephebe remained liminal. The sexuality of the male body is more ambivalent here than in David's earlier, stoic, conventionally masculine Revolutionary figures. Such gender diffusion did occur however in David's post-Revolutionary work such as *The Sabine Women* (1799) or the blatantly homoerotic *Leonidas at Thermopylae,* with its softened male bodies and embracing male couple, and in the works of a number of David's students at the turn of the century.

43. Exceptions to this exist, such as the somewhat more sensual androgynes of Aubrey Beardsley (see for example, *Siegfried, acte II,* 1893, ink drawing, Cecil Higgins Art Gallery, Bedford, England). However, in general, the images of the androgyne were more closely aligned with the disembodied (or homoerotic) attitude of the aesthetes.

44. Barbara Spackman, in *Decadent Genealogies: The Rhetoric of Sickness from Baudelaire to D'Annunzio* (Ithaca, NY: Cornell University Press, 1989), p. 22, stated that "The highest development [in the fin de siècle] is a neuter(ed) being, a being in whom high and low, masculine and feminine are inseparable."

45. Péladan was a reactionary, a misogynist, and a Roman Catholic, but his ideas definitely belonged to the Symbolist Idealist milieu. See Michael Marlais, *Conservative Echoes in Fin-de-siècle Parisian Art Criticism* (University Park, PA: Pennsylvania State University Press, 1992), pp. 139–47, who compares his ideas to those of Aurier. For the relation of Péladan to the occult, see Geurt Imanse, "Occult Literature in France," in *The Spiritual in Art: Abstract Painting, 1890–1985,* edited by Edward Weisburger, exhibition organized by Maurice Tuchman, Los Angeles County Museum of Art (New York: Abbeville Press, 1986), pp. 355–60.

46. Péladan's book is vol. VIII of his *La Décadence latine: Éthopée,* 1892.

47. Cited in William R. Olander, "Ferdnand Khnopff, Art or the Caresses," *Arts Magazine* 51 (June 1977): 118.

48. For a short discussion of the androgyne as a sign of the occult in the Symbolist period, see Imanse, "Occult Literature," pp. 358–59.

49. See Spackman, *Decadent Genealogies,* pp. 72ff., for a description of androgyny as male and as asexual. See Weil, *Androgyny,* passim. Dijkstra, *Idols of Perversity,* p. 200, relates the androgyne to the images of the effeminate male in the period, claiming that such images, along with "supermasculine muscle men—began taking over what had been considered feminine tasks" such as the figure of Ideal love.

50. Gustave Moreau, "Moreau's Commentaries," in Julius Kaplan, ed., *Gustave Moreau,* exhibition catalogue (Los Angeles: Los Angeles County Museum of Art, 1974), p. 142; also cited in Heller, "Some Observations," p. 12.

51. Pacteau, "The Impossible Referent," p. 70, speaking of J. B. Pontalis, "L'insaisissable entre-deux," in "Bisexualité et différence des sexes," *Nouvelle Revue de psychanalyse* (Spring 1973): 16.

52. Péladan, *Comment on devient fée. Erotique. Amphithéâtre des sciences mortes* (Paris: Chamnel et Cie., 1893), vol. 2, p. 305: "l'art a créé un être surnaturel, l'androgyne, auprès duquel Vénus disparaît."

53. For the Symbolists, the notion of the asexual "proper" bourgeois woman, represented in numerous texts and images of the Realist period as threatened by the dangerously "bourgeois" appearance of the deviant prostitute, shifted to the much more clearly purist icon of the innocent virgin.

54. This work is titled on the back of the canvas as "Figures dans un paysage de printemps."

55. Such a desiccated image of the "golden age" reigned at the time, signaling the decline of the Classical past as a viable cultural model.

56. In 1899, Osbert added the name of Ste Geneviève to the title.

57. In the United States at the end of the century, women appropriated the androgyne as an ideal that challenged gender hierarchy, but their efforts were unsuccessful. See Carroll Smith-Rosenberg, "The New Woman as Androgyne: Social Disorder and Gender Crisis, 1870–1936," in *Disorderly Conduct: Visions of Gender in Victorian America,* ed. Carroll Smith-Rosenberg (New York: Knopf, 1985), pp. 245–349.

58. For some, women did not contain a male side, and "male" women artists were considered to be the height of perversity. The hermaphrodite, conversely, was sometimes imaged as a femme fatale, as in the work of the English artist Aubrey Beardsley (noted in Gail Gelburd, *Androgyny in Art,* exhibition catalogue [Hempstead, NY: Emily Lowe Gallery, Hofstra University, 1982], n.p.), and thus a sign of female cooptation of male sexuality.

59. According to Péladan's spokesman, Tammuz (cited in Dijkstra, *Idols of Perversity,* p. 273). Péladan portrayed his character, Lesbian Lady Astor (Nino-Nina) in *Le Vice suprême* [Paris: Laurent, 1884], as "l'androgyne pâle, vampire suprême des civilisations vieillies, dernier monstre avant le feu du ciel" (cited in Busst, "The Image of the Androgyne," pp. 55–56). Busst pointed out (p. 56), however, that Péladan does not preserve his distinction between his androgyne and his gynander who represents not only the lesbian but a type of femme fatale.

60. See Weil, *Androgyny,* p. 67 and passim. The association of masculine characteristics with sexual prerogative meant that a sexualized woman was necessarily usurping masculine privilege.

61. Janet Wolff, "Reinstating Corporeality: Feminism and Body Politics," in *Feminine Sentences,* pp. 130, 124.

62. Freud, "Medusa's Head," p. 274. The example he gives of this principle is from Rabelais: "the Devil took to flight when the woman showed him her vulva."

63. "par son idéal, le héros conscient aspire aux cimes, par sa passion, la femme conduit au gouffre" (*Le Symbolisme en Europe,* exhibition catalogue [Paris: Éditions des Musées Nationaux, 1976], p. 136, entry 133). A. J. L. Busst, "The Image of the Androgyne," in *Romantic Mythologies,* argued that the asexual androgyne actually represented cerebral sexuality (through the imagination) at the end of the century. Citing particularly the work of Moreau, he related "the Decadent association of lasciviousness and continence" to the "continually unsatisfied and continually solicited" desires of those who turn away from "reality." Such desires "only become stronger, fix on to ever loftier ideals" (pp. 48, 46).

64. Pacteau, "The Impossible Referent," p. 71.

65. Dijkstra, *Idols of Perversity,* p. 289, characterized the angel as male and related it to Péladan's androgynous male character, Tammuz. This figure could as well represent the asexual "good" woman, but that is unlikely considering the role of power that it plays.

66. Busst, "The Image of the Androgyne," p. 47, speaking of an earlier period in the century, argued that the androgyne was often seen as a "cerebral lecher," one who had transcended physical sexuality but erotically fantasized.

67. Péladan, *La Decadence latine: Éthopée,* vol. 8, *L'Androgyne* (Geneva: Éditions Slatkine, [1892] 1979), p. 165.

68. Busst, "The Image of the Androgyne," p. 55, noted the "tremendous vogue of homosexuality and of Lesbianism in particular during the nineteenth century . . . celebrated from Gautier through Baudelaire, Swinburne and Verlaine to Condor and Péladan . . . This extremely widespread vice [*sic*] found an apt symbol in the image of the androgyne, with which it had a very ancient connection. In Plato's *Banquet,* . . . both male and female homosexuality was associated by Aristophanes with the myth of the androgyne . . ."

69. Homosexuality was a major topic of concern during the Symbolist period. Antony Copley, *Sexual Moralities in France, 1780–1980* (London: Routledge, 1989), chap. 6, pp. 135–54, described the change of homosexual status from criminal to pathological during the Third Republic.

70. Kate Linker, "Representation and Sexuality," in *Art After Modernism: Rethinking Representation,* edited by Brian Wallis (New York: New Museum of Contemporary Art;

Boston: David R. Godine, Publisher, Inc., 1984), p. 401, noted that women are "employed to comprise a stable, masculine subject."

71. Huyssen, "Mass Culture as Woman," p. 231.

CHAPTER SIX

1. Octave Uzanne, *Parisiennes de ce temps en leurs divers milieux, états et conditions* (Paris: Mercure de France, 1910), p. 264.

2. Tamar Garb, *Sisters of the Brush: Women's Artistic Culture in Late Nineteenth-Century Paris* (New Haven: Yale University Press, 1994), p. 162, citing Céline Renooz.

3. Ibid., especially chap. 6.

4. Michelle Perrot, "The New Eve and the Old Adam: Changes in French Women's Condition at the Turn of the Century," translated by Helen Harden-Chenut, in *Behind the Lines: Gender and the Two World Wars,* edited by Margaret Randolph Higonnet, Jane Jenson, Sonya Michel, Margaret Collins Weitz, pp. 51–60 (New Haven: Yale University Press, 1987).

5. Uzanne spoke of the following areas in which women artists were thought to work best: "dans la miniature, la peinture des fleurs, le roman, le style épistolaire et la causerie, partout, en un mot, où le sentiment, l'esprit, la délicatesse dominent" ["in miniature, the painting of flowers, the novel, the epistolary style and chatty essays or reviews, especially, in a word, where sentiment, the spirit, and delicacy dominate"] (p. 263). See also Rozsika Parker and Griselda Pollock, *Old Mistresses: Women, Art and Ideology* (New York: Pantheon Books, 1981), pp. 1–49; Tamar Garb, "Berthe Morisot and the Feminizing of Impressionism," in *Perspectives on Morisot,* edited and with an introduction by T. J. Edelstein (New York: Hudson Hills Press, 1990), p. 59; and Kathleen Adler and Tamar Garb, introduction to *The Correspondence of Berthe Morisot,* compiled and edited by Denis Rouart, translated by Betty W. Hubbard (London: Camden Press, 1986).

6. Tamar Garb comes to this conclusion as well in "Berthe Morisot."

7. The point of evoking her here is not to concern ourselves with the avant-garde nature of her practice, as an Impressionist artist who later moved to a more synthetic style and whose work was admired by other avant-garde artists, but with her reception. So much has been written on Morisot's art that it need not be elaborated upon here. I direct readers to Anne Higonnet, *Berthe Morisot* (New York: Harper & Row, 1990); Tamar Garb, "Berthe Morisot," pp. 57–66.

8. Beth Genné, "Two Self-Portraits by Berthe Morisot," *Psychoanalytic Perspectives on Art,* II (1987), pp. 156–57, citing Jean Renoir, *Renoir, My Father,* translated by R. Weaver and D. Weaver (Boston: Little, Brown, 1958), pp. 159, 253, 301.

9. Genné, "Two Self-Portraits," p. 167, n. 40, noted the problematic term "femininity": "clearly a loaded term and one that needs to be further discussed, was often used both in praise and criticism of [Morisot's] work." She cites Pissarro's approval of Morisot, who said that she had such "a splendid feminine talent . . . [she] brought honor to our Impressionist group" (p. 166, n. 38, citing Camille Pissarro, *Letters to His Son Lucien,* translated by L. Abel, edited by J. Rewald [Santa Barbara and Salt Lake City: Peregrine Smith, 1981], p. 333). Duret, who although generally favorable, "also felt the need to justify [his] praise by making sure to distinguish her from others of her gender." Writing on her painting of 1879, *Jeune femme au bal,* he said, "The impression is that of a work

feminine in its delicacy, but never falling into that dryness and affectation which usually characterizes a woman's workmanship" (Genné, p. 167, note 40, citing Th. Duret. See Duret's important article, "Les Peintres Impressionistes" [1878], in *Critique d'avant-garde* [Paris: G. Charpentier, 1885], pp. 82–83). Also see Garb, "Berthe Morisot," pp. 58ff., and passim, and her "'L'Art Féminin': The Formation of a Critical Category in Late Nineteenth-Century France," *Art History* 12, no. 1 (March 1989): p. 50 and n. 51.

10. Aurier, "Deux Expositions: Berthe Morisot," *Mercure de France* (July 1892): 259–60.

11. Tamar Garb, "Revising the Revisionists: The Formation of the Union des Femmes Peintres et Sculpteurs," *Art Journal* 48, no. 1 (Spring 1989): 63–64.

12. Garb, " 'L'Art Féminin,' " pp. 47ff.

13. The increasing number of women who chose art as their profession, and their inequitable treatment in the annual Salons, led to the founding of the *Union des femmes peintres et sculpteurs* in May 1881. See Garb, "Revising the Revisionists," and *Sisters of the Brush.*

14. In the face of what they saw as the crisis in contemporary French art—"innovation for its own sake and careless disregard for the nation's traditions"—these women were determined to assert "their natural conserving instincts to preserve what was good and noble in France's artistic heritage" (Garb, "Revising the Revisionists," p. 67).

15. Garb, " 'L'Art Féminin,' " p. 54. See pp. 52ff. for a closer examination of the reform program.

16. Although women were not allowed in the École des Beaux-Arts until 1896, they learned to paint in the Academic style from relatives, in their own second-rate schools, or with Academic masters. A number of women exhibiting at the *Salons des femmes* also employed an Academic style. Charles Rosen and Henri Zerner, *Romanticism and Realism: The Mythology of Nineteenth-Century Art* (New York: W. W. Norton & Co., 1984), p. 206, define the *pompier* as "painters of brilliant reputation during their lifetimes who specialized in large historical and religious pictures—the so-called *grandes machines* . . ." For Gardner, see Madeleine Fidell-Beaufort, "Elizabeth Jane Gardner Bouguereau: A Parisian Artist from New Hampshire," *Archives of American Art Journal* 24, no. 2 (1984). Garb, " 'L'Art Féminin,' " p. 43, notes that it was not only the moralistic content but the Academic style that made work such as Gardner's acceptable.

17. Fidell-Beaufort, "Elizabeth Jane Gardner Bouguereau," p. 3.

18. "With the opening of Julien's [*sic*], I discarded my boy costume and left the Gobelin[s] School to enroll at Julien's" (Gardner, cited in H. Barbara Weinberg, *The Lure of Paris: Nineteenth-Century American Painters and Their French Teachers* [New York: Abbeville Press, 1991], p. 253, from McCabe's interview, "Mme. Bouguereau," 1910, p. 16, n. 79). Weinberg suggested that it may have been Gardner's "pluck" that caused Julian to admit women in 1873.

19. Weinberg, *The Lure of Paris,* p. 255, citing McCabe's interview, "Mme. Bouguereau," 1910, p. 16.

20. Terry Eagleton, *The Ideology of the Aesthetic* (Oxford: Basil Blackwell, 1990), pp. xiv–xv: "It is not enough for a woman or colonial subject to be defined as a lower form of life: they must be actively *taught* this definition, and some of them prove to be brilliant graduates in this process. It is astonishing how subtle, resourceful and quick-witted men and women can be in proving themselves to be uncivilized and thickheaded.

In one sense, of course, this 'performative contradiction' is cause for political despondency; but in the appropriate circumstances it is a contradiction on which a ruling order may come to grief."

21. According to Foucault, dividing practices work not only to divide subjects from each other, but also objectify the subject within him/herself. See Michel Foucault, "The Subject and Power," in *Art After Modernism: Rethinking Representation,* edited by Brian Wallis (New York: The New Museum of Contemporary Art, 1984), pp. 417, 420. As Pierre Bourdieu, *Distinction: A Social Critique of the Judgement of Taste,* translated by Richard Nice (Cambridge: Harvard University Press, 1984), p. 471, also noted: "Dominated agents, . . . tend to attribute to themselves what the distribution attributes to them, refusing what they are refused ('That's not for the likes of us'), adjusting their expectations to their chances, defining themselves as the established order defines them, reproducing in their verdict on themselves the verdict the economy pronounces on them, in a word, condemning themselves to what is in any case their lot . . ." See Kaja Silverman, "Histoire d'O," in *Pleasure and Danger: Exploring Female Sexuality,* edited by Carole Vance (Boston: Routledge and K. Paul, 1984) for the actual effect of such discourses on women's bodies. Bourdieu argued accordingly that in practice, "below the level of consciousness and discourse," the values resulting from such dividing practices that make up "the social order" are "progressively inscribed in people's minds" (pp. 468, 470–71).

22. Judith Butler, *Gender Trouble: Feminism and the Subversion of Identity* (London: Routledge, 1990), pp. 32, 145, passim.

23. A *Catalogue des oeuvres de Mlle. Bashkirtseff* was published, after her death at age twenty-four from tuberculosis, by the *Union des Femmes peintres et sculpteurs* in 1885.

24. After her early death, her family later silenced her discontent by excising undesirable passages from her journal to create a fictional image of an angelic (if still gifted) woman and to conceal the actual sexual, creative, feminist woman. Rozsika Parker and Griselda Pollock, *The Journal of Marie Bashkirtseff,* translated by Mathilde Blind (London: Virago, 1985), p. xiii, noted that Marie Bashkirtseff "was a much more ardent and conscious feminist than the [edited] Journal allows," as revealed in the unedited version of Bashkirtseff's journal discovered by Colette Cosnier, *Marie Bashkirtseff: Un Portrait sans retouches* (Paris: P. Horay, 1985).

25. Parker and Pollock, *The Journal of Marie Bashkirtseff,* p. xxvi, and citing Cosnier, *Un portrait,* p. 220; Parker and Pollock, p. 350 of *The Journal.*

26. Société Nationale des Beaux-Arts, Salon d'Automne, Salon des Indépendants, etc. (See Reine-Marie Paris, *Camille Claudel (1864–1943)* [Paris: Gallimard, 1984], pp. 302–4; also p. 61.)

27. Her debut was at the Salon of 1886, which was reported favorably in *L'Art.* She received an honorable mention at the Salon of 1888 for the group, *Sakountala* (Musée Chateauroux). (See "La Femme moderne par elle-même," *Revue Encyclopédique,* no. 169 [1896], p. 854.) Despite shortages of financing and other problems, her reputation grew.

28. Paris, *Camille Claudel (1864–1943),* p. 78. Gabrielle Réval wrote briefly but with high praise of Claudel in "Les Artistes femmes au Salon de 1903," *Femina,* no. 55 (1 May 1903): 520–21. An undated picture of her is reproduced in Réval's article, wherein Claudel appears well dressed and in good form.

29. Paris, *Claudel, 1864–1943,* p. 304. Meredith Martindale, in her introduction to Reine-Marie Paris, *Camille Claudel,* exhibition catalogue (Washington, D.C.: The National Museum of Women in the Arts, 1988), p. 9.

30. See, for example, Jacques Cassar, *Dossier Camille Claudel* (Paris: Librairie Séguier, 1987), p. 97, citing Lucien Bourdeau, *La Revue Encyclopédique* (1893, p. 823).

31. Reine-Marie Paris, *Camille: The Life of Camille Claudel, Rodin's Muse and Mistress,* translated by Liliane Emery Tuck (New York: Arcade Publishing, 1988), p. 221. Mathias Morhardt, "Mlle Camille Claudel," *Mercure de France* (March 1898), reprinted in Cassar, *Dossier Camille Claudel,* pp. 455–97. He also sent the manuscript to Rodin for approval before it was published.

32. Morhardt, "Mlle Camille Claudel," p. 456.

33. Bruno Gaudichon, *Camille Claudel (1864–1943),* exhibition catalogue (Paris: Musée Rodin, 1984), p. 46. This work is also called *Inspired.*

34. "Decoration" most likely refers here to the Symbolist aesthetic rather than to the supposed feminine aptitude for decoration and arrangement discussed in the preceding chapter. See Cassar, *Dossier Camille Claudel,* p. 402, where he is citing Octave Mirbeau in an 1893 article on Camille Claudel found by Cassar in the Archives of Paul Claudel.

35. Ibid., p. 403, citing Octave Mirbeau in 1893; Meredith Martindale, in Paris, *Claudel,* p. 9, citing Mirbeau, "Ça et là," *Le Journal quotidien littéraire, artistique et politique* (12 May 1895).

36. Cassar, *Dossier Camille Claudel,* p. 97, citing Bourdeau, *La Revue Encyclopédique,* 1893, p. 823, who "reprend les articles de Léon Daudet et d'Octave Mirbeau."

37. Her work is "d'une pensée si mâle, que l'on s'arrête surrpris par cette beauté d'art qui nous vient d'une femme. J'arrive à me répéter à moi-même cet étonnement" ["of such masculine ideas (conceptions) that one stops surprised by the beauty of this art which comes to us from a woman. Astonishment continues to come over me"] (Cassar, *Dossier Camille Claudel,* p. 402, citing Mirbeau [1893]). The masculine, virile qualities in her art made her so interesting to him. "C'est d'un art très haut, très mâle et qui fait de Mademoiselle Claudel une des plus intéressantes artistes de ce temps" ["It is a very elevated [eminent] art, very masculine, which makes Mlle Claudel one of the most interesting artists of our time"] (ibid., p. 403).

38. See Mirbeau, "Ça et là". However, he cautioned his readers not to speak too loudly because some people were upset by Mlle Claudel and would resent such high praise for her. Such a statement further mystifies the relationship of Claudel to the art world. Kristen Frederickson, "Carving Out a Place: Gendered Critical Descriptions of Camille Claudel and Her Sculpture," *Word & Image* 12, no. 2 (April–June 1996): 165, pointed out other critics who used the term genius to describe Claudel, but always with the caveat of her difference. This article, published after I completed writing this manuscript, confirms many of the same points I make here about Claudel criticism and the critics' linkage of her art to her biography.

39. Cassar, *Dossier Camille Claudel,* p. 401, citing Mirbeau in 1893. At one point, Mirbeau attempted to help Claudel get work, concerned as he was with her dire financial situation. In his 1895 article, he noted that she needed help—she could not support herself with her work. This, he said, was abominable. He wrote to Rodin about a project to help her, but it seemingly never came to fruition. Mirbeau especially appreciated *The Gossipers* (plate 4). (Cassar, *Dossier Camille Claudel,* pp. 114–17, citing Mirbeau).

40. Uzanne, *Parisiennes de ce temps,* pp. 271–72. He bemoaned the fact that the profession of *femme peintre* meant the demise in the big cities of modest women trained in good traditions and domestic principles (p. 265).

41. Cassar, *Dossier Camille Claudel,* p. 402, citing Mirbeau in 1893.

42. See Paris, *Claudel, 1864–1943,* pp. 302–6. It is not only anxiety about originality that these criticisms expressed but also irritation at a woman artist for overstepping her bounds.

43. See Judith Butler, "Performative Acts and Gender Constitution: An Essay in Phenomenology and Feminist Theory," in *Performing Feminisms: Feminist Critical Theory and Theatre,* edited by Sue-Ellen Case, pp. 270–82 (Baltimore: Johns Hopkins University Press, 1990).

44. Claudine Mitchell, "Intellectuality and Sexuality: Camille Claudel, the Fin-de-Siècle Sculptress," *Art History* 12, no. 4 (December 1989): 419 and passim. See her article for analyses of *La Valse, Clotho* and *L'Age mûr* in particular. She does not call these critics—Mirbeau, Marx, Geffroy, Mauclair, Morice—Symbolists, although they all identified more or less closely with that camp and their ideals reflect its tenets. She is one of the very few to write about Claudel as an "intellectual in her own right" rather than as trapped in her biography. Mitchell goes a long way toward rectifying the contemporary readings of Claudel's work as autobiographical. She argues that these works were understood as symbols, whose intellectual content was applauded by critics. This intellectuality, defined by Roger Marx as "the appropriation of the sign to the idea, the artist's ability to make emotion and thought visible," was also the aim of Symbolism (Mitchell, p. 422, citing Marx in 1899).

45. Mitchell claimed that the critics, whom I label as Symbolist, were "exponents of intellectuality in art" who "never questioned the legitimacy of Claudel's representation of sexuality" but viewed it as related to the "anxiety living could take" and the "imprisonment of sexuality within the instincts, the inability to control passion, and the quest for sexual love" ("Intellectuality and Sexuality," p. 434). However, I would argue that their acceptance of Claudel's representation of sexuality, justified by its supposedly "intellectual and moral" concerns, was generally based on an avoidance of "dirty sexuality." They saw her sexual representation as rising above mundane, physical acts, and a product of her "passionate discontent." See Mitchell's discussion of Mirbeau (p. 424).

46. Mirbeau in 1893, cited in ibid., pp. 423–24.

47. "Paul Claudel comparaît la vocation de Camille à celle d'un Rimbaud, d'un Van Gogh, d'un Verlaine" (Fayard, p. 24, in Cassar, *Dossier Camille Claudel*). Paul wrote several significant articles on his sister, one before her incarceration and one after her death: "Camille Claudel statuaire," *L'Occident* (August 1905); "Ma soeur Camille," exhibition catalogue (Musée Rodin, 1951). In this catalogue, he compared Claudel's *L'Abandon* to Rodin's *Le Baiser* (pp. 5–6). Paul's reading of this work gives credit to the independence and power of Camille's work, but he also acts out of his antagonism toward Rodin, not only for the artist's treatment of his sister, and his possible jealousy of Rodin as Camille's lover, but also because of Rodin's sexuality for which he was well known and which disgusted Paul Claudel. Asselin argues in the same vein. See the reprint of Henry Asselin, Deux émissions de la Radiodiffusion Télévision française: "La Vie douloureuse de Camille Claudel, Sculpteur," 1956, in Cassar, *Dossier Camille Claudel,* pp. 449–50.

48. Mitchell, "Intellectuality and Sexuality," pp. 432ff., 434, and passim. Mitchell discusses Claudel's relationship to this debate and the critics' refusal to accept her participation in it.

49. Fayard in her preface to Cassar, *Dossier Camille Claudel*, p. 24.

50. Gaudichon, *Catalogue raisonnée: Camille Claudel (1865–1943)*, p. 43. Typical of her art practice, Claudel made different works based on a single composition but rendered them in various materials and sizes and changed the composition as she saw fit. *Sakountala* exists under the names *The Abandonment* and *Vertumnus and Pomona*. Figure 6.7 is the marble version exhibited under the title of *Vertumnus and Pomona*. This same image is reproduced on the cover of Paris's work *Camille* but titled *Çacountala*. See Paris, *Camille*, p. 229, for the various versions. Paris, *Claudel*, translated *L'Abandon* as *Abandonment*. Anne Higonnet, "Myths of Creation: Camille Claudel and Auguste Rodin," *Significant Others: Creativity and Intimate Partnership*, edited by Whitney Chadwick and Isabelle de Courtivron (New York: Thames and Hudson, 1993), pp. 15–29, translated the work as *Abandon* and spoke about "erotic desire from a woman's point of view" (p. 28).

51. Paris, *Claudel*, p. 25.

52. Ibid., 14. Paris later, in the catalogue entry, said that *The Beseecher* "precedes the tragedy of Claudel's breakup with Rodin" (p. 23).

53. Ibid., p. 14. For an excellent discussion of a similar treatment of Claudel's *L'Age mûr* (1895), see Frederickson, "Carving Out a Place," pp. 171–73.

54. Paris, *Claudel*, p. 16.

55. Fayard, in Cassar, *Dossier Camille Claudel*, p. 16. Many more examples could be cited. Authors consistently, without proof, related her life to her art. Anne Rivière, in Gaudichon, *Camille Claudel (1864–1943)*, exhibition catalogue (Paris: Musée Rodin, 1984), p. 19, noted "sa version définitive sera *L'Age mûr*, allégorie de sa rupture avec Rodin" ["her definitive version will be *Maturity*, an allegory of her rupture with Rodin"]. Paul, too, conflates the two. In his essay for the catalogue of her exhibition in 1951, "Ma soeur Camille," he identified and described her in *L'Age mûr* (1898—second project) as the kneeling woman, "Implorante, humiliée, à genoux tenue! Tout est fini! C'est ça pour toujours qu'elle nous a laissé à regarder!" [Beseeching, humiliated, fallen on her knees! Everything is over! She has let the whole world see her this way!] (cited by Rivière, p. 20).

56. He reportedly cried about his loss before friends. See Paris, *Claudel, 1864–1943*, p. 113; also, in E. and J. de Goncourt's *Journal* (March 1894). Claudel may have been upset by the loss of Rodin, but it was her decision to leave.

57. Ursula Heiderich's recent essay is symptomatic of such gendered interpretations. Speaking of the ambivalent and troubling feelings aroused in both Claudel and Rodin by the demise of their relationship, and the threat of the powerful feelings that Claudel aroused in Rodin, she alleged that Rodin could transcend his despair while Claudel deteriorated: "Several of Rodin's sculptures bearing the features of Claudel date from after the end of the couple's relationship: Rodin was able to exorcise the wedding of genius to the demonic in his artistic work. But for Claudel, this symbiosis was the fatal trigger that initiated a human and artistic catastrophe" (Heiderich, "The Muse and Her Gorgon's Head: On the Problem of Individuation in the Work of Camille Claudel," translated by John Ormrod, in *Rodin: Eros and Creativity*, edited by Rainer Crone and Siegfried Salzmann [Munich: Prestel-Verlag, 1992], p. 222).

58. Paris, *Claudel, 1864–1943*, p. 52, paraphrased from the French. She did give her credit for developing a personal style in a final series of works, a style "quite different from Rodin's": *The Flute Player, Fortune, The Wave, The Gossipers*. Still, she

saw even some of these late works as reflecting her state of mind in relation to Rodin.

59. The contract is dated 1886 and was discovered in the Musée Rodin archives. Odile Ayral-Clause, "Camille Claudel, Jessie Lipscomb and Rodin," *Apollo* 145, no. 424 (1997), cited the contract and related it to Claudel's conscious scheme to use Rodin to establish a successful career, otherwise difficult for a woman artist, and to marry him (pp. 25–26). Frederickson, "Carving Out a Place," p. 163, also discusses this document.

60. Other versions include *Woman Seated Before a Fireplace* and *Intimacy*. Claudel also modeled a number of small figures that she observed from her studio on Avenue d'Italie (see Morhardt in Cassar, *Dossier Camille Claudel*, pp. 475, esp. 477). "And they're clothed," unlike Rodin's figures, she reported to Paul (Robert Wernick, "Camille Claudel's Tempestuous Life of Art and Passion," *Smithsonian* 16 [September 1985]: p. 61). All the figurines are lost or were destroyed by Claudel.

61. Paris, *Claudel*, p. 24.

62. Anne Pingeot, ed., *"L'Age mûr" de Camille Claudel*, exhibition catalogue, Musée d'Orsay (Paris: Éditions de la Réunion des Musées Nationaux, 1989), p. 21.

63. Paris, *Claudel, 1864–1943*, p. 309.

64. Anne Rivière, *L'Interdite: Camille Claudel, 1864–1943* (Paris: Éditions Tierce, 1987), p. 35.

65. Not all of Claudel's works suggest such a female gaze, however. A work by Claudel from 1897, *L'Ecume (The Foam)*, marble and onyx, conveys a different and somewhat more conventional attitude toward the female body. The woman lies in the typical pose of the nude, hip up, hand on chin, exposed and open to the gaze directed at her body.

66. Paris, *Claudel, 1864–1943*, pp. 211, 310, n. 8, citing Claudel in E. Claris, *De l'Impressionnisme en sculpture* (Paris: La Nouvelle Revue, 1902). Claudel is obviously being ironic and critical of these "others."

67. Henry Asselin, cited in Paris, *Claudel, 1864–1943*, p. 219.

68. Paris, *Camille*, p. 25.

69. This work is also known as *La Confiance (The Secret)*, according to Paris, *Camille*, p. 172.

70. See Charles Morice, cited in Gaudichon, *Catalogue raisonné: Camille Claudel (1865–1943)*, p. 72, and Octave Mirbeau, cited in Cassar, *Dossier Camille Claudel*, pp. 114–17. Maurice Rheims claimed that "cette oeuvre (. . .) compte parmi les plus originales et les plus étranges de l'histoire de la statuaire" ["this work . . . is among the most original and the strangest in the history of statuary"] (Gaudichon, *Catalogue raisonnée: Camille Claudel (1865–1943)*, p. 11, citing Maurice Rheims, *La Sculpture au XIXe siècle* [Paris: Arts et Métiers Graphiques, 1972], p. 141). Cassar, *Dossier Camille Claudel*, p. 213, noted that there were imitations of *The Gossipers*.

71. Morhardt, in Cassar, *Dossier Camille Claudel*, pp. 488, 490. He included *The Wave* in this description. More research needs to be done to discover specific meanings for these works within their cultural context.

72. Recent interest in the language and voice of women comes from many fronts. See Hélène Cixous, "Laugh of the Medusa," in *New French Feminisms*, edited and with an introduction by Elaine Marks and Isabelle de Courtivron (New York: Schocken Books, 1981), pp. 245–64; Julia Kristeva's "semiotic" in which women (and others) represent the voice of the marginal breaking through the phallic order, *Revolution in*

Poetic Language, translated by Margaret Waller, with an introduction by Leon S. Roudiez (New York: Columbia University Press, 1984; originally published in 1974); and Luce Irigaray, *This Sex Which Is Not One,* translated by Catherine Porter (Ithaca: Cornell University Press, 1985).

73. She studied with the Academic *pompier* Jules Lefebvre. For a short biography, see *Le Symbolisme en Europe,* catalogue entries Geneviève Lacambre (Paris: Éditions des Musées Nationaux, 1976), exhibition catalogue, p. 219.

74. Bram Dijkstra, *Idols of Perversity: Fantasies of Feminine Evil in Fin-de-Siècle Culture* (New York: Oxford University Press, 1986), p. 392, described this work in exaggerated terms as a "truly revolutionary feminist statement for its period" and the figure in it as "independent, confident, and assertive."

75. Philippe Jullian, *The Symbolists,* translated by Mary Anne Stevens (London: Phaidon, 1973), p. 238.

76. Many Symbolists were enamored of the British Pre-Raphaelites. Aurier referred to them as predecessors in his article, "Le Symbolisme."

77. Aurier wrote a catalogue for the exhibition, parts of which were reprinted in the *Mercure de France* 5 (July 1892): 260–63, in which he noted her work approvingly.

CHAPTER SEVEN

1. Robert Goldwater, *Symbolism* (New York: Harper and Row, 1979), p. 11, briefly suggests that Gauguin also created femme fatale images, but without explanation.

2. Gauguin to Bernard, Pont-Aven, September 1889, *Lettres de Paul Gauguin à Émile Bernard, 1888–1891* (Geneva: P. Cailler, 1954), p. 80.

3. In her *L'Union ouvrière* of 1843. Claire Goldberg Moses, *French Feminism in the Nineteenth Century* (Albany: State University of New York, 1984), p. 108.

4. Flora Tristan, *The Workers' Union,* translated and with an introduction by Beverly Livingston (Urbana: University of Illinois Press, 1983), "Why I Mention Women," pp. 75–98. She referred specifically to proletarian women in this section.

5. Flora Tristan, *Flora Tristan's London Journal, 1840,* translated by Dennis Palmer and Giselle Pincetl, *Promenades dans Londres* (Charlestown, MA: Charles River Books, 1980), pp. 72–73.

6. Tristan, *London Journal,* p. 73. But Tristan goes on to demand other work alternatives for women and sexual equality.

7. Moses, *French Feminism,* p. 108. He later shot Flora, but she survived.

8. Gauguin most likely read his grandmother's works, for he was widely read according to accounts. In a letter to Bernard from Le Pouldù, 1889, he asks his friend, "Soyez assez aimable pour m'envoyer le livre de ma grand'mère (Flora Tristan la St. Simonnienne)," *Lettres de Paul Gauguin à Émile Bernard,* no. VIII, p. 88. See also the letter from Paul-Émile Colin to Charles Chassé, cited in *The Art of Paul Gauguin,* exhibition catalogue, Richard Brettell, Françoise Cuchin, Claire Frèches-Thory, and Charles F. Stuckey, Gallery of Art, Washington, D.C., and the Art Institute of Chicago, 1988, p. xxiv. Gauguin speaks of Tristan in *Avant et après:* "My grandmother was an amusing old lady. Her name was Flora Tristan. Proudhon said she had genius. Knowing nothing about this, I take Proudhon's word for it.

"She was connected with all sorts of socialist affairs, among them the workers' unions. The grateful workers set up a monument to her in the cemetery of Bordeaux. It is probable that she did not know how to cook. A socialist-anarchist blue-stocking! To

her, in association with Père Enfantin, was attributed the founding of a certain religion, the religion of Mapa, in which Enfantin was the god Ma and she the goddess Pa.

"Between the truth and the fable I have never been able to distinguish, and I offer you this for what it is worth. She died in 1844; many delegations followed her coffin. What I can tell you with confidence, however, is that Flora Tristan was a very pretty and noble lady. She was an intimate friend of Madame Desbordes-Valmore. I also know that she spent her whole fortune in the workers' cause, travelling ceaselessly. Between whiles she went to Peru to see her uncle, Citizen Don Pio de Tristan de Moscoso (of an Aragonese family)." (Paul Gauguin, *Paul Gauguin's Intimate Journals,* Van Wyck Brooks's translation of *Avant et après;* preface by Emil Gauguin [New York: Liverright, 1949], pp. 150–53.)

9. He could have encountered the idea in any number of places, however. Broude cites the opinions of Degas's friend Diego Martelli, who "condemned marriage as a form of prostitution, describing it as 'nothing but a state of subjection and slavery, or, better still, a private form of prostitution for a woman, compared with public prostitution' " (Norma Broude, "Edgar Degas and French Feminism, ca. 1880: 'The Young Spartans,' the Brothel Monotypes, and the Bathers Revisited," *The Art Bulletin* 70, no. 4 [December 1988]: 649). Frederick Engels also espoused this philosophy in *The Origin of the Family:* "the whole bourgeois form of marriage is no more than prostitution." (Paraphrased from Engels in Khalid Kishtainy, *The Prostitute in Progressive Literature* [London, New York: Allison & Busby, 1982], p. 47, from Karl Marx and Frederick Engels, *Selected Works* [Moscow, 1951], vol. 2, p. 209.)

10. For similar interpretations of this painting, see Wayne Anderson, *Gauguin's Paradise Lost* (New York: Viking Press, 1971), pp. 100ff.; and especially Vojtech Jirat-Wasiutynski, "Paul Gauguin in the Context of Symbolism," Ph.D. diss. Princeton University, 1975, pp. 188–268. Abigail Solomon-Godeau, "Going Native," *Art in America* 77, no. 7 (July 1989): 123 and 161, n. 8, referred to Anderson's interpretations of Gauguin's works as "unified around the central theme of the woman's life cycle, wherein the crucial event is the loss of virginity . . . ," and characterized it as "grotesquely misogynist." Anderson's statements such as "The maiden courts rape as Christ courted death" (p. 103, in reference to *The Loss of Virginity*) are insupportable. But I believe that *this* painting is related exactly to that theme of regeneration, and if misogyny is present, it is as much attributable to Gauguin as to Anderson.

11. Gauguin, in a letter to Émile Bernard from Pont-Aven, 1889, *Lettres à Bernard,* p. 80, describing this painting, characterized the fox in *Be In Love,* as the "Indian symbol of perversity."

12. Paul Gauguin, *Noa Noa: Voyage to Tahiti,* translated by Jonathan Griffin (Oxford: Bruno Cassirer, 1961), p. 24, from Gauguin's text and his notes inserted into it. This edition is from the manuscript found only in 1951 by Jean Loizé, who claims in his postscript that it is the only one entirely by Gauguin's hand. Other scholars rely on the longer version of Gauguin's text "enhanced and enlarged" by Charles Morice, while I prefer to focus more on the statements made completely by Gauguin in his original edition.

13. As Nicholas Wadley, among others, suggests in his Introduction to Paul Gauguin's *Noa Noa: Gauguin's Tahiti,* ed. Nicholas Wadley, trans. Jonathan Griffin (Oxford: Phaidon, 1985), p. 8.

14. Gauguin, *Noa Noa: Voyage to Tahiti,* pp. 23–24.

15. Paul Gauguin, *Noa Noa,* edited by André Balland; preface, study, biography, notes and bibliography by Jean Loizé (Paris: A. Balland, 1966), p. 28.

16. Much depends here on whether by "laws" Gauguin meant social laws such as Western dividing practices between heterosexual/homosexual or male/female roles or "natural" laws of morality in an ideal and pure site such as Tahiti.

17. Gauguin, *Noa Noa: Voyage to Tahiti,* p. 24.

18. John House and MaryAnne Stevens, eds., *Post-Impressionism: Cross-Currents in European Painting,* exhibition catalogue of the Royal Academy of Arts (London: Weidenfeld and Nicolson, 1979), p. 77, catalogue entry on this painting.

19. Gauguin, *Noa Noa: Gauguin's Tahiti,* note, p. 24.

20. House and Stevens, *Post-Impressionism,* p. 77.

21. In a drawing after *Man with an Axe* (1893–94; pen, brown ink, india ink, highlighted with brush and gouache on tracing paper; collection of Edward McCormick Blair), the woman in the background has disappeared altogether.

22. See also *Children Wrestling,* 1888, oil on canvas, Josefowitz Collection, in which the two bodies seem to be embracing rather than wrestling. Gauguin's fascination and flirtation with Émile Bernard's seventeen-year-old sister, Madeleine, in Pont-Aven, suggests a continued interest in young women as well, as suggested in House's and Stevens's *Post-Impressionism,* p. 84.

23. In this context, Gauguin's androgynes might also be read as a critique of the feminized avant-garde exemplified in the image of the aesthete. The quotes are from Gauguin, *Noa Noa: Voyage to Tahiti,* p. 24.

24. See Stephen F. Eisenman, *Gauguin's Skirt* (London: Thames and Hudson, 1997), pp. 104ff., and Niko Besnier, "Polynesian Gender Liminality Through Time and Space," *Third Sex, Third Gender: Beyond Sexual Dimorphism in Culture and History,* edited by Gilbert Herdt (New York: Zone Books, 1996), pp. 285–328, esp. pp. 296ff. Besnier, p. 299, noted that homosexual acts alone are "neither a necessary nor a sufficient criterion" for gender-liminal status (that is, the *mahu*). Even so, such acts or the potential for them is central to the determination of a *mahu* (pp. 299–300). Yet *mahus* may opt out of this role and even become family men (pp. 310–11).

25. "The gender-liminal person's prestige does not result directly from his liminal status, because liminality in and of itself is anything but prestigious; but prestige and power may result from certain secondary associations of liminality. . . . Whatever its nature, gender liminality is the locus of a great deal of ambiguity, conflict and contestation in Polynesian societies" (Besnier, "Polynesian Gender," pp. 318, 328).

26. Eisenman described several of Gauguin's paintings of possible *mahus.* However, in my opinion these works do not have the same erotic charge as the figure in *The Man with an Axe.* The activity of this man does not fit Besnier's descriptions of the work of *mahu* men (p. 296).

27. As Peter Brooks has suggested in "Gauguin's Tahitian Body," in *The Expanding Discourse: Feminism and Art History,* edited by Norma Broude and Mary D. Garrard (New York: Icon/Harper Collins, 1992), pp. 331–45, Gauguin's idealized fantasy of Tahiti as the primitive site of innocence, tranquility, and sexual liberation was a culture-wide phenomenon, established in the French imaginary by their first contact with the island in the eighteenth century.

28. For, of course, the working-class woman was imaged as prostitute by nature rather than by culture.

29. Gauguin's reply to Strindberg's letter, n.d. (5 February 1895, according to Herschel B. Chipp, *Theories of Modern Art: A Source Book by Artists and Critics* [Berkeley: University of California Press, 1973], p. 83).

30. In Gauguin, *Noa Noa: Voyage to Tahiti*, p. 37.

31. Ibid., p. 26. Abigail Solomon-Godeau, "The Primitivism Problem," *Art in America* (February 1991): 41, describes the extreme polarities of this mechanism: "the European fantasy of the primitive can be embodied on the one hand as a myth of origins, of noble savages, of a collective childhood of humanity, or, alternatively, as the very figure of atavism, savagery, violence, untrammeled sexuality—the projected, exteriorized heart of darkness."

32. Chipp, *Theories,* pp. 67–69. From *Cahier pour Aline* (Tahiti, 1893).

33. Goldwater, *Symbolism,* p. 199, citing Gauguin without reference. A much poorer translation of this same passage appears in Paul Gauguin, *The Writings of a Savage,* translated by Eleanor Levieux; edited by Daniel Guérin; introduction by Wayne Anderson (New York: Viking Press, 1978), p. 137, from Gauguin's notes on his original copy of *Noa Noa.* The text goes on to suggest some intelligence, although she remained naive and mysterious to Gauguin: "Like Eve, the body is still an animal thing. But the head has progressed with evolution, the thinking has acquired subtlety, love has imprinted an ironic smile on the lips, and naïvely she searches in her memory for the 'why' of times past and present" (ibid.). See the original passage in Paul Gauguin, *Oviri: Écrits d'un sauvage,* texts chosen and presented by Daniel Guérin (Paris: Gallimard, 1974), pp. 169–70.

34. Cited in Abigail Solomon-Godeau, "Going Native," *Art in America* 77, no. 7 (July 1989): 123. He wrote to Willumsen in 1890, prior to his departure: "I am going soon to Tahiti . . . where the material necessities of life can be had without money . . . the Tahitians, on the contrary, happy inhabitants of the unknown paradise of Oceania, know only sweetness of life. To live, for them, is to sing and to love . . ." (Chipp, *Theories,* p. 79).

35. Gauguin, *Noa Noa,* André Balland, ed., p. 25. Gauguin's original manuscript.

36. Gauguin, *Noa Noa,* edited and introduced by Nicholas Wadley, translated by Jonathan Griffin (London, 1972), p. 23, cited in Solomon-Godeau, "Going Native," p. 125. This passage is quite similar to Gauguin, *Noa Noa: Voyage to Tahiti,* p. 21: "I saw plenty of calm-eyed young women, I wanted them to be willing to be, in a word, taken: crude capture. In a way [it was a] longing to rape." In 1985, Wadley published the Griffin translation again (*Noa Noa: Gauguin's Tahiti*), with "a few corrections." This passage was changed to read: "I saw plenty of calm-eyed young women, I wanted them to be willing to be taken without a word: taken brutally. In a way a longing to rape" (p. 23).

37. Morice himself had sold this edition as a "first manuscript" in 1908 (Loizé in *Noa Noa: Voyage to Tahiti,* p. 58).

38. Paul Gauguin, *Noa Noa,* Édition définitive (Paris: G. Crès et cie., 1929), p. 49. According to Loizé, Gauguin was not happy with Morice's revisions (*Noa Noa: Voyage to Tahiti,* p. 57).

39. Eisenman, *Gauguin's Skirt,* chap. 2, "Sex in Tahiti."

40. Gauguin, *Noa Noa,* Balland edition, p. 25.

41. *Writings of a Savage,* p. 137. See the French version, *Oviri,* p. 169.

42. Gauguin, *Noa Noa,* Crès edition (1929), p. 49.

43. "Et puis on disait de beaucoup qu'elles étaient malades—malades de ce mal que

les Européens ont apporté aux sauvages comme un premier et sans doute essentiel élé-ment de civilisation" (*Noa Noa,* Crès edition, p. 49).

44. Suggested by Keith Krysinski, a student in my seminar at Northwestern University, fall quarter, 1993. Eisenman, *Gauguin's Skirt,* pp. 119–35, argued that this painting, translated as *The Specter Watches Over Her,* represented a bimorphous androgyne, the spiritual and the material. The Albright-Knox Gallery uses the earlier translation, so I have as well.

45. "barbarism . . . is for me a rejuvenation" (in Chipp, *Theories,* p. 82, from Gauguin's letter to Strindberg). See also his letter to Morice, 1903 (ibid., pp. 84–86), in which he compares his own ability to survive to the "Indian who smiles during his torture," and calls himself a savage.

46. Solomon-Godeau, "Going Native," p. 127.

47. Solomon-Godeau refers to Gauguin's use of sources as the "reprocessing of already constituted signs" (ibid., pp. 127–28). She suggested that this reprocessing is present in his art, his life and his myth. I question the modernist notion that the use of others' images is plagiarism. I believe Gauguin's images transform his sources. His "plagiarism" as well as his racism and sexism do not entirely negate the power of his art.

48. If the topos of the femme fatale was too evil for Gauguin's purposes, a less overwhelming sexualized female such as Symbolist artist Lévy-Dhurmer's *Eve,* 1896 (figure 5.16), or Renoir's nudes, such as *Blonde Bather* (figure 8.9), could not contain the deeper instincts and forces that Gauguin's Tahitian women as representatives of the primitive and/or the maternal were meant to embody.

49. Desire for very young "innocent" girls was prevalent at the time as well but could hardly be conceptualized in "positive" images of mature sexual roles.

50. Griselda Pollock, *Avant-Garde Gambits, 1888-1893: Gender and the Color of Art History,* (New York: Thames and Hudson, 1993), also suggested that Gauguin's Tahitian women were images of the desire for the maternal.

CHAPTER EIGHT

1. The date of her birth is in question.

2. Edgar Degas was her mentor, Puvis de Pierre Chavannes probably her lover, and she was painted by Pierre-Auguste Renoir and Henri Toulouse-Lautrec among others.

3. She also painted still-lifes, portraits, and landscapes, but this chapter focuses on her use of the nude because it relates to Symbolist themes such as "woman as nature." For other women painting female nudes in the first decade of the twentieth century, see Gill Perry, *Women Artists and the Parisian Avant-Garde* (Manchester, New York: Manchester University Press, 1995), pp. 118–39.

4. Here cited by Nesto Jacometti, *Suzanne Valadon* (Geneva: P. Cailler, 1947), n.p.

5. John Storm, *The Valadon Drama: The Life of Suzanne Valadon* (New York: E. P. Dutton & Co., 1959), p. 75. Storm's book, written in the 1950s, draws on the last living links to Valadon for his source material and is thus based almost solely on reminiscences. As he noted, it is important to take advantage of those links before they too are gone, but he constructed a personality and a life that is much too coherent considering the material available on Valadon and seemingly filled his narrative with flights of imagination.

6. Ibid., pp. 111–12; Storm claimed that Gauguin's work had a powerful effect on Valadon when she saw it at the Exposition Universelle of 1889 (works from Martinique):

"[S]he had for some time formed a sentimental attachment [to him], crediting him with her artistic heritage in much the same way as she had heard the other Montmartre artists credit Cézanne with theirs. She painted with great fervor 'in homage to that fine artist,' and went on a trip to Brittany" (p. 178).

7. As she told Gustave Coquiot (ibid., pp. 113–14).

8. Bernard Dorival, preface, *Suzanne Valadon,* Musée National d'Art Moderne (17 March–30 April), 1967, exhibition catalogue, p. 8. Her later nudes are more directly related to early-twentieth-century images of the nude from Vallotton to Matisse and to women artists such as Emilie Charmy. See Perry, *Women Artists,* passim., for the relationship to Charmy.

9. Dorival, *Suzanne Valadon,* p. 7.

10. See Patricia Mathews, "Returning the Gaze: Diverse Representations of the Nude in the Art of Suzanne Valadon," *The Art Bulletin* 73, no. 3 (September 1991): 415–30. I thank the *Art Bulletin* for permission to reprint a small portion of this article. The majority of Valadon's models—friends as well as hired women—were from the working class. Valadon seemed to prefer heavier women, an ideal that conflicted with the norm. She emphasized this even in her portraits of middle-class women, such as *Portrait of Mme Coquiot* (1915; Musée de Menton, Menton, France).

11. T. J. Clark has demonstrated the critics' anxiety over what they perceived to be Manet's representation of the working class in *Olympia* within the Academic context of the bourgeois representation of the female nude (*The Painting of Modern Life: Paris in the Art of Manet and His Followers* [New York: Alfred A. Knopf, 1985], chap. 2, "Olympia's Choice").

12. There is an extensive literature on the perception of the working-class woman as prostitute and the prostitute as degenerate. For the working-class woman perceived as a prostitute, see Eunice Lipton, *Looking Into Degas: Uneasy Images of Women and Modern Life* (Berkeley: University of California Press, 1986); Sander Gilman, *Difference and Pathology: Stereotypes of Sexuality, Race, and Madness* (Ithaca, NY: Cornell University Press, 1985); Alain Corbin, *Filles de noce (Women for Hire: Prostitution and Sexuality in France after 1850),* translated by Alan Sheridan (Cambridge: Harvard University Press, 1990); and Césare Lombroso, *La Femme criminelle et la prostituée,* translated by Guglielmo Ferrero (Paris: F. Alcan, 1896). Valadon's nude women are ambiguous on this point but, in general, they lack a sexual charge altogether (see Mathews, "Returning the Gaze").

13. Their transgression lay not in their representation of class, since most images of women covertly contained class status, but in their flaunting of the transgression of class boundaries. See Clark, *The Painting of Modern Life,* chap. 4, "A Bar at the Folies-Bergère," and Lipton, *Looking Into Degas,* especially chaps. 2 and 3.

14. Models in Montmartre, for example, were unemployed women or women in working-class professions such as waitresses. Jeanine Warnod, *Suzanne Valadon* (Paris: Flammarion, 1981), p. 21, described them gathering each Sunday in the Place Pigalle in Paris where artists would come and make their choices.

15. Race, like class, was often sexualized. See Gilman, *Difference and Pathology.*

16. Rozsika Parker and Griselda Pollock, Introduction to *The Journal of Marie Bashkirtseff,* translated by Mathilde Blind (London: Virago, 1985), p. xxviii.

17. See Mathews, "Returning the Gaze," pp. 415–30.

18. We recall that the nude figures in Claudel's *The Waltz* shocked the critics, and

she then clothed them. Even Valadon, however, covered the male genitals in *Adam and Eve* after complaints.

19. For a discussion of the sexuality of her later paintings of nudes, see Mathews, "Returning the Gaze," pp. 415–30.

20. When these aspects were noticed, they were not seen to conflict with her wild nature.

21. Dorival, *Suzanne Valadon,* p. 6. These women, "ses creatures les plus vulgaires," are chosen for "leur anatomie épaisse, de leur aspect canaille." She paints as well "visages volontiers laids, usés par la misère, le plaisir ou le vice, à l'expression butée . . ." He speaks of "la . . . vérité charnelle" in all of her works.

22. "La sensualité avec cette femme fougueuse et implacable s'exprime au détriment de la sensibilité. . . . Elle déteste les femmes et se venge du charme qu'elles peuvent avoir en les condamnant par le trait, par la ressemblance d'autant plus fidèle que pas un détail n'en est négligé pour les idéaliser le moins possible" ["This mad and implacable woman expresses sensuality to the detriment of sensibility . . . She detests women and takes revenge against the charm of some women by condemning them to a resemblance so faithful that no detail is neglected and they are idealized as little as possible"]. In Jean Vertex, *Le Village inspiré* (Chez l'auteur, 1950), cited in Warnod, *Suzanne Valadon,* p. 73.

23. Disgust for the "low" is typical of the bourgeois need to differentiate oneself and create status within the hierarchy of existence. See Peter Stallybrass and Allon White, *The Politics and Poetics of Transgression* (Ithaca, NY: Cornell University Press, 1986), p. 191 and passim. Images by men such as the femme fatale embodied a similar conflicted response of disgust and desire.

24. Storm, *The Valadon Drama,* p. 15.

25. Ibid., p. 59. In these passages, we recognize the disdain for the learned and for education and the desire for the innocent and pure that imbued primitivism.

26. *The Genealogy of Morals,* borrowed from Toulouse-Lautrec, along with the poetry of Jehan Rictus, Maurice Rollinat, and Baudelaire (Warnod, *Suzanne Valadon,* p. 34).

27. See Clark, *The Painting of Modern Life,* chap. 2, "Olympia's Choice."

28. Cited in Warnod, *Suzanne Valadon,* p. 66.

29. "l'œuvre gravé de Suzanne Valadon, . . . fait éclater au grand jour les mérites singuliers et l'incomparable puissance d'une des seules femmes-peintres qui ont su mater le métal dur. Au XVIIIe siécle, de ravissantes mains contriubèrent à l'illustration du livre; au XIXe siécle, Mary Cassatt et Berthe Morisot menèrent l'une avec brio, l'autre avec la plus aristocratique fièvre, des jeux délicats sur le cuivre. Trop fines, trop civilisées, aucune, cependant, n'osa porter le crayon ou la pointe comme une arme offensive en guerre à la façon des mâles" ["the engravings of Suzanne Valadon, . . . will one grand day make manifest the singular merits and the incomparable power of one of the only women painters who has been able to subdue the difficult process. In the eighteenth century, some ravishing hands contributed to book illustration; in the nineteenth century, Mary Cassatt and Berthe Morisot carried out delicate performances on copper, the one with brio, the other with the most aristocratic fever. Too refined, too civilized, no one, however, dared take the pencil [or charcoal] or the etching needle as an offensive weapon of war in the fashion of men"] (Robert Beachboard, *La Trinité Maudite, Valadon—Utrillo—Utter* [Paris: Amiot-Dumont, 1952], citing Claude Roger-Marx, "Les Dessins de Suzanne Valadon," in *Suzanne Valadon. Dessins, Pastels,* exhibition catalogue [Paris: Galerie Paul Pétridès, 1962], p. 35).

30. "Et cette sûreté de regard sans lyrisme se reflète dans son art d'une manière si frappante qu'on a pu le qualifier d'asexué et que, le comparant à celui d'autres femmes-peintres, on a parlé de sa «virilité» Or, cette lucidité froide et si peu féminine a guidé le crayon bien avant le pinceau" ["And this surety of regard without lyricism is reflected in her art in a manner so striking that it was possible to call it asexual and that, comparing it to that of other women painters, its 'virility' was self-evident. . . . For, this cold and so unfeminine lucidity has guided the pencil well before the brush"] (Beachboard, *La Trinité Maudite,* p. 38).

31. Francis Carco, *Le Nu dans la peinture moderne (1863–1920)* (Paris: Crès, 1924), pp. 144–45.

32. "Rien de commun, en effet, entre ses ouvrages et ceux des dames de la peinture" (Dorival, *Suzanne Valadon,* p. 5).

33. Ibid., p. 9. Contradictions are to my mind the strength of her art. Dorival here reinforced the intellectual weakness of women so central to the Symbolist aesthetic.

34. "Douée de virile puissance, d'une énergie insoupçonnée chez une femme, toute parcourue de fougue et d'amour, elle peint d'une manière directe, instinctive, sans tâtonnements ni repentirs. . . . sa couleur est franche, agressive, même et parfois corrosive, presque hostile" ["Endowed with a virile power, with an unsuspected energy for a woman, permeated by ardor and love, she paints in a direct manner, instinctively, without gropings or regrets. . . . her color is frank, even aggressive, and sometimes corrosive, almost hostile"] (Jacometti, *Suzanne Valadon,* n.p.).

35. Roger-Marx, however, made a point of insisting that her work could stand up to major male artists. See Roger-Marx, "Les Dessins de Suzanne Valadon," pp. 5–6.

36. My emphasis. Storm, *The Valadon Drama,* p. 15, in speaking of her encounter with Utter. Robert Rey, too, described Valadon in terms of her diminutive physical appearance, her "court menton carré" ["short, square chin"] and called her a "gamine" (Robert Rey, *Suzanne Valadon: Les Peintres Français Nouveaux,* no. 14 [Paris: Éditions de la nouvelle revue française, 1922], p. 4).

37. See, for example, Storm, *The Valadon Drama;* Beachboard, *La Trinité Maudite;* and Jacometti, *Suzanne Valadon.*

38. R. H. Wilenski, *Modern French Painters* (London: Faber & Faber, 1947 [1940]), p. 48. She never modeled for Degas. His only other mention of her cannot avoid recognizing her life work as an artist, but only in passing. She is noted among a large group of artists who painted portraits of Mme Maria Lani (p. 315).

39. Roy McMullen, *Degas, His Life, Times, and Work* (London: Secker & Warburg, 1985), p. 434.

40. Not to the degree of Utrillo, whose career was successfully managed by his stepfather André Utter, but she made a quite respectable income.

41. See Anne Higonnet, "Myths of Creation: Camille Claudel and Auguste Rodin," in *Significant Others: Creativity and Intimate Partnership,* edited by Whitney Chadwick and Isabelle de Courtivron (New York: Thames and Hudson, 1993), pp. 15–29, for Rodin's reputation as and experience of the sexual nature of artistic creativity. C. J. Bulliet, *The Courtezan Olympia: An Intimate Survey of Artists and Their Mistress Models* (New York: Covici Friede, 1930), p. 2, cited in Rosemary Betterton, "How Do Women Look?" in *Looking On: Images of Femininity in the Visual Arts and Media,* edited by Rosemary Betterton (New York: Pandora, 1987), p. 224. Betterton described this relationship as well: "Some male painters explicitly connected their artistic powers with sexual potency. Au-

guste Renoir . . . was alleged to have said: 'I paint with my prick' " (ibid.). Balzac, again, was preeminent in articulating this concept of woman as mistress and muse. See Gretchen R. Besser, *Balzac's Concept of Genius: The Theme of Superiority in the "Comédie humaine"* (Geneva: Librairie Droz, 1969), p. 215. Renoir later cited a conversation with Cézanne, in which Cézanne referred to models as sluts (Meyer Schapiro, *Modern Art: 19th & 20th Centuries, Selected Papers* [New York: George Braziller, 1982], p. 30).

42. Models were generally from the working class, and many may well have been prostitutes. France Borel, *The Seduction of Venus: Artists and Models* (New York: Skira / Rizzoli, 1990), p. 115, claimed (without reference) that "historically, the academic models were often women of easy virtue."

43. Rey, *Suzanne Valadon,* p. 7, says she was introduced to Degas by the sculptor Bartholomé, to whom Lautrec had shown her work.

44. Storm, *The Valadon Drama,* p. 87.

45. Ibid., pp. 88–89. Many others cite this statement. Valadon changed her name from Marie-Clémentine to Suzanne at the suggestion of either Toulouse-Lautrec, who according to Storm (p. 79), called it "too prosaic." Others have claimed that Degas suggested she change it. See also pp. 90–91.

46. Tabarant, *L'Oeuvre* (December 1921), cited in Rey, *Suzanne Valadon,* pp. 14–15.

47. Jacometti, *Suzanne Valadon,* n.p.

48. Aspects of art by avant-garde males, such as Van Gogh, also seen as wild or mad bohemians, were obscured as well. See Griselda Pollock on Van Gogh, "Agency and the Avant-Garde," *Block* 15 (1989): 4–15. However, for women conditioned by gender difference, this obfuscation took different and often less credible forms than in descriptions of art by men.

49. Her work employed "Post-Impressionist" (that is, Symbolist) color, brushstroke, and form. When she worked with Symbolist themes, she approached them very differently, as we shall see.

50. For examples of such artists, see Carol Duncan, "Virility and Domination in Early 20th Century Vanguard Painting," in Norma Broude and Mary D. Garrard, eds., *Feminism and Art History: Questioning the Litany* (New York: Harper and Row, 1982), pp. 293–313.

51. See Mathews, "Returning the Gaze," for this narrative strategy in other of Valadon's works.

52. I am indebted to Thalia Gouma-Peterson for this insight.

53. Betterton, "How Do Women Look?" pp. 227–28.

54. Warnod, *Suzanne Valadon,* p. 75: "Dans *La Joie de vivre* . . . de 1911 . . . , les nus maniérés aux gestes emphatiques s'ébattent devant un jeune athlète (Utter) dans une verdure naturelle."

55. Munch was in Paris from 1889 to 1892. See Robert Goldwater, *Symbolism* (New York: Harper and Row, 1979), p. 216.

56. Morris Berman, *Coming to Our Senses: Body and Spirit in the Hidden History of the West* (New York: Bantam Books, 1990), pp. 45ff., on the history of mirrors.

57. See Joan Riviere, "Womanliness as a Masquerade" (1929) in *Formations of Fantasy,* edited by Victor Burgin, James Donald, Cora Kaplan (London: Routledge, 1989), pp. 35–44.

58. "la vulgarité de cette femme qui fume, son accoutrement, l'attitude familière du corps épais et commun, de décor de bazar bariolé comme un tapis d'Orient, tout cela devait paraître ces caractéristiques qui imposent l'humanité, la force et la vérité de

l'oeuvre" ["the vulgarity of this smoking woman, her dress, the intimate posture of her thick and common body, the gawdy decor like an oriental tapestry, all this ought to make apparent the characteristics which give humanity, force and the strength to the work"]. Cited in the entry on this Valadon work in the *Museé d'Art Moderne: Catalogue des collections* (Paris: Centre Georges Pompidou, Beaubourg, 1986), p. 586.

59. See Clark, "Olympia's Choice," in *The Painting of Modern Life,* pp. 111–46.

60. A number of Gauguin's Tahitian nudes, some more similar in composition to Valadon's *Négresse,* could have been used here. However, the Metropolitan Museum image is so widely known and so benign—in the Washington/Chicago catalogue, it was called a "private viewing of a female realm" (Richard Brettell, Françoise Cachin, Claire Frèches-Thory, Charles F. Stuckey, *The Art of Paul Gauguin,* exhibition catalogue [National Gallery of Art, Washington, D.C.; The Art Institute of Chicago, 1988], p. 425)—that I thought it a better choice. Catalogue numbers refer to this text. Other images that bear comparison are *Te arii vahine (The Noble Woman),* 1896, Pushkin State Museum of Fine Arts, Moscow, catalogue no. 215; *Aita tamari vahine Judith te parari (The Child-woman Judith Is Not Yet Breached;* known as Annah the Javanaise), 1893–94, private collection, catalogue no. 160; *Te nave nave fenua (The Delightful Land),* 1892, Ohara Museum of Art, Kurashiki, Japan, catalogue no. 148; and *Parau na te varua ino (Words of the Devil),* 1892, National Gallery of Art, Washington, DC, catalogue no. 147.

61. Gilman, *Difference and Pathology,* pp. 112–13 and passim.

62. She was a mulatto woman, a mistress of Valadon's son, Maurice Utrillo. See Thérèse Diamand Rosinsky, *Suzanne Valadon* (New York: Universe, 1994), p. 93.

63. See especially Claudine Mitchell, "Intellectuality and Sexuality: Camille Claudel, the Fin-de-Siècle Sculptress," *Art History* 12, no. 4 (December 1989): 417–45.

64. See Eve Kosofsky Sedgwick, "The Privilege of Unknowing," *Genders* 1 (1988): 102–24.

65. Valadon seemed to have remained aloof toward feminist (or any other) politics generally but had several encounters in which she responded positively. "Sur l'invitation du peintre Marie-Anne Camax-Zoegger, et malgré sa répugnance pour la 'peinture de dames,' elle accepte de prendre part au Salon des Femmes Artistes Modernes, où elle exposera jusqu'à sa mort" ["On the invitation of the painter Marie-Anne Camax-Zoegger, and despite her repugnance for 'peinture de dames,' she agreed to take part in the Salon des Femmes Artistes Modernes, where she exhibited her work until her death"] (Dorival, *Suzanne Valadon,* p. 15).

CONCLUSIONS

1. Foucault, *La vonlonté de savoir,* cited in Alan Sheridan, *Michel Foucault: The Will to Truth* (New York: Tavistock, 1980), p. 186. My argument here also owes a debt to the works of Mikhail Bakhtin.

2. See Renato Poggioli, *The Theory of the Avant-Garde,* translated by Gerald Fitzgerald (New York: Harper & Row-Icon Editions, 1971; originally published in 1962), especially chaps. 1–4.

3. Peter Stallybrass and Allon White, *The Politics and Poetics of Transgression* (Ithaca, NY: Cornell University Press, 1986), p. 5. For a discussion of transgression as a strategy of bourgeois identity, see pp. 200–201.

4. See also Joan W. Scott, "Experience," *Feminists Theorize the Political,* edited by Judith Butler and Joan W. Scott (New York and London: Routledge, 1992), pp. 22–40.

Bibliography

Alaya, Flavia. "Victorian Science and the 'Genius' of Woman." *Journal of the History of Ideas* 38 (1977): 261–80.

Amishai-Maisels, Ziva. *Gauguin's Religious Themes*. New York: Garland Publishing, Inc., 1985.

Anderson, Wayne. *Gauguin's Paradise Lost*. New York: Viking Press, 1971.

Asselin, H. "Camille Claudel et les sirènes de la sculpture." *La Revue Française* (April 1966): 8.

———. "La Vie douloureuse de Camille Claudel, sculpteur." Deux émissions de la Radiodiffusion Télévision française, 1956.

Auerbach, Nina. *Woman and the Demon: The Life of a Victorian Myth*. Cambridge, MA: Harvard University Press, 1982.

Aurier Archives. Family Chateau, near Moulins, France.

Aurier, G.-Albert. "Deux Expositions: Berthe Morisot." *Mercure de France* (July 1892): 259–60.

———. "Deuxième Exposition des peintres impressionnistes et symbolistes." Exhibition Preface, Le Barc de Boutteville, Paris. Reprinted in *Mercure de France* (July 1892): 260–63.

———. *Oeuvres posthumes*. Edited by Remy de Gourmont. Paris: 1893.

———. "Théatre libre: 'Le Canard sauvage' d'Ibsen." *Mercure de France* (June 1891): 363–65.

———, ed. *Le Moderniste illustré*. Nos. 1–23 (6 April–28 September, 1889).

Auspitz, Katherine. *The Radical Bourgeoisie: The Ligue de l'enseignement and the Origins of the Third Republic, 1866–1885*. Cambridge: Cambridge University Press, 1982.

Ayral-Clause, Odile. "Camille Claudel, Jessie Lipscomb and Rodin." *Apollo* 146, no. 424 (1997): 21–26.

Bader, Clarisse. *La Femme française dans les temps modernes.* 2d ed. Paris: Perrin et Cie, 1885.

Ballet, Gilbert. *Rapports de l'hystérie et de la folie.* Clermont-Ferrand: G. Mont-Louis, 1894.

Balzac, Honoré. *Louis Lambert,* edited by Marcel Bouteron and Jean Pommier. Paris: Librairie José Corti, 1954.

———. *Oeuvres complètes.* Paris: Paul Ollendorff, 1904–52.

Bann, Stephen. *The Clothing of Clio: A Study of the Representation of History in Nineteenth-Century Britain and France.* Cambridge: Cambridge University Press, 1984.

Barrows, Susanna. *Distorting Mirrors: Visions of the Crowd in Late Nineteenth-Century France.* New Haven, CT: Yale University Press, 1981.

Bashkirtseff, Marie. *The Journal of Marie Bashkirtseff.* See entries under Rozsika Parker and Griselda Pollock; also Colette Cosnier.

Bataille, Georges. *Eroticism: Death and Sensuality.* Translated by Mary Dalwood. San Francisco: City Lights Books, 1986.

Battersby, Christine. *Gender and Genius: Towards a Feminist Aesthetics.* Bloomington: Indiana University Press, 1990.

Baudelaire, Charles. *Critique d'Art.* 2 vols. Edited by Claude Pichois. Paris: Librairie Armand Colin, 1965.

———. *Les Fleurs du mal.* Introduction to 1833 edition by Th. Gautier. Translated by Richard Howard. Boston: D. R. Godine, 1982.

———. *The Painter of Modern Life and Other Essays.* Translated and edited by Jonathan Mayne. Originally published in 1863. New York: Da Capo Press, 1986.

Beachboard, Robert. *La Trinité Maudite: Valadon—Utrillo—Utter.* Paris: Amiot-Dumont, 1952.

Bebel, Auguste. *La Femme dans le passé, le présent et l'avenir.* Presentation by Anne-Marie Sohn. Paris and Geneva: Ressources, Slatkine Reprints, 1979 (originally published, 1891).

Becker, George. *The Mad Genius Controversy: A Study in the Sociology of Deviance.* Beverly Hills: Sage Publications, 1978.

Benjamin, Walter. "Paris, Capital of the Nineteenth Century." In *Reflections: Essays, Aphorisms, Autobiographical Writings,* edited by Peter Demetz. New York: Harcourt Brace Jovanovich, 1978.

Bernheimer, Charles. "Degas's Brothels: Voyeurism and Ideology." *Representations* 20 (1987): 158–86.

Besnier, Niko. "Polynesian Gender Liminality Through Time and Space." In *Third Sex, Third Gender: Beyond Sexual Dimorphism in Culture and History,* edited by Gilbert Herdt. New York: Zone Books, 1996.

Besser, Gretchen R. *Balzac's Concept of Genius: The Theme of Superiority in the "Comédie humaine."* Geneva: Librairie Droz, 1969.

Betterton, Rosemary. "How Do Women Look?" In *Looking On: Images of Femininity in the Visual Arts and Media,* edited and with an Introduction by Rosemary Betterton, pp. 217–34. New York: Pandora, 1987.

Boime, Albert. "The Teaching of Fine Arts and the Avant-Garde in France During the Second Half of the Nineteenth Century." *Arts Magazine* (December 1985): 46–57.

Bois, Jules. *L'Eve nouvelle.* Paris: Léon Chailley, 1896.

———. "La Femme nouvelle." *Revue Encyclopédique.* No. 169 (1896): 832–33.

Bordo, Susan. *Unbearable Weight: Feminism, Western Culture, and the Body.* Berkeley: University of California Press, 1993.

Borel, France. *The Seduction of Venus: Artists and Models.* New York: Skira/Rizzoli, 1990.

Bourdieu, Pierre. *La Distinction: Critique social du jugement.* Paris: Minuit, 1979.

————. *Distinction: A Social Critique of the Judgement of Taste.* Translated by Richard Nice. Cambridge: Harvard University Press, 1984.

Brettell, Richard, Françoise Cachin, Claire Frèches-Thory, Charles F. Stuckey. *The Art of Paul Gauguin.* Exhibition catalogue, National Gallery of Art, Washington, DC; The Art Institute of Chicago, Chicago, 1988.

Brooks, Peter. "Gauguin's Tahitian Body." In *The Expanding Discourse: Feminism and Art History,* edited by Norma Broude and Mary D. Garrard, pp. 331–45. New York: HarperCollins, 1992.

Broude, Norma, and Mary D. Garrard, eds. *The Expanding Discourse: Feminism and Art History.* New York: Icon / HarperCollins, 1992.

————. *Feminism and Art History: Questioning the Litany.* New York: Harper and Row, 1982.

Broude, Norma. "Edgar Degas and French Feminism, ca. 1880): 'The Young Spartans,' the Brothel Monotypes, and the Bathers Revisited." *The Art Bulletin* 70 (December, 1988): 640–59.

Brunetière, F. "Revue Littéraire. Le Génie dans l'art, à l'occasion d'un livre récent." *Revue des Deux Mondes* 62, no. 2 (1884): 935–44.

Buchloh, Benjamin H. D., Serge Guilbaut, and David Solkin, eds. *Modernism and Modernity.* The Vancouver Conference Papers. Halifax: Press of the Nova Scotia College of Art and Design, 1983.

Bulliet, C. J. *The Courtezan Olympia: An Intimate Survey of Artists and Their Mistress-Models.* New York: Covici Friede, 1930.

Bürger, Peter. *Theory of the Avant-Garde.* Translated by Michael Shaw, with a foreword by Jochen Schulte-Sasse. Volume 4: *Theory and History of Literature.* Minneapolis: University of Minnesota Press, 1984.

Burhan, Filiz Eda. "Visions and Visionaries: Nineteenth-Century Psychological Theory, the Occult Sciences and the Formation of a Symbolist Aesthetic in France." 1979. Ph.D. diss. Princeton University.

Busst, A. J. L. "The Image of the Androgyne in the Nineteenth Century." In *Romantic Mythologies,* edited by Ian Fletcher. New York: Barnes & Noble, 1967.

Butler, Judith. *Gender Trouble: Feminism and the Subversion of Identity.* London: Routledge, 1990.

————. "Performative Acts and Gender Constitution: An Essay in Phenomenology and Feminist Theory." In *Performing Feminisms: Feminist Critical Theory and Theatre,* edited by Sue-Ellen Case, pp. 270–82. Baltimore: Johns Hopkins University Press, 1990.

Carco, Francis. *Le Nu dans la peinture moderne (1863–1920).* Paris: Crès, 1924.

Caren, François. *An Economic History of Modern France.* New York: Columbia University Press, 1979.

Cassar, Jacques. *Dossier Camille Claudel.* Paris: Librairie Séguier, 1987.

Charrier, Edmée. *L'Evolution intellectuelle féminine. Le Développement intellectuel de la femme. La Femme dans les professions intellectuelles.* Paris: Librairie du Recueil Sirey, 1937.

Cheetham, Mark. *The Rhetoric of Purity: Essentialist Theory and the Advent of Abstract Painting.* Cambridge, U.K.: Cambridge University Press, 1991.

Chéliga, Marya. "Les Femmes et les Féministes: Les Hommes Féministes." *Revue Encyclo-pédique* No. 169 (1896): 825–31.

Chipp, Herschel B. *Theories of Modern Art: A Source Book by Artists and Critics*. Berkeley: University of California Press, 1973 (1968).

Claris, E. *De l'Impressionisme en sculpture*. Paris: La Nouvelle Revue, 1902.

Clark, T. J. *The Painting of Modern Life: Paris in the Art of Manet and His Followers*. New York: Knopf, 1985.

Claudel, Paul. "Camille Claudel statuaire." *L'Occident* (August 1905).

———. *Journal*. 2 vols. Paris: Gallimard, 1968.

———. "Ma soeur Camille." Exhibition catalogue, Musée Rodin, 1951.

Clayson, Hollis. *Painted Love: Prostitution in French Art of the Impressionist Era*. New Haven: Yale University Press, 1991.

Copley, Antony. *Sexual Moralities in France, 1780–1980*. London: Routledge, 1989.

Corbin, Alain. *Les Filles de noce: Misère sexuelle et prostitution aux 19e et 20e siècles*. Paris: Aubier Montaigne, 1978.

———. *Filles de noce (Women for Hire: Prostitution and Sexuality in France after 1850)*. Translated by Alan Sheridan. Cambridge: Harvard University Press, 1990.

Cosnier, Colette. *Marie Bashkirtseff: Un portrait sans retouches*. Paris: P. Horay, 1985.

Crow, Thomas. "Modernism and Mass Culture in the Visual Arts." In *Modernism and Modernity*. The Vancouver Conference Papers, edited by Benjamin H. D. Buchloh, Serge Guilbaut, and David Solkin, pp. 215–64. Halifax: Press of the Nova Scotia College of Art and Design, 1983.

Darwin, Charles. *The Descent of Man*. Princeton, NJ: Princeton University Press, 1981 (originally published, 1871).

Delsemme, Paul. *Téodor de Wyzewa et le Cosmopolitisme Littéraire en France à l'époque du symbolisme*. Brussels: Presses Universitaires de Bruxelles, 1967.

———. *Un Théoricien du symbolisme: Charles Morice*. Paris: Nizet, 1958.

Denis, Maurice. *Du Symbolisme au classicisme: Théories*. Paris: Hermann, 1964 (originally published, 1912).

Deschamps, Dr. Albert. *La Femme nerveuse. Essai de psychologie et de psychoghrapie*. Clermont-Ferrand: G. Mont-Louis, 1892.

Devillier, G. "Le Travail des femmes. Opinions sur les aptitudes, l'éducation et les occupations féminines." *Revue Encyclopédique*, no. 169 (1896): 909.

Dictionnaire général de la langue française du commencement du XVIIe Siècle jusqu'à nos jours. Adolphe Hatzfeld et Arsène Darmesteter, eds. 2 vols. 6th ed. Paris: Librairie Delagrave, 1920.

Didi-Huberman, Georges. *Invention de l'Hystérie, Charcot et l'Iconographie photographique de la Salpêtrière*. Paris: Macula, 1982.

Dijkstra, Bram. *Idols of Perversity: Fantasies of Feminine Evil in Fin-de-Siècle Culture*. New York: Oxford University Press, 1986.

Doane, Mary Ann. *Femmes Fatales: Feminism, Film Theory, Psychoanalysis*. New York and London: Routledge, 1991.

Dorival, Bernard. Preface, *Suzanne Valadon*. Exhibition catalogue. Paris: Musée National d'Art Moderne, 1967.

Dorra, Henri, ed. *Symbolist Art Theories: A Critical Anthology*. Berkeley: University of California, 1994.

Driskel, Michael Paul. *Representing Belief: Religion, Art and Society in Nineteenth-Century France.* University Park: Pennsylvania State Press, 1992.

Dufour, Médéric. *Une Philosophie de l'impressionisme. Étude sur l'esthétique de Jules Laforgue.* Paris: Léon Vanier, A. Messein, 1904.

Duret, Th. *Critique d'avant-garde.* Paris: G. Charpentier, 1885.

Eagleton, Terry. *Ideology: An Introduction.* London: Verso, 1991.

———. *The Ideology of the Aesthetic.* Oxford: Basil Blackwell, 1990.

Eggum, Arne. "The Major Paintings," In *Edvard Munch: Symbols and Images.* Washington, D.C.: National Gallery of Art, 1978.

Ehrenreich, Barbara, and Deirdre English. *Complaints and Disorders: The Sexual Politics of Sickness.* Old Westbury, NY: Feminist Press, 1973.

———. *For Her Own Good: 150 Years of the Experts' Advice to Women.* Garden City, NY: Anchor Books, 1979.

Eisenman, Stephen F. *Gauguin's Skirt.* London: Thames and Hudson, 1997.

———. *The Temptation of Saint Redon: Biography, Ideology and Style in the "Noirs" of Odilon Redon.* Chicago: University of Chicago Press, 1992.

Elwitt, Sanford. *The Making of the Third Republic: Class and Politics in France, 1868–1884.* Baton Rouge: Louisiana State University Press, 1975.

Epstein, Cynthia Fuchs. *Deceptive Distinctions: Sex, Gender, and the Social Order.* New Haven and New York: Yale University Press, Russell Sage Foundation, 1988.

Evans, Martha Noel. *Fits and Starts: A Genealogy of Hysteria in Modern France.* Ithaca, NY: Cornell University Press, 1991.

Evett, Elisa. *The Critical Reception of Japanese Art in Late Nineteenth-Century Europe.* Ann Arbor: UMI Research Press, 1982.

Fausto-Sterling, Anne. *Myths of Gender: Biological Theories About Women and Men.* New York: Basic Books, Inc., 1985.

Feher, Michael. "Of Bodies and Technology." *Discussions in Contemporary Culture.* No. 1. Edited by Hal Foster. Seattle: Bay Press, 1987.

Feldman, Jessica R. *Gender on the Divide: The Dandy in Modernist Literature.* Ithaca, NY: Cornell University Press, 1993.

Fénéon, Félix. "The Impressionists in 1886." In *Nineteenth-Century Theories of Art,* edited by Joshua C. Taylor. Berkeley: University of California Press, 1987.

Fidell-Beaufort, Madeleine. "Elizabeth Jane Gardner Bouguereau: A Parisian Artist from New Hampshire." *Archives of American Art Journal* 24, no. 2 (1984): 2–9.

Foster, Hal. "For a Concept of the Political in Contemporary Art." In *Recodings: Art, Spectacle, Cultural Politics.* Port Townsend, WA: Bay Press, 1985.

Foucault, Michel. *The Archaeology of Knowledge and the Discourse on Language.* Translated by A. M. Sheridan Smith. New York: Pantheon Books, 1972.

———. *The History of Sexuality Volume I: An Introduction.* Translated by Robert Hurley. New York: Vintage Books, 1980 [1976].

———. *Madness and Civilization: A History of Insanity in the Age of Reason.* Translated by Richard Howard. New York: Vintage Books, 1973.

———. "Noam Chomsky and Michel Foucault. Human Nature: Justice Versus Power." In *Reflexive Water: The Basic Concerns of Mankind,* by A. J. Ayer, et al., edited by Fons Elders, pp. 168ff. London: Souvenir Press, 1974.

———. "The Subject and Power." In *Art After Modernism: Rethinking Representation,*

edited by Brian Wallis, pp. 417–32. New York: The New Museum of Contemporary Art, 1984.

Fouillée, Alfred. "Le Mouvement idéaliste en France." *Revue des Deux Mondes* 134 (1896): 276–304.

———. "La Psychologie des sexes et ses fondements physiologiques." *Revue des Deux Mondes* (15 September 1895).

———. *Tempérament et caractère selon les individus, les sexes et les races.* Edited by Félix Alcan. Paris: Germer-Baillière, 1901.

Frank, Louis. *L'Education domestique des jeunes filles ou la formation des méres.* Paris: Larousse, 1904.

———. *Essai sur la condition politique de la femme. Étude de sociologie et de législation.* Paris: Arthur Rousseau, 1892.

Frederick, Karl. *Modern and Modernism: The Sovereignty of the Artist, 1885–1925.* New York: Atheneum, 1985.

Frederickson, Kristen. "Carving Out a Place: Gendered Critical Descriptions of Camille Claudel and Her Sculpture." *Word & Image* 12, no. 2 (1996): 161–73.

Freeman, Judi. "Chronologies: Artists and the Spiritual." In *The Spiritual in Art: Abstract Painting 1890–1985,* edited by Edward Weisberger, pp. 393–419. Exhibition organized by Maurice Tuchman. Exhibition catalogue, Los Angeles County Museum of Art. New York: Abbeville Press, 1986.

Freud, Sigmund. *The Standard Edition of the Complete Psychological Works of Sigmund Freud.* 24 vols. Translated and edited by James Strachey. London: Hogarth Press and The Institute of Psycho-Analysis, 1953–74.

Galton, Francis, Sir. *Hereditary Genius: An Inquiry Into Its Laws and Consequences.* London: Macmillan and Co., Ltd., 1914 (originally published, 1869).

Gamman, Lorraine, and Margaret Marshment, eds. *The Female Gaze: Women as Viewers of Popular Culture.* Seattle: The Real Comet Press, 1989.

Garb, Tamar. "Berthe Morisot and the Feminizing of Impressionism." *Perspectives on Morisot,* introduced and edited by T. J. Edelstein, pp. 57–66. New York: Hudson Hills Press, 1990.

———. "'L'Art Féminin': The Formation of a Critical Category in Late Nineteenth-Century France." *Art History* 12 (March, 1989): 39–65.

———. "Renoir and the Natural Woman." *The Oxford Art Journal* 8 (1985): 3–15.

———. "Revising the Revisionists: The Formation of the Union des Femmes Peintres et Sculpteurs." *Art Journal* 48 (Spring, 1989): 63–70.

———. *Sisters of the Brush: Women's Artistic Culture in Late Nineteenth-Century Paris.* New Haven: Yale University Press, 1994.

Gaudichon, Bruno. "Catalogue." *Camille Claudel (1864–1943).* Exhibition catalogue. Musées Rodin Paris and Sainte-Croix, Poitiers. Paris: Musée Rodin, 1984.

Gauguin, Paul. *Correspondance de Paul Gauguin: Documents, Tèmoignages.* Edited by Victor Merlhès. Paris: Fondation Singer-Polignac, 1984.

———. *Intimate Journals.* Translation of *Avant et après* by Van Wyck Brooks. Preface by Emil Gauguin. New York: Liveright, 1949.

———. *Lettres de Paul Gauguin à Émile Bernard, 1888–1891.* Geneva: Pierre Cailler, 1954.

———. *Noa Noa.* Édition Définitive. Paris: G. Crès et Cie, 1929. (With Charles Morice; first published 1901.)

———. *Noa Noa*. Edited by André Balland. Preface, study, biography, notes and bibliography by Jean Loizé. Paris: A. Balland, 1966. (Gauguin's original MSS.)

———. *Noa Noa*. Translated by O. F. Theis. New York: Greenberg Publisher, 1927.

———. *Noa Noa: Gauguin's Tahiti*. Edited and introduced by Nicholas Wadley. Translated by Jonathan Griffin. Oxford: Phaidon, 1985. (New edition of Griffin's translation of Gauguin's original mss.)

———. *Noa Noa: Voyage to Tahiti*. Postscript by Jean Loizé. Translated by Jonathan Griffin. Oxford: Bruno Cassirer, 1961. (Translation of Gauguin's original mss.)

———. *Oviri: Écrits d'un sauvage*. Texts chosen and presented by Daniel Guérin. Paris: Gallimard, 1974.

———. *The Writings of a Savage*. Edited by Daniel Guérin. Translated by Eleanor Levieux. Introduced by Wayne Anderson. New York: Viking Press, 1978.

Geffroy, Gustave. "Le Travail des femmes. Opinions sur les aptitudes, l'éducation et les occupations féminines." *Revue Encyclopédique*. No. 169 (1896): 909.

Gelburd, Gail. *Androgyny in Art*. Catalogue. Hempstead, NY: Emily Lowe Gallery, Hofstra University, 1982.

Genné, Beth. "Two Self-Portraits by Berthe Morisot." *Psychoanalytic Perspectives on Art* 2 (1987): 133–70.

Gillespie, Michael Allen. *Hegel, Heidegger, and the Ground of History*. Chicago: University of Chicago Press, 1984.

Gilman, Sander L. *Difference and Pathology: Stereotypes of Sexuality, Race, and Madness*. Ithaca, NY: Cornell University Press, 1985.

Goldstein, Jan. *Console and Classify: The French Psychiatric Profession in the Nineteenth Century*. Cambridge: Cambridge University Press, 1987.

Goldwater, Robert. *Symbolism*. New York: Harper and Row, 1979.

Gould, Stephen Jay. *The Mismeasure of Man*. New York: W. W. Norton & Co., 1981.

Gourmont, Remy de. "L'art et le peuple." *Style* (July 1899): 197.

———. *Chemin*. Fragments IV, "Sur le rôle de l'art." 1899.

———. *L'idéalisme*. Paris: Mercure de France, 1893.

———. *Le Livre des masques: portraits symbolistes: gloses et documents sur les écrivains d'hier et d'aujourd'hui*. Paris: Mercure de France, 1891.

———. "Le Symbolisme." *La Revue Blanche* 6 (June 1892): 322.

Green, Nicholas. *The Spectacle of Nature: Landscape and Bourgeois Culture in Nineteenth-Century France*. Manchester, U.K.: Manchester University Press, 1990.

Guinon, Georges. *Les Agents Provocateurs de l'hystérie*. Paris: Delahaye et Lecrosnier, 1889.

Hall, Stuart, and Tony Jefferson, eds. *Resistance through Rituals: Youth Subcultures in Post-War Britain*. London: Hutchinson, 1976.

Halperin, Joan Ungersma. *Félix Fénéon: Aesthete and Anarchist in Fin-de-Siècle Paris*. New Haven, CT: Yale University Press, 1988.

———. "Scientific Criticism and 'le beau moderne' of the Age of Science." *Art Criticism* 1 (1979): 55–71.

Haraway, Donna. *Primate Visions: Gender, Race, and Nature in the World of Modern Science*. New York: Routledge, 1989.

———. *Simians, Cyborgs, and Women: The Reinvention of Nature*. London: Free Association Books, 1991.

Heiderich, Ursula. "The Muse and her Gorgon's Head: On the Problem of Individuation

in the Work of Camille Claudel." Translated by John Ormrod. In *Rodin: Eros and Creativity,* edited by Rainer Crone and Siegfried Salzmann, pp. 222–26. Munich: Prestel-Verlag, 1992.

Heller, Reinhold. "Some Observations Concerning Grim Ladies, Dominating Women, and Frightened Men Around 1900." *The Earthly Chimera and the Femme Fatale: Fear of Woman in Nineteenth-Century Art.* Chicago: University of Chicago Press, 1981.

Herbert, Eugenia W. *The Artist and Social Reform: France and Belgium, 1885–1898.* New York: Books for Libraries, division Arno Press, 1980 (originally published, 1961).

Higonnet, Anne. *Berthe Morisot.* New York: Harper & Row, 1990.

———. *Berthe Morisot's Images of Women.* Cambridge: Harvard University Press, 1992.

———. "Myths of Creation: Camille Claudel and Auguste Rodin." In *Significant Others: Creativity and Intimate Partnership,* edited by Whitney Chadwick and Isabelle de Courtivron, pp. 15–29. New York: Thames and Hudson, 1993.

Higonnet, Margaret Randolph, Jane Jenson, Sonya Michel, and Margaret Collins Weitz, eds. *Behind the Lines: Gender and the Two World Wars.* New Haven: Yale University Press, 1987.

Horkheimer, Max. *Critical Theory.* Translated by Matthew J. O'Connell. New York: Seabury Press, 1972.

Horkheimer, Max, and Theodor W. Adorno. *Dialectic of Enlightenment.* Translated by John Cumming. New York: Herder and Herder, 1972 (originally published, 1944).

Horney, Karen. "The Dread of Woman." In *Feminine Psychology,* edited by Harold Kelman. New York: W. W. Norton, 1967.

House, John, and MaryAnne Stevens, eds. *Post-Impressionism: Cross-Currents in European Painting.* Exhibition catalogue. Royal Academy of Arts. London: Weidenfeld and Nicolson, 1979.

Huret, Jules. *Enquête sur l'Evolution littéraire.* Vanves: Les Éditions Thot, 1982. Reprint, *L'Echo de Paris* (3 March–5 July 1891).

Hutton, Patrick H., editor-in-chief. *Historical Dictionary of the Third French Republic, 1870–1940.* London: Aldwych, 1986.

Huysmans, J. K. *Against the Grain.* Translated by John Howard. Introduced by Havelock Ellis. New York: Lieber & Lewis, 1922 (originally published, 1888).

Huyssen, Andreas. "Mass Culture as Woman: Modernism's Other." In *Art Theory and Criticism: An Anthology of Formalist Avant-Garde, Contextualist, and Post-Modernist Thought,* edited by Sally Everett. Jefferson, NC: McFarland and Co., 1991.

Imanse, Geurt. "Occult Literature in France." In *The Spiritual in Art: Abstract Painting 1890–1985,* edited by Edward Weisberger, pp. 355–60. Exhibition organized by Maurice Tuchman. Exhibition catalogue, Los Angeles County Museum of Art. New York: Abbeville Press, 1986.

Jacobus, Mary. *Reading Woman: Essays in Feminist Criticism.* New York: Columbia University Press, 1986.

Jacometti, Nesto. *Suzanne Valadon.* Geneva: P. Cailler, 1947.

Jayne, Kristie. "The Cultural Roots of Edvard Munch's Images of Women." *Woman's Art Journal* 10 (Spring/Summer 1989): 28–34.

Jensen, Robert. *Marketing Modernism in Fin-de-Siècle Europe.* Princeton: Princeton University Press, 1994.

Jirat-Wasiutynski, Vojtech. "Paul Gauguin in the Context of Symbolism." Ph.D. dissertation. Princeton University, 1975.

Joly, Henri. *Psychologie des grands hommes.* 2d ed. Paris: Librairie Hachette et Cie, 1891.

Jordanova, Ludmilla. *Sexual Visions: Images of Gender in Science and Medicine between the Eighteenth and Twentieth Centuries.* Madison, WI: University of Wisconsin Press, 1989.

Jullian, Philippe. *The Symbolists.* Translated by MaryAnne Stevens. London: Phaidon, 1973.

Kaplan, E. Ann. "Is the Gaze Male?" In *Powers of Desire: The Politics of Sexuality,* edited by Ann Snitow, Christine Stansell, and Sharon Thompson, pp. 309–27. New York: Monthly Review Press, 1983.

Kishtainy, Khalid. *The Prostitute in Progressive Literature.* London and New York: Allison and Busby, 1982.

Kristeva, Julia. *Powers of Horror: An Essay on Abjection.* Translated by Leon S. Roudiez. New York: Columbia University Press, 1982.

"La Femme moderne par elle-même." *Revue Encyclopédique,* no. 169 (1896): 841–95.

Lacan, Jacques. *Feminine Sexuality: Jacques Lacan and the "École freudienne."* Edited and introduced by Juliet Mitchell and Jacqueline Rose. Translated by Jacqueline Rose. New York and London: W. W. Norton & Co. and Pantheon Books, 1985.

Laforgue, Jules. *Oeuvres Complètes: Mélanges Posthumes.* 7th ed. Paris: Société du Mercure de France, 1919.

Lehmann, A. G. *The Symbolist Aesthetic in France, 1885–1895.* Oxford: Basil Blackwell, 1950.

Lejay, Julien. "L'Economie politique et la méthode synthétique." *La Plume* 3 (15 July 1892): 325.

Lerner, Harriet E. "The Hysterical Personality: A Woman's Disease." In *Women and Mental Health,* edited by Elizabeth Howell and Marjorie Bayes. New York: Basic Books Inc., 1981.

Le Symbolisme en Europe. Exhibition catalogue. Entries by Geneviève Lacambre. Paris: Éditions des Musées Nationaux, 1976.

Levi, Eliphas (Alphonse Constant). *Fables et symboles avec leur explication où sont révélés les grands secrets de la direction du magnétisme universel et des principes fondamentaux du grand oeuvre.* Paris: Germer-Baillière, 1862.

———. *Histoire de la magie.* Paris: Germer-Baillière, 1860.

Levine, Steven Z. "Monet, Fantasy, and Freud." In *Psychoanalytic Perspectives on Art.* Edited by Mary Matthews Gedo. No. 1 (1985): 29–55.

Linker, Kate. "Representation and Sexuality." In *Art After Modernism: Rethinking Representation.* Edited by Brian Wallis, pp. 391-415. New York: New Museum of Contemporary Art; Boston: David R. Godine Publisher, Inc., 1984.

Lipton, Eunice. *Looking Into Degas: Uneasy Images of Women and Modern Life.* Berkeley: University of California Press, 1986.

Lombroso, Césare. *L'Homme de génie.* Preface by Charles Richet. Paris: F. Alcan, 1889.

———. *La Femme criminelle et la prostituée.* Translated by Guglielmo Ferrero. Paris: F. Alcan, 1896.

———. *The Man of Genius.* Translation from the Italian. London: Walter Scott, Ltd., 1898.

Loubert, Jacques. *Le Problème des Sexes.* Paris: V. Giard et E. Brière, 1900.

MacFarlane, Alan. *The Culture of Capitalism.* Oxford: Basil Blackwell Ltd., 1987.

MacOrlan, Pierre. *Montmartre: Souvenirs.* Brussels: Chabassol, 1946.

Magraw, Roger. *France 1815–1914: The Bourgeois Century.* New York and Oxford: Oxford University Press, 1986.

Mainardi, Patricia. *Art and Politics of the Second Empire: The Universal Expositions of 1855 and 1867*. New Haven: Yale University Press, 1987.

———. *The End of the Salon: Art and the State in the Early Third Republic*. Cambridge: Cambridge University Press, 1993.

Marion, H. *Psychologie de la femme*. Paris: Colin, 1905.

Marlais, Michael. *Conservative Echoes in Fin-de-Siècle Parisian Art Criticism*. University Park: Pennsylvania State University Press, 1992.

———. "Conservative Style/Conservative Politics: Maurice Denis in Le Vésinet." *Art History* 16 (March 1993): 125–46.

Martin-Fugier, Anne. *La Bourgeoise, Femme au temps de Paul Bourget*. Paris: Bernard Grasset, 1983.

Mathews, Patricia. *Aurier's Symbolist Art Criticism and Theory*. Ann Arbor: UMI Research Press, 1986.

———. "Aurier and Van Gogh: Criticism and Response." *The Art Bulletin* 68 (March 1986): 94–104.

———. "The Gender of Creativity in the French Symbolist Period." In *Women and Reason*, edited by Elizabeth D. Harvey and Kathleen Okruhlik, pp. 163–85. Ann Arbor: University of Michigan Press, 1992.

———. "Passionate Discontent: The Creative Process and Gender Difference in the French Symbolist Period." *Allen Memorial Art Museum Bulletin* 43 (Summer 1988): 21–30.

———. "Returning the Gaze: Diverse Representations of the Nude in the Art of Suzanne Valadon." *The Art Bulletin* 73 (September 1991): 415–30.

Mauclair, Camille. "Choses d'Art." *Mercure de France* 13 (February 1895): 235–38.

———. "Note sur l'Idée Pure." *Mercure de France* 6 (September 1892).

———. "Pour l'idéalisme." *Essais d'Art Libre* I (July 1892).

McDougall, Kathleen Mary. "Sexuality and Creativity in the 1890s: Economy of Self in the Social Organism." Ph.D. diss., Department of English, University of Toronto, 1995.

McMillan, James F. *Housewife or Harlot: The Place of Women in French Society, 1870–1940*. New York: St. Martin's Press, 1981.

McMullen, Roy. *Degas: His Life, Times and Work*. London: Secker and Warburg, 1985.

Mercier, Alain. *Le Symbolisme français: Les sources ésotériques et occultes de la poésie symboliste, 1870–1914*. Paris: Nizet, 1969.

Michaud, Guy. *Message poétique du symbolisme*. Paris: Librairie Nizet, 1947.

Michelet, Jules. *Woman (La Femme)*. Translated by J. W. Palmer. New York: Rudd & Carleton, 1860.

Mill, J. S. *L'Assujettissement des femmes*. Translated from English by John Milner. In *Symbolists and Decadents*. London and New York: Studio Vista/Dutton, 1971.

Miller, Michael B. *The Bon Marché: Bourgeois Culture and the Department Store*. Princeton: Princeton University Press, 1981.

Milner, John. *Symbolists and Decadents*. London and New York: Studio Vista/Dutton, 1971.

Mirbeau, Octave. "Ça et là." *Le Journal quotidien littéraire, artistique et politique* (12 May 1895).

Mitchell, Claudine. "Intellectuality and Sexuality: Camille Claudel, the Fin-de-Siècle Sculptress." *Art History* 12, no. 4 (1989): 417–45.

Moi, Toril, ed. *The Kristeva Reader*. New York: Columbia University Press, 1986.

Moore, George. *Modern Painting*. London: Walter Scott, Ltd., 1898.

Moréas, Jean. "Les Décadents," *Les Premières armes du symbolisme*, pp. 28–34. Edited by Léon Vanier. Paris: Léon Vanier, 1889.

———. "Les Poètes décadents." In *Les Premières armes du symbolisme*, pp. 28-34. Edited by Léon Vanier. Paris: Léon Vanier, 1889.

Moreau, Gustave. "Moreau's Commentaries." In *Gustave Moreau*, exhibition catalogue edited by Julius Kaplan. Los Angeles: Los Angeles County Museum of Art, 1974.

Moreau de Tours, J. *La Psychologie morbide dans ses rapports avec la philosophie de l'histoire, ou de l'influence des névropathies sur le dynamisme intellectuel*. Paris: V. Masson, 1859.

Morhardt, Mathias. "Mlle Camille Claudel." *Mercure de France* (March 1898).

Morice, Charles. *Le Christ de Carrière*. Paris: Édition de la Libre Esthétique, 1899.

———. *La Littérature de tout à l'heure*. Paris: Perrin et Cie, 1889.

———. *Paul Gauguin*. Paris: H. Floury, 1919.

Morisot, Berthe. *The Correspondance de Berthe Morisot*. Edited by Denis Rouart. Paris: Quatre Chemins, 1950.

———. *Correspondence of Berthe Morisot*. Translated by Betty Hubbard. Edited by Denis Rouart. Introduction and notes by Kathleen Adler and Tamar Garb. London: Camden Press, 1986.

Moses, Claire Goldberg. *French Feminism in the Nineteenth Century*. Albany: State University of New York Press, 1984.

Mosse, George L. *Nationalism and Sexuality: Respectability and Abnormal Sexuality in Modern Europe*. New York: Howard Fertig, 1985.

Musée d'Art Moderne: Catalogue des collections. Paris: Centre Georges Pompidou, Beaubourg, 1986.

Nietzsche, Friedrich. "On the Uses and Disadvantages of History for Life" 1874. In *Untimely Meditations*. Translated by R. J. Hollingdale. Cambridge: Cambridge University Press, 1983.

———. *The Will to Power*. Translated by Walter Kaufmann and R. J. Hollingdale. Edited by Walter Kaufmann. New York: Random House, 1968.

Nord, Philip G. *Paris Shopkeepers and the Politics of Resentment*. Princeton, NJ: Princeton University Press, 1986.

Nordau, Max. *Degeneration*. Translated from 2nd ed. of the German [no name given]. New York: D. Appleton and Co., 1896.

———. *Psycho-Physiologie du génie et du talent*. Translated from the German by Auguste Dietrich. Paris: Félix Alcan, 1898.

Nye, Robert A. *Crime, Madness & Politics in Modern France*. Princeton, NJ: Princeton University Press, 1984.

O'Connor, Francis V. "The Psychodynamics of the Frontal Self-Portrait." *Psychoanalytic Perspectives on Art* 1 (1985): 169–221. "The Psychodynamics of Modernism: A Postmodern View. Part I. Baudelaire and the Elementalism of Melancholy," *Psychoanalytic Perspectives on Art* 2 (1987).

Olander, William R. "Ferdnand Khnopff, Art or the Caresses." *Arts Magazine* 51 (June 1977): 116–21.

Orwicz, Michael R. "Anti-Academicism and State Power in the Early Third Republic." *Art History* 14 (1991): 571–92.

Owen, Alex. *The Darkened Room: Women, Power and Spiritualism in Late Victorian England*. Philadelphia: University of Pennsylvania Press, 1990.

Pacteau, Francette. "The Impossible Referent: Representations of the Androgyne." In *Formations of Fantasy,* edited by Victor Burgin, James Donald, and Cora Kaplan. London: Routledge, 1989.

Paris, Reine-Marie. *Camille Claudel.* Exhibition catalogue. Washington, DC: The National Museum of Women in the Arts, 1988.

———. *Camille Claudel (1864–1943).* Paris: Éditions Gallimard, 1984.

———. *Camille: The Life of Camille Claudel, Rodin's Muse and Mistress.* Translated from the French, *Camille Claudel 1864–1943* (1984), by Liliane Emery Tuck. New York: Seaver Books, 1988.

Paris, Reine-Marie, and Arnaud de la Chapelle. *L'Oeuvre de Camille Claudel: Catalogue raisonné.* Paris: Adam Biro, 1991.

Parker, Rozsika, and Griselda Pollock. *The Journal of Marie Bashkirtseff.* Translated by Mathilde Blind. London: Virago, 1985.

———. *Old Mistresses: Women, Art and Ideology.* New York: Pantheon Books, 1981.

Péladan, Joséphin. *Comment on devient fée. Erotique.* Vol. II. *Amphithéâtre des science mortes.* 3 vols. Paris: Chamuel et Cie, 1893.

———. *La Queste du graal.* Paris: Salon de la Rose + Croix, 1892.

———. *La Décadence Latine: Éthopée. Le Vice suprême,* vol. 1; *L'Androgyne,* vol. 8; *La Gynandre,* vol. 9. Paris: Laurent, 1886–1926. Reprint: Geneva: Slatkine, 1979.

Perrot, Michelle. "The New Eve and the Old Adam: Changes in French Women's Condition at the Turn of the Century." Translated by Helen Harden-Chenut. In *Behind the Lines: Gender and the Two World Wars,* edited by Margaret Randolph Higonnet, Jan Jenson, Sonya Michel, Margaret Collins Weitz, pp. 51–60. New Haven: Yale University Press, 1987.

Perry, Gill. *Women Artists and the Parisian Avant-Garde.* Manchester and New York: Manchester University Press, 1995.

Pick, Daniel. *Faces of Degeneration: A European Disorder, c.1848–c.1918.* Cambridge: Cambridge University Press, 1989.

Pigeaud, Jackie. "Le Génie et la folie: Étude sur la 'Psychologie morbide . . .' de J. Moreau de Tours." In *Art et Folie. Littérature, Médecine, Société,* no. 6, edited by Jackie Pigeaud. Nantes: Université de Nantes, 1984.

Pingeot, Anne, ed. *"L'Age mûr" de Camille Claudel.* Exhibition catalogue, Musée d'Orsay. Paris: Éditions de la Réunion des Musées Nationaux, 1989.

Poggioli, Renato. *The Theory of the Avant-Garde.* Translated by Gerald Fitzgerald. New York: Harper and Row, Icon Editions, 1971 (originally published, 1962).

Pollock, Griselda. "Agency and the Avant-Garde." *Block* 15 (1989): 4–15.

———. *Avant-Garde Gambits 1888–1893: Gender and the Color of Art History.* New York: Thames and Hudson, 1993.

———. "Modernity and the Spaces of Femininity." In *Vision and Difference: Femininity, Feminism and Histories of Art,* pp. 50–90. New York: Routledge, 1988.

Poovey, Mary. "'Scenes of an Indelicate Character': The Medical 'Treatment' of Victorian Women." *Representations,* no. 14 (Spring 1986).

Porter, Roy. *A Social History of Madness: The World Through the Eyes of the Insane.* New York: Weidenfeld and Nicolson, 1987.

Praz, Mario. *The Romantic Agony.* 2d ed. Translated from the Italian by Angus Davidson. New York: Oxford University Press, 1954.

Price, Sally. *Primitive Art in Civilized Places.* Chicago: University of Chicago Press, 1989.

Proudhon, P.-J. *La Pornocratie ou les femmes dans les temps modernes.* Paris: A. Lacroix, 1875.

Puckett, Elisabeth. "The Symbolist Criticism of Painting: France, 1880–1895." Ph.D. diss., Bryn Mawr, n.d. (1940s).

Rearick, Charles. *Pleasures of the Belle Epoque: Entertainment and Festivity in Turn-of-the-Century France.* New Haven, CT: Yale University Press, 1985.

Renooz, Mme C. "Charcot dévoilé." *Revue scientifique des femmes* I (1888).

Réval, Gabrielle. "Les Artistes femmes au Salon de 1903." *Femina,* no. 55 (1 May 1903): 520–21.

Rewald, John. *Post-Impressionism from Van Gogh to Gauguin.* 3d ed. rev. New York: Museum of Modern Art, 1978.

Rey, Robert. *Suzanne Valadon: Les Peintres Français Nouveaux.* No. 14. Paris: Éditions de la nouvelle revue française, 1922.

Reynolds, Kimberley, and Nicola Humble. *Victorian Heroines: Representations of Femininity in Nineteenth-Century Literature and Art.* New York: New York University Press, 1993.

Ribot, Th. *L'Hérédité psychologique,* 2d ed. Paris: Librairie Germer-Baillière, 1882.

Riviere, Joan. "Womanliness as a Masquerade." In *Formations of Fantasy,* edited by Victor Burgin, James Donald, and Cora Kaplan, pp. 35–44. London: Routledge, 1989 (originally published, 1929).

Rivière, Anne. *L'Interdite: Camille Claudel, 1864–1943.* Paris: Éditions Tierce, 1987.

Rivière, Anne, Bruno Gaudichon, and Danielle Ghanassia. *Camille Claudel: Catalogue raisonné.* Paris: Adam Biro, 1996.

Roger-Marx, Claude. "Les Dessins de Suzanne Valadon." In *Suzanne Valadon: Dessins, Pastels.* Exhibition catalogue. Paris: Galerie Paul Pétridès, 1962.

Rosen, Charles, and Henri Zerner. *Romanticism and Realism: The Mythology of Nineteenth-Century Art.* New York: W. W. Norton and Co., 1984.

Rosinsky, Thérèse Diamand. *Suzanne Valadon.* New York: Universe Publishing, 1994.

Rotonchamps, J. de. *Paul Gauguin, 1848–1903.* Introduction by J. P. Stern. Paris: Crès, 1925.

Rubinstein, David. *Before the Suffragettes: Women's Emancipation in the 1890s.* New York: St. Martin's Press, 1986.

Russett, Cynthia Eagle. *Sexual Science: The Victorian Construction of Womanhood.* Cambridge: Harvard University Press, 1989.

Saisselin, Rémy G. *The Bourgeois and the Bibelot.* New Brunswick, NJ: Rutgers University Press, 1984.

Schapiro, Meyer. *Modern Art: 19th & 20th Centuries, Selected Papers.* New York: George Braziller, 1982.

Schiller, Friedrich. *Lettres sur l'éducation esthétique. Oeuvres de Schiller.* 8 Volumes. Edited and translated by Ad. Régnier. Paris: Hachette, 1859-62.

Schopenhauer, Arthur. *The World as Will and Representation.* Translated by E. F. J. Payne. 2 vols. New York: Dover, 1969.

Schubert, Gudrun. "Women and Symbolism: Imagery and Theory." *The Oxford Art Journal* 3 (April 1980): 29–34.

Schuré, Edouard. *Les Grands initiés.* Paris, 1889. Reprint, Paris: Perrin et Cie, 1960.

Scott, Joan W. "Experience." In *Feminists Theorize the Political,* edited by Judith Butler and Joan W. Scott, pp. 22–40. New York: Routledge, 1992.

Séailles, Gabriel. *Essai sur le Génie dans l'Art.* Paris: F. Alcan, 1883; second edition 1897.

Sedgwick, Eve Kosofsky. *Between Men: English Literature and Male Homosocial Desire.* New York: Columbia University Press, 1985.

————. "The Beast in the Closet: James and the Writing of Homosexual Panic." In *Sex, Politics, and Science in the Nineteenth-Century Novel,* edited by Ruth Bernard Yeazell, pp. 148–86. Selected Papers from the English Institute, 1983–84, New Series, no. 10. Baltimore: The Johns Hopkins University Press, 1986.

————. "The Privilege of Unknowing." *Genders* 1 (1988): 102–24.

Sekula, Allan. "The Body and the Archive." *October* 39 (1986): 3–64.

Sérusier, Paul. *ABC de la Peinture.* Paris: Librairie Floury, 1950.

Shaw, Jennifer. "The Figure of Venus: Rhetoric of the Ideal and the Salon of 1863." *Art History* 14, no. 4 (December 1991): 540–70.

Sheon, Aaron. "Van Gogh's Understanding of Theories of Neurosis, Neurasthenia and Degeneration in the 1880s." In *Van Gogh 100.* Edited by Joseph D. Masheck. Westport CT: Greenwood Press, 1996.

Sheridan, Alan. *Michel Foucault: The Will to Truth.* New York: Tavistock, 1980.

Shiff, Richard. *Cézanne and the End of Impressionism: A Study of the Theory, Technique, and Critical Evaluation of Modern Art.* Chicago: University of Chicago Press, 1984.

Showalter, Elaine. *The Female Malady: Women, Madness, and English Culture, 1830–1980.* New York: Penguin Books, 1987.

————. *Sexual Anarchy: Gender and Culture at the Fin de Siècle.* New York: Viking, 1990.

Silverman, Debora Leah. "Nature, Nobility, and Neurology: The Ideological Origins of 'Art Nouveau' in France, 1889–1900." Ph.D. diss., Princeton University, 1983. Ann Arbor, MI: University Microfilms International.

————. "The 'New Woman,' Feminism, and the Decorative Arts in Fin-de-Siècle France." In *Eroticism and the Body Politic,* edited by Lynn Hunt, pp. 144–63. Baltimore: The Johns Hopkins University Press, 1991.

Simmel, Georg. "The Metropolis and Mental Life." In *Classic Essays on the Culture of Cities,* edited by Richard Sennett, pp. 47–60. Englewood Cliffs, NJ: Prentice-Hall, Inc., 1969.

Skultans, Vieda. *Madness and Morals.* London: Routledge & Kegan Paul, 1975.

Smith-Rosenberg, Carroll. "The New Woman as Androgyne: Social Disorder and Gender Crisis, 1870–1936." In *Disorderly Conduct: Visions of Gender in Victorian America,* edited by Carroll Smith-Rosenberg, pp. 245–349. New York: Knopf, 1985.

Solomon-Godeau, Abigail. "Going Native." *Art in America* 77, no. 7 (July 1989): 118–29, 161.

————. *Male Trouble: A Crisis in Representation.* London: Thames and Hudson, 1997.

————. "The Primitivism Problem." Book Review. *Art in America* (February 1991): 41–45.

————. "Male Trouble: A Crisis in Representation." *Art History* 16 (June 1993): 286–312.

Sonn, Richard D. *Anarchism and Cultural Politics in Fin-de-Siècle France.* Lincoln: University of Nebraska Press, 1989.

Spackman, Barbara. *Decadent Genealogies: The Rhetoric of Sickness from Baudelaire to D'Annunzio.* Ithaca, NY: Cornell University Press, 1989.

Spitz, Ellen Handler. "A Critique of Pathography: Freud's Original Psychoanalytic Approach to Art." *Psychoanalytic Perspectives on Art.* Edited by Mary Mathews Gedo. Volume 1 (1985): 7–28.

Stallybrass, Peter, and Allon White. *The Politics and Poetics of Transgression.* Ithaca, NY: Cornell University Press, 1986.

Starkie, Enid. *Baudelaire*. Norfolk, CT: New Directions, 1958.

Stearns, Peter N. *Be a Man! Males in Modern Society*. 2d ed. New York and London: Holmes & Meier, 1990.

Storm, John. *The Valadon Drama: The Life of Suzanne Valadon*. New York: E. P. Dutton & Co., 1959.

Taine, Hippolyte. *Notes sur Paris: Vie et opinionis de M. Frédéric Thomas Graindorge*. Paris: Hachette, 1901.

———. *Philosophie de l'Art*. Paris: 1865.

Taylor, Joshua C., ed. *Nineteenth-Century Theories of Art*. Berkeley: University of California Press, 1987.

Terdiman, Richard. *Discourse/Counter-Discourse: The Theory and Practice of Symbolic Resistance in Nineteenth-Century France*. Ithaca, NY: Cornell University Press, 1985.

Torgovnick, Marianna. *Gone Primitive: Savage Intellects, Modern Lives*. Chicago: University of Chicago Press, 1990.

Toulouse, Edouard. *Enquête médico-psychologique sur les rapports de la supériorité intellectuelle avec la névropathie*. Paris: Société d'Éditions Scientifiques, 1896.

Tristan, Flora. *Flora Tristan's London Journal, 1840*. Translation of *Promenades dans Londres* by Dennis Palmer and Giselle Pincetl. Charlestown, MA: Charles River Books, 1980.

———. *The Workers' Union*. Translated and introduced by Beverly Livingston. Urbana: University of Illinois Press, 1983.

Uzanne, Octave. *La Femme à Paris, nos contemporaines; notes successive sur les parisiennes de ce temps dans leurs divers milieu, état et conditions*. Paris: Ancienne Maison Quantin, 1894.

———. *The Modern Parisienne*. London: W. Heinemann, 1912 (originally published, 1894).

———. *Parisiennes de ce temps en leurs divers milieux, états et conditions*. Paris: Mercure de France, 1910.

Valadon, Suzanne. *Suzanne Valadon*. Exhibition catalogue. Paris: Musée National d'Art Moderne. Preface by Bernard Dorival. Paris: Réunion des Musées Nationaux, 1967.

———. *Suzanne Valadon*. Exhibition catalogue, Martigny, Switzerland, Fondation Pierre Gianadda. Director of the exhibition, Daniel Marchesseau. Martigny: Fondation Pierre Gianadda, 1996.

Valéry, Paul. "Tante Berthe." In *Degas, Manet, Morisot*. Translated by David Paul. Vol. 12 of *The Collected Works of Paul Valéry*. New York: Pantheon, 1960.

Van Gogh, Vincent. *The Complete Letters of Vincent Van Gogh*. Translated by J. Van Gogh-Bonger. Greenwich, CT: New York Graphic Society, 1958.

Vanier, Léon, ed. *Les Premières Armes du symbolisme*. Paris: Léon Vanier, 1889.

Varnedoe, Kirk. "Gauguin." In *Primitivism in 20th Century Art: Affinity of the Tribal and the Modern*, 2 vols., edited by William Rubin. Paris: Flammarion, 1991.

Veblen, Thorstein. *The Theory of the Leisure Class*. New York: Dover Publications, 1994.

Veith, Ilza. *Hysteria: The History of a Disease*. Chicago: University of Chicago Press, 1965.

Véron, Eugene. *L'Esthétique*. Paris: C. Reinwald et Cie., 1878.

de Vigny, Alfred. *Oeuvres complètes*. 2 vols. Edited by F. Baldensperger. Paris: Gallimard, 1948.

Wagner, Richard. "Écrit sur Beethoven." Translated by Téodor de Wyzewa. *La Revu wagnérienne* (1934): 38–39.

Wajeman, Gerard. *Le Maître et l'hystérique*. Paris: Navarin, 1982.

Warnod, Jeanine. *Suzanne Valadon*. Paris: Flammarion, 1981.

Weber, Eugen. *France: Fin de Siècle*. Cambridge, MA: Belknap Press, 1986.

Weber, Max. *The Protestant Ethic and the Spirit of Capitalism*. Translated by Talcott Parsons. Los Angeles: Roxbury Publishing Co., 1998 (originally published 1904).

Weil, Kari. *Androgyny and the Denial of Difference*. Charlottesville: University Press of Virginia, 1992.

Weinberg, H. Barbara. *The Lure of Paris: Nineteenth-Century American Painters and Their French Teachers*. New York: Abbeville Press, 1991.

Weininger, Otto. *Sex and Character*. Translated from German. London: William Heinemann, 1975 (originally published, 1903).

Weisberger, Edward, ed. *The Spiritual in Art: Abstract Painting 1890–1985*. Organized by Maurice Tuchman. Exhibition catalogue, Los Angeles County Museum of Art. New York: Abbeville Press, 1986.

Welsh, Robert P. "Sacred Geometry: French Symbolism and Early Abstraction." In *The Spiritual in Art: Abstract Painting 1890–1985,* edited by Edward Weisberger. Exhibition organized by Maurice Tuchman. Pp. 63–88. Exhibition catalogue, Los Angeles County Museum of Art. New York: Abbeville Press, 1986.

Wernick, Robert. "Camille Claudel's Tempestuous Life of Art and Passion." *Smithsonian* 16 (September 1985): 57–62.

Wilenski, R. H. *Modern French Painters*. London: Faber & Faber, 1947 (originally published, 1940).

Williams, Linda. "When the Woman Looks." In *Re-Visions: Essays in Feminist Film Criticism,* edited by Patricia Mellencamp, Mary Ann Doane, and Linda Williams, pp. 83–99. Frederick, MD: University Publishers of America, 1984.

Williams, Raymond. *Culture and Society 1780–1950*. London: Chatto & Windus, 1958.

Williams, Rosalind H. *Dream Worlds: Mass Consumption in Late Nineteenth-Century France*. Berkeley: University of California Press, 1982.

Wolff, Janet. *Feminine Sentences: Essays on Women and Culture*. Berkeley: University of California Press, 1990.

Wright, Gordon. *France in Modern Times: 1760 to the Present*. Chicago: Rand McNally, 1960.

de Wyzewa, Téodor. *Nos Maîtres: Études et Portraits Littèraires*. Paris: Perrin et Cie, 1895.
———. *Peintres de jadis et d'aujourd'hui*. Paris: Perrin et Cie, 1903.

Zeldin, Theodore. *France, 1848–1945*. 2 vols. Oxford: Clarendon, 1973.

Zizek, Slavoj. *The Sublime Object of Ideology*. London: Verso, 1989.

Zola, Émile. *L'Oeuvre*. Paris: Bibliothèque-Charpentier, 1902.

Index